Heavenly Beauty

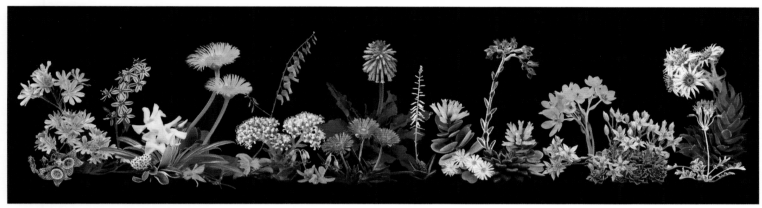

Art Photography of Succulents

天外奇妍 多肉植物艺术摄影

李长顺 著
Li Changshun

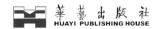

华艺出版社
HUAYI PUBLISHING HOUSE

图书在版编目（CIP）数据

天外奇妍：多肉植物艺术摄影/李长顺著．
—北京：华艺出版社，2011.10
ISBN 978-7-80252-338-8

Ⅰ．①天… Ⅱ．①李… Ⅲ．①植物－艺术摄影－中国
－现代－摄影集 Ⅳ．①J429.5

中国版本图书馆CIP数据核字(2011)第198014号

天外奇妍
——多肉植物艺术摄影

著　　者	李长顺
出 版 人	石永奇
责任编辑	郑治清
装帧设计	海　洋
出版发行	華藝出版社
地　　址	北京市海淀区北四环中路229号海泰大厦10层
邮政编码	100191
网　　站	www.huayicbs.com
印　　刷	北京雅昌彩色印刷有限公司
开　　本	787×1092毫米　1/8
印　　张	41.75
版　　次	2011年11月北京第1版
印　　次	2011年11月北京第1次印刷
书　　号	ISBN 978-7-80252-338-8/J · 031
定　　价	860.00元

Heavenly Beauty
-- Art Photography of Succulents

Author Li Changshun

Director Shi Yongqi

Executive Editor Zheng Zhiqing

Art Director Hai Yang

Publisher HuaYi Publishing House

目 录 | Contents

序

美的晶莹剔透！美的饱满润泽！美的含蓄内敛！

这是打开李长顺先生《天外奇妍·多肉植物艺术摄影》大型画册的惊叹。

摄影作为一门艺术，与书法、绘画一样，具有直观、生动、夺目的效果，都是给人以真、善、美的视觉享受。中国传统艺术，一直以自然为最高准则。老子曰："人法地，地法天，天法道，道法自然"。中国古代，无论诗词歌赋、音乐绘画，都以表现自然为主要方向，在彰显自然美的同时，又注重"动情于中"、"寄情山水"。薄薄一本《诗经》，描写的鸟兽虫鱼就多达110种，草木蔬果有134种。"桃之夭夭，灼灼其华"，散发出的是生机与活力。"采采芣苢，薄言有之"，被寄予的是少女的缱绻情怀。"采采卷耳，不盈顷筐"，是为"嗟我怀人"。果树小草处处都流动着诗意和情趣。

人有云：从心灵观世界，以艺术悟人生。中国的传统，不仅强调以物传情，更重视借物明志，始终强调把艺术作品视为容纳儒家推崇道、德、仁、义的一种载体。孔子有言："志于道，据于德，依于仁，游于艺"。艺讲究"外师造化，中得心源"，要以大自然为师，在学习大自然、描绘大自然之外，更要将大自然的美与人自身内在的信仰与品行合二为一，这才是"尽善尽美"。陶渊明的"采菊东篱下，悠然见南山"，就是以不屑争艳春夏、独享寒凉秋意的菊花，象征自己不与世俗同流的品格。"冰霜正惨凄，终岁常端正。岂不罹凝寒，松柏有本性"，在赞颂松柏经寒不衰、清刚坚劲之时，亦彰显了坚韧不屈、大义凛然的正气。

然而，现代社会随着科学技术的高歌猛进，人们越来越流于肤浅，贪图安逸，追求享乐。豪车洋房、绯闻八卦、游戏传奇、快餐文化充斥着人们的大脑、禁锢着人们的思维，让人忘却了自然、丧失了想象。人们再也难以感悟花鸟虫鱼的私语静谧，再也难以凝听丝

竹管弦的清音幽韵，再也无法体会轻车俊马之奔驰、飘风急雨之骤至的快意。

幸运的是李长顺先生这本大型画册给了我们一份希望，让我们有了重新认识大自然、触摸大自然、感悟大自然的机会。李长顺先生是我的老领导，对我有知遇之恩。他为人正直、学养深厚，在音乐、戏剧、语言方面都有专攻，书法造诣更是不凡。李长顺先生是位有心人、用心人。其不仅在摄影领域，在多肉植物养植方面，亦可称得上是国内首屈一指的专家。李长顺先生所拍摄的这些作品不仅反映了作者摄影技艺之精妙，展现了作者对自然大美的极致追求和痴醉，同时也深刻地蕴喻着作者对世界、对人生的一种包容、谦和、达观的态度。

这本大型画册呈送给广大读者的是一次美的释怀、美的洗礼、美的享受，我相信读者在阅读欣赏当中必能把天下奇妍变成自己心中的奇艳。

中华文化发展促进会副会长 辛旗

二〇一一年九月六日

Foreword

These plants look so radiant! So brimming with life! So elegant!

These were my first impressions of the amazing succulents collected in *Heavenly Beauty: Art Photography of Succulents* by Mr. Li Changshun.

Photography, like calligraphy and painting, is the art of creating visual enjoyment by capturing truth, kindness and beauty in an intuitive and appealing manner. In the traditional Chinese arts, nature has always been valued as the ultimate standard of excellence. Laozi, an ancient Chinese philosopher and founder of Taoism, believed that "Man takes Earth as its model; Earth takes Heaven as its model; Heaven takes Tao as its model; Tao takes what is natural as its model." In poetry, music, painting or any other art forms, ancient artists concentrated their efforts on recreating natural beauty while emphasizing emotional interaction with the subject matter, yielding works which are both evocative and expressive of deep emotion. *The Book of Poetry*, the earliest existing collection of Chinese poems, depicts as many as 110 types of animals and mentions no less than 134 kinds of plants. "The peach tree beams so red; how brilliant are its flowers!" That's how nature reveals its renewed vigor. "We gather plantain ears. Let's gather them with cheers!" That's what young girls sing, expressing their great passion for life. "I gather the mouse-ear; with a basket to fill." That's what the lonely wife thought to herself, as she absent-mindedly filled her basket because "I miss my husband dear." In a word, even grass and fruit trees can give color to life and inspire poetic creation.

It's said that one should see the world with the heart and contemplate life through art. Chi-

nese artists traditionally use physical objects to give free rein to their feelings and, more importantly, present their ethical and philosophical ideas by embodying the Confucian concepts of morality, humaneness and righteousness in their works. As Confucius said, "Let the will be set on the path of duty. Let every attainment in what is good be firmly grasped. Let perfect virtue be accorded with. Let relaxation and enjoyment be found in the polite arts." A famous painter in ancient China once claimed that "Outwardly nature has been my teacher; but inwardly I follow the springs of inspiration in my own heart." While seeking inspiration from nature, artists should perfect their skills by combining natural beauty with their personal morality. In writing "I pick fenceside asters at will; carefree I see the southern hill", the ancient poet Tao Yuanming, detached from worldly desires, imagined himself as an unyielding aster that stands in the chilly air to defend its pride against flamboyant flowers growing in warmer weather. "Though ice and frost look sad and drear, the tree stands straight throughout the year. Does it not fear the biting cold? It stands on its own as of old." These verses are not only paying tribute to the hardiness and uprightness of the pine tree, but also advocating its tenacity and awe-inspiring righteousness.

Back in the modern world, people are more shallow-minded than ever as science and technology continue to advance. In frantic pursuit of pleasure and material well-being, they are obsessed with fancy cars, and houses, and fast-food culture featuring celebrity gossip, worthless games and hollow stories. With their minds strangled, they are out of touch with nature and have thus lost their imaginations. They can never hear the little whispers among animals and plants, nor do they appreciate the unpolished tones produced by traditional

musical instruments. Gone are the days when people let themselves go on galloping horses or in driving rain and howling wind.

It's a relief, however, that Mr. Li has given us a gleam of hope with this extensive album, which reintroduces nature into modern life and reminds us of its wonders. As my former mentor, Mr. Li has helped me build my career. As an honorable and learned man, he has extensive knowledge of music, theatre and language; in addition, he's even an accomplished calligrapher. Mr. Li always keeps his mind sharp and is a leading expert on succulent cultivation as well as photography. The photos in this album, created with his refined photography skills, exhibit his persistent pursuit of and attachment to the wonders of nature, and explain his reflections on life and the world in a tolerant, modest and optimistic way.

This album is an extraordinary visual experience for all readers. I am confident that it will leave heavenly beauty imprinted on your mind.

Xin Qi, Vice President, China Association for Promotion of Culture

Sep. 6, 2011

前　言

　　李长顺先生的大型画册《天外奇妍·多肉植物艺术摄影》，是他继《天外奇妍·李长顺仙人掌及多肉植物养植与摄影》后，又一部独具魅力的精彩力作。他以独特的视角和艺术感知，娴熟的光影驾驭，向我们展现了一个无比神奇、瑰丽的多肉植物世界。

　　这是一部奇趣之书。相信每一个翻阅它的人，都会为它独有的魅力所吸引，为它强烈的视觉冲击所震撼。李长顺先生爱好广泛，所涉猎的领域无不苛求完美、精致。积年频繁的外事活动使他具有广阔的视野、丰富的历练和至高的追求。厚积而薄发，对书画、文学、戏曲、收藏的痴迷使他的摄影作品蕴含着丰富的文化内涵。创新是摄影艺术永恒的追求。摄影题材和对象的雷同，源于摄影者视角的雷同。李长顺先生正是以一种不甘趋步、锐意创新的精神，独辟蹊径，涉足于这个几乎无人涉足的多肉植物世界，耗时数年，历经辛苦，完成了这部彰显个性与深度的呕心沥血之作。李长顺先生也是著名的仙人掌和多肉植物养植专家，画册中许多植物珍品都是他自己培育养植的。对多肉植物性征的充分了解、对多肉花卉的深情倾注，才使得这一帧帧画面拍摄得如此生动和传情。画册中许多花卉都是国内外难得一见的珍稀或濒危物种，能把她们最美丽、灿烂的瞬间拍摄下来并汇集成册，难度之大，实非常人所能。没有一番辛勤的奔波、求索和积累是很难完成的。因此，这也更凸显了这本画册的弥足珍贵。

　　多肉植物就广义而言，包括了仙人掌科和其它科的肉质植物，是一个涉及几十个科、近一万种植物的大家族。由于仙人掌科植物种类繁多，栽培普遍，且具有刺座这一特殊器官，习惯上将它们单列出来，称仙人掌类植物，而把其它科的肉质植物仍称为多肉植物。这本画册拍摄的就是除仙人掌类之外的各种多肉植物。

　　多肉植物主要分布于美洲和非洲大陆，其它地区和我国也有部分分布。多肉植物可

分为叶多肉植物、茎多肉植物和茎基型多肉植物。为适应干旱的环境，它们的叶、茎或露出地表的根部变得肥厚多汁，以贮存更多的水分。这一极具观赏性的植物类群因其独特的风姿备受人们的喜爱，世界各地的植物园林都专辟有多肉植物的展区和温室供人们观赏。多肉植物还具有极高的经济和实用价值。如早在数百年前就已传入我国的芦荟，就是兼具药用、保健和美容等多种功效的著名多肉植物。多肉植物在代谢方式上也与众不同。由于它们多生长于干旱、半干旱地区，其植株的气孔白天关闭以减少水分的蒸发，夜间打开气孔，吸收二氧化碳，呼出氧气。在越来越注重健康、环保的今天，多肉植物这一独特的代谢方式使它愈来愈成为人们居室、案头的新宠。

当我们第一次看到像卵石一样的植物从"石缝"中开出艳丽的花朵时，无不为之惊叹。这种叫做"生石花"的多肉植物是如此可爱而奇特。而这仅仅是多肉植物世界万千奇特中的一点而已。这些美丽的生灵纷繁多彩，形态各异。它们有的端严劲秀，有的婀娜妖柔，有的绚丽夺目，有的淡雅清新。由于地理条件的不同，它们有的株形高大，如高达一二十米的马达加斯加象腿木和澳大利亚的昆士兰瓶树；有的则小如石砾，如非洲的肉锥花等番杏科植物。那些茎干粗壮的块根类植物，则如古木老枝，酷似我国的盆景树桩。多肉植物的花形态多样，大小悬殊，或形同秋菊，或状似海星，或宛若飞蝶，或垂如吊钟；有的花径微至毫米，有的可达数十公分。它们颠覆了国人对花卉的传统形象和概念，让人们由衷地慨叹大千世界的无奇不有和大自然的鬼斧神工。产于美洲的大型龙舌兰需栽培数年甚至数十年才得开花。高大的柱状花序高达数米，顶部繁花密布如黄罗伞盖，谓为壮观。一旦花落子熟，植株很快枯亡。这一枯一荣，诠释着生命的延续和伟大。

花卉是美与爱的象征，是幸福与友谊的象征，是梦想，是希望。它使我们看到了人们赖以生存的这个世界更多的灿烂与精彩。中国是爱花的国度，花卉资源丰富，养植历史悠久，栽培技术精湛。近年来，我国的多肉植物养植事业发展迅速，已拥有一大批养植业者和众多的爱好者，多肉花卉也已逐渐走进国人的家庭。身处楼厦喧嚣的闹市，人们渴望亲近绿色，渴望大树合抱、绿荫匝地，渴望千花万蕊，姹紫嫣红。《天外奇妍》的出版，引领我们走进了这个令人神往的绿色世界，让我们得以领略这迥然不同的光影和色彩，尽情感受大自然赐予我们的美好的一切。

编者

二〇一一年六月十六日

Foreword

Heavenly Beauty: Art Photography of Succulents is Mr. Li Changshun's latest major photo album, an exciting follow-up to Heavenly Beauty: Li Changshun's Cultivation and Photography of the Cacti and other Succulents. Using his refined artistic sense and photography skills, Mr. Li unfolds the wonderful world of succulents from unusual angles.

This is an intriguing photo album, one that will fascinate readers and provide them with extraordinary visual experiences. Mr. Li Changshun pursues perfection in all his various interests. Years devoted to international exchanges have broadened his horizons and elevated his artistic pursuits. He takes keen interest in painting and calligraphy, literature, Chinese opera and art collecting, and these in turn add a cultural dimension to his photographic works. Photographic art is constantly in pursuit of creativity. The predictable choice of subjects often seen in photography has its roots in photographers' limited artistic sense. Mr. Li, however, looks at these almost ignored succulents with an unconventional and creative mind, and has put years of hard work into this enlightening album marked by his individual style. Mr. Li is also an expert on cacti and succulents, and he has cultivated many of the rarities collected in the album by himself. It's his encyclopedic knowledge of succulents and passion for their flowers that bring these photographs to life. Although a number of the collected flowers are rare or endangered species both in China and abroad, he has somehow managed to present their most glorious moments in this album, something that would have been impossible without numerous tiring trips and serious studies over the past few years. These features make the album even more valuable.

Succulents, in the broad sense, include members of Cactaceae and succulents plants of other families, covering dozens of families and nearly ten thousand species. Cactaceae are diverse and widespread, and have all evolved the areole, the signature structure that identifies them as cacti. This family is distinct from other succulent plants which are more commonly referred to as succulents and featured in this album.

Succulents are native to the Americas and Africa and also found in other regions including China. They're subdivided into leaf succulents, stem succulents and caudiciform succulents. To adapt to arid climates or soil conditions, they've developed succulent leaves, stems or roots above the soil surface to store water. This plant group is highly ornamental and enjoys wide popularity, as exemplified by collections held by botanical gardens worldwide in their exhibitions or greenhouses. Succulents also have significant economic and practical value. *Aloe*, for example, was first introduced into China hundreds of years ago and gained renown for its medicinal effects and use in health and beauty treatments. Succulents have a unique method of metabolism. Since they mainly grow in arid and semi-arid regions, their stomatas remain closed during the day to minimize water loss and stay open during night hours to capture carbon dioxide and release oxygen. This distinctive mechanism has contributed to their popularity as houseplants among people increasingly concerned with health and the environment.

It's always breathtaking the first time you see beautiful flowers emerge from the "fissures" between the leaves of those pebble-like plants. Often known as "living stones," these lovely plants represent a microcosm of the fascinating world of succulents. The beautiful creatures range in shape from upright to snaky and in color from flamboyant to delicate. Geographical differences have helped create the towering 10-20 meter Madagascar's Moringa or Queen-

sland Bottle Tree native to Australia, as well as the pebble-sized *Conophytums* and other Mesembs native to Africa. The disproportionately thick-stemmed caudiciform and pachycaul succulents come in the shape of time-worn tree trunks or dwarf trees like those commonly seen in Chinese pot gardening. Flowers of succulents take various forms and can resemble *Chrysanthemums*, starfish, butterflies or pendant clocks. They also vary from several millimeters to several centimeters in diameter. Succulents have reversed the traditional images of flowers and enhanced our admiration for the unpredictability of nature. The large agaves native to the Americas only produce flowers after years or even decades of cultivation. In some species soaring inflorescences rise several meters high and bear a cluster of visually impressive flowers, only to die shortly after the mature flowers fall off. This cycle of growth and decay embodies the unending grandeur of life.

Flowers give expression to beauty and love as well as happiness and friendship. They carry with them dreams and hopes, and they give a clearer picture of our beautiful world. Ornamental plants are popular and abundant in China, and the country has a long and rich history of cultivation. Recent years have seen a rapid rise in cultivation of succulents in China by a large group of specialists and enthusiasts, which indicates their increasing popularity. Amid the clamorous concrete jungles, people want to feel closer to nature, to shady trees and blooming flowers. Heavenly Beauty guides us into this entrancing green world and gives a taste of the visual feast of our amazing natural world.

Editor
June 16, 2011

综合篇
Overview

走进奇特的多肉植物世界
Amazing Succulents

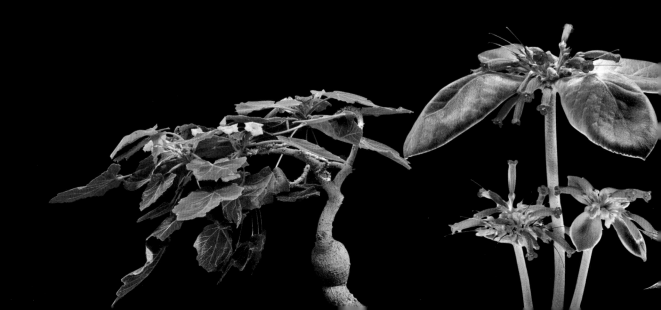

13

姹紫嫣红 *Beautiful and luxuriant*

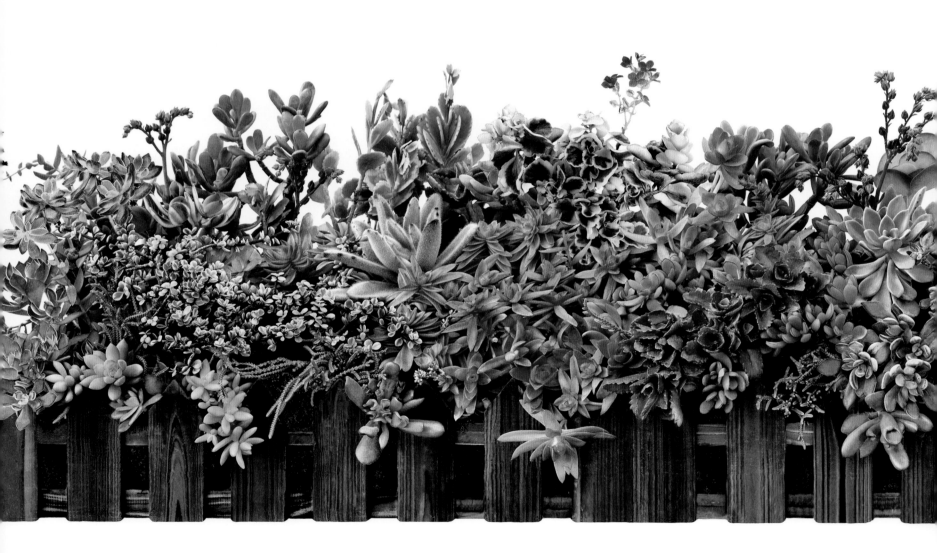

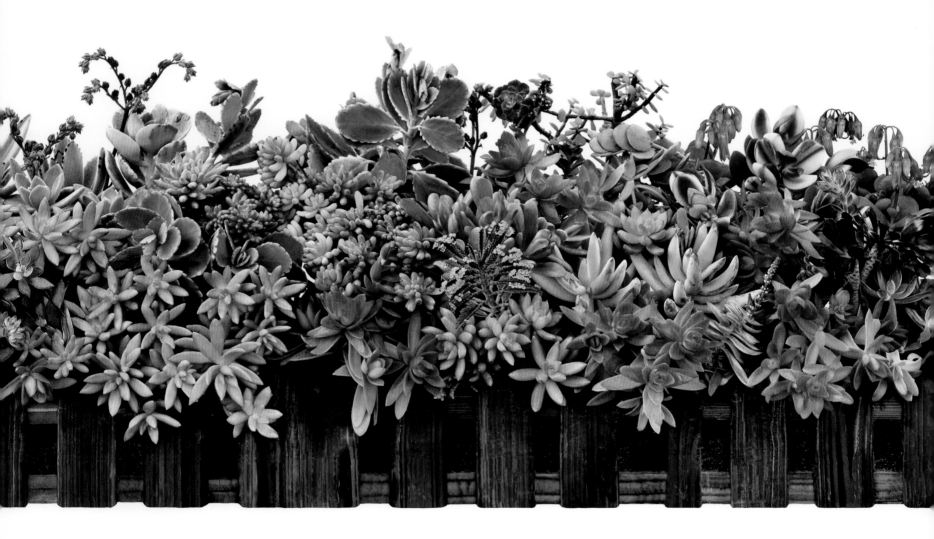

玉洁冰清 *Pure and noble*

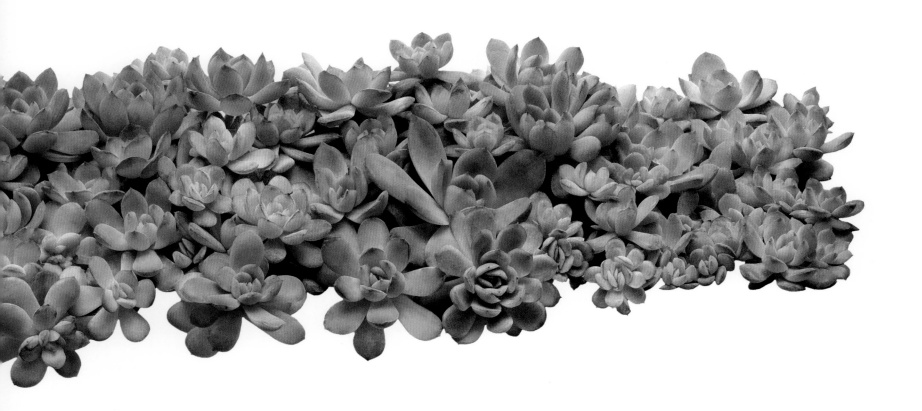

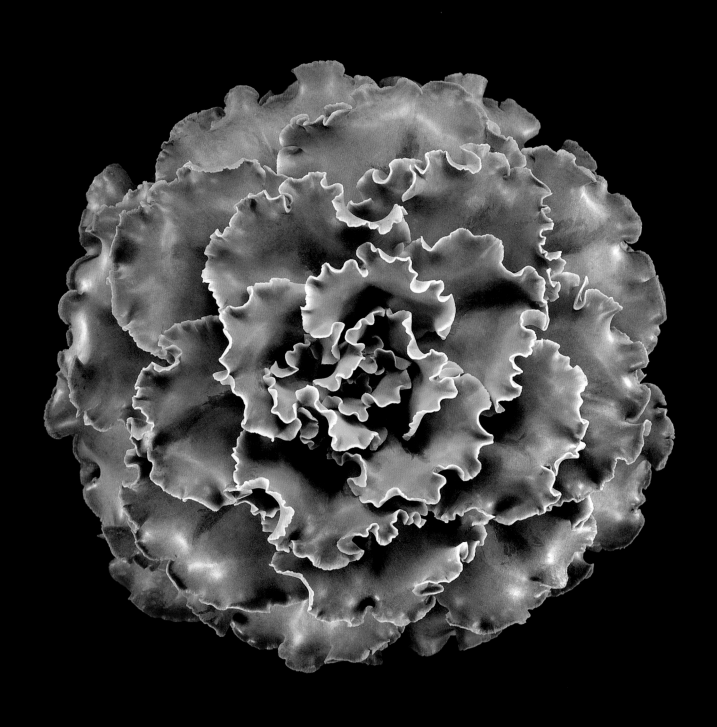

高砂之翁
Echeveria ' Takasagono-okina '

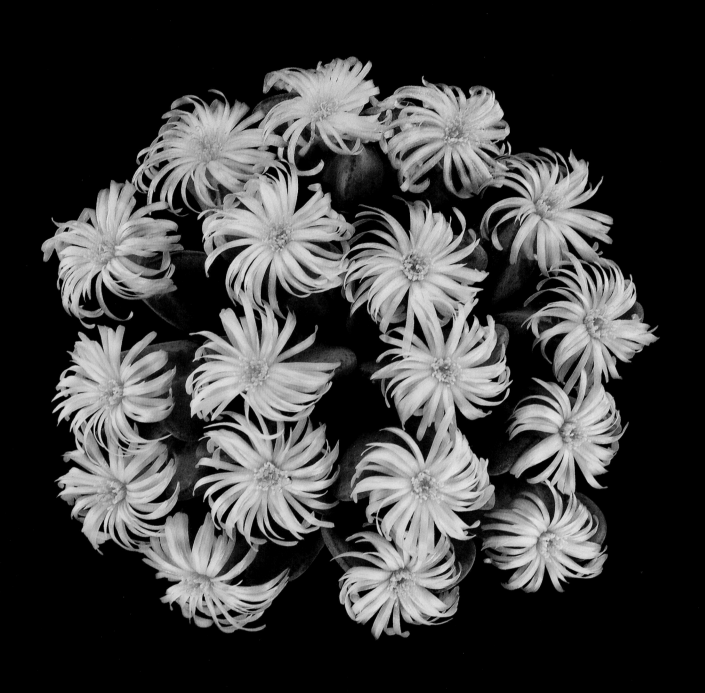

小菊之舞
Conophytum ' Kogikunomai'

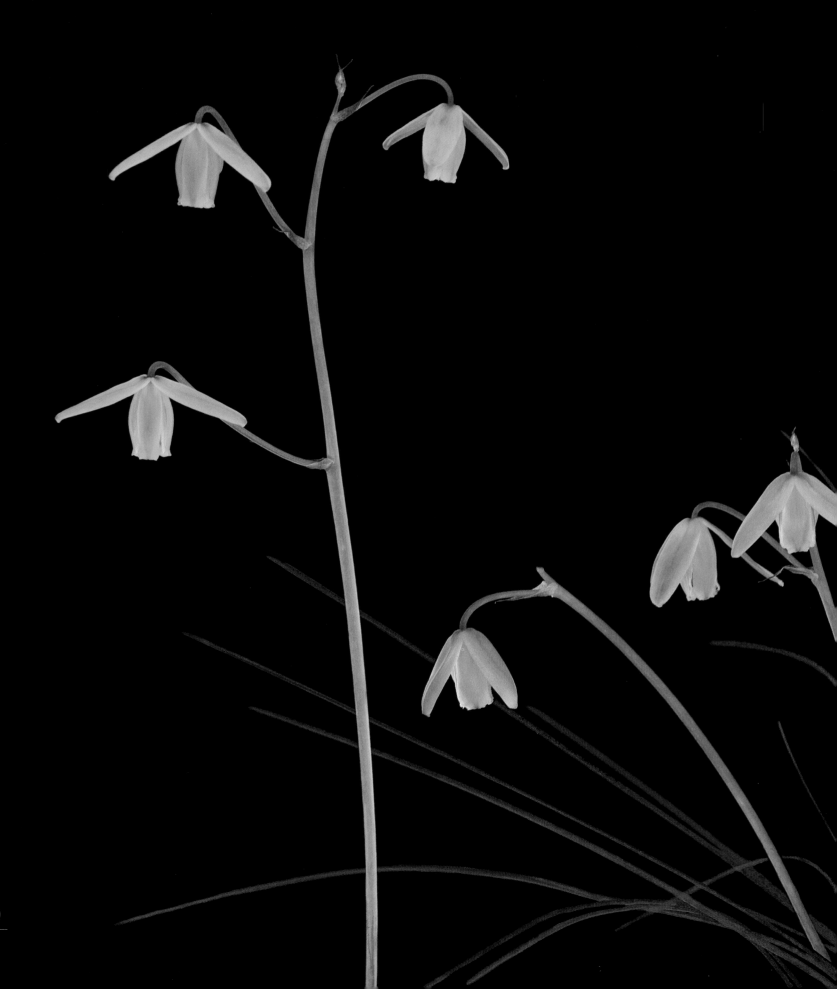

哨兵花
Albuca shawii

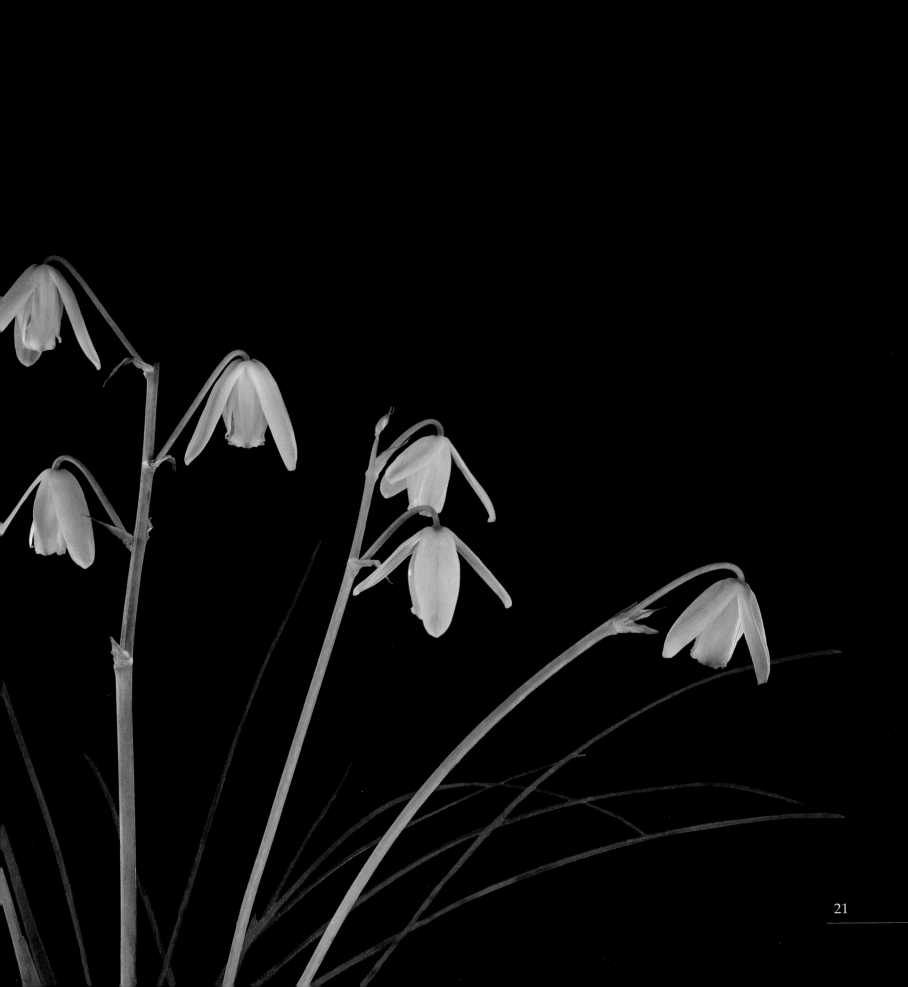

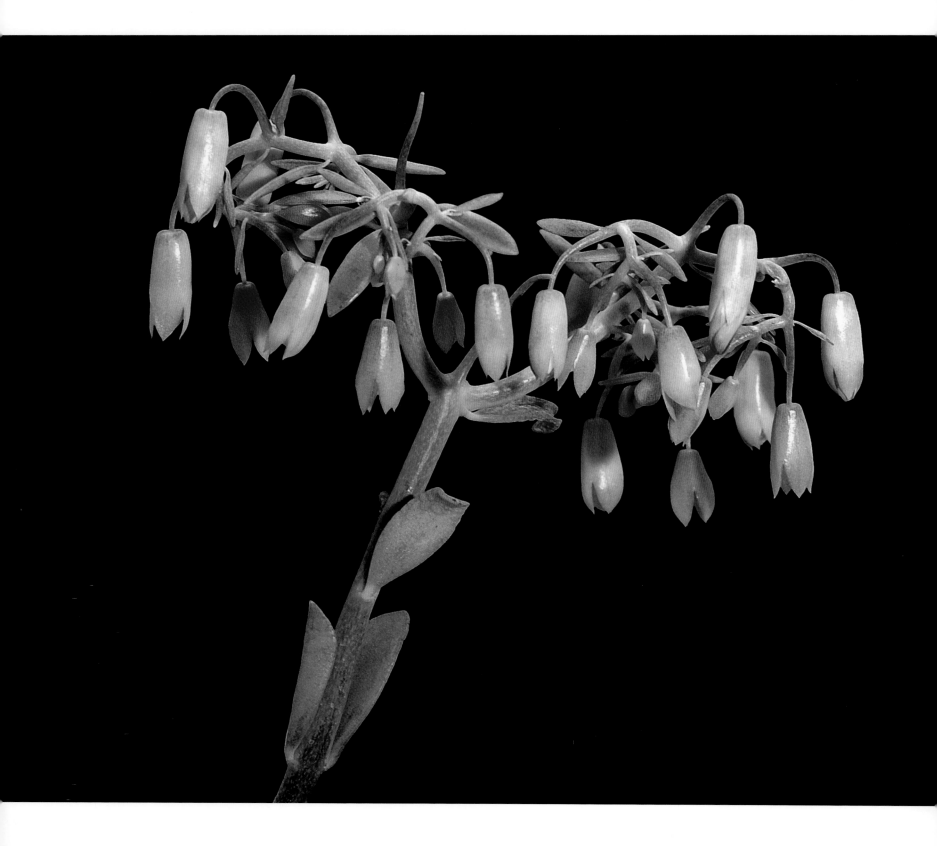

蝴蝶之舞
Kalanchoe fedtschenkoi

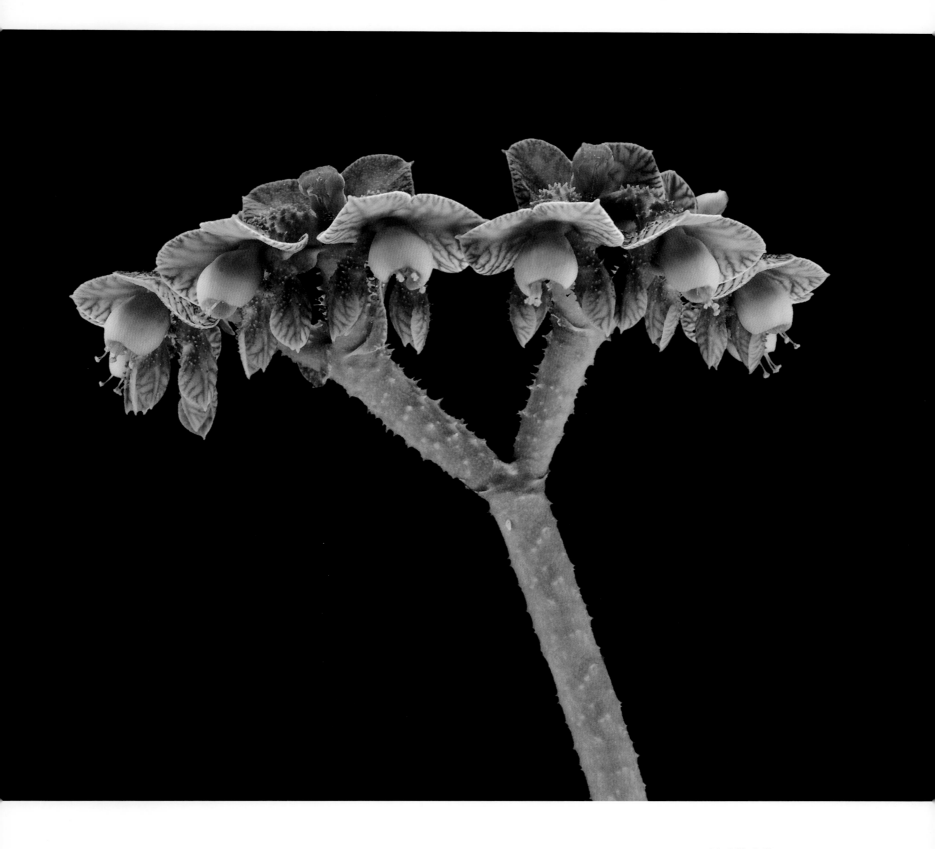

刺毛单腺戟
Monadenium echinulatum

紫镜
Massonia pustulata

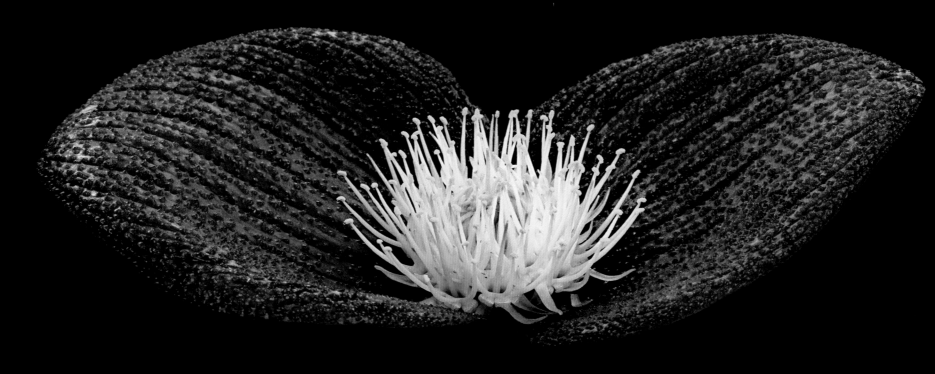

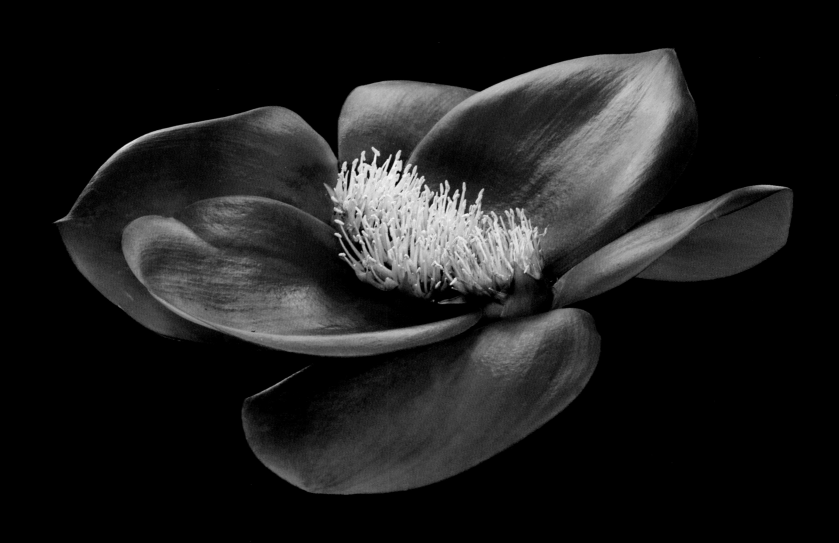

艳镜
Massonia depressa

翔凤
Cheiridopsis peculiaris

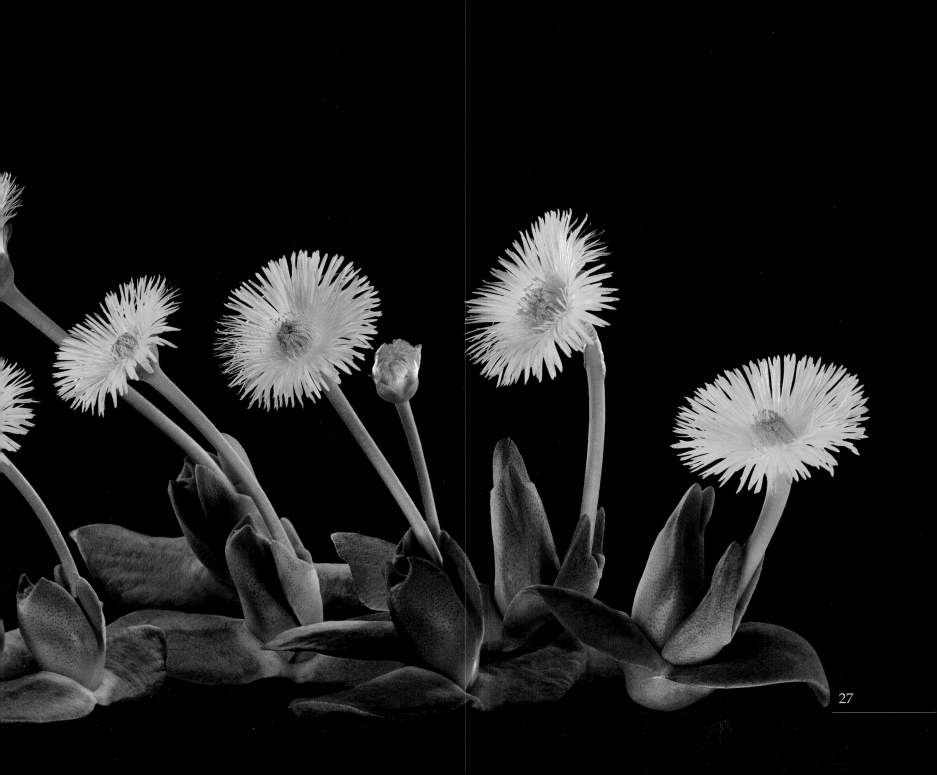

锦蝶
Kalanchoe delagoensis

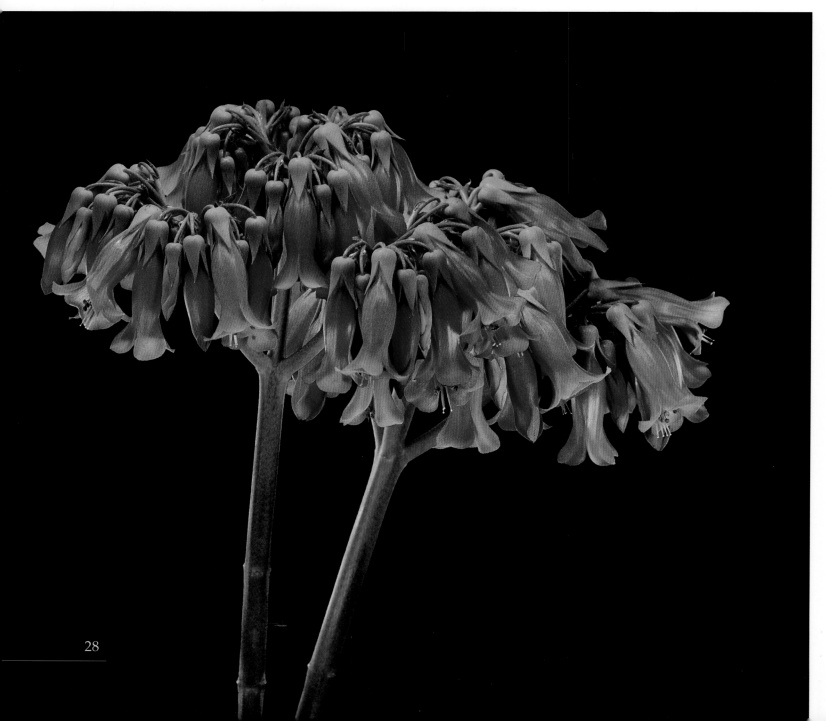

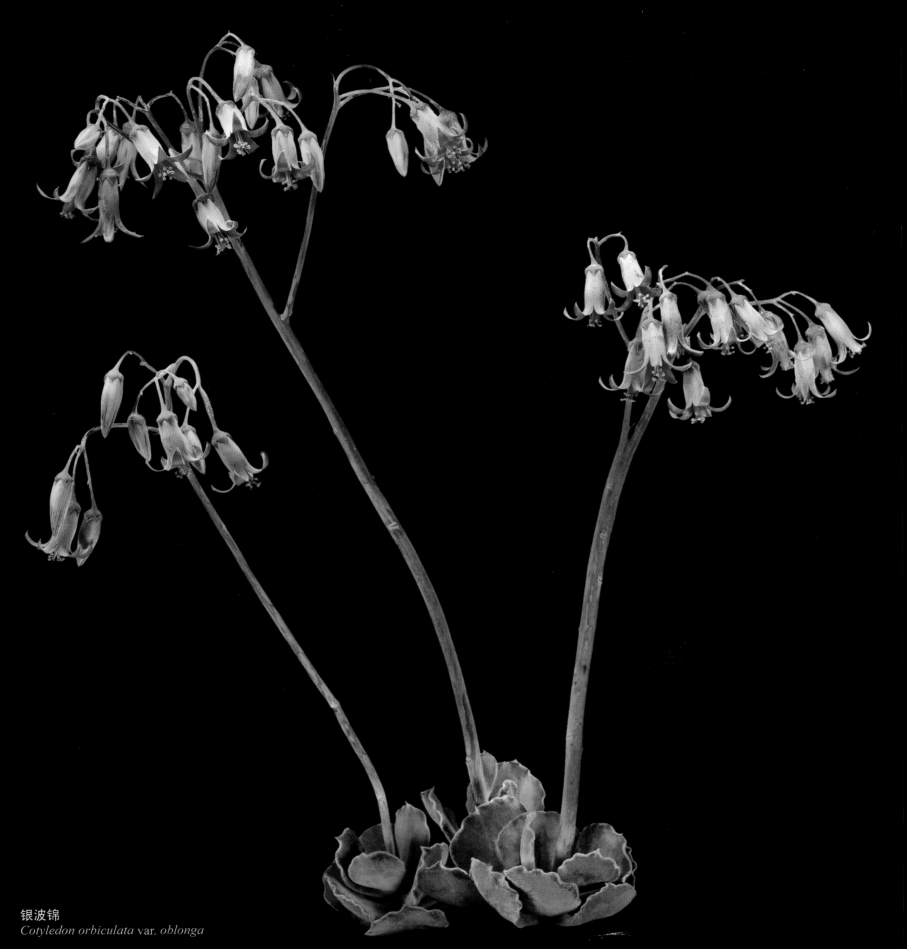

银波锦
Cotyledon orbiculata var. *oblonga*

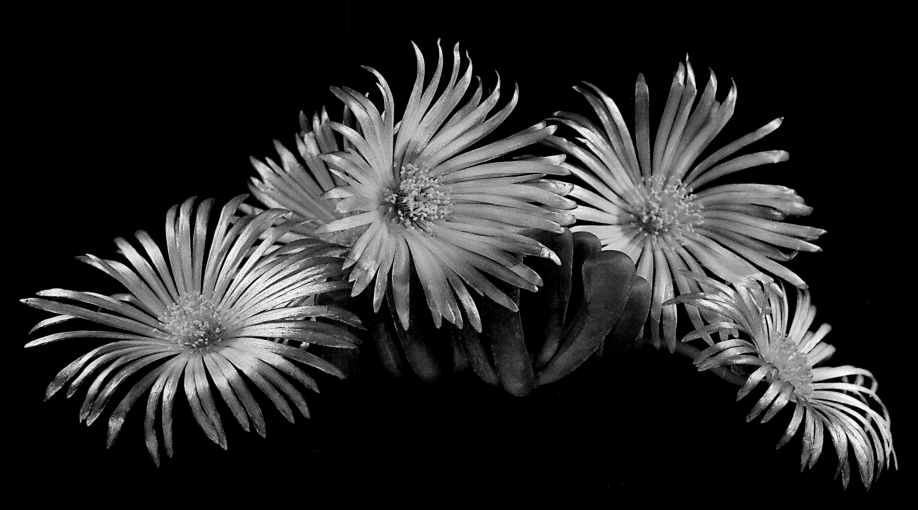

五十铃玉
Fenestraria rhopalophylla ssp. *aurantiaca*

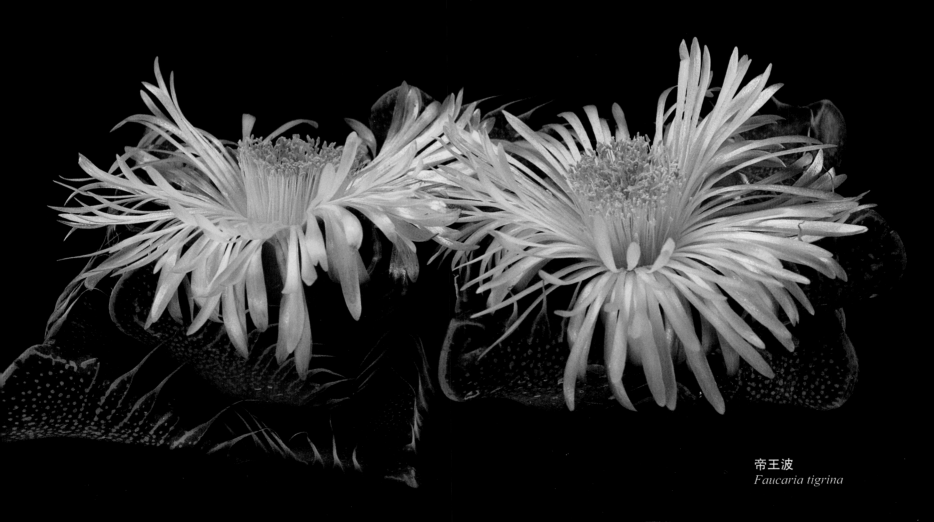

帝王波
Faucaria tigrina

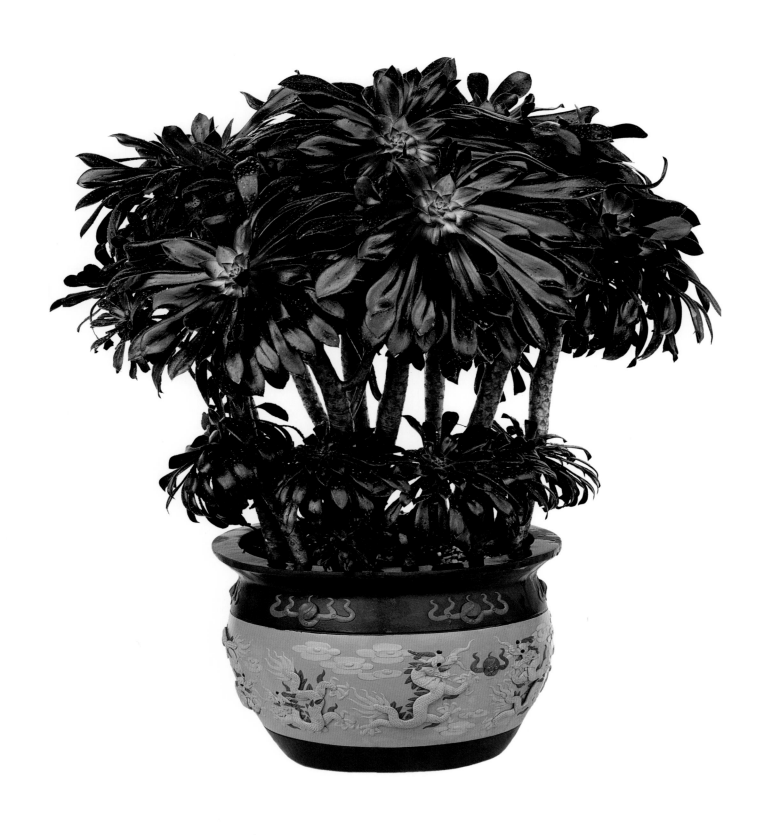

黑法师
Aeonium arboretum 'Zwartkop'

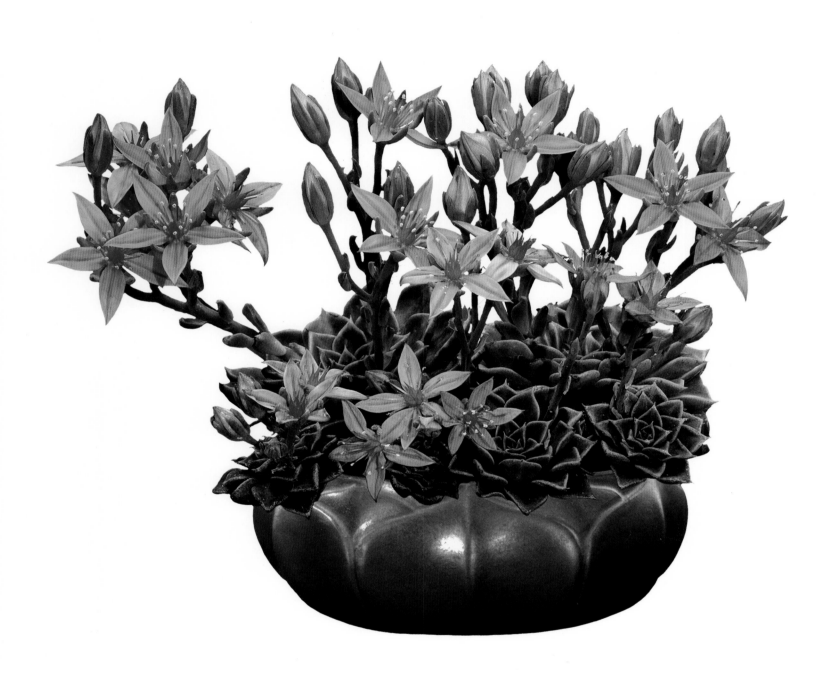

美丽莲
Graptopetalum bellum

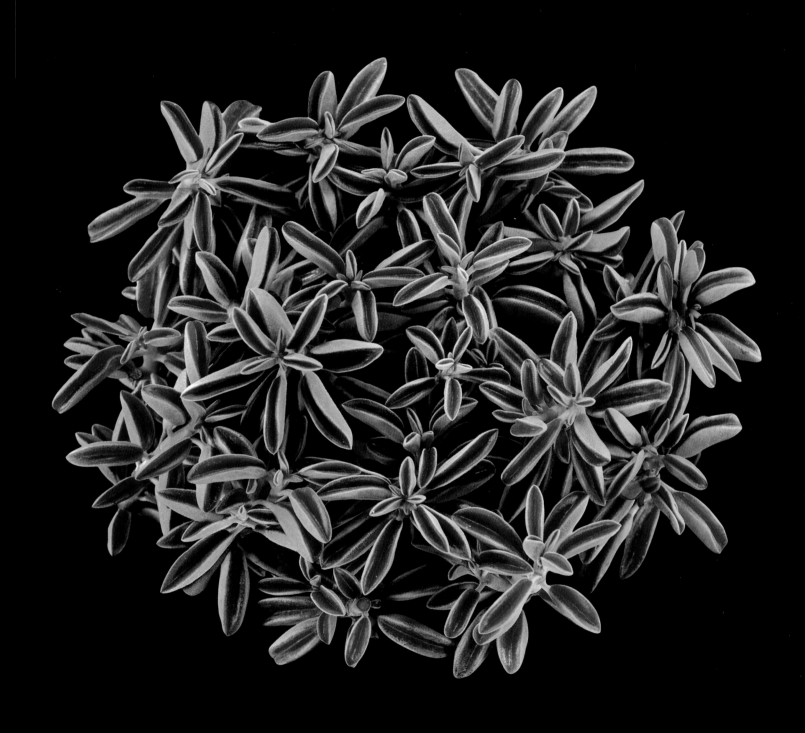

粗面椒草
Peperomia asperula

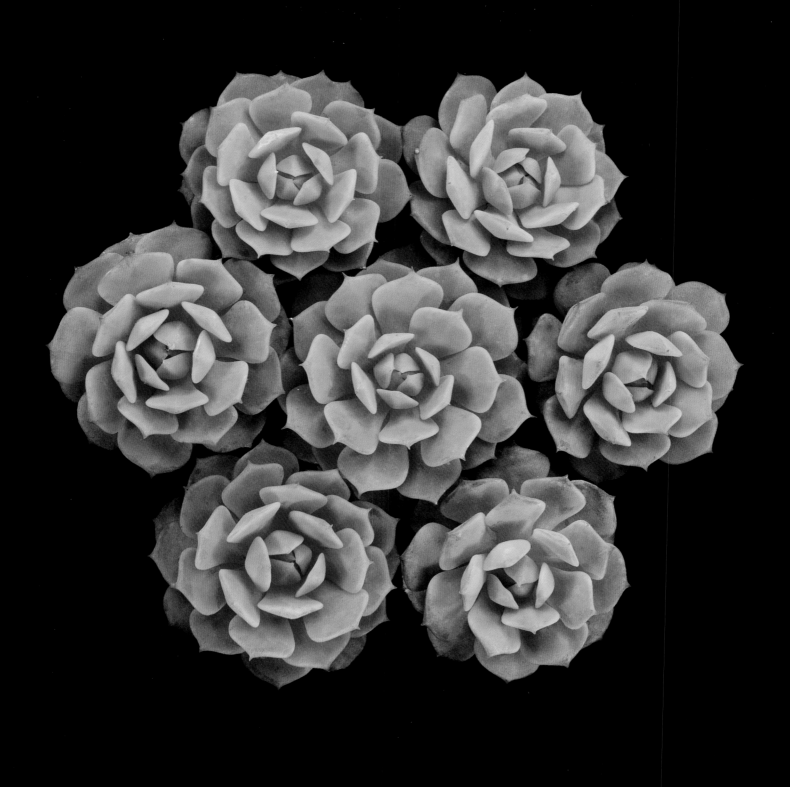

静夜
Echeveria derenbergii

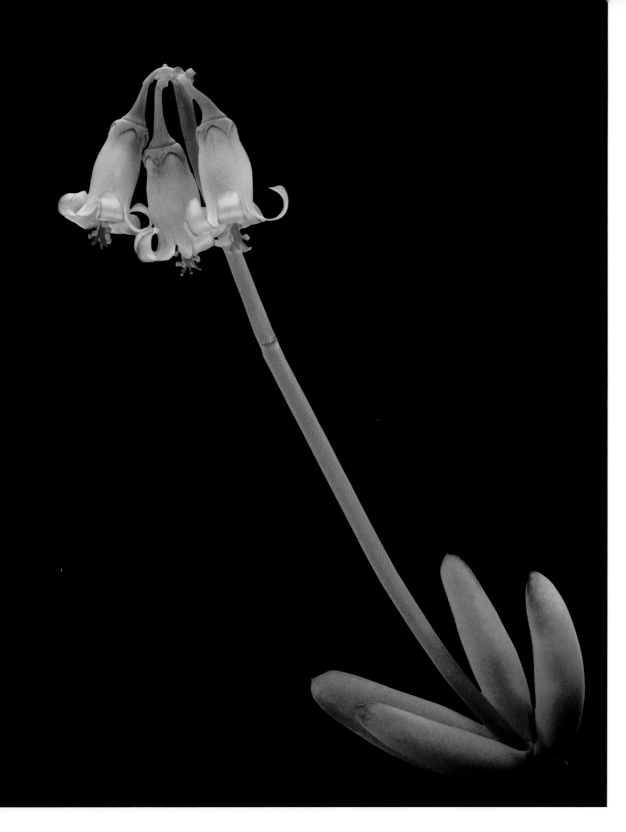

福娘
Cotyledon orbiculata

草火花
Lewisia cotyledon

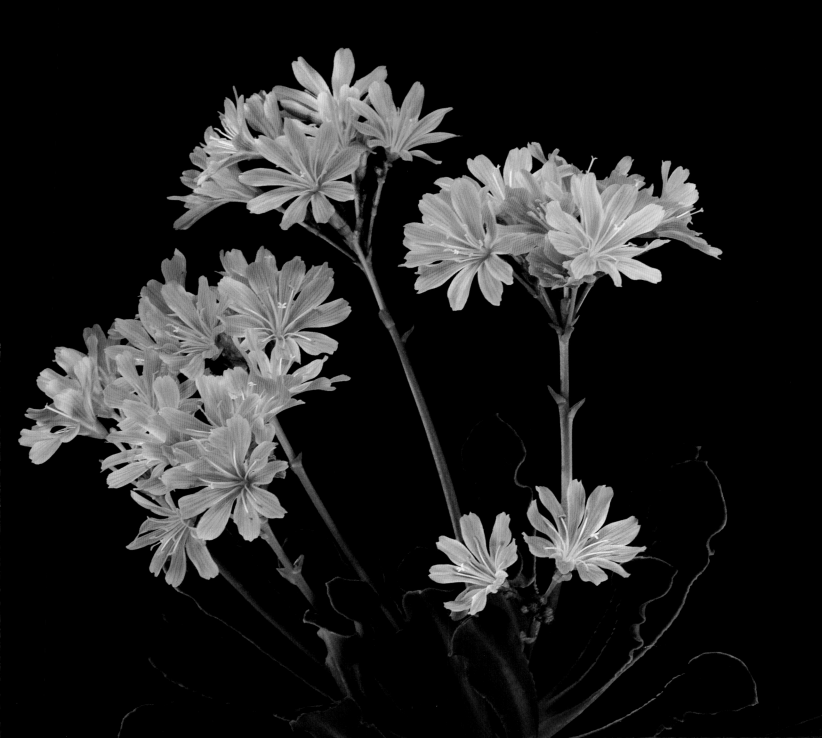

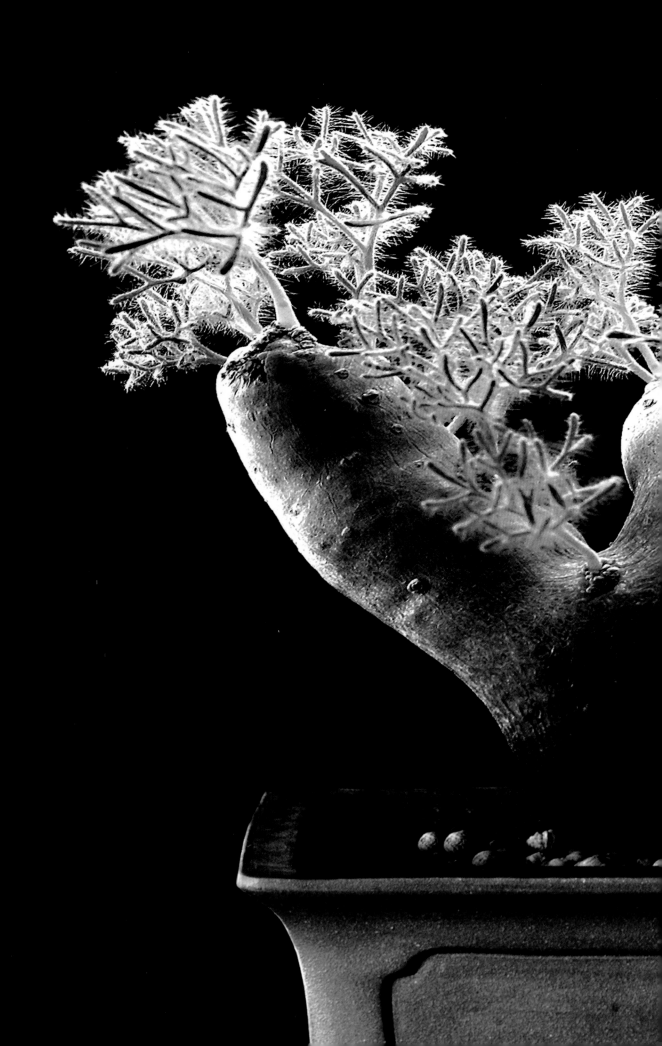

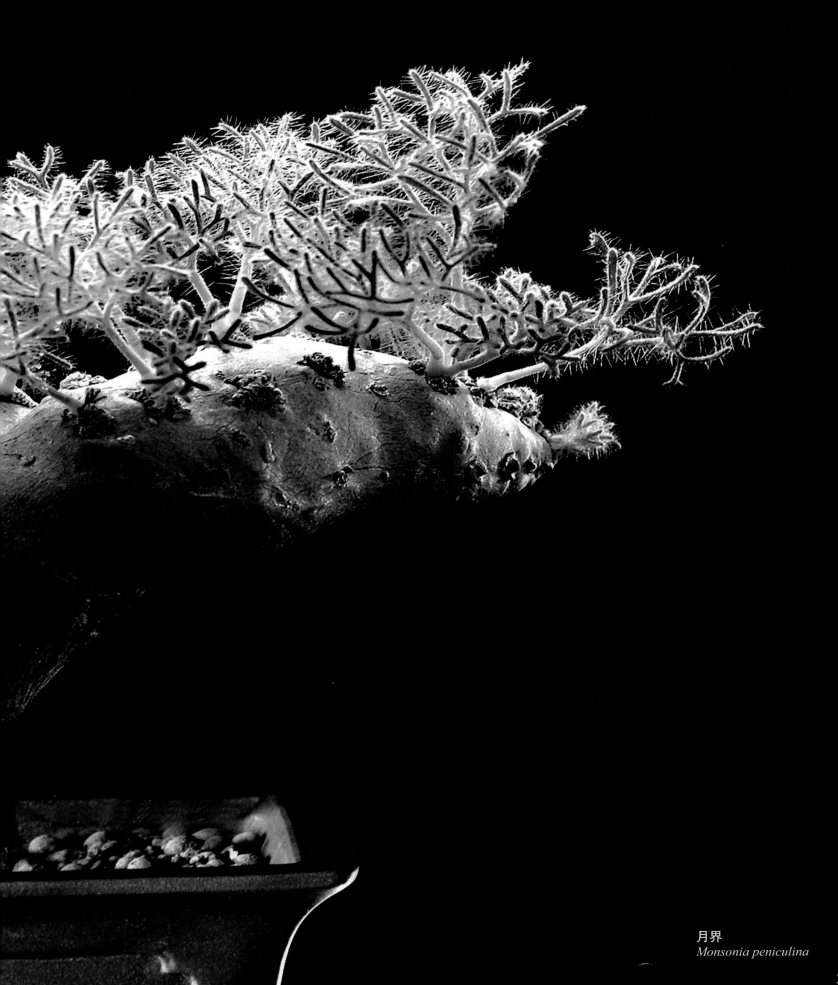

月界
Monsonia peniculina

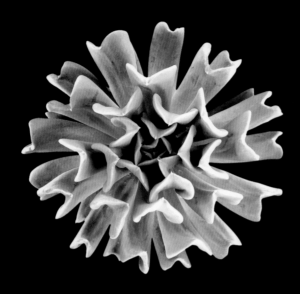

特叶玉莲
Echeveria runyonii 'Topsy Turvy'

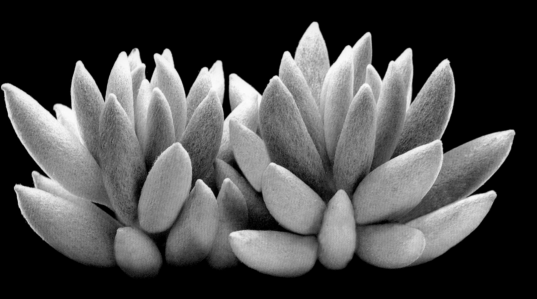

银月
Senecio haworthii

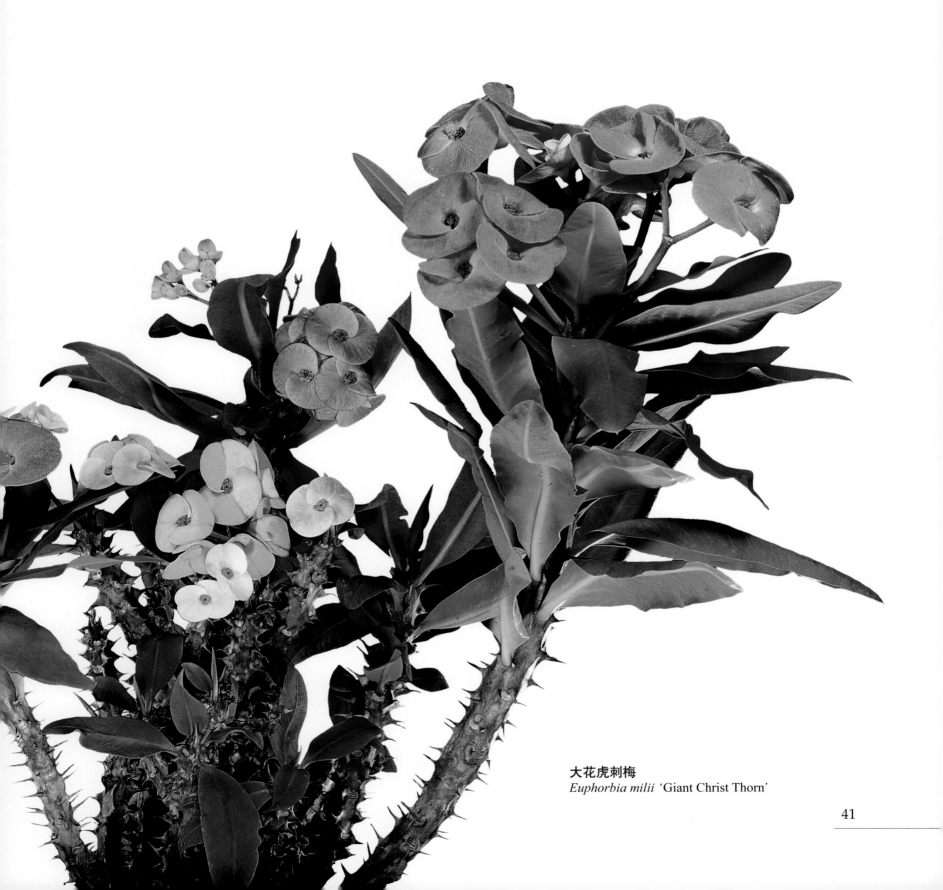

大花虎刺梅
Euphorbia milii 'Giant Christ Thorn'

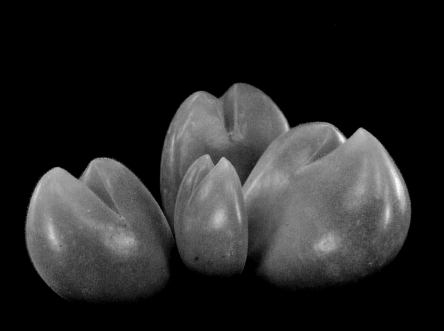

藻玲玉
Gibbaeum nuciforme

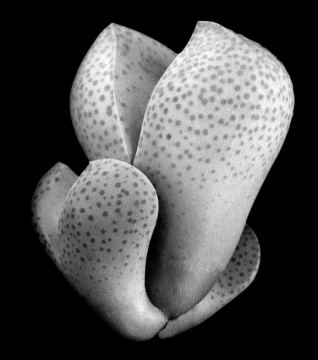

奇凤玉
Dinteranthus microspermus

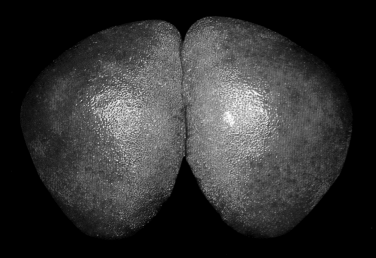

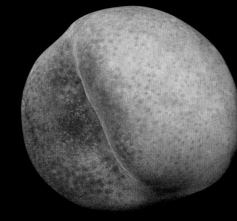

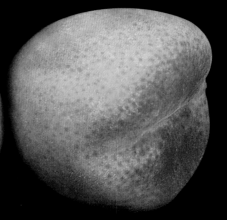

富士山
Conophytum burgeri

仙桃
Conophytum subfenestratum

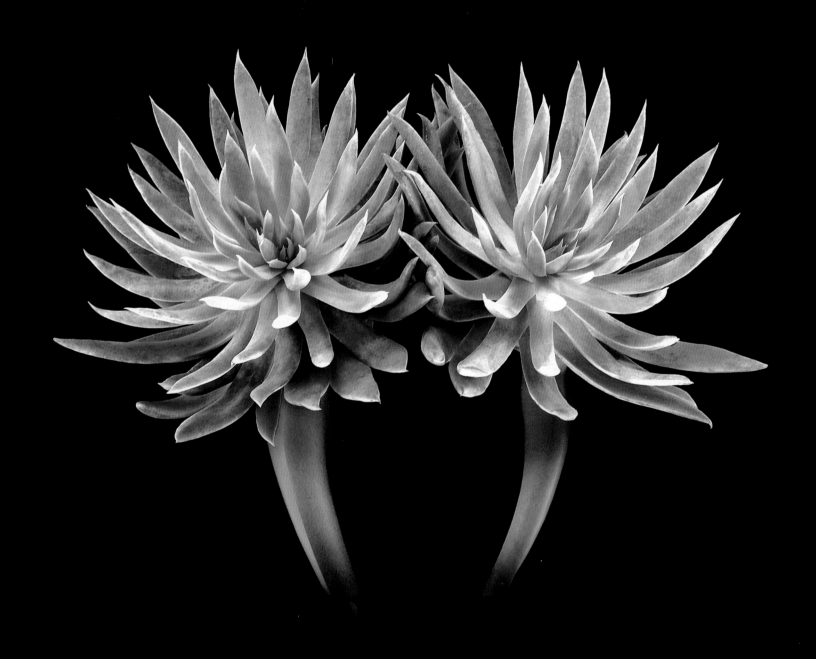

白石莲
Dudleya nubigena

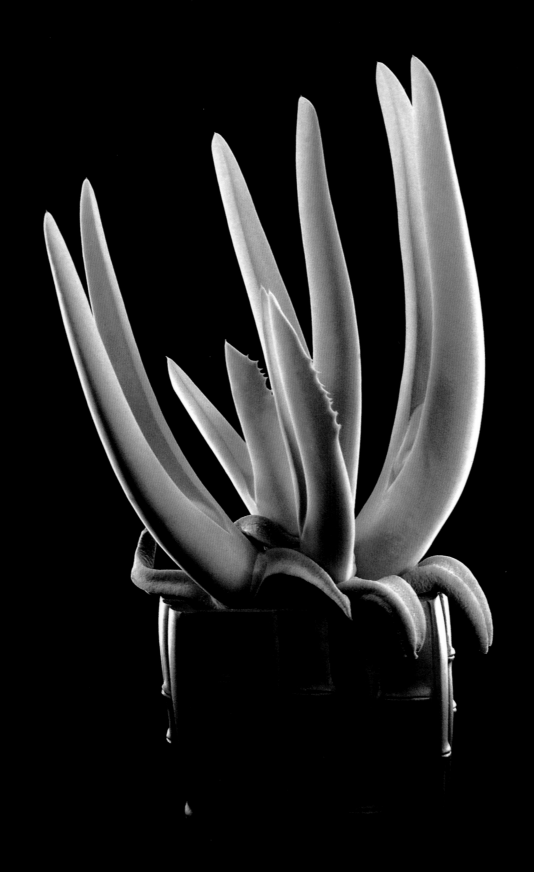

慈光锦
Cheiridopsis denticulata

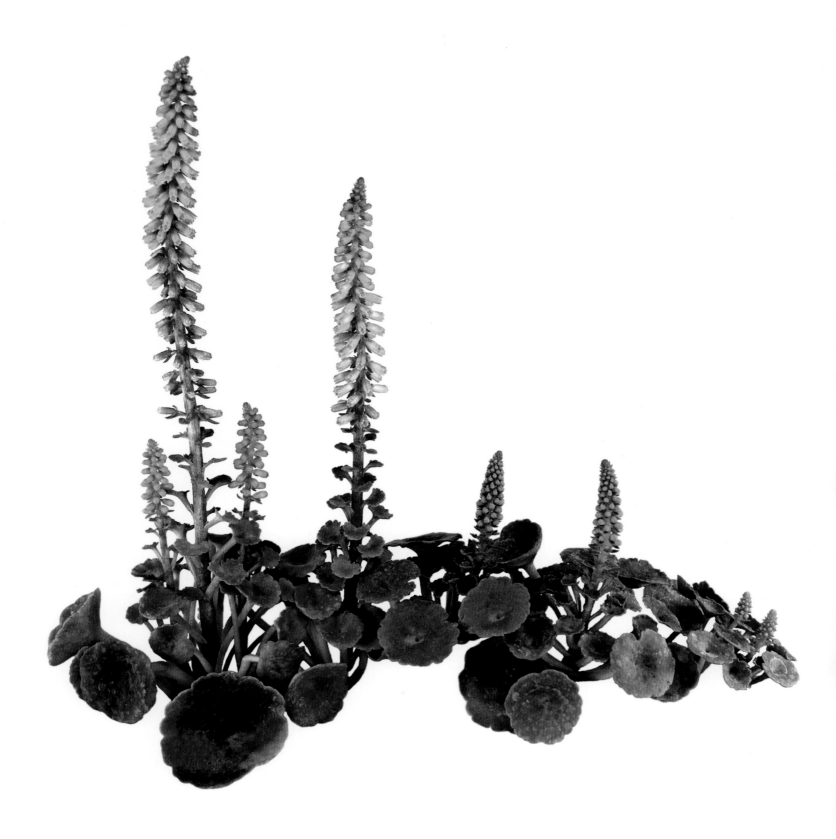

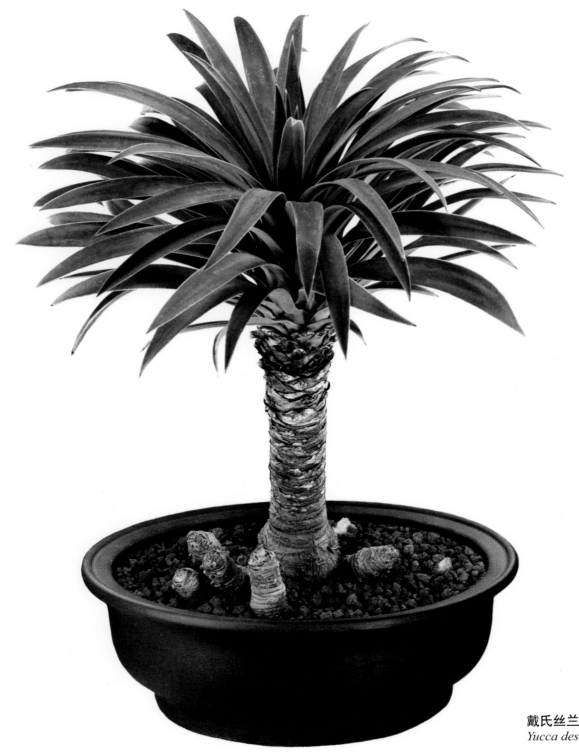

戴氏丝兰
Yucca desmetiana

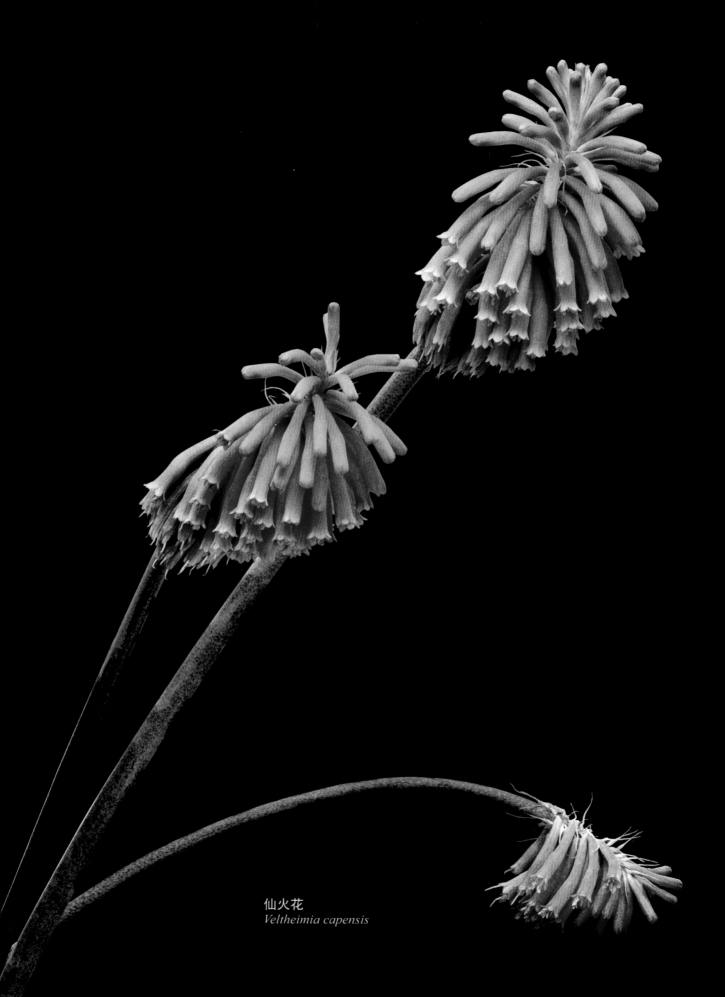

仙火花
Veltheimia capensis

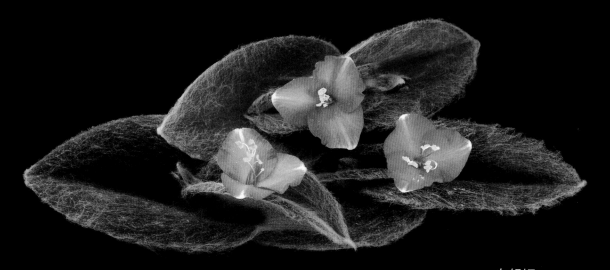

白绢姬
Tradescantia sillamontana

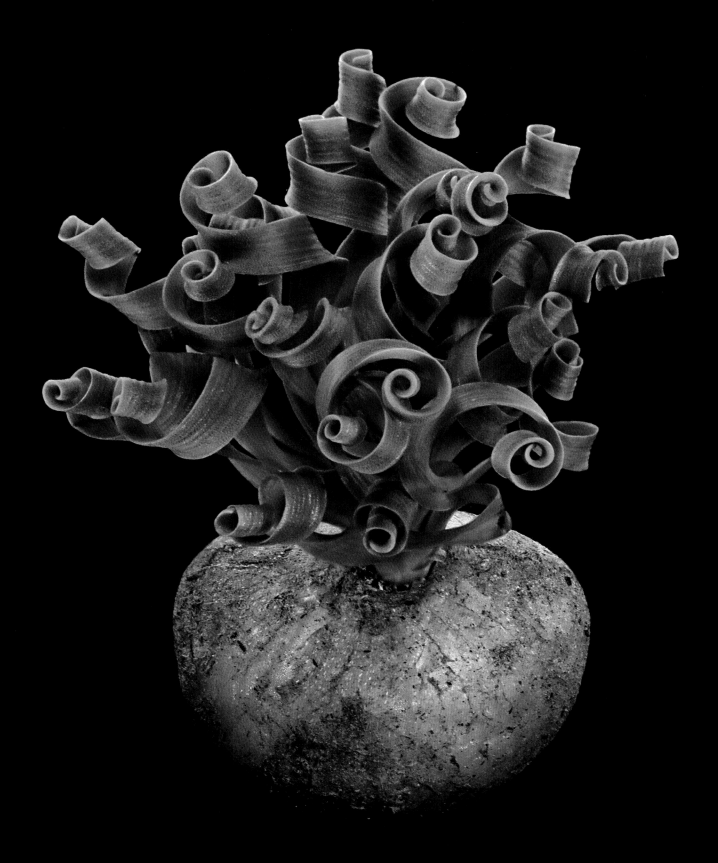

贵妇人
Ornithogalum concordianum

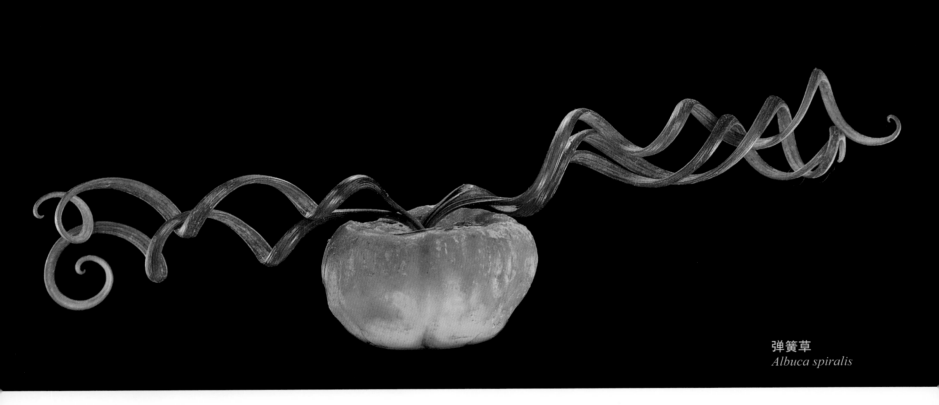

弹簧草
Albuca spiralis

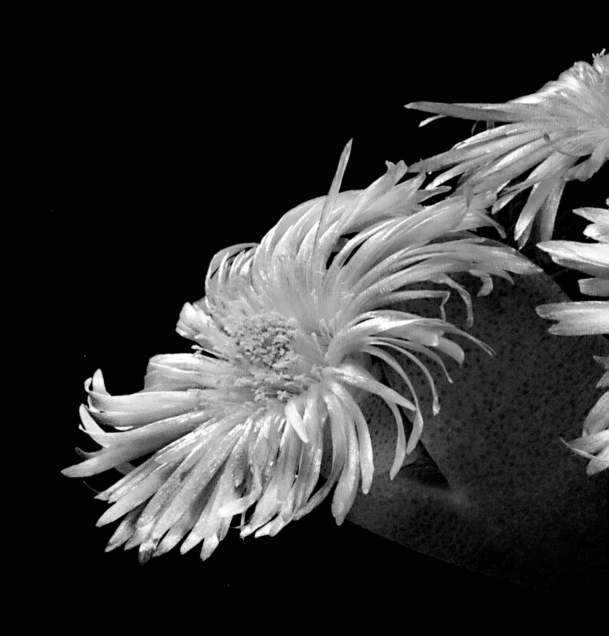

神风玉
Cheiridopsis pillansii

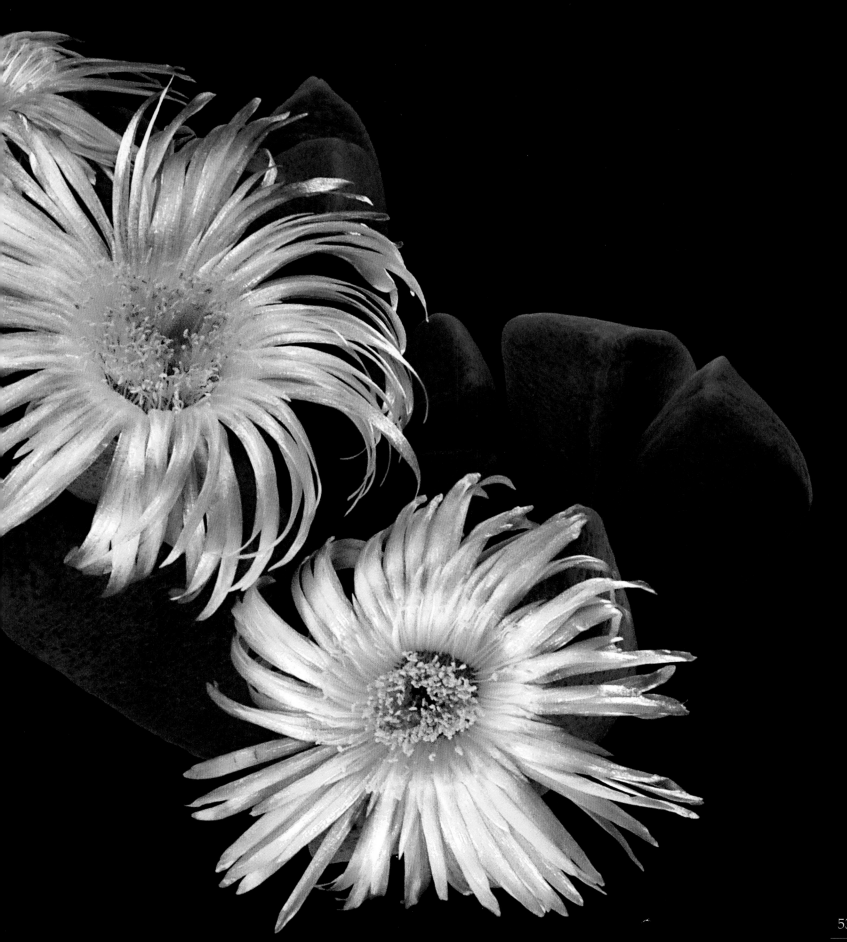

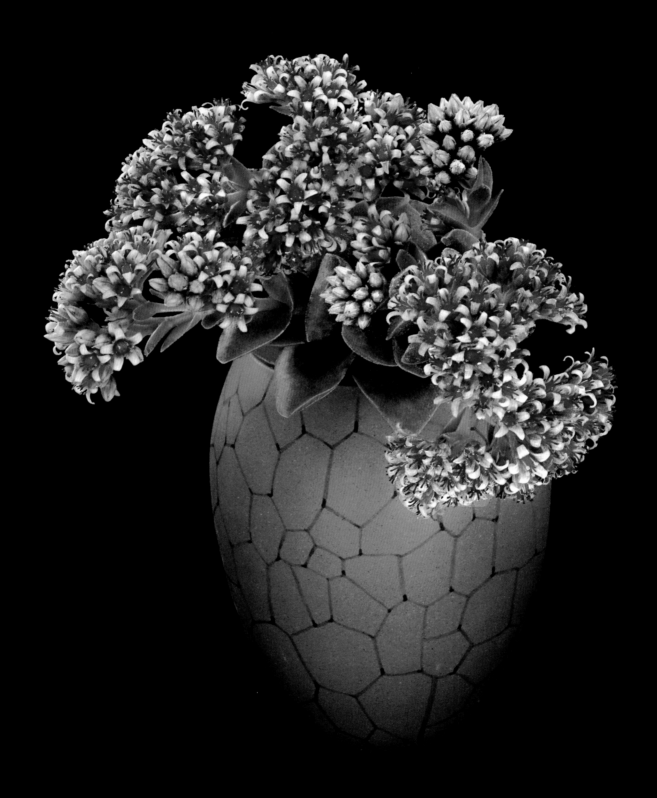

神童
Crassula ‘Spring Time’

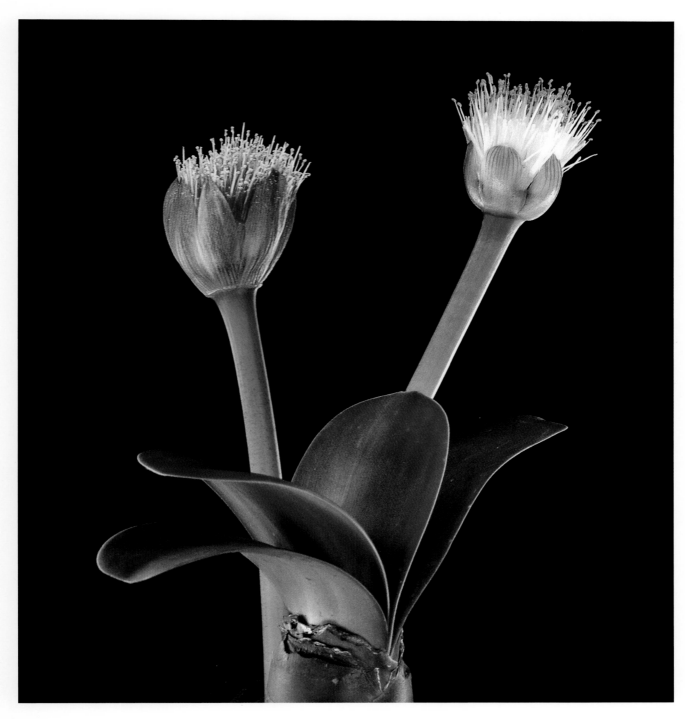

眉刷
Haemanthus natalensis/Haemanthus albiflos

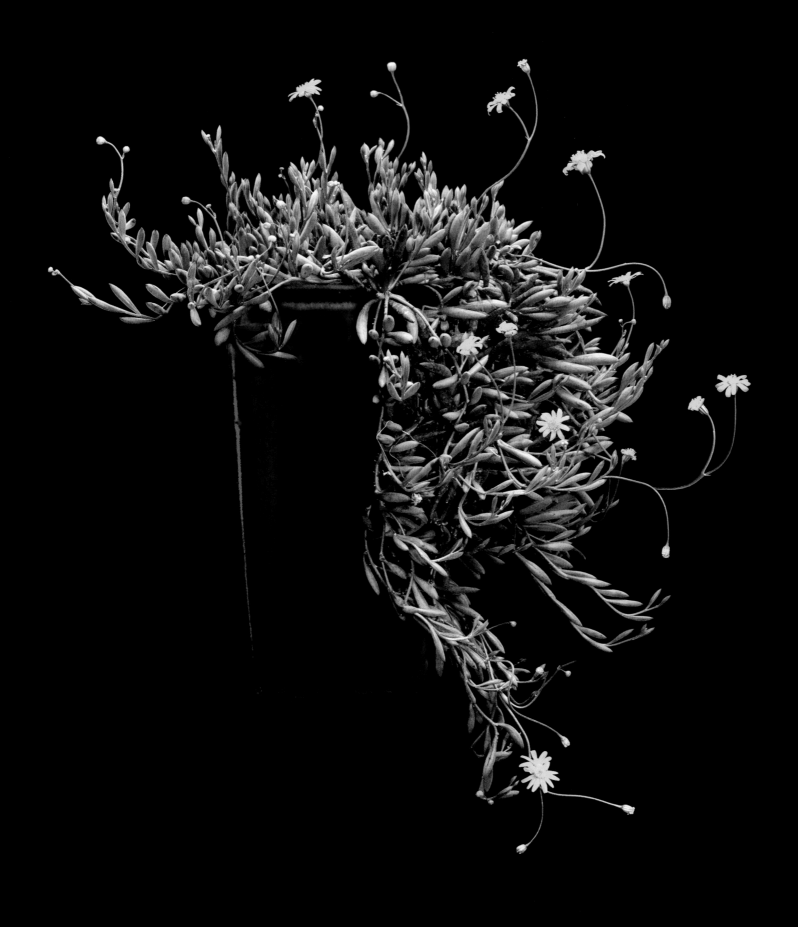

紫月
Othonna capensis 'Ruby Necklace

56

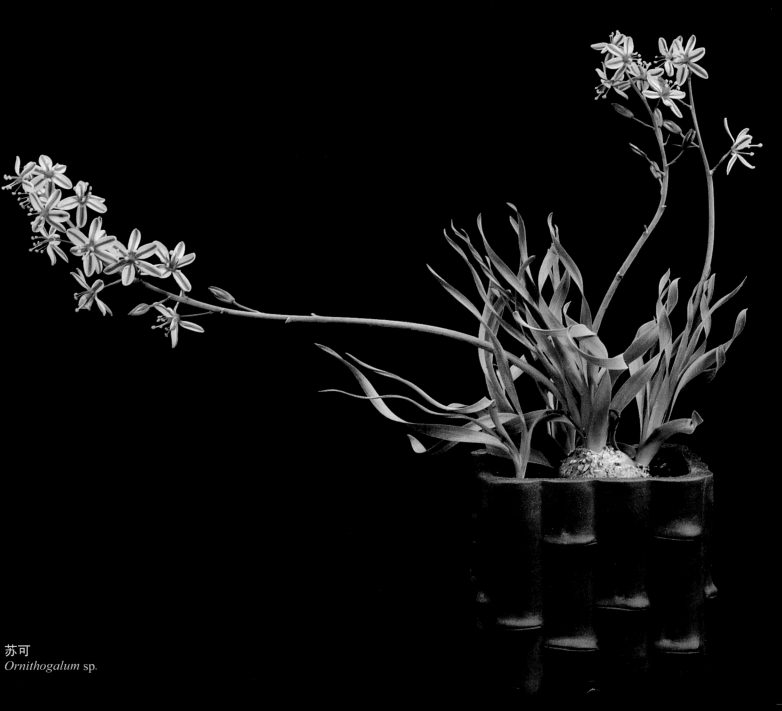

苏可
Ornithogalum sp.

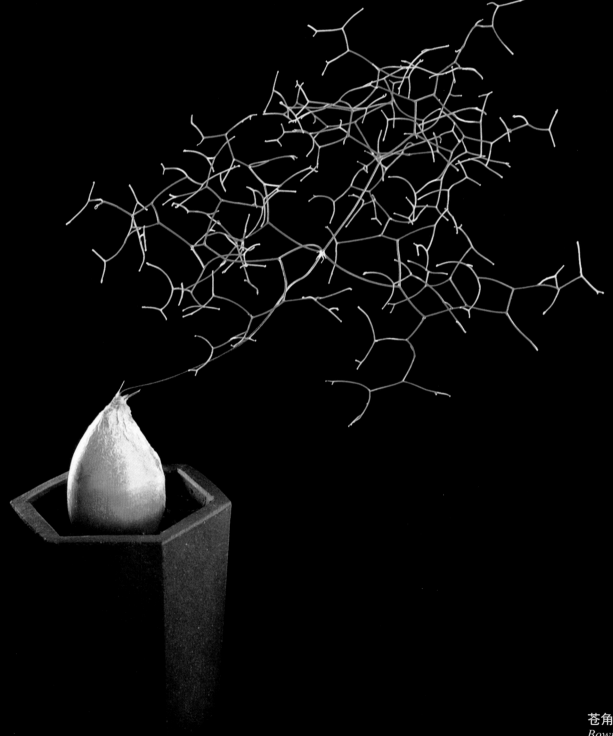

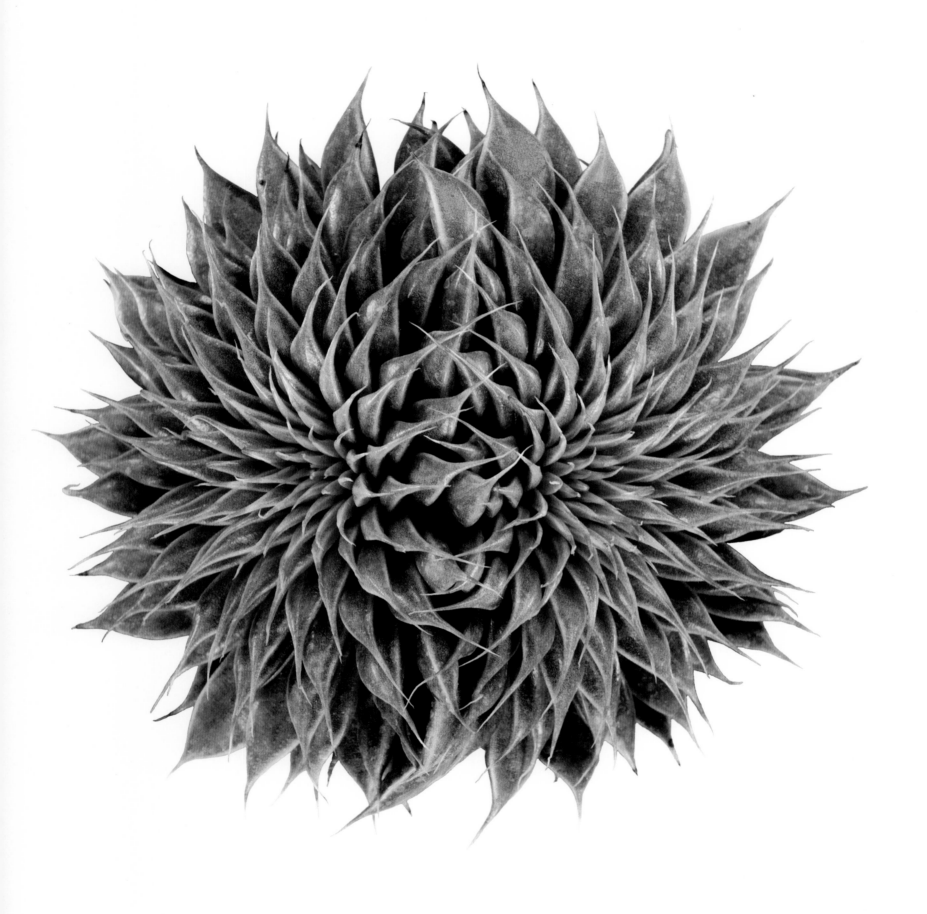

银星
×*Graptoveria* 'Silver Star'

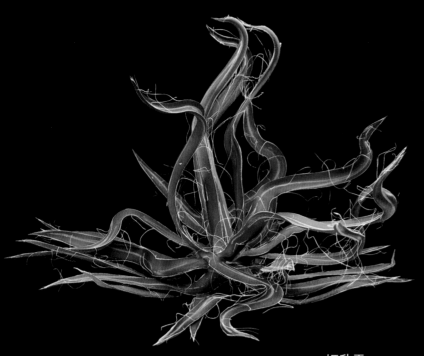

姬乱雪
Agave parviflora

绿蚕
Crassula perforata f.

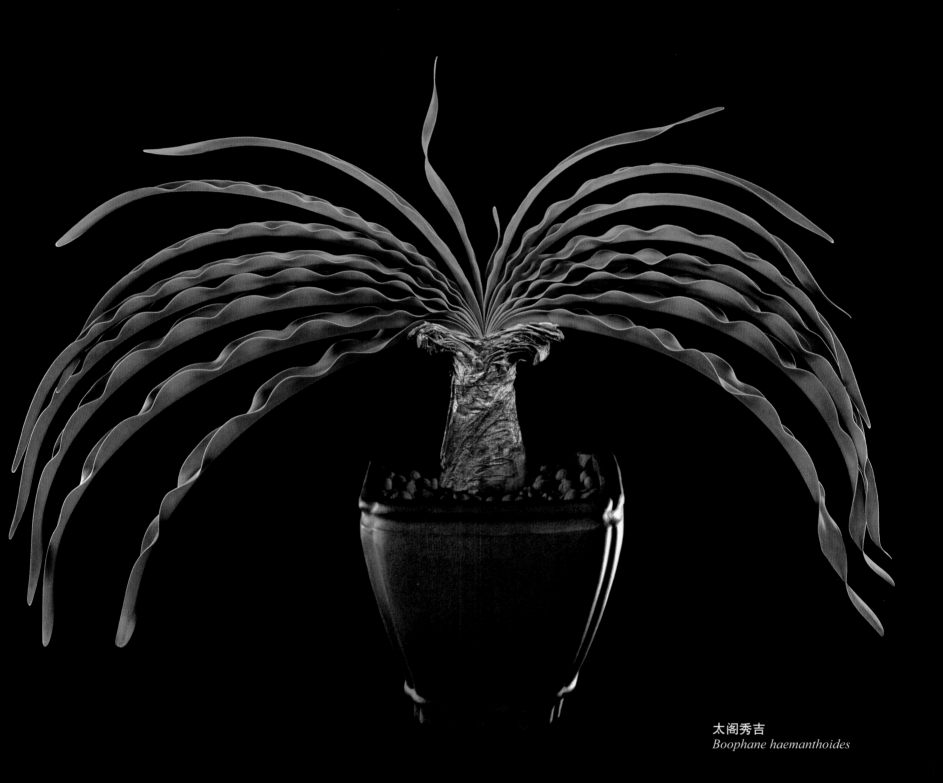

太阁秀吉
Boophane haemanthoides

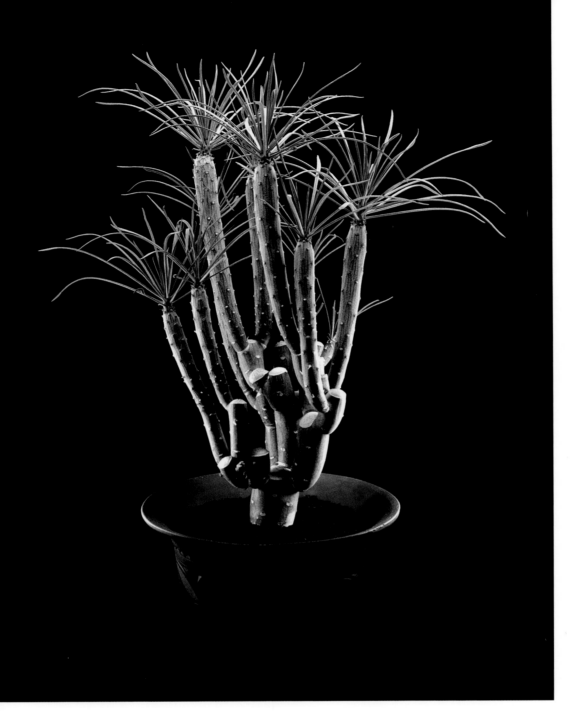

天龙
Senecio kleinia

铺地兰松
Senecio talinoides ssp. *mandraliscae*

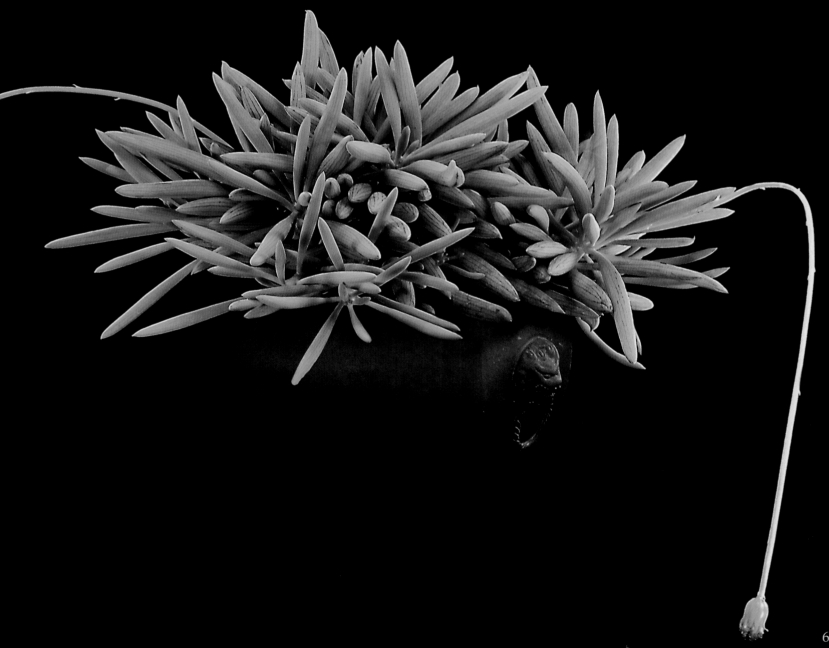

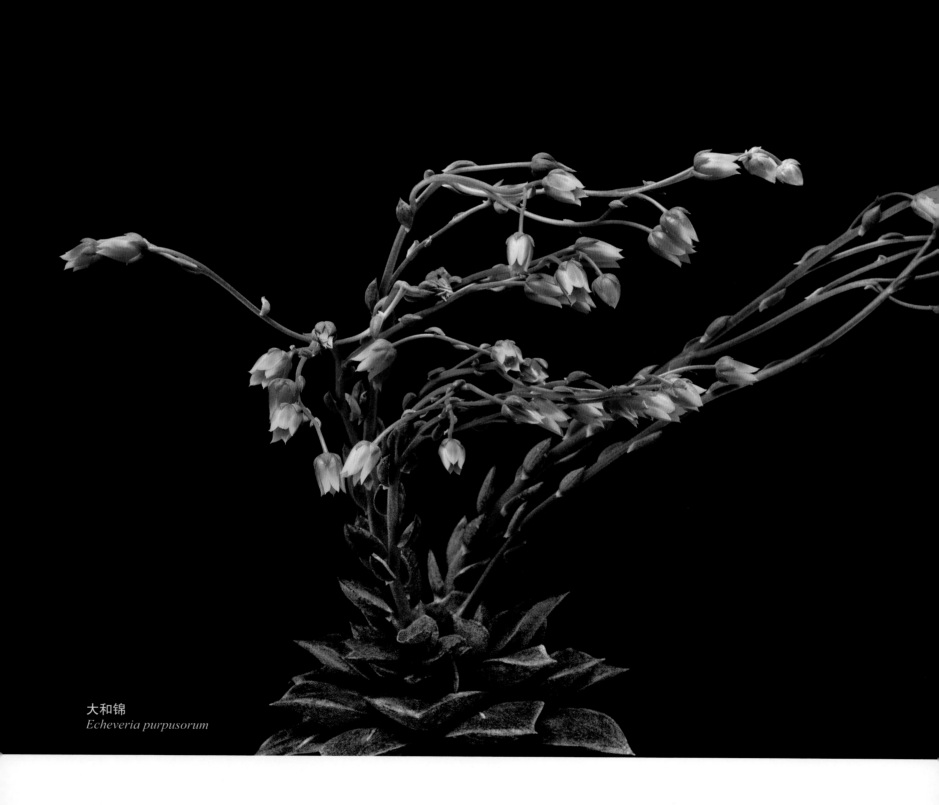

大和锦
Echeveria purpusorum

月十字
Ruschia subpaniculata

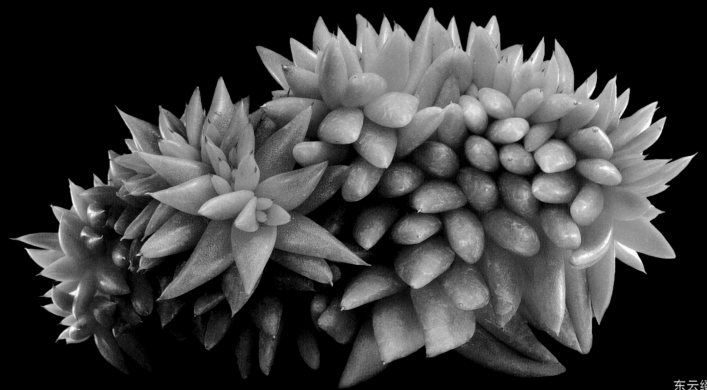

东云缀化
Echeveria agavoides 'Cristata'

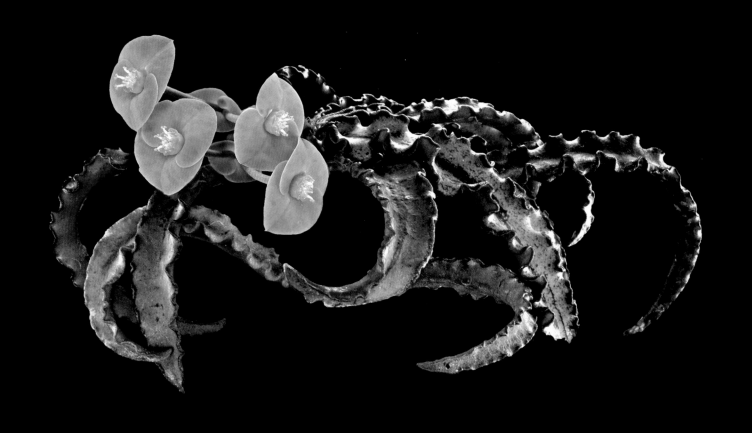

皱叶藩郎麒麟
Euphorbia francoisii var. *crassicaulis*

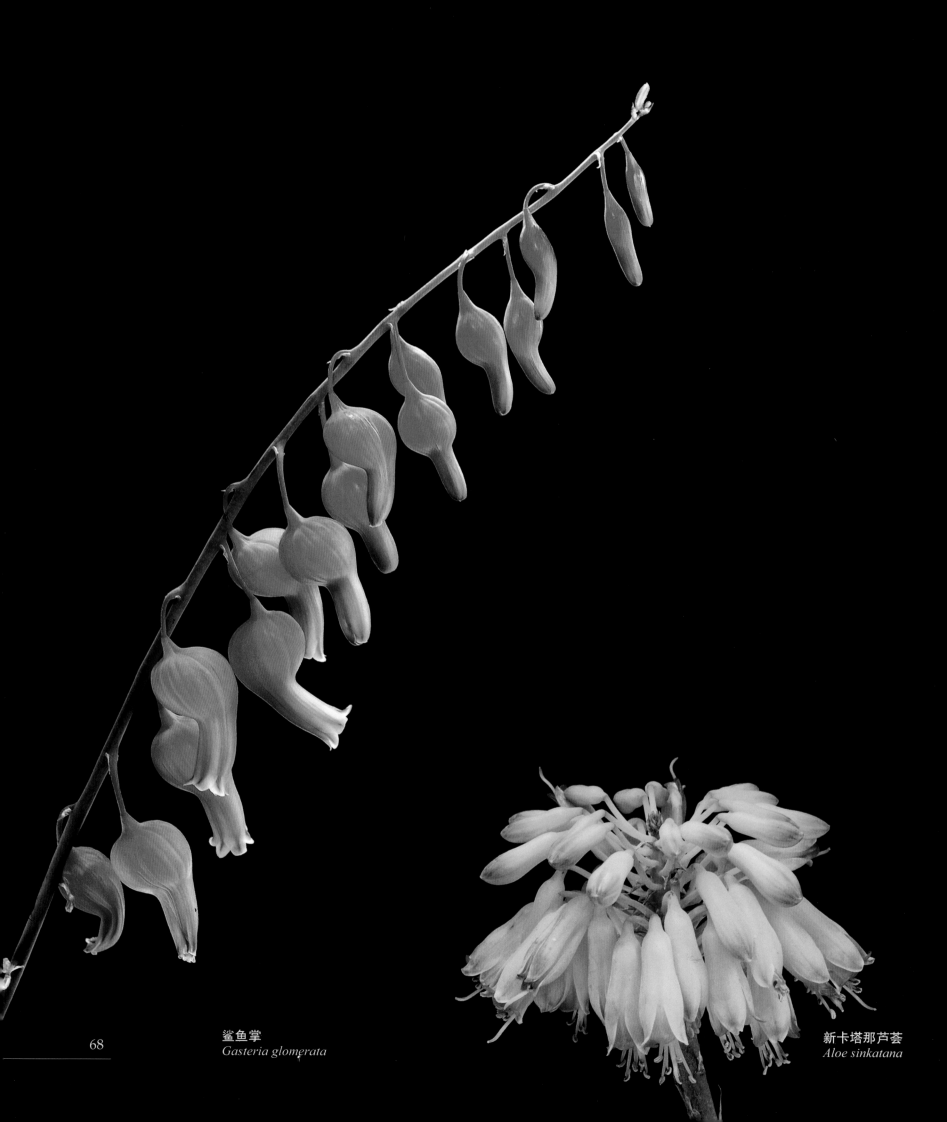

鲨鱼掌
Gasteria glomerata

新卡塔那芦荟
Aloe sinkatana

绿之鼓
Xerosicyos danguyi

稚儿姿
Crassula deceptor

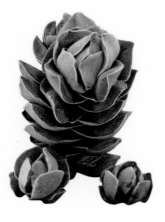

象牙塔
Crassula 'Ivory Pagoda'

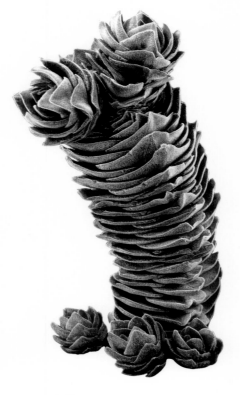

方塔
Crassula 'Budda's Temple'

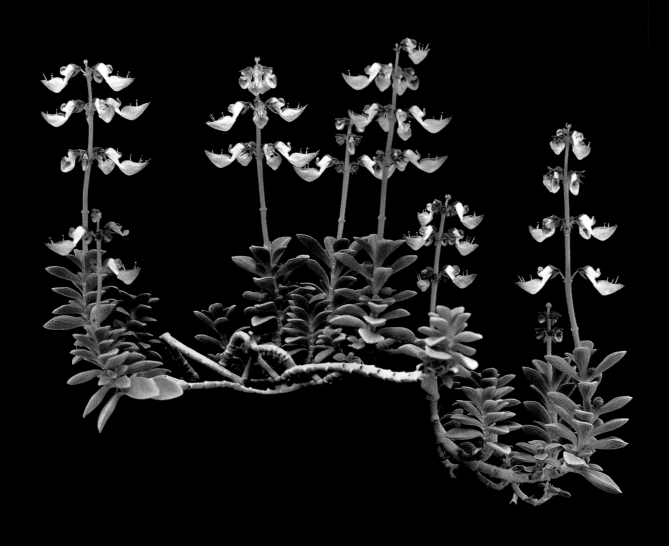

天蓝鞘蕊花
Coleus coerulescens

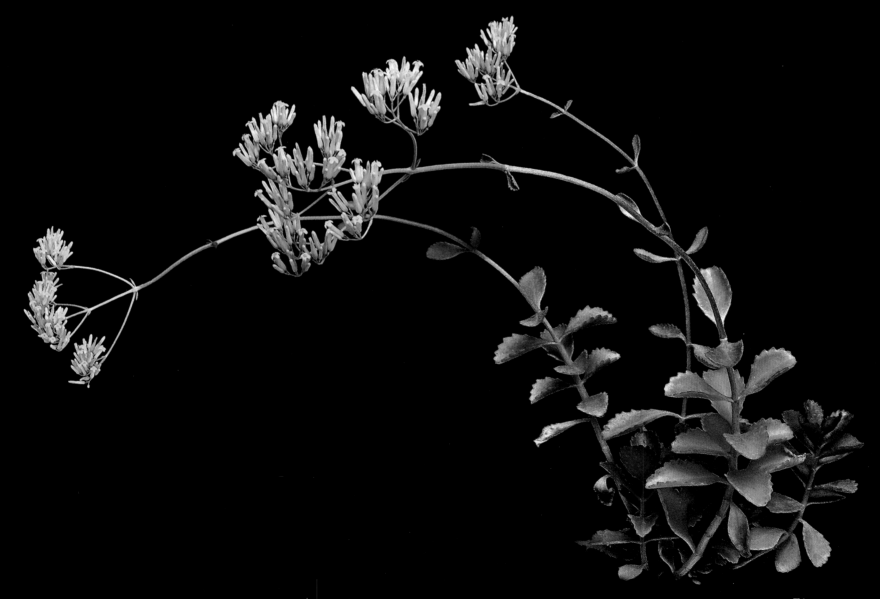

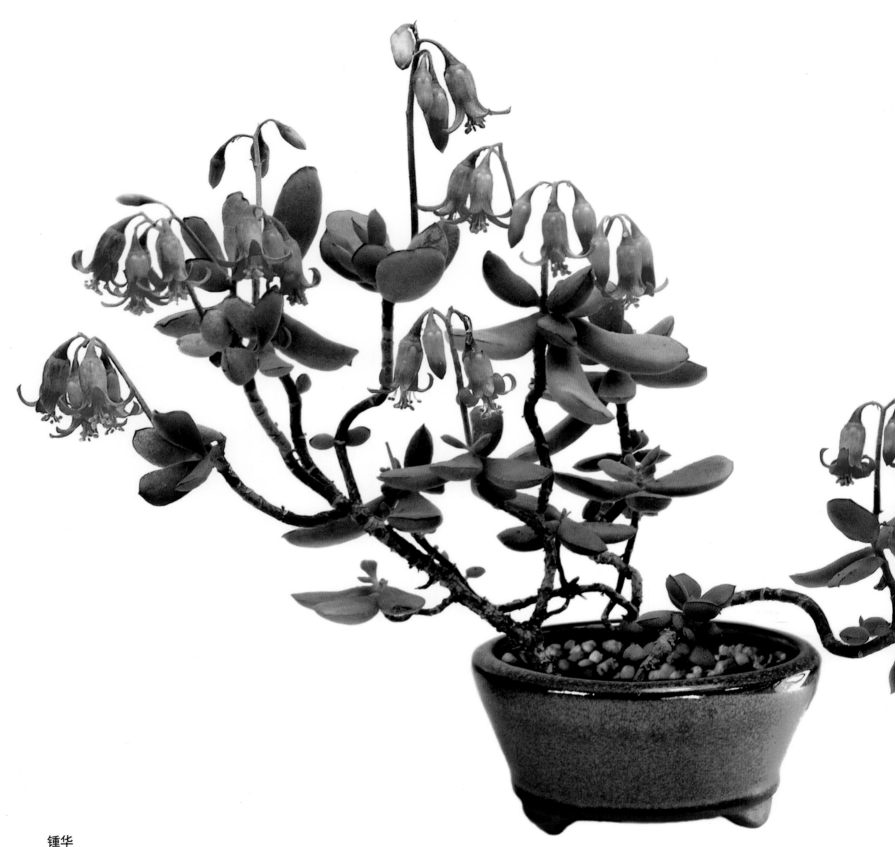

锤华
Cotyledon eliseae

粗茎金景天
Aichryson pachycaulon

惠比须笑
Pachypodium brevicaule

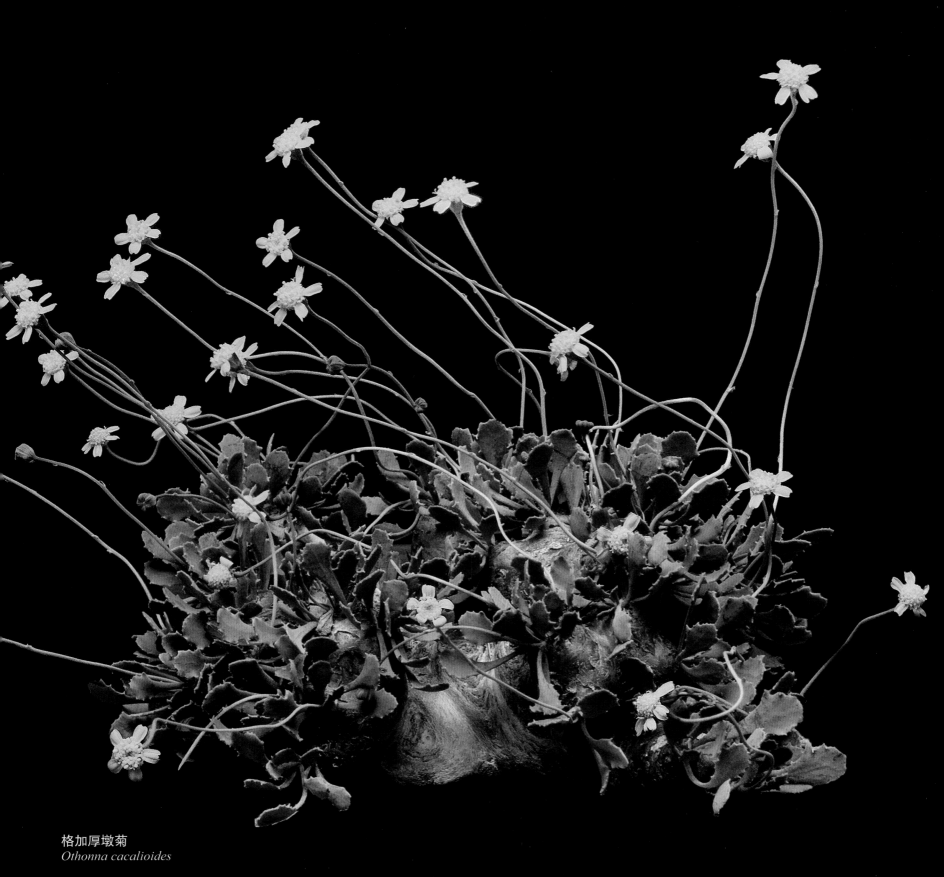

格加厚墩菊
Othonna cacalioides

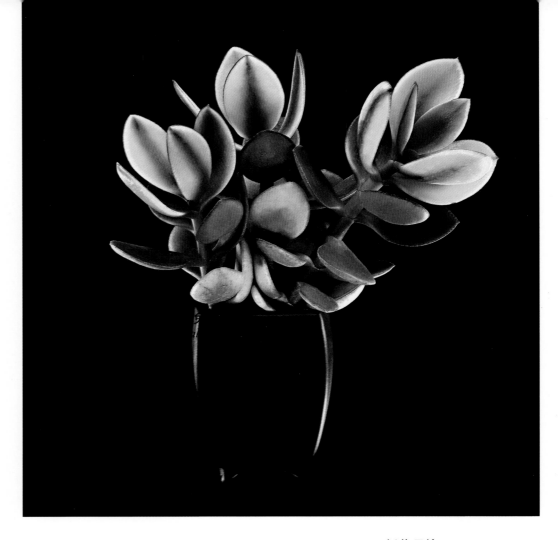

新花月锦
Crassula ovata ' Variegata '

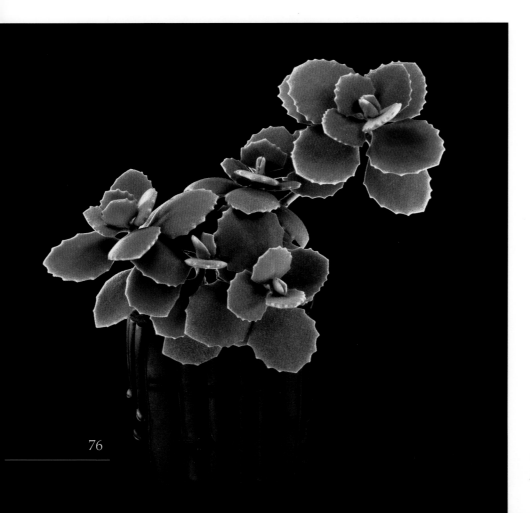

千兔耳
Kalanchoe millotii

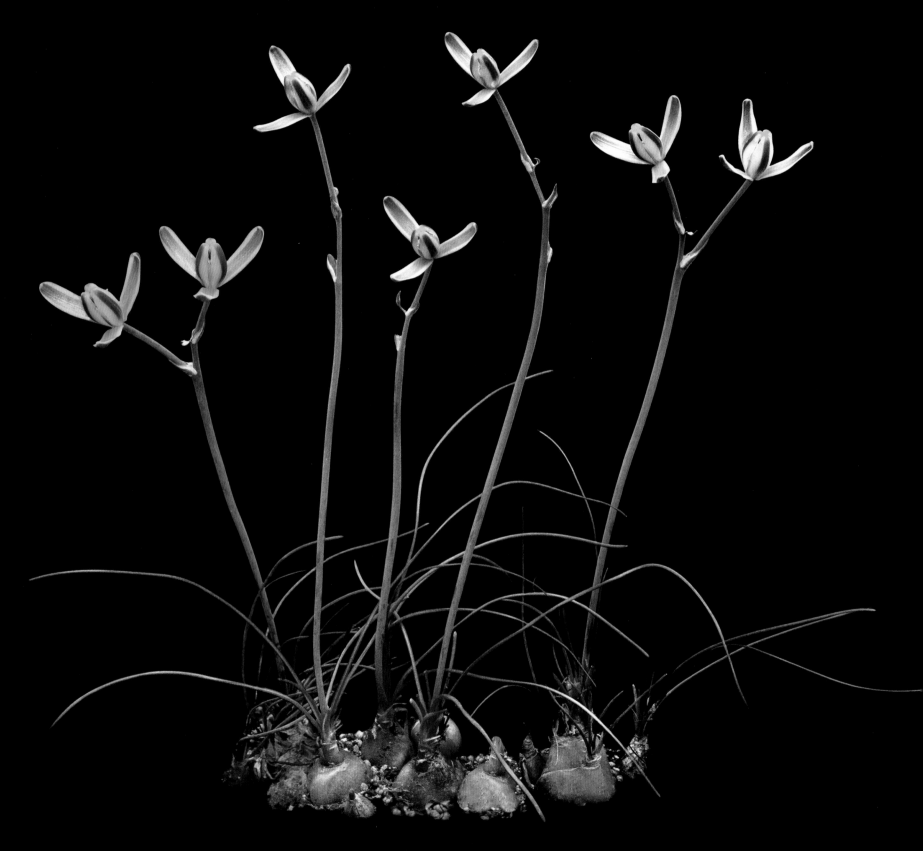

白仙花
Albuca 'Augrabies Hills'

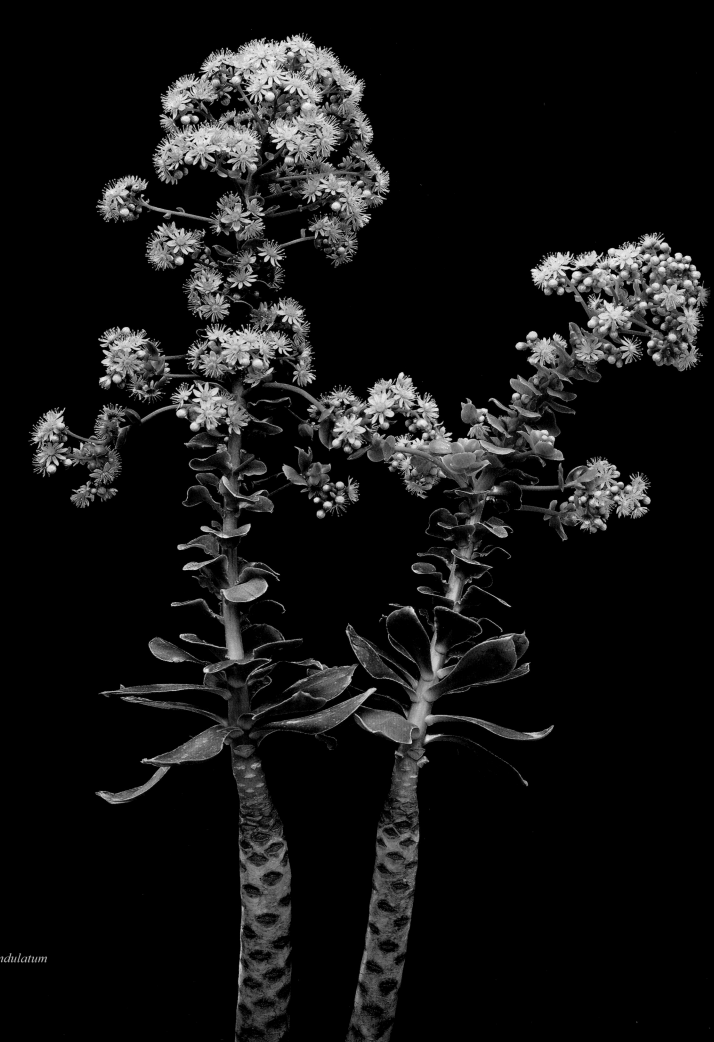

艳姿
Aeonium undulatum

奇峰锦
Tylecodon wallichii

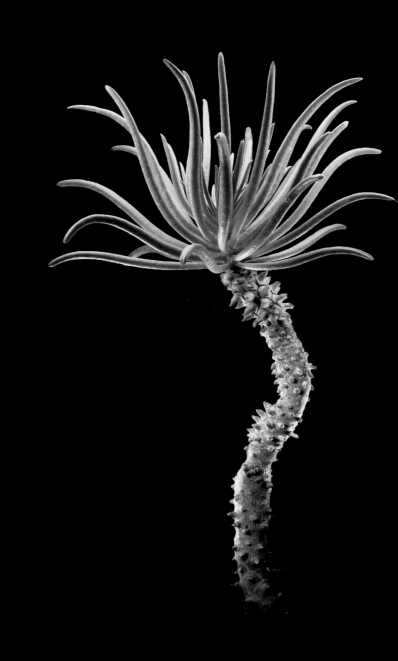

奇峰锦
Tylecodon wallichii

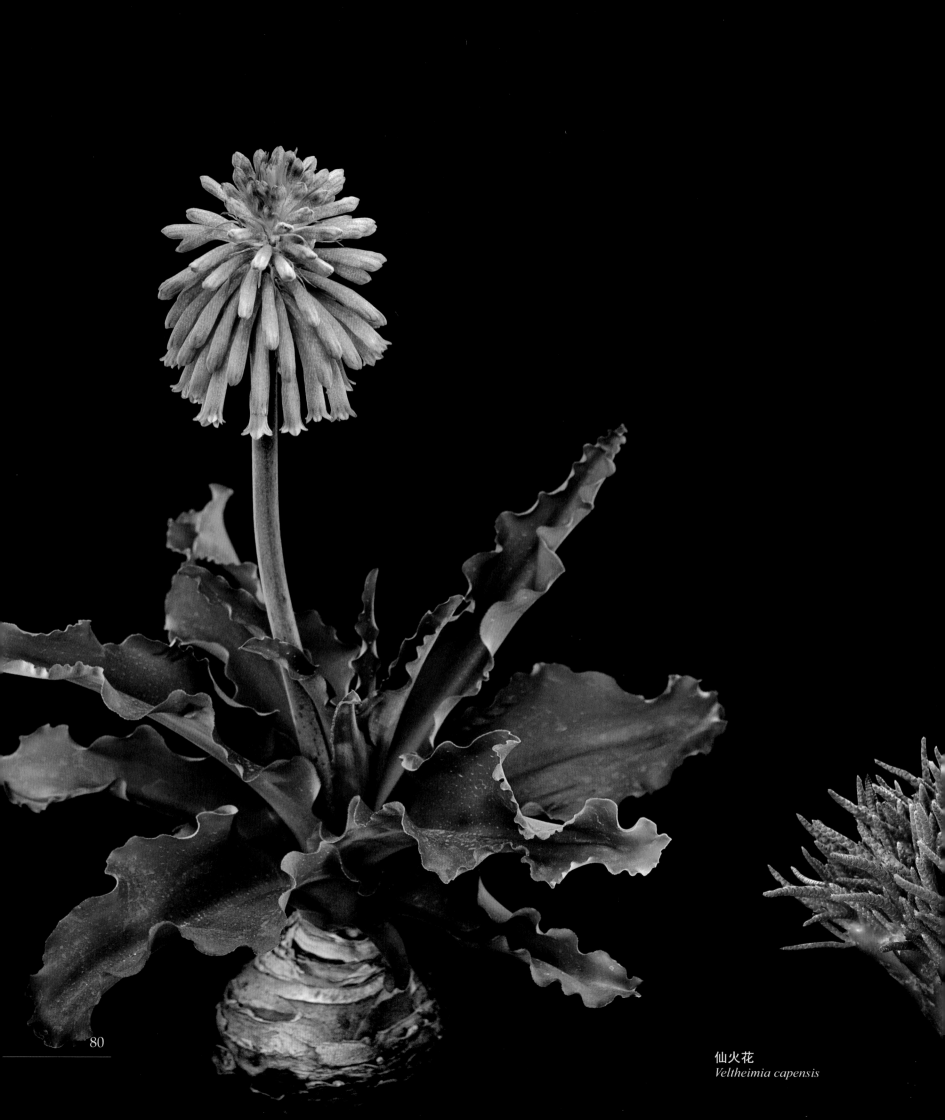

仙火花
Veltheimia capensis

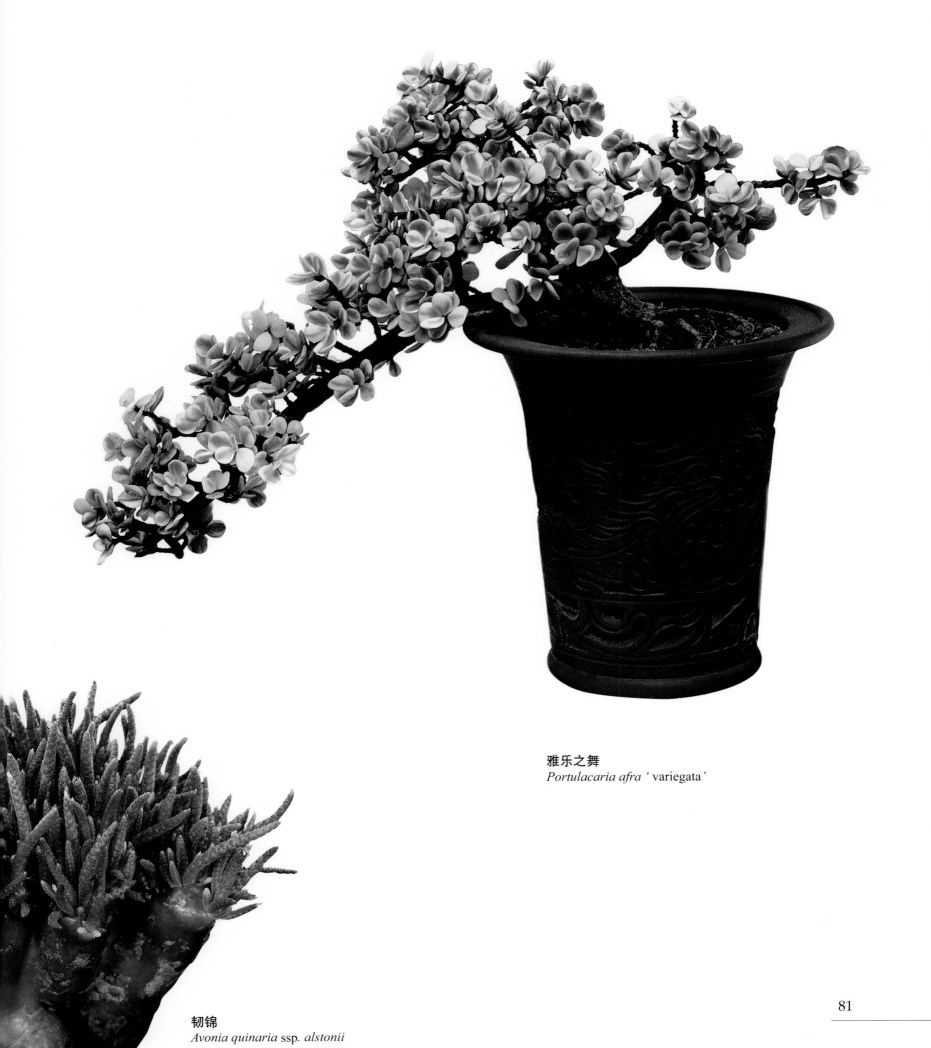

雅乐之舞
Portulacaria afra ' variegata '

韧锦
Avonia quinaria ssp. *alstonii*

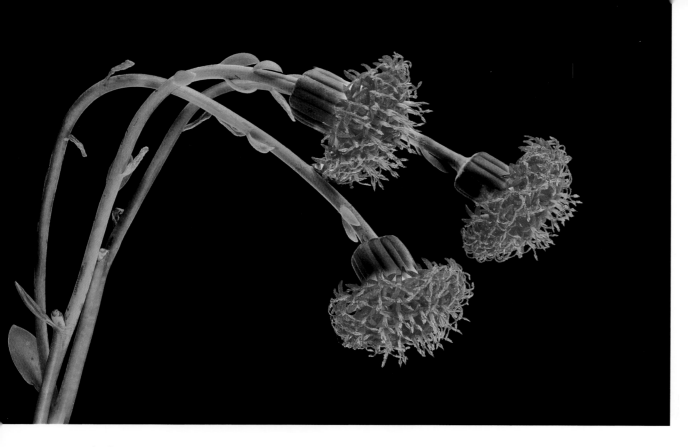

初鷹
Senecio pendulus

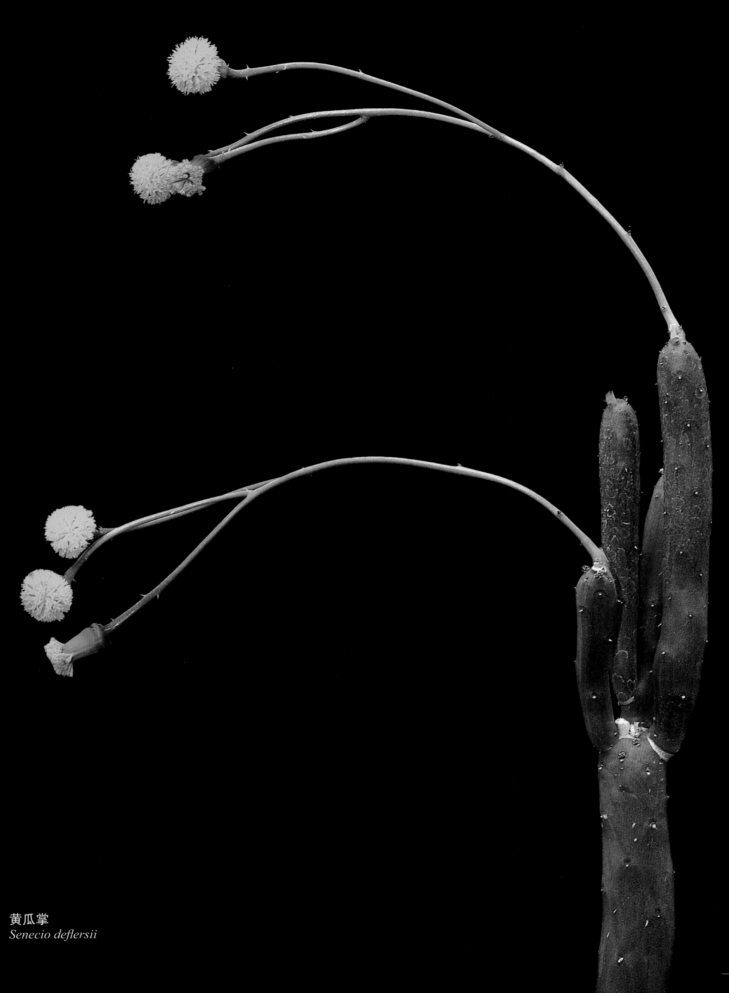

黄瓜掌
Senecio deflersii

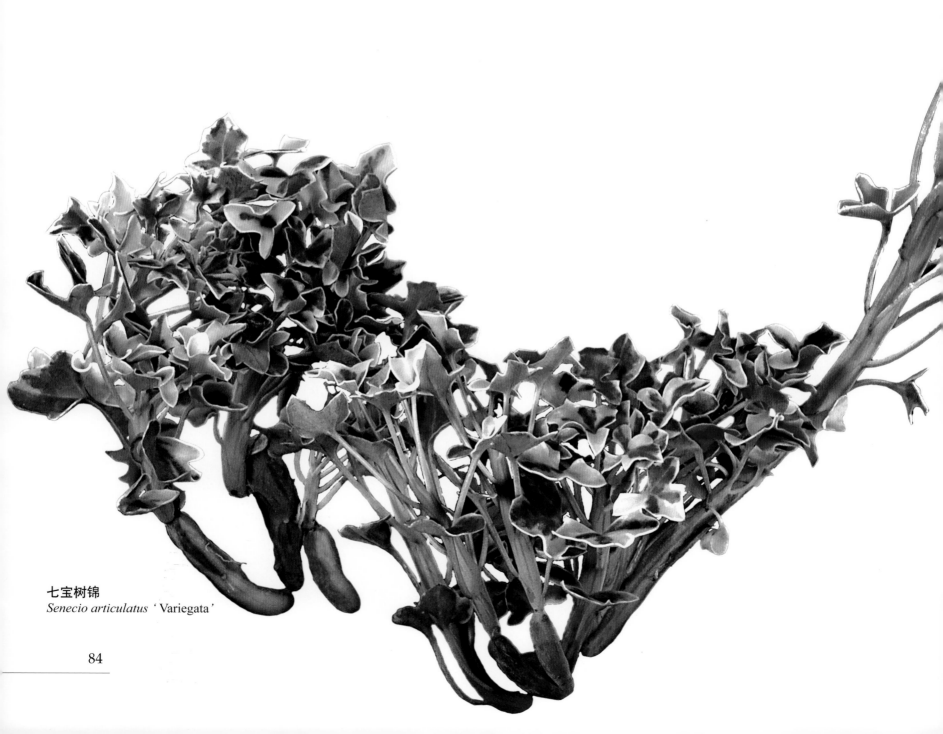

七宝树锦
Senecio articulatus ‘Variegata’

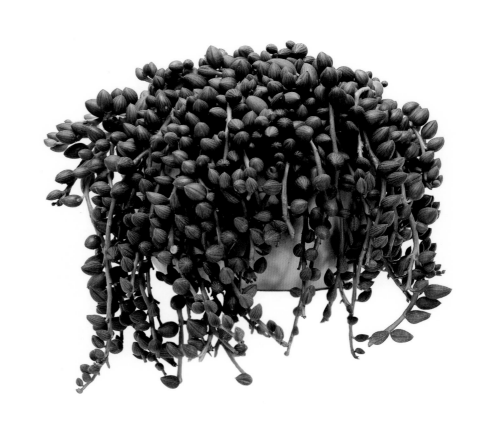

京童子
Senecio herreanus

紫蛮刀
Senecio crassissimus

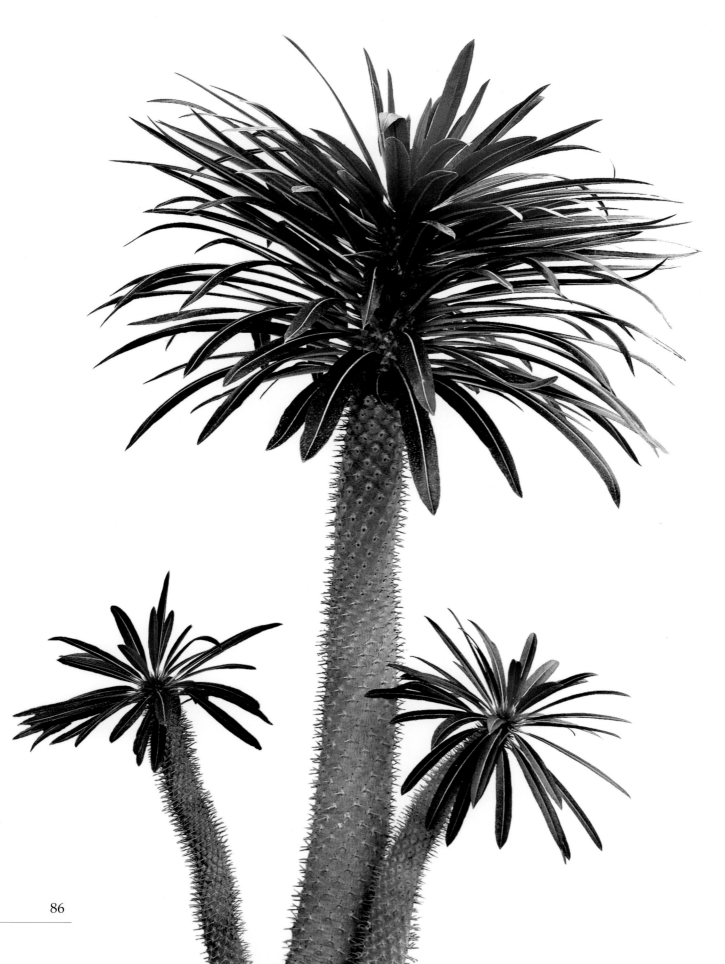

非洲霸王树
Pachypodium lamerei

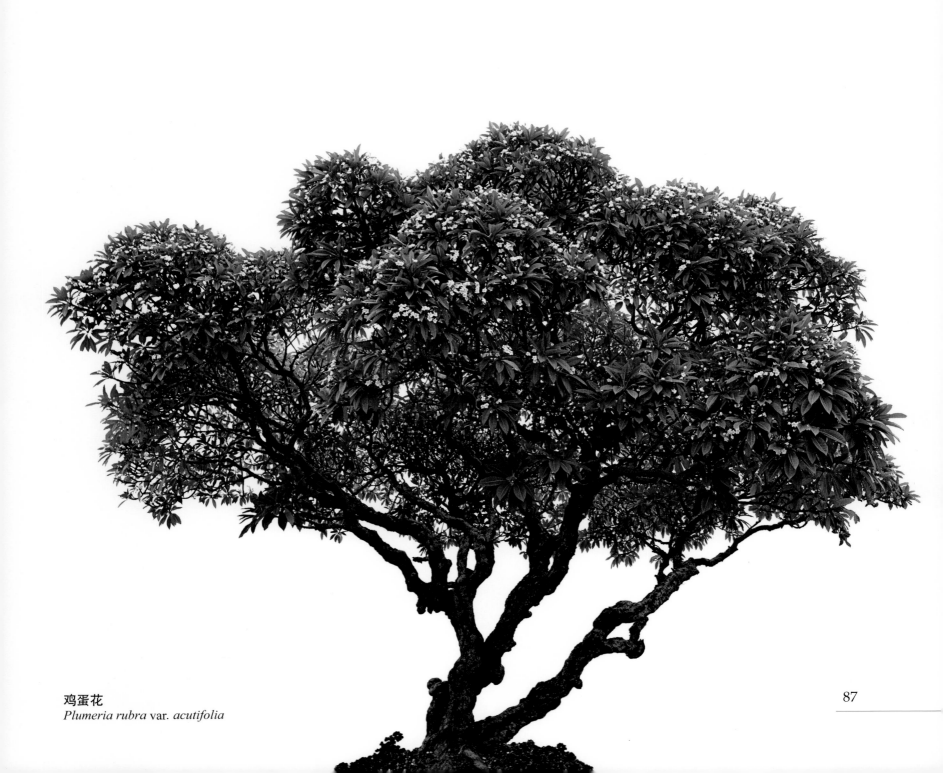

鸡蛋花
Plumeria rubra var. *acutifolia*

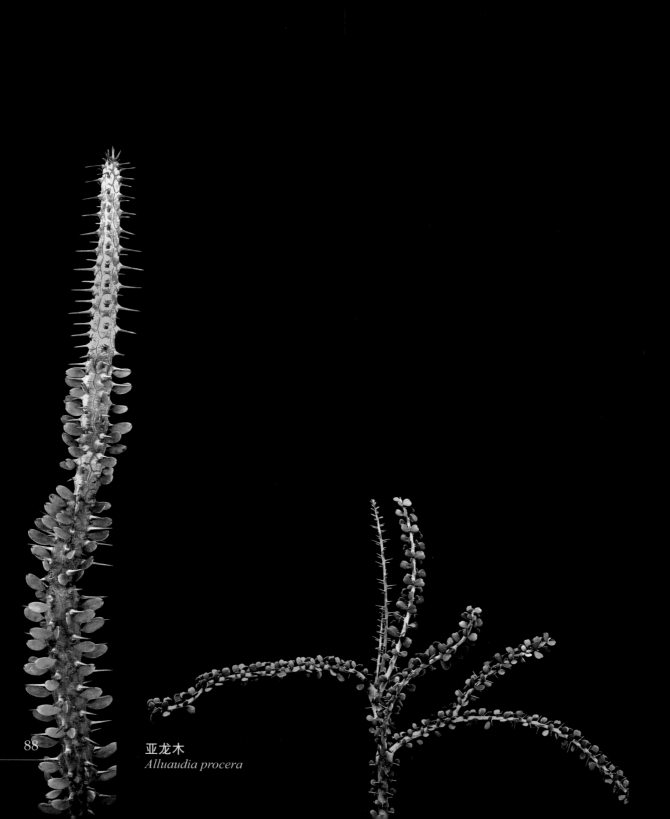

亚龙木
Alluaudia procera

七贤人
Alluaudia humbertii

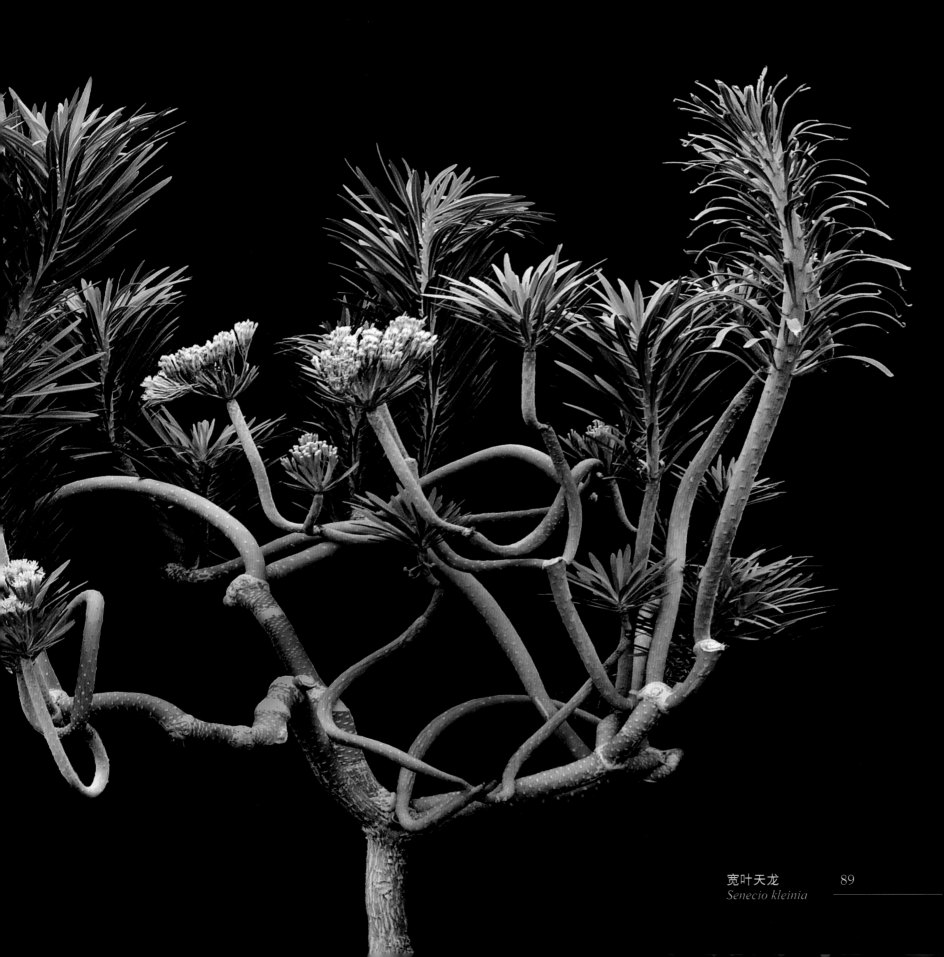

宽叶天龙　　89
Senecio kleinia

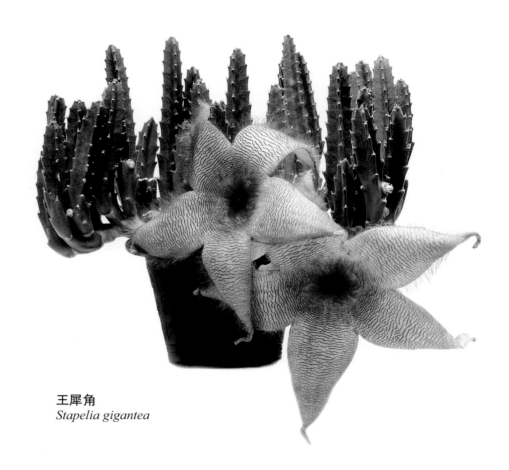

王犀角
Stapelia gigantea

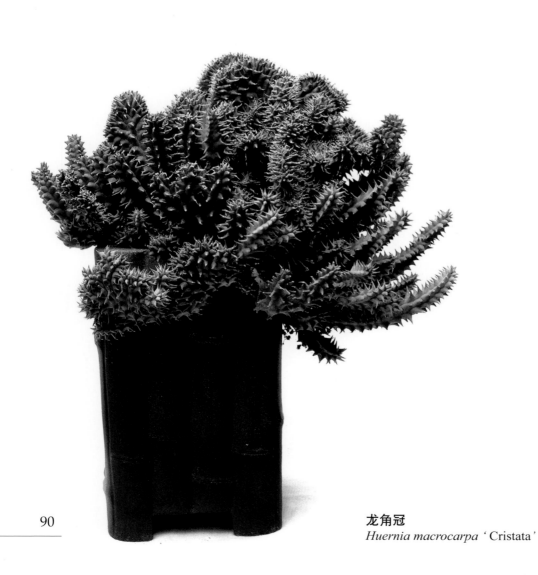

龙角冠
Huernia macrocarpa‘Cristata’

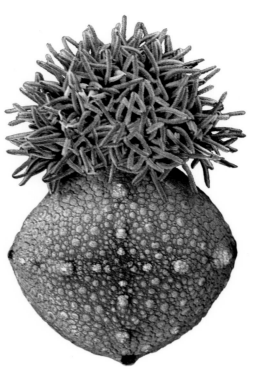

方凝蹄
Pseudolithos cubiformis

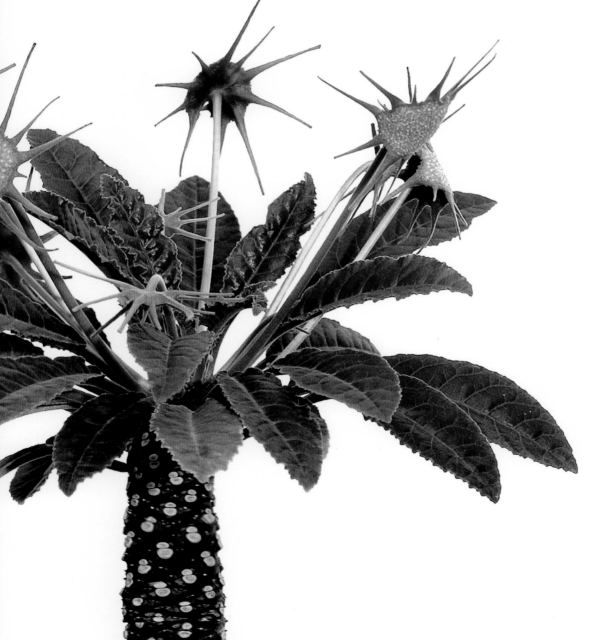

臭桑
Dorstenia foetida

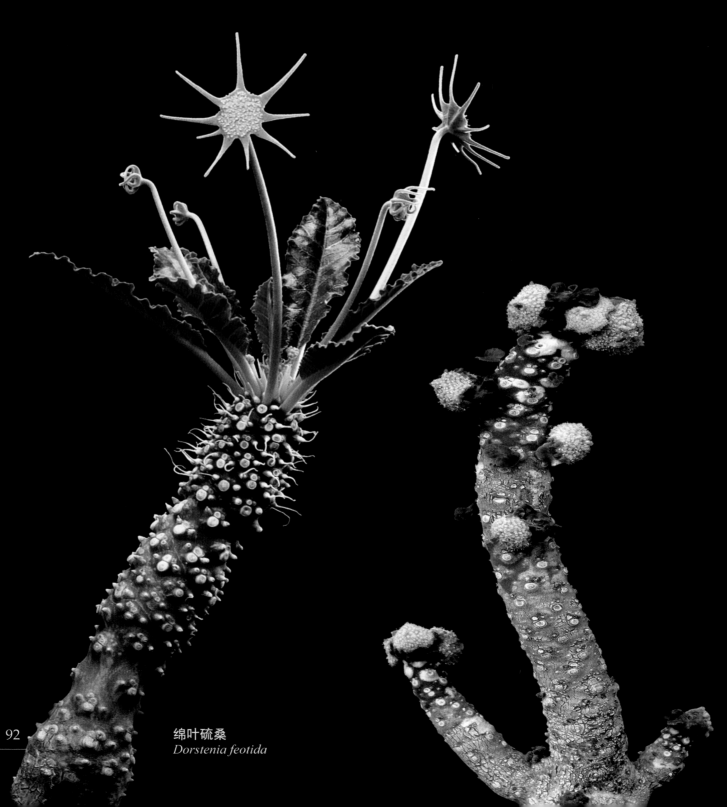

绵叶硫桑
Dorstenia feotida

圆叶硫桑
Dorstenia gypsophia

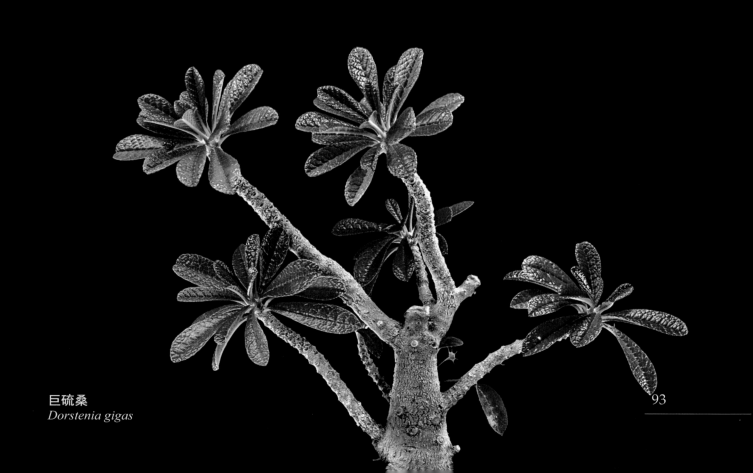

巨硫桑
Dorstenia gigas

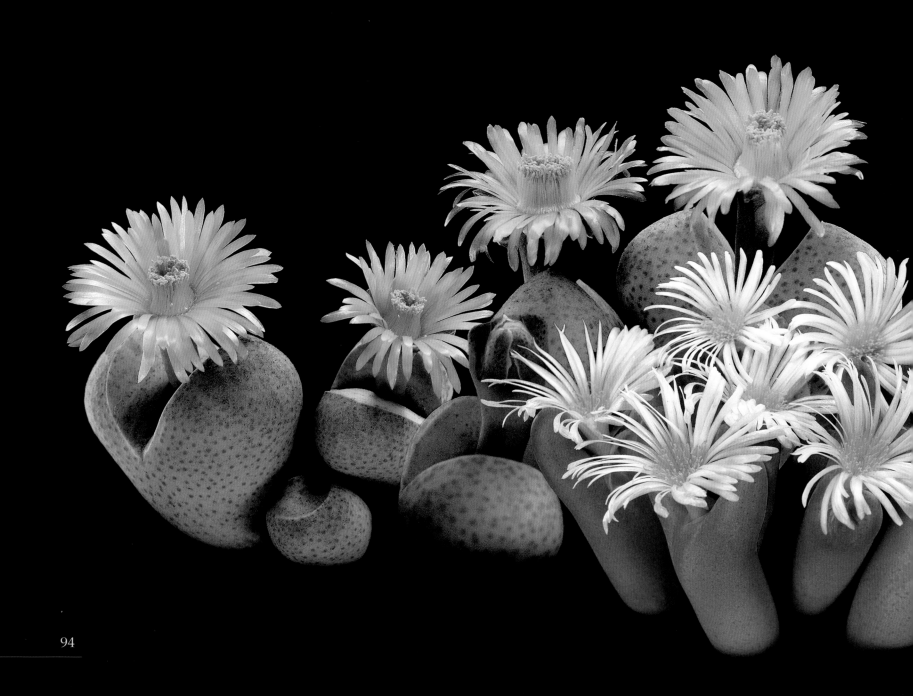

番杏篇
Aizoaceae

番杏科包含多种多肉草本或亚灌木植物，大多数种类高度肉质化，其分布以南非最为集中。番杏科常见的栽培种类很多，如生石花、肉锥花等，因其玲珑小巧，如石似玉且花色艳丽，为众多爱好者锺爱。

Members of Aizoaceae include various succulent herbs and subshrubs,Most of them are highly fleshy and found in southern Africe. Among its commonly known cultivars are Lithops and Conophytum, which have gained popularity for their jade-like appearanceand brightly colored flowers.

妖玉
Dinteranthus puberulus

白花大枪
Conophytum biloum 'Leucanthum'

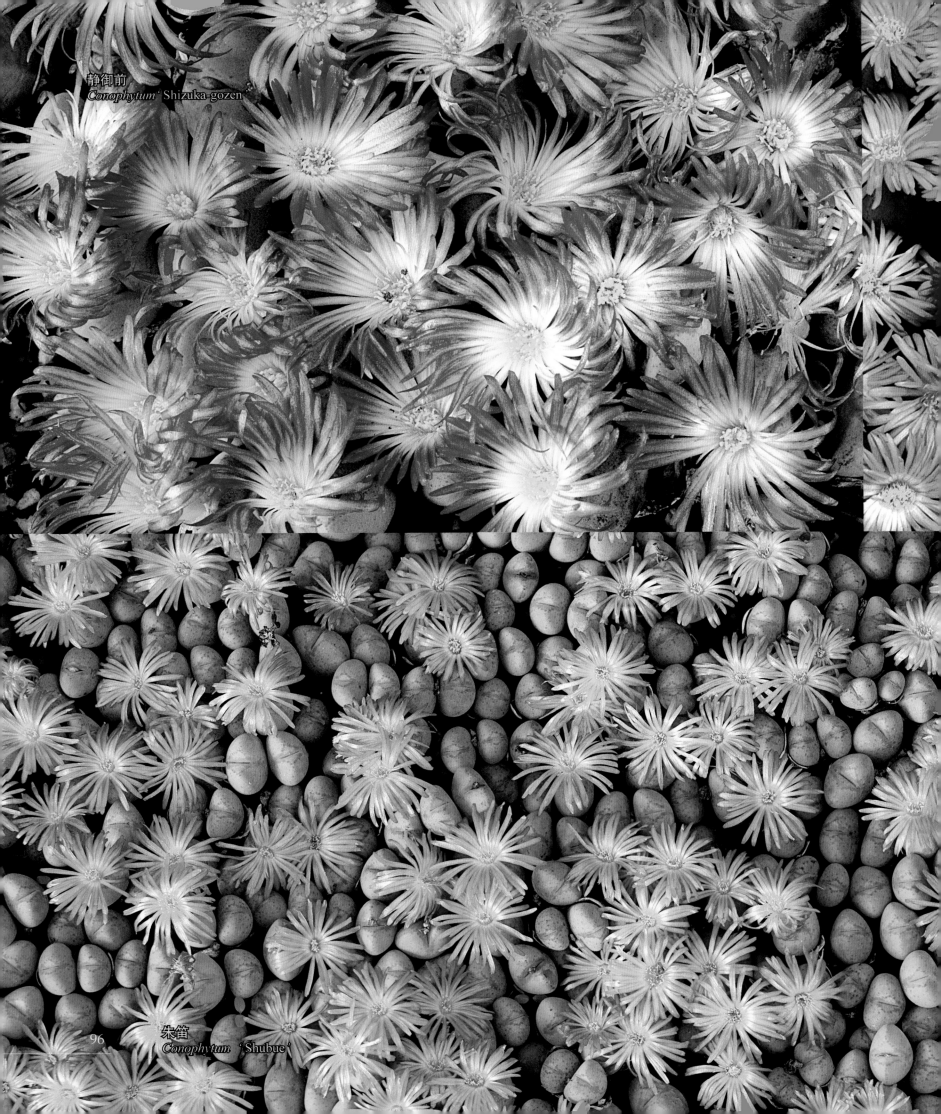

静御前
Conophytum 'Shizuka-gozen'

96 朱笛
Conophytum 'Shubue'

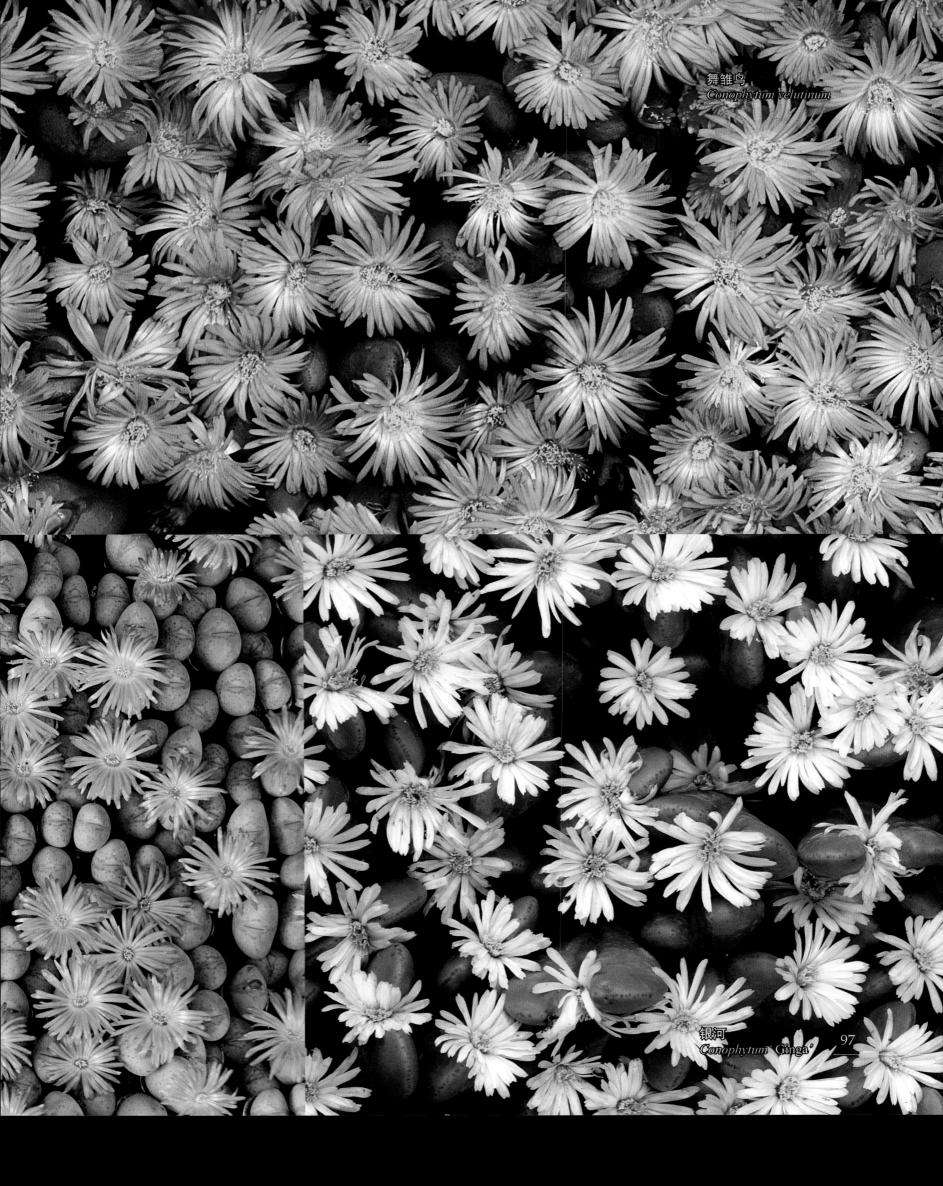

舞雏鸟
Conophytum velutinum

银河
Conophytum 'Ginga'

97

白凤菊
Oscularia pedunculata

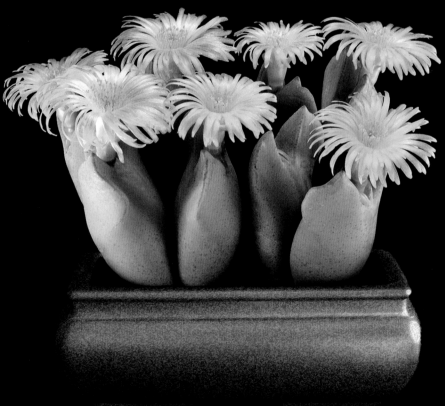

赤耳少将
Conophytum bilobum var. *muscosipapillatum* 'Chirstiansenianum'

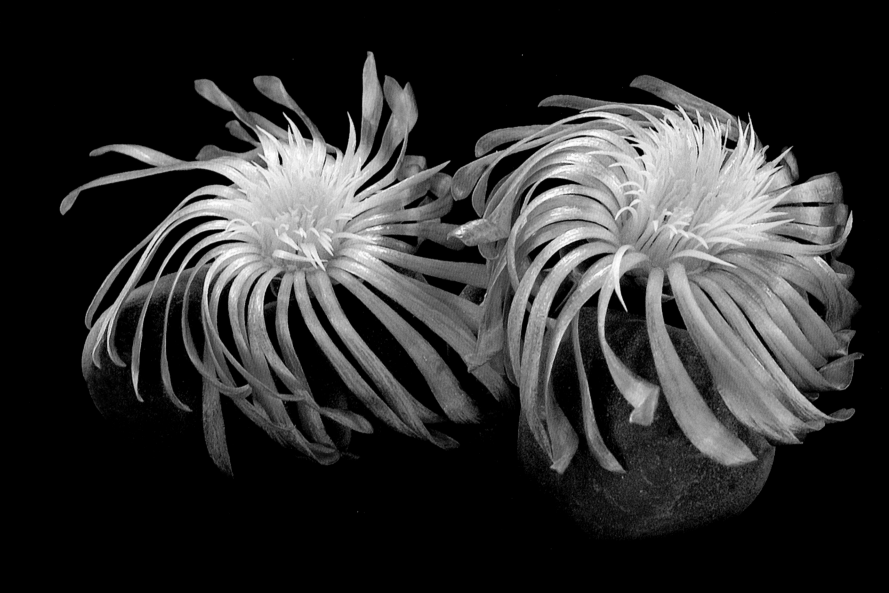

无比玉
Gibbaeum dispar

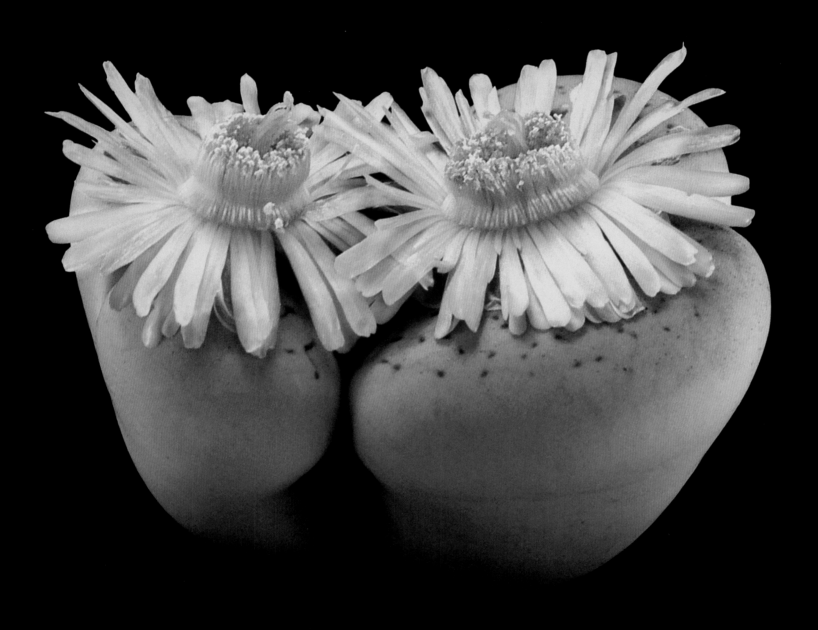

绫耀玉
Dinteranthus vanzylii

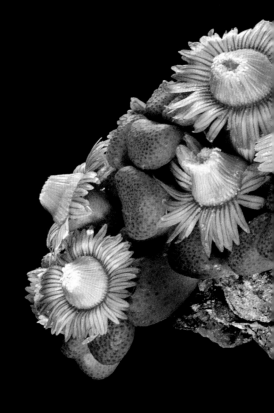

唐扇
Aloinopsis schooneesii

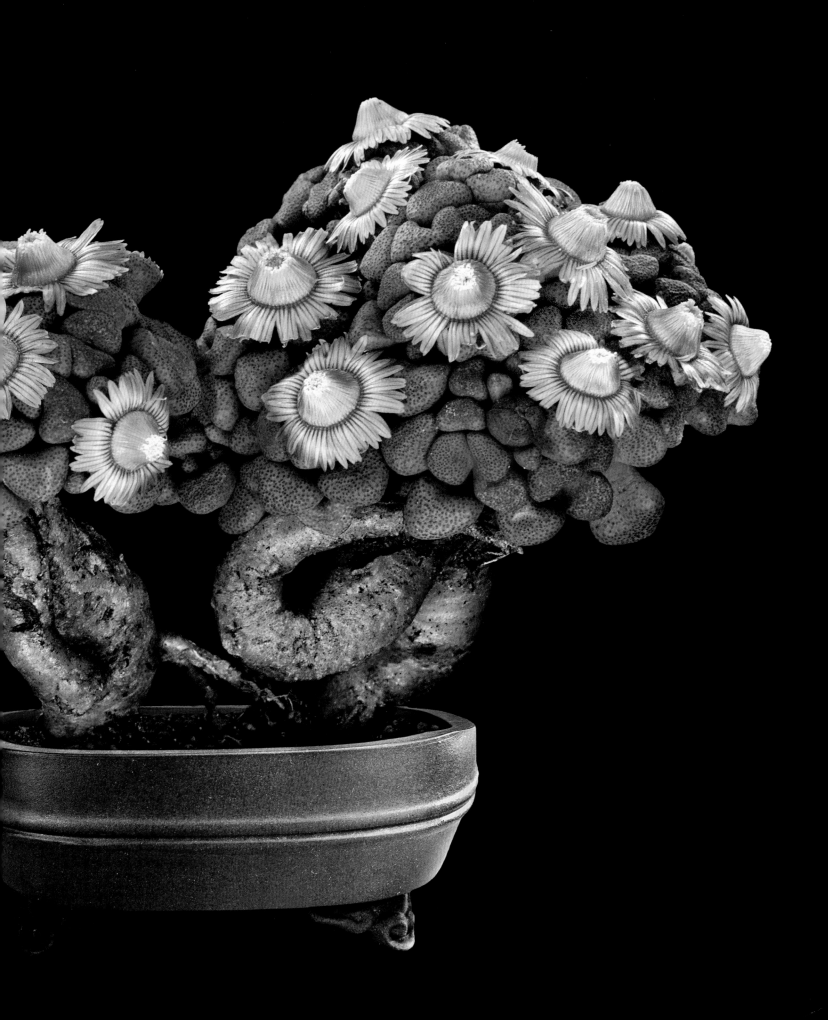

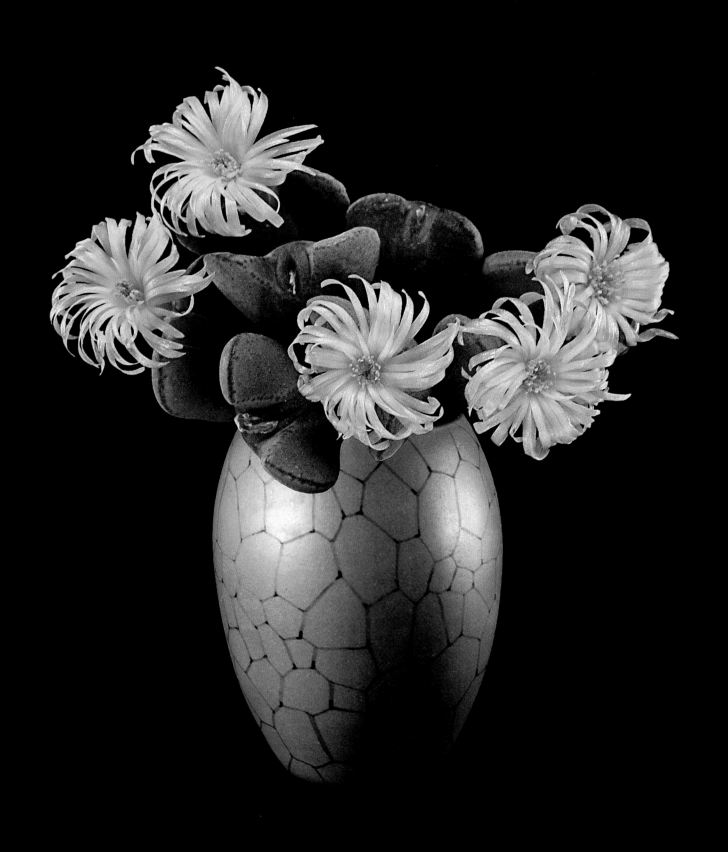

小菊之舞
Conophytum 'Kogikunomai'

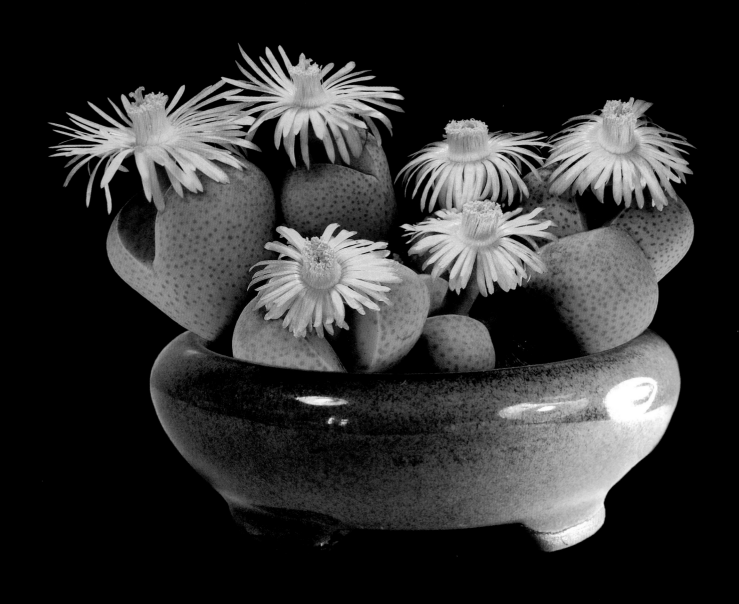

幻玉
Dinteranthus wilmotianus

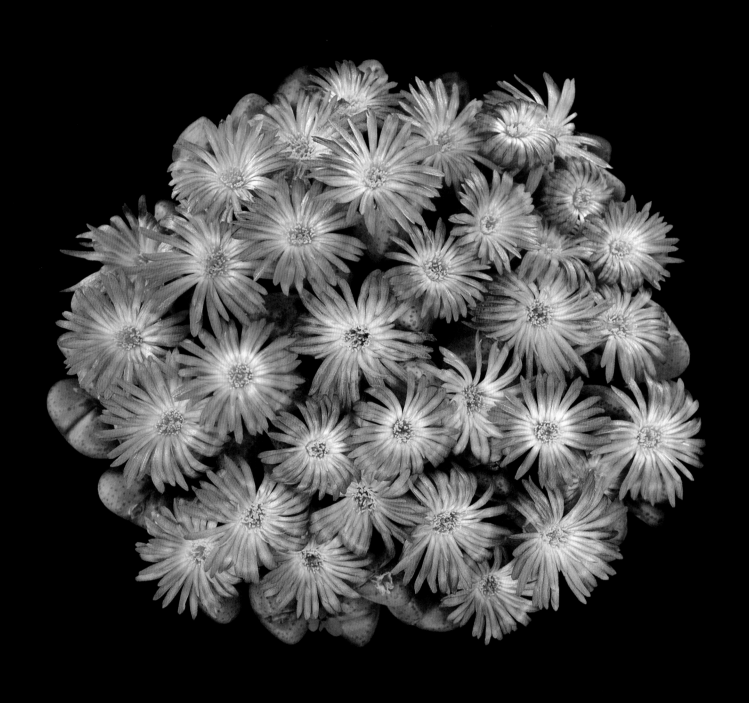

舞雏鸟
Conophytum velutinum

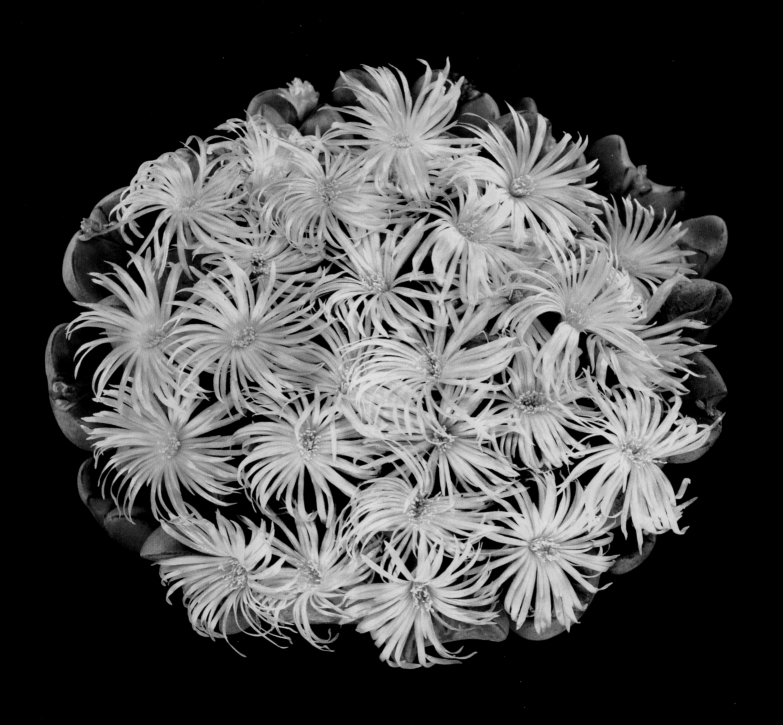

小菊之舞
Conophytum ' Kogikunomai '

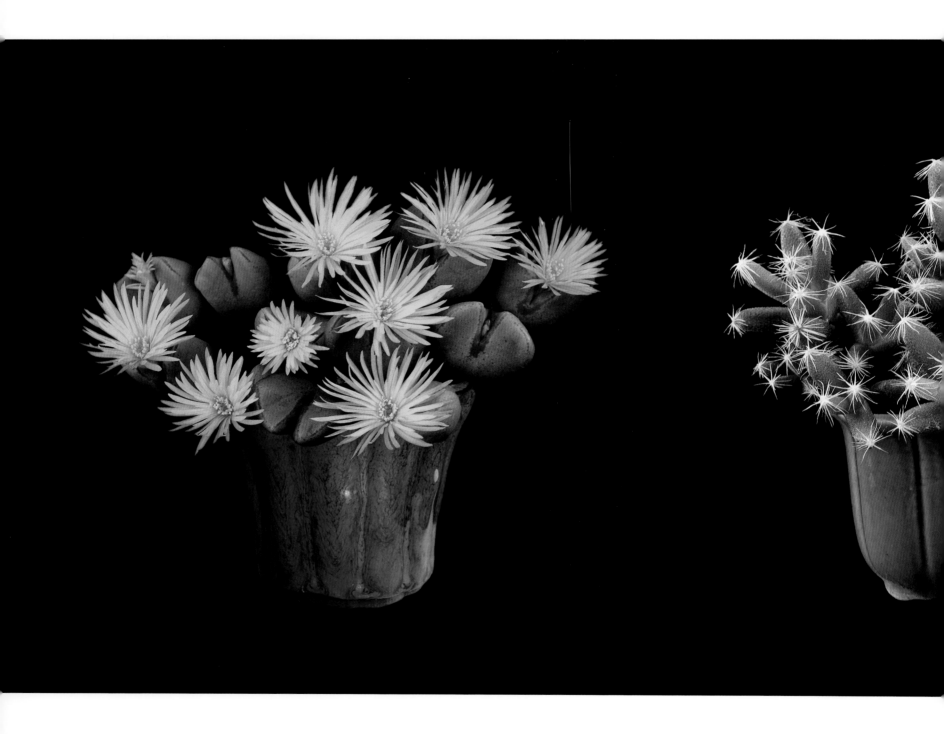

少将
Conophytum bilobum

紫晃星
Trichodiadema densum

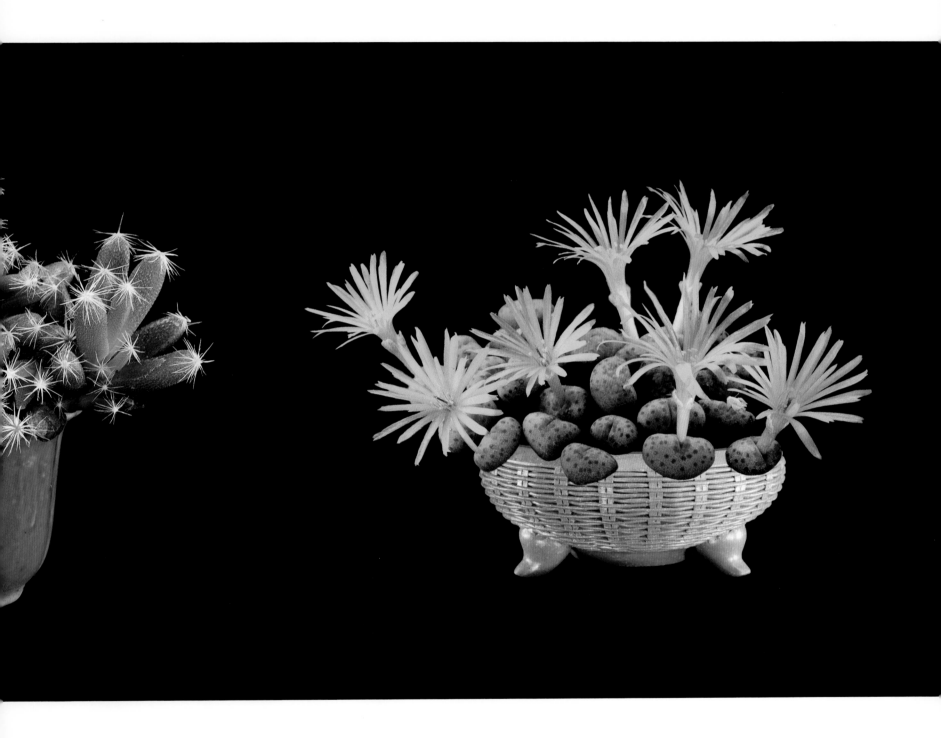

新玉彦
Conophytum flavum ssp. *novicium*

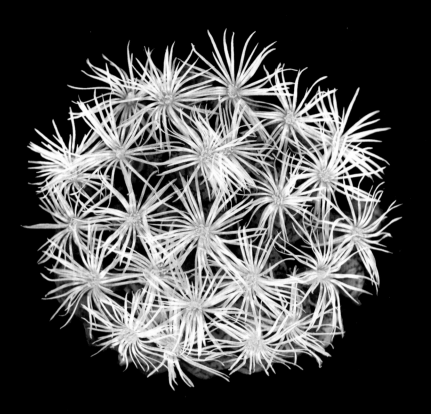

福宫玉
Conophytum uviforme

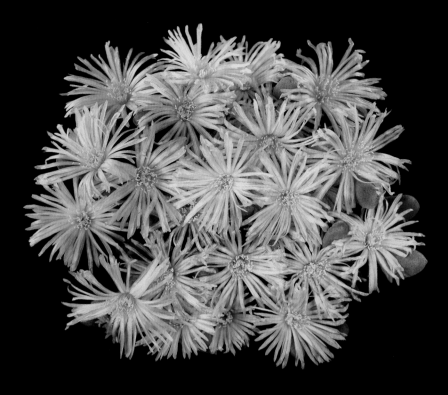

厚叶少将
Conophytum bilobum 'Tumidum'

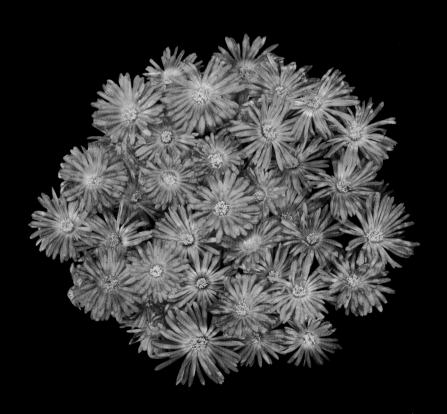

金将
Conophytum 'Kinshou'

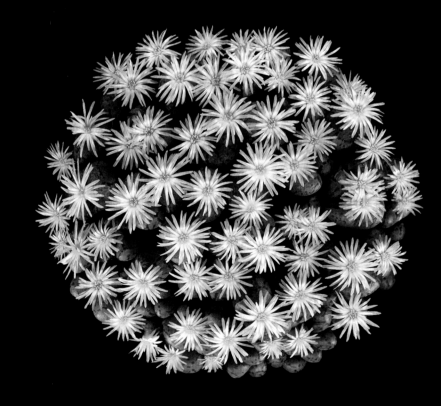

青春玉
Conophytum ficiforme

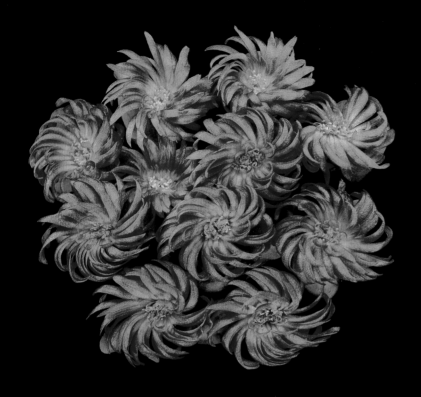

御之光
Conophytum cv.

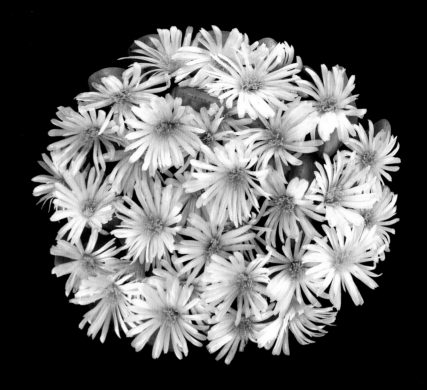

银河
Conophytum‘Ginga’

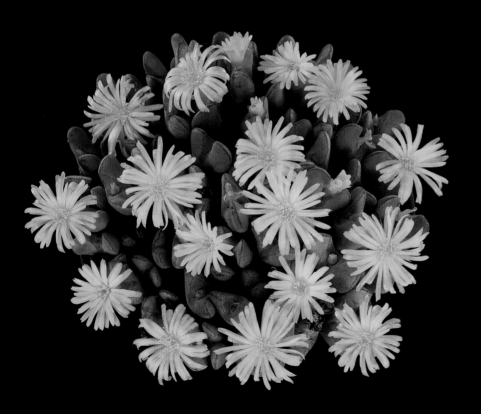

少将
Conophytum bilobum

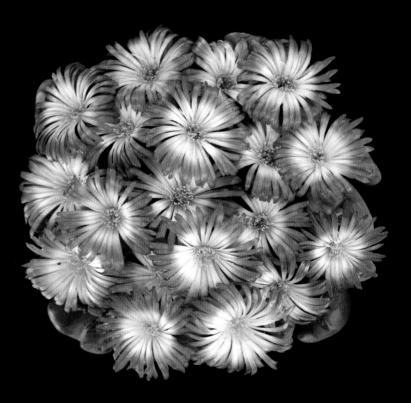

蛇之目
Conophytum‘Janome’

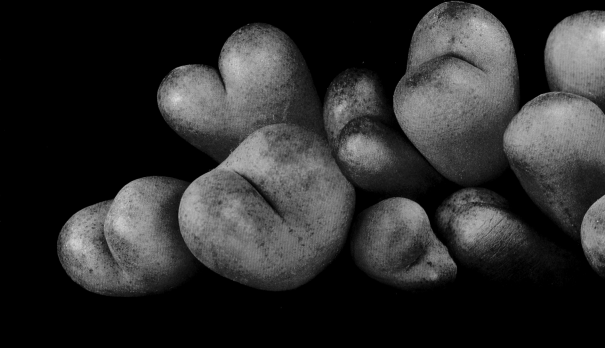

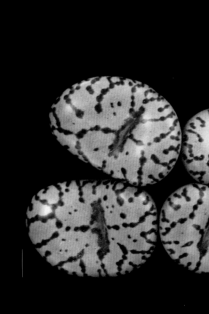

丰彩内侍
Conophytum obcordellum ˙Multicolor˙

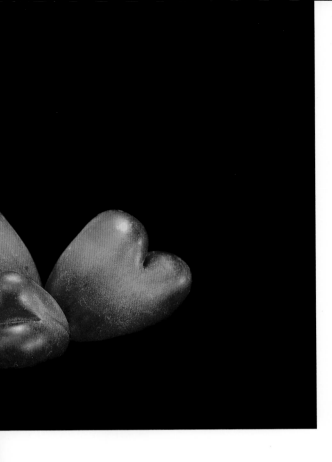

挽霞
Conophytum ‘Wanxia’

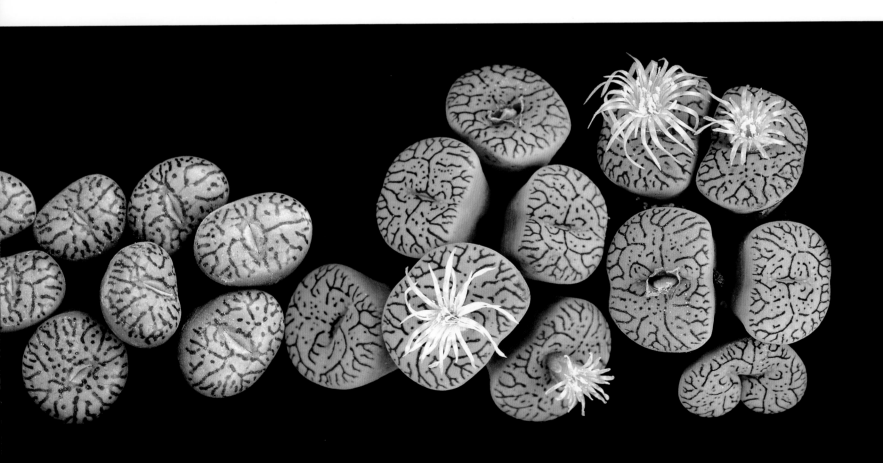

墨小锥
Conophytum minimum ‘Wittebergense’

墨小锥
Conophytum minimum ‘Wittebergense’

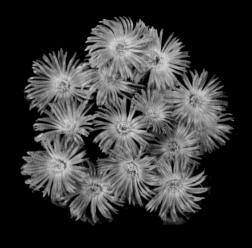

少将杂交种
Conophytum bilobum (hybrid)

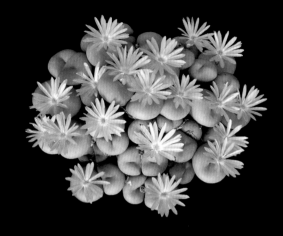

静御前
Conophytum ˙Shizuka-gozen˙

凤雏玉
Conophytum minutum

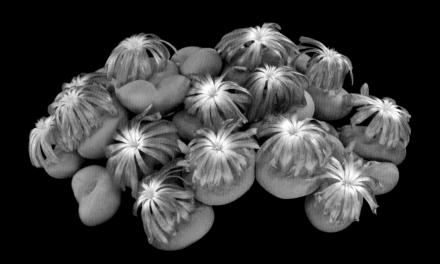

群碧玉
Conophytum minutum

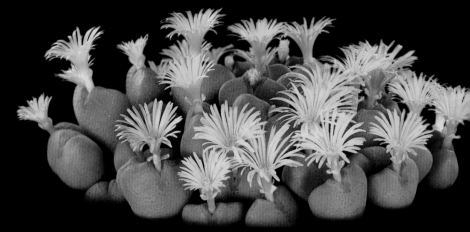

舞踏会
Conophytum ˙Butokai˙

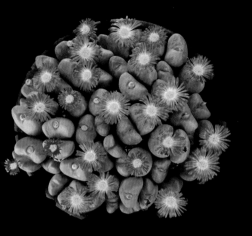

舞雏鸟
Conophytum velutinum

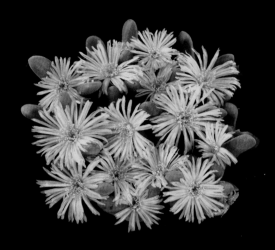

厚叶少将
Conophytum bilobum ' Tumidum '

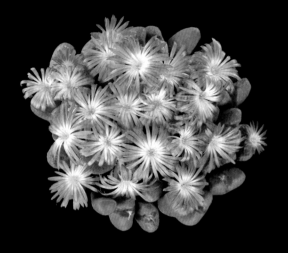

明窗玉
Conophytum violaciflorum

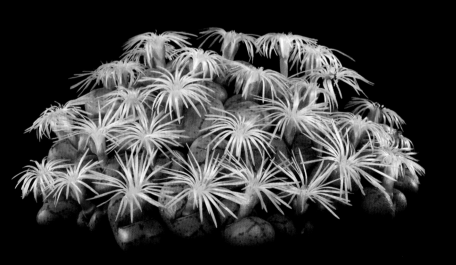

八重垣姬
Conophytum ficiforme ' Yaegakihime '

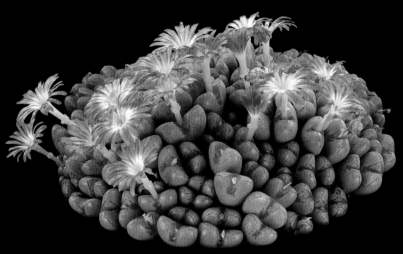

明窗玉
Conophytum violaciflorum

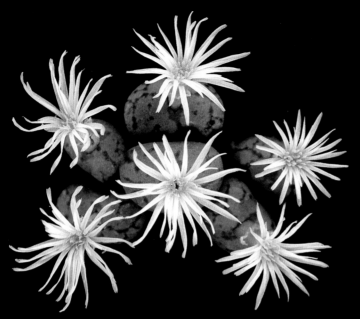

丰彩内侍
Conophytum obcordellum ‘ Multicolor ’

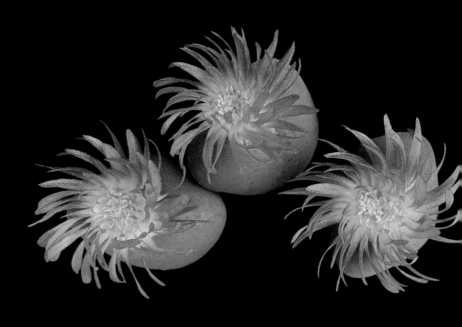

花车
Conophytum ‘ Kiyasya ’

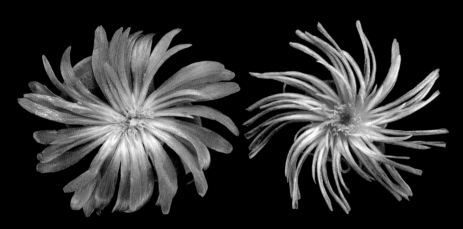

圣铃玉
Conophytum praesectum

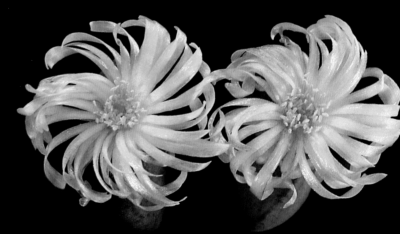

小菊之舞
Conophytum ‘ Kogikunomai ’

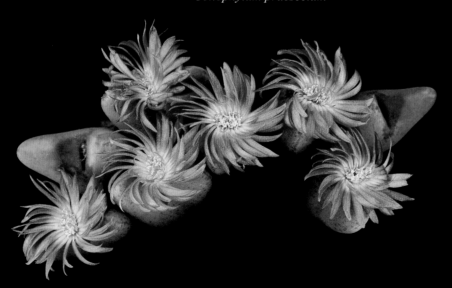

虹之花
Conophytum ‘ Niji-no-hana ’

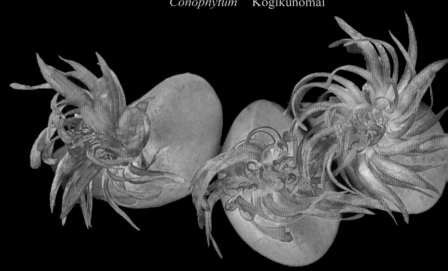

京御所
Conophytum ‘ Kyougosyo ’

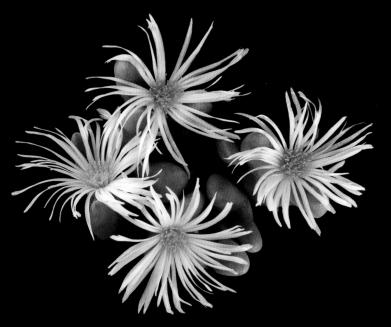

白秋
Conophytum bilobum 'Leucanthum'

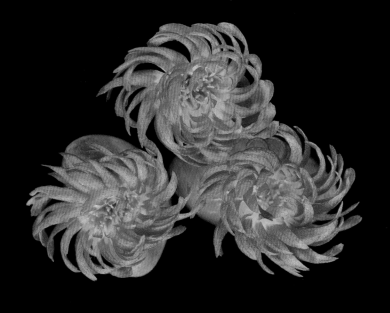

御所车
Conophytum 'Goshu-Goruma'

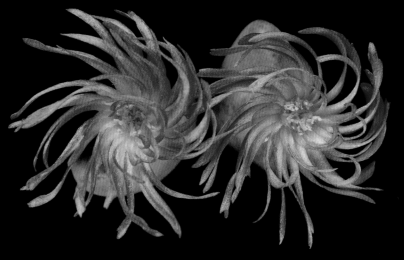

花车
Conophytum 'Kiyasya'

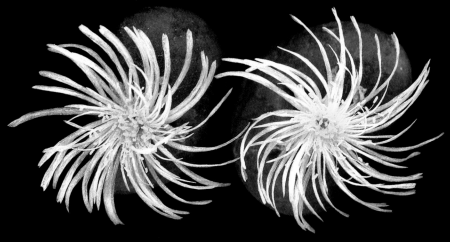

莫氏玉
Conophytum maughanii

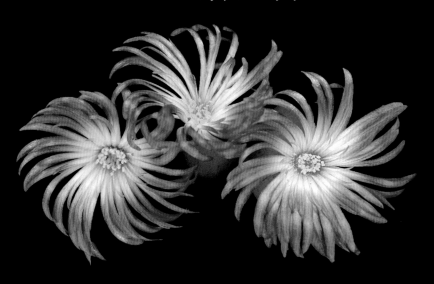

静御前
Conophytum 'Shizuka-gozen'

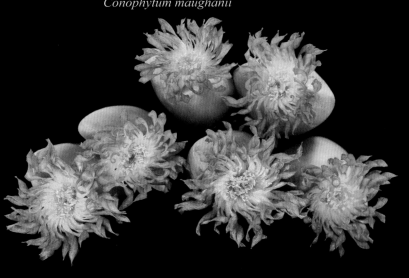

花狮子
Conophytum 'Hanajishi'

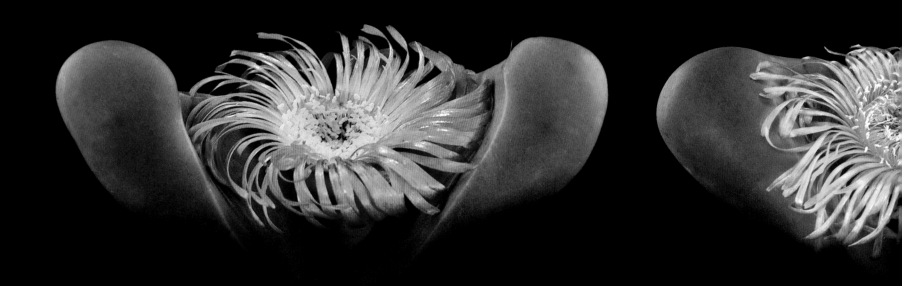

金铃
Argyroderma cvs.

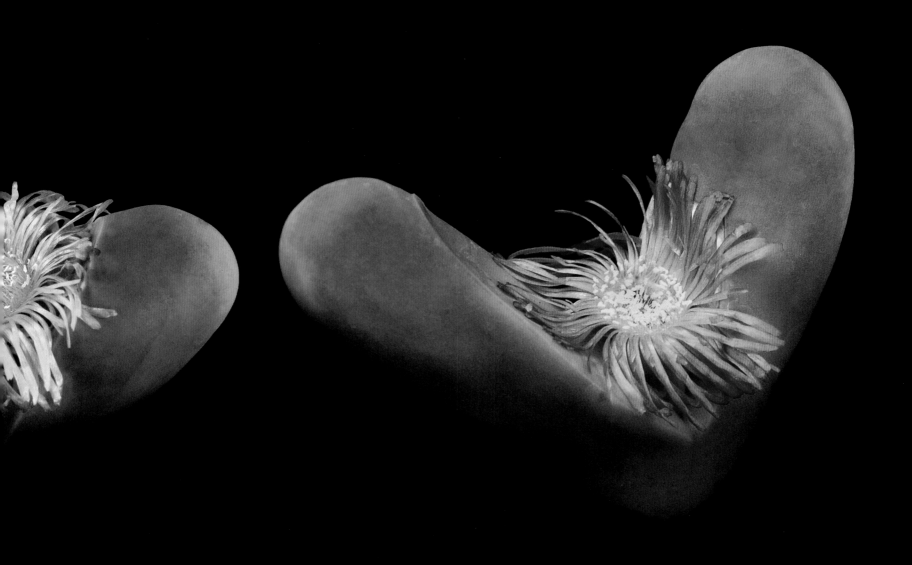

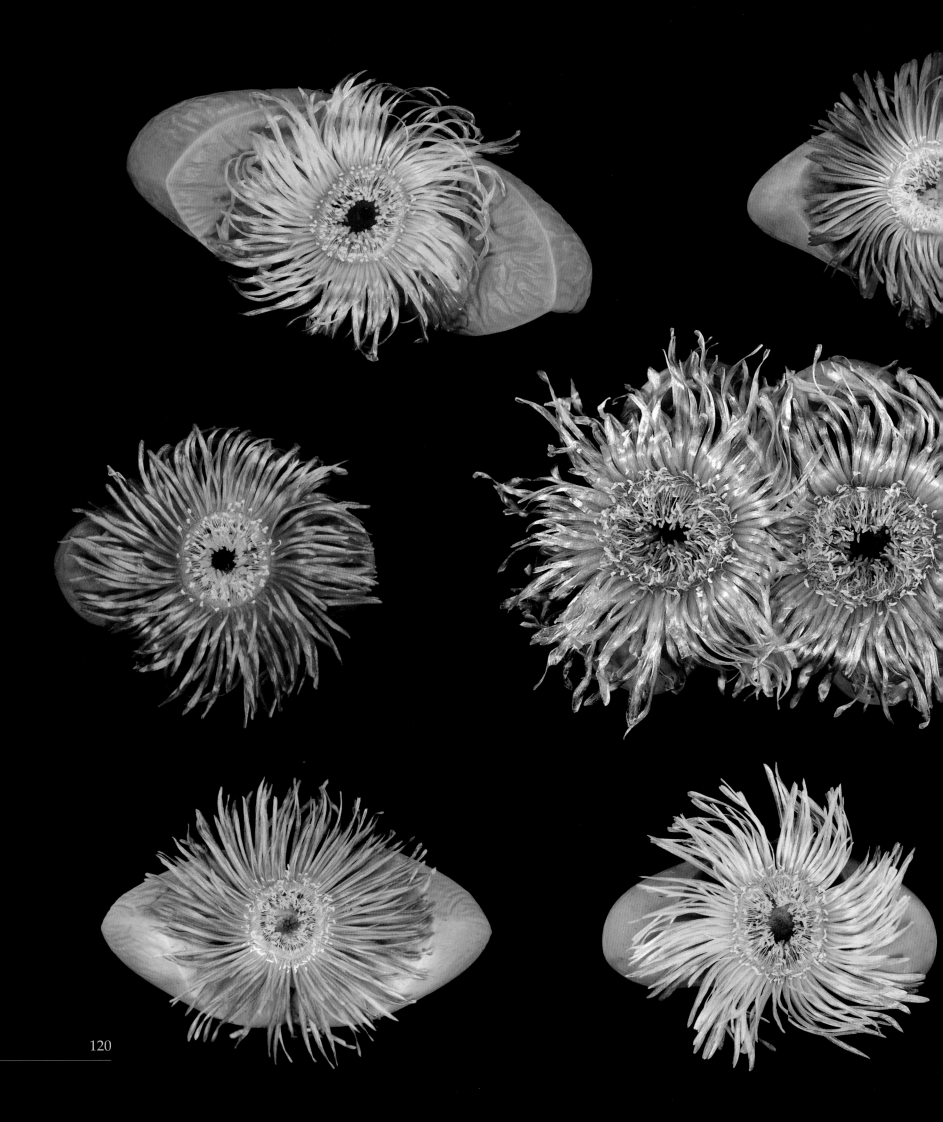

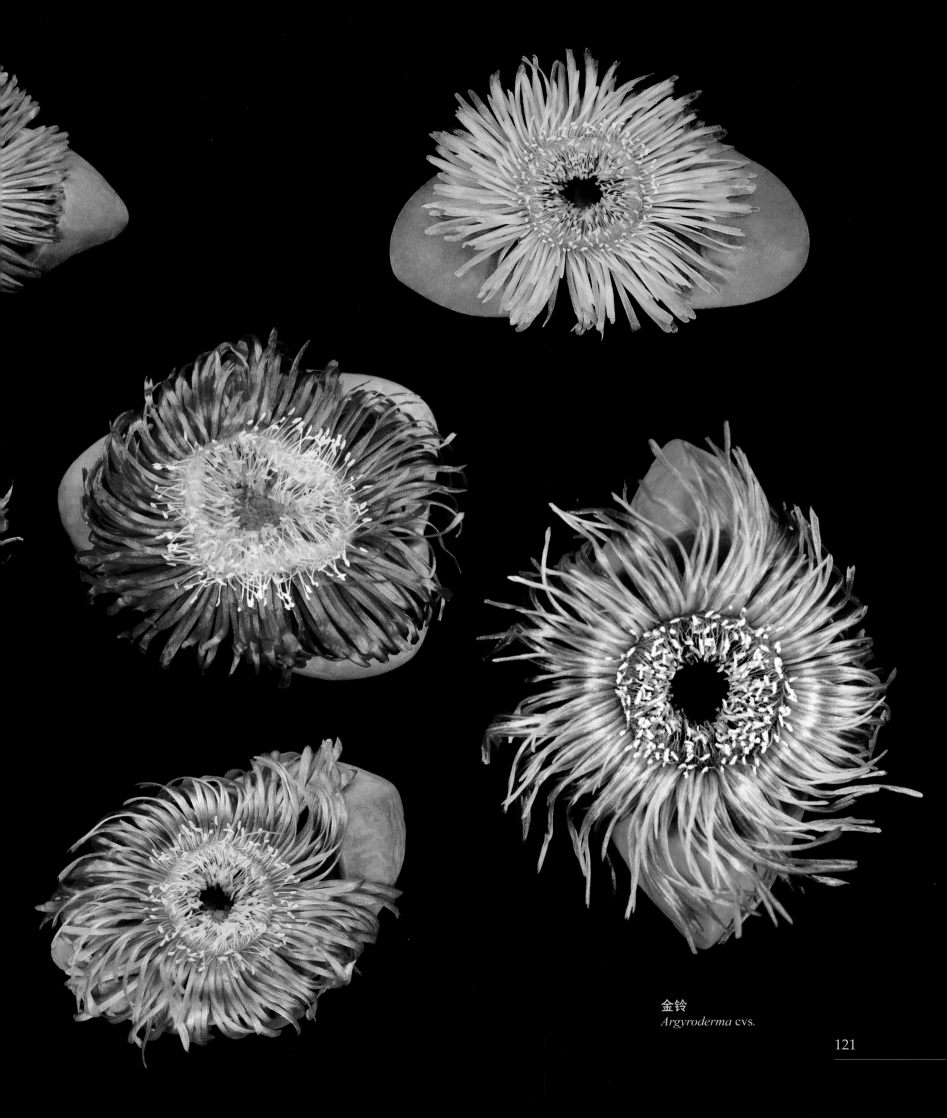

金铃
Argyroderma cvs.

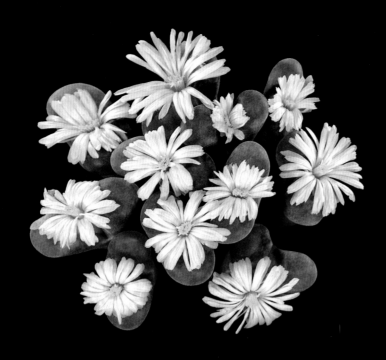

青铃
Conophytum longum

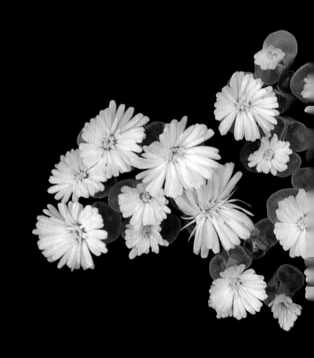

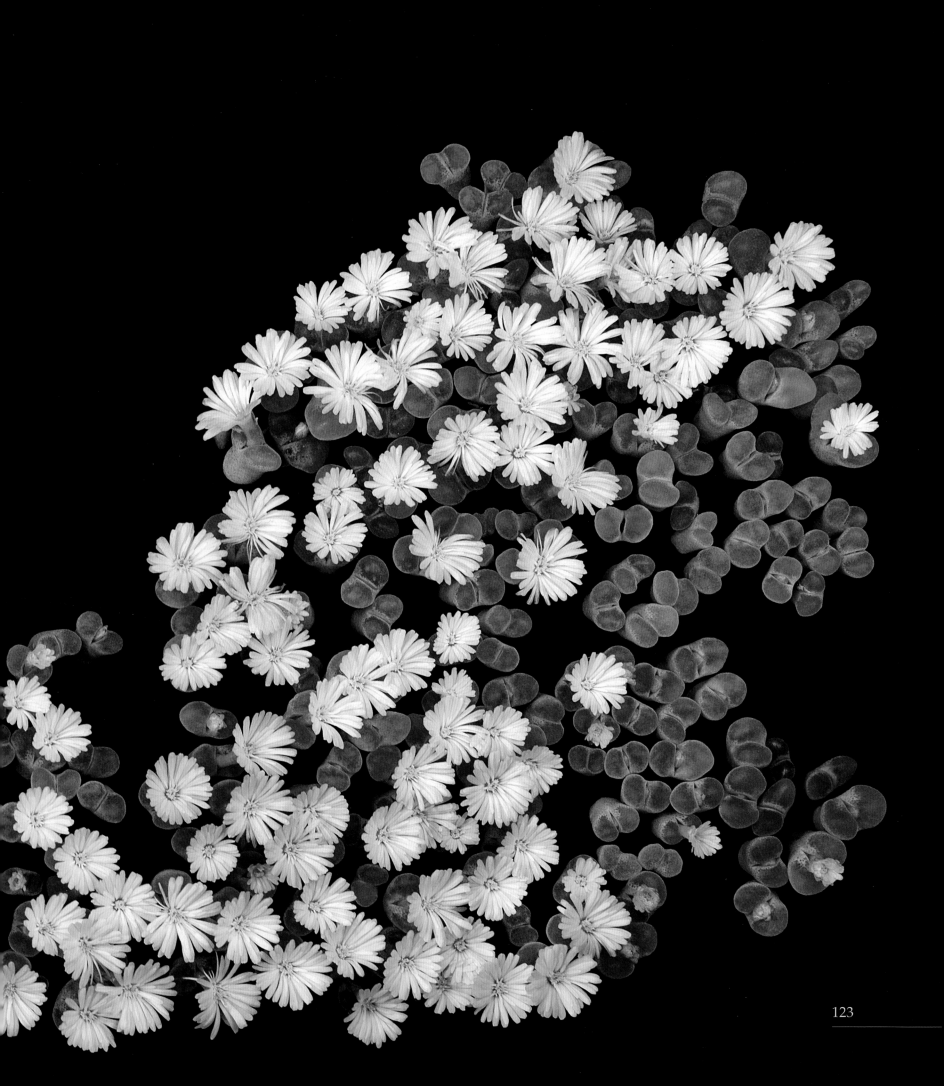

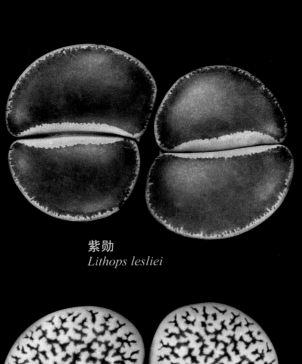

紫勋
Lithops lesliei

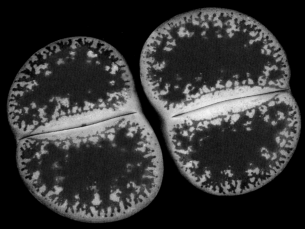

白花黄太阳玉
Lithops aucampiae 'Betty's Beryl'

丸贵
Lith

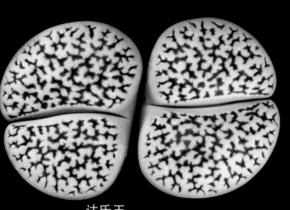

达氏玉
Lithops hookeri var. *dabneri*

日轮玉
Lithops aucampiae

紫勋
Lith

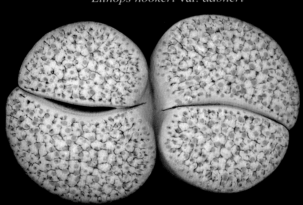

乐地玉
Lithops fulviceps var. *lactinea*

白花黄紫勋
Lithops lesliei 'Albinica'

荣玉
Lith

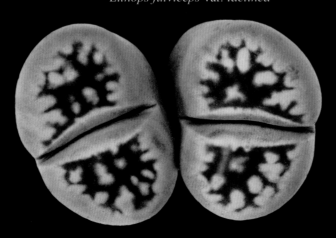

花纹玉
Lithops karasmontana

平滑朝贡玉
Lithops verruculosa var. *glabra*

橄榄
Lithe

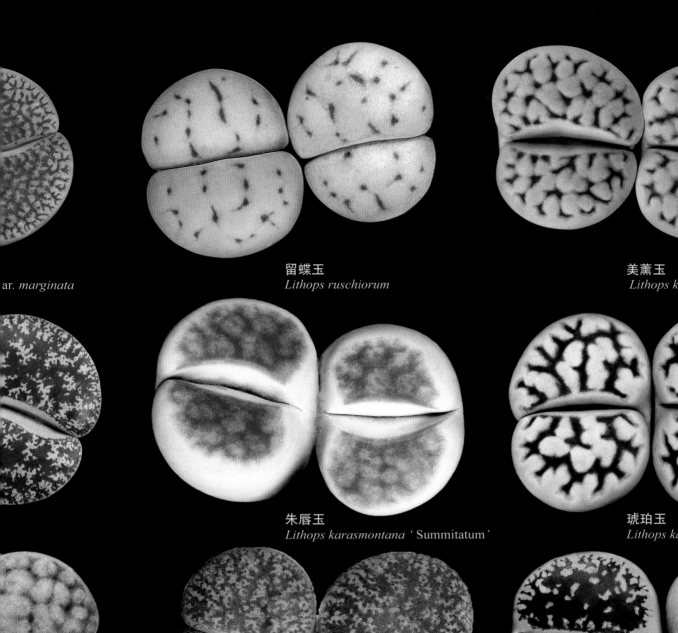

ar. *marginata*

留蝶玉
Lithops ruschiorum

美薰玉
Lithops karasmontana

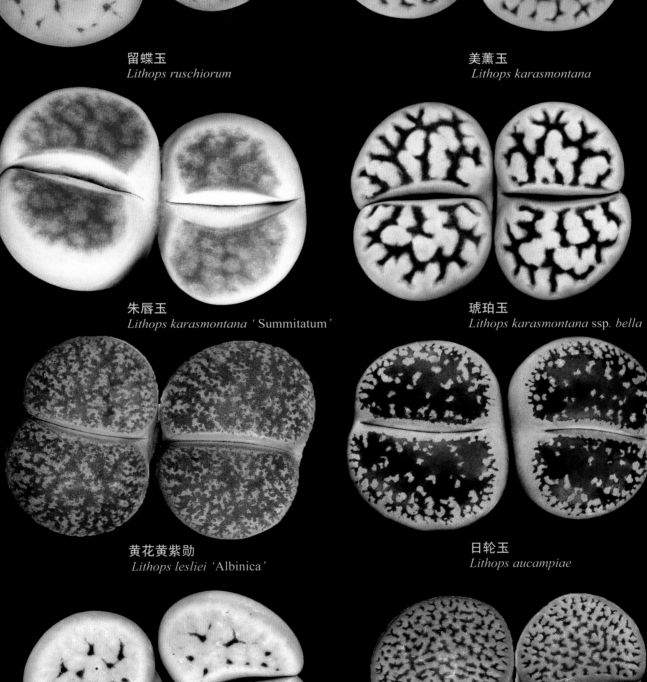

朱唇玉
Lithops karasmontana 'Summitatum'

琥珀玉
Lithops karasmontana ssp. *bella*

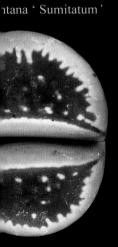

ntana 'Sumitatum'

黄花黄紫勋
Lithops lesliei 'Albinica'

日轮玉
Lithops aucampiae

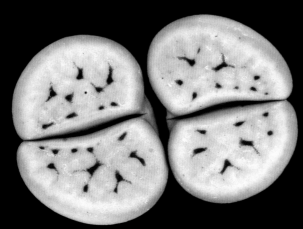

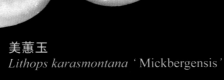

美薰玉
Lithops karasmontana 'Mickbergensis'

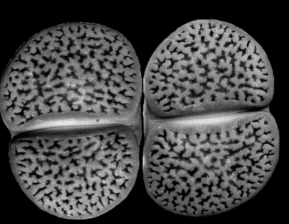

富贵玉
Lithops hookeri

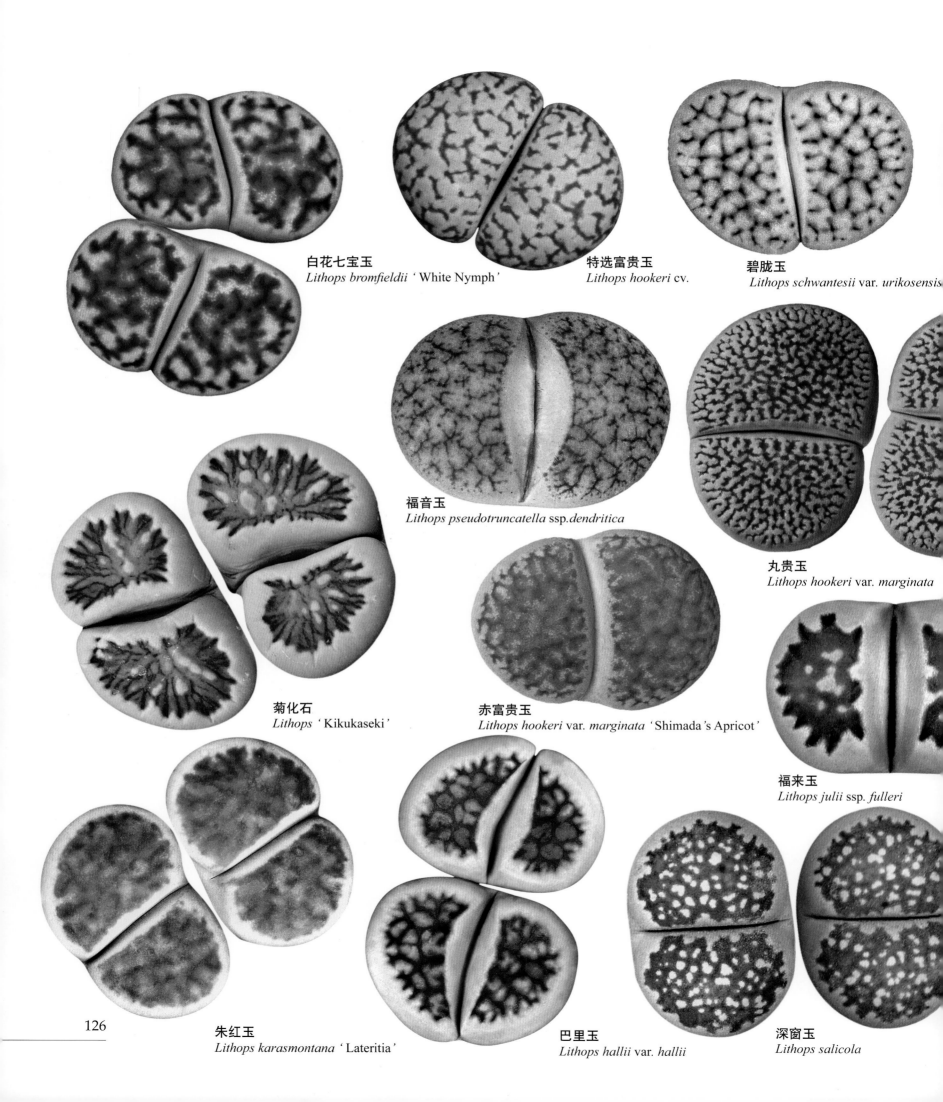

白花七宝玉
Lithops bromfieldii 'White Nymph'

特选富贵玉
Lithops hookeri cv.

碧胧玉
Lithops schwantesii var. *urikosensis*

福音玉
Lithops pseudotruncatella ssp. *dendritica*

丸贵玉
Lithops hookeri var. *marginata*

菊化石
Lithops 'Kikukaseki'

赤富贵玉
Lithops hookeri var. *marginata* 'Shimada's Apricot'

福来玉
Lithops julii ssp. *fulleri*

朱红玉
Lithops karasmontana 'Lateritia'

巴里玉
Lithops hallii var. *hallii*

深窗玉
Lithops salicola

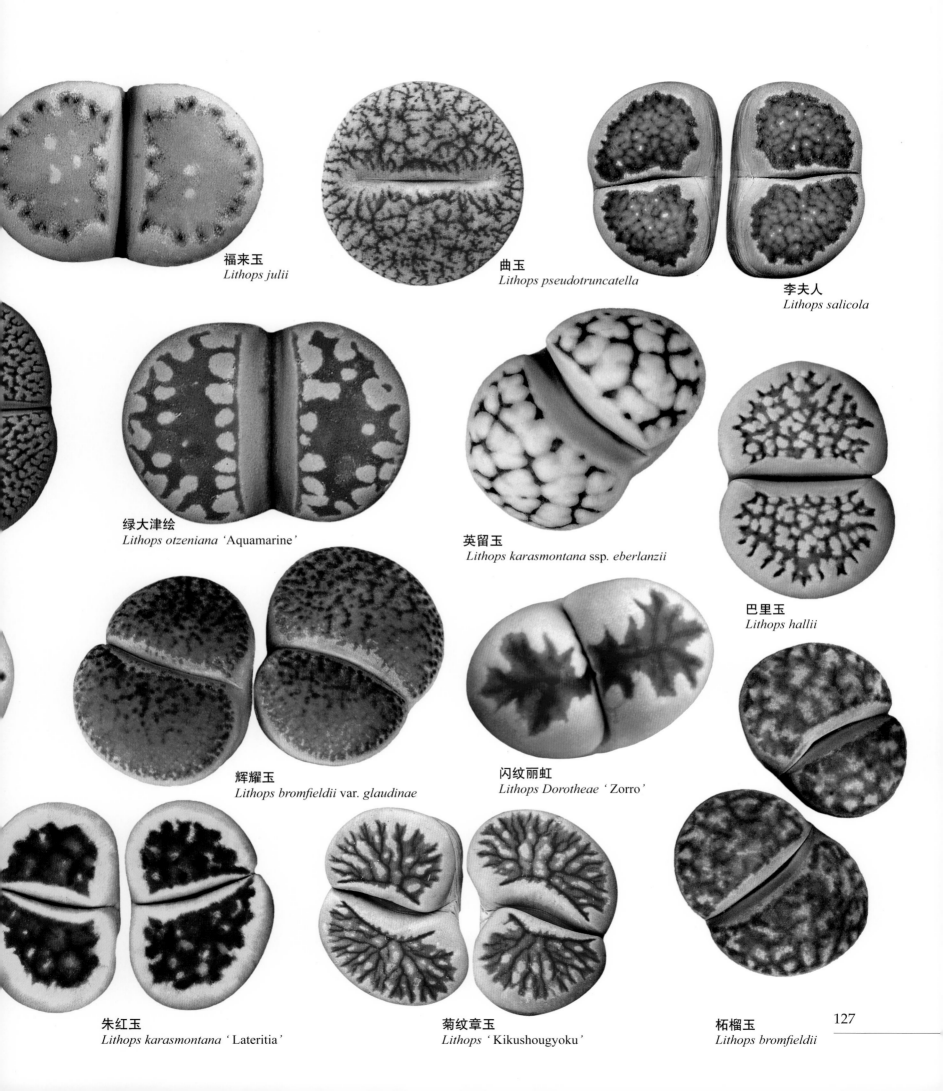

福来玉
Lithops julii

曲玉
Lithops pseudotruncatella

李夫人
Lithops salicola

绿大津绘
Lithops otzeniana 'Aquamarine'

英留玉
Lithops karasmontana ssp. *eberlanzii*

巴里玉
Lithops hallii

辉耀玉
Lithops bromfieldii var. *glaudinae*

闪纹丽虹
Lithops Dorotheae 'Zorro'

朱红玉
Lithops karasmontana 'Lateritia'

菊纹章玉
Lithops 'Kikushougyoku'

柘榴玉
Lithops bromfieldii

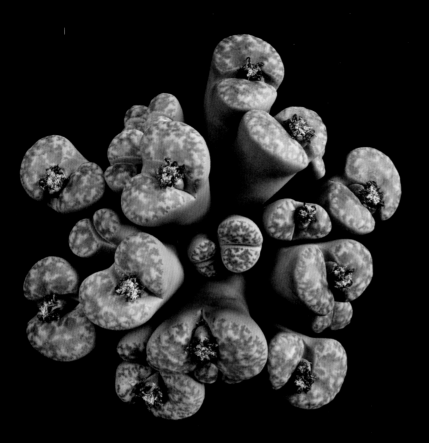

黄鸣弦玉
Lithops bromfieldii var. *insularis* 'Sulphurea'

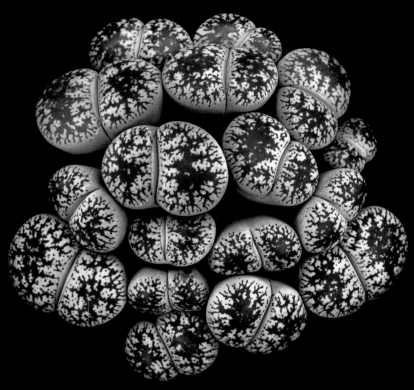

弁天玉
Lithops lesliei var. *venteri*

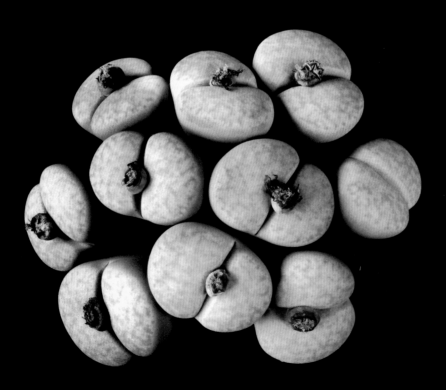

宝贵玉
Lithops pseudotruncatella ssp. volkii

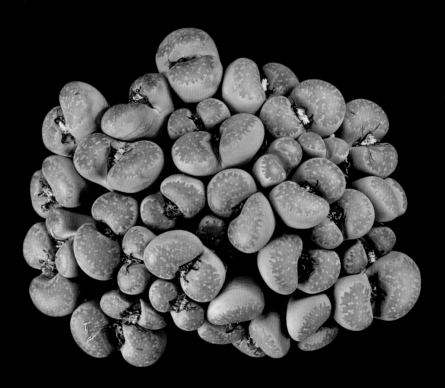

丽典玉
Lithops villetii

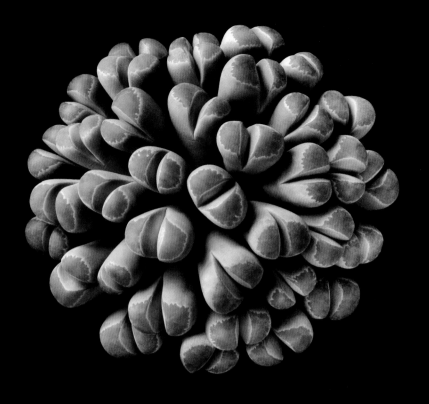

橄榄玉
Lithops olivacea

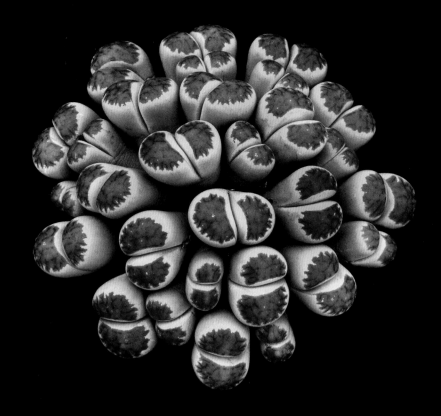

丽虹玉
Lithops dorotheae

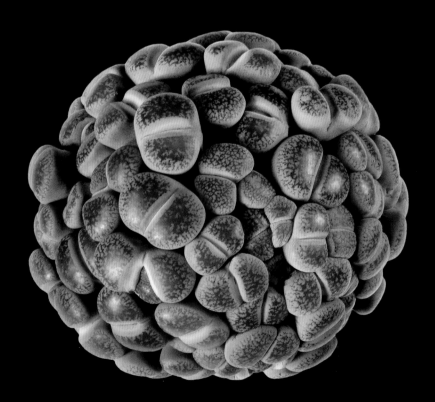

日轮玉
Lithops aucampiae

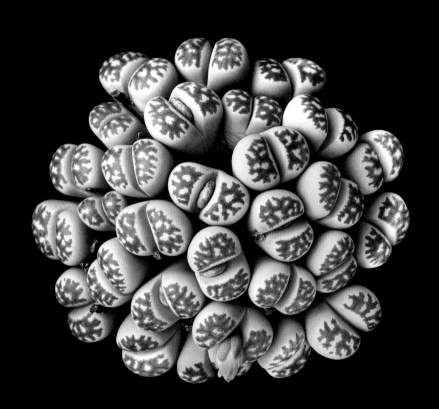

丽虹玉
Lithops dorotheae

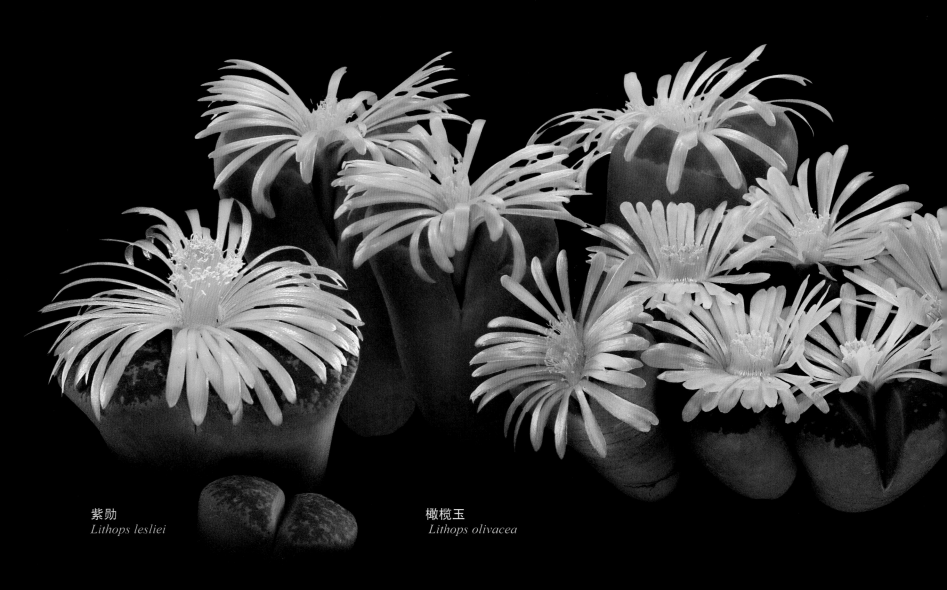

紫勋
Lithops lesliei

橄榄玉
Lithops olivacea

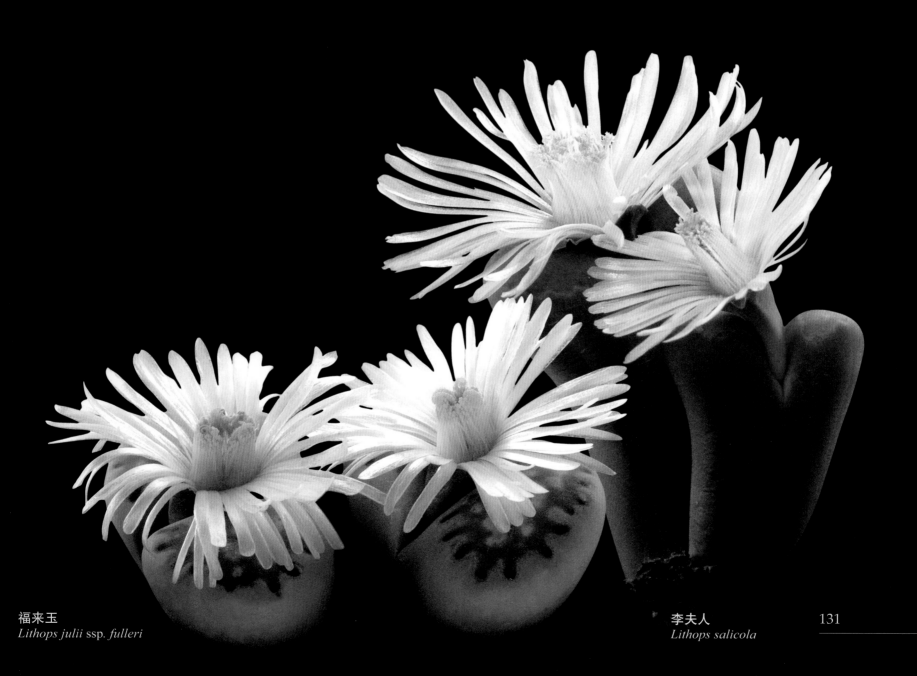

福来玉
Lithops julii ssp. *fulleri*

李夫人
Lithops salicola

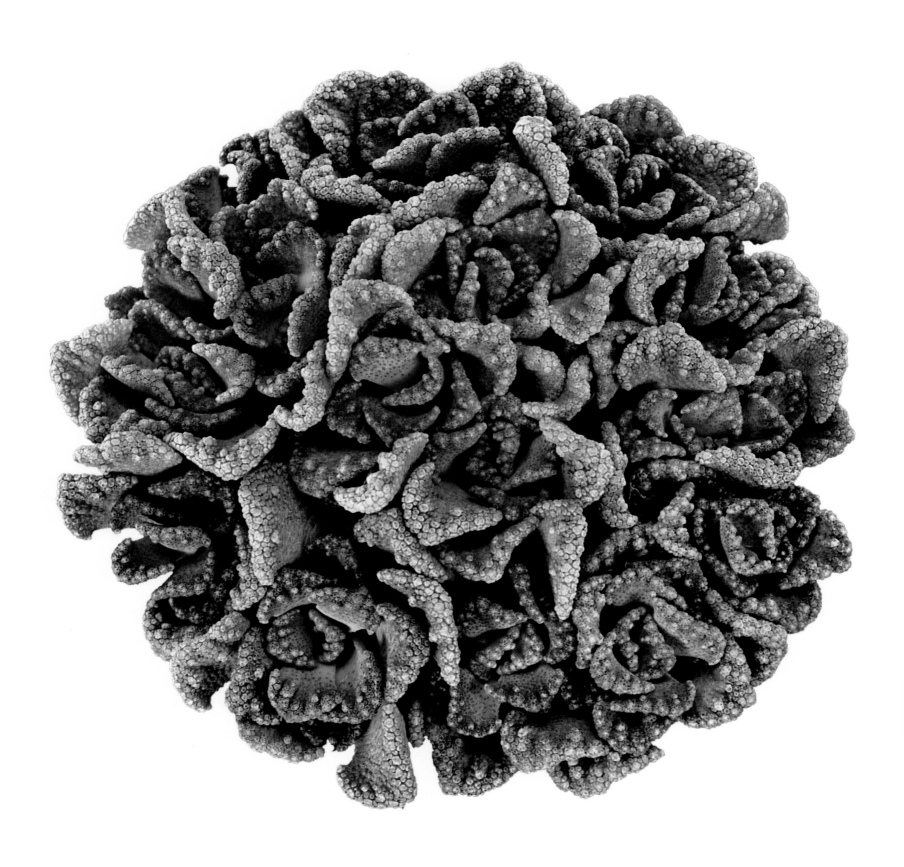

天女簪
Titanopsis calcarea

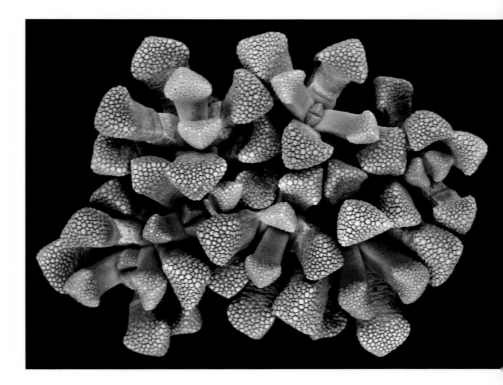

天女影
Titanopsis schwantesii

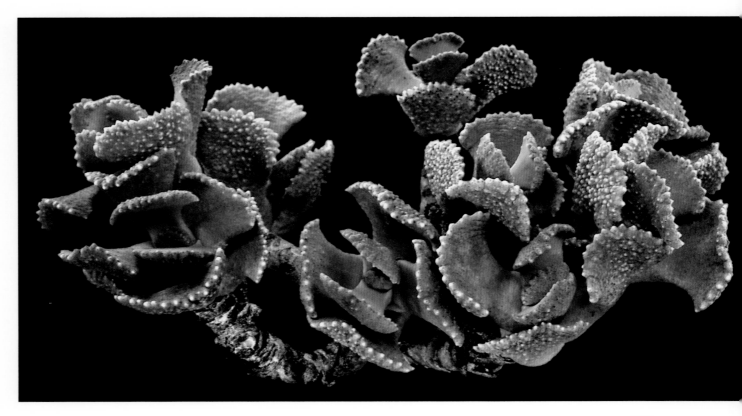

天女云
Aloinopsis malherbei

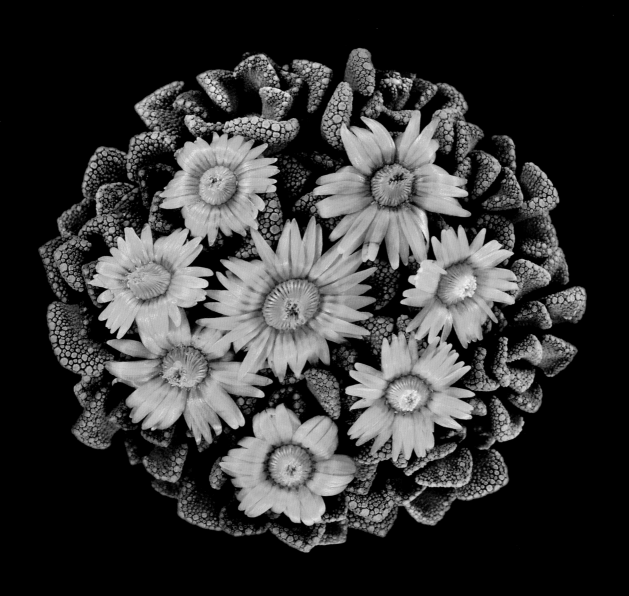

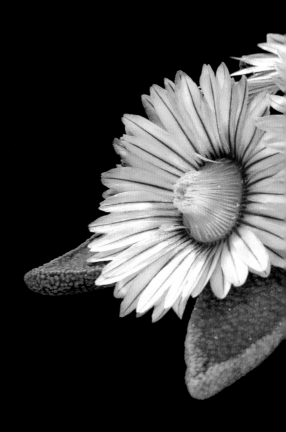

天女簪
Titanopsis calcarea

134

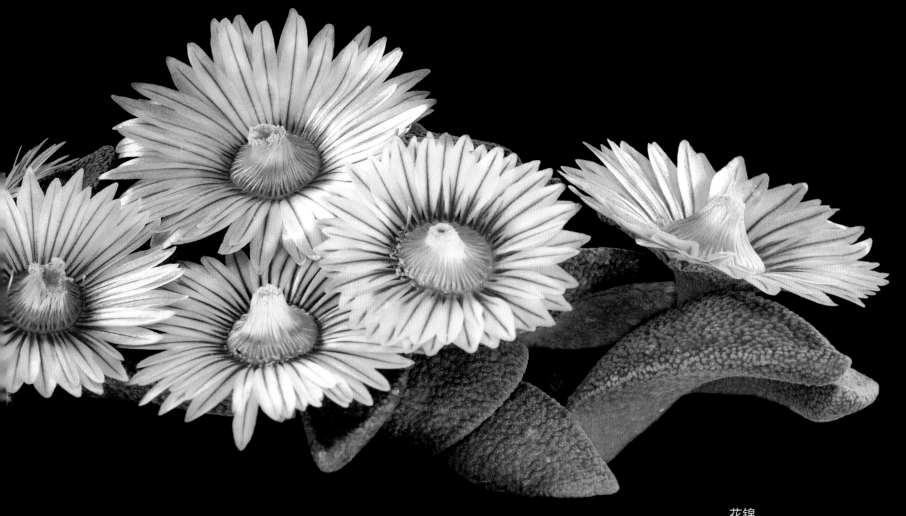

花锦
Aloinopsis rubrolineata

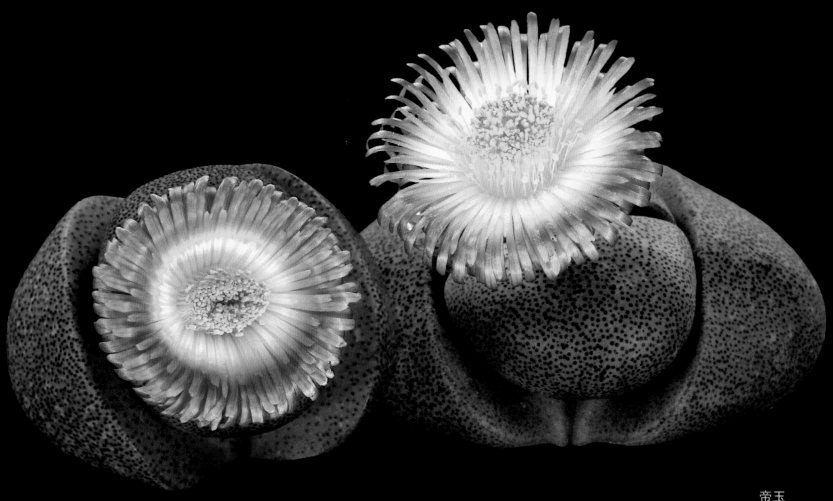

帝玉
Pleiospilos nelii

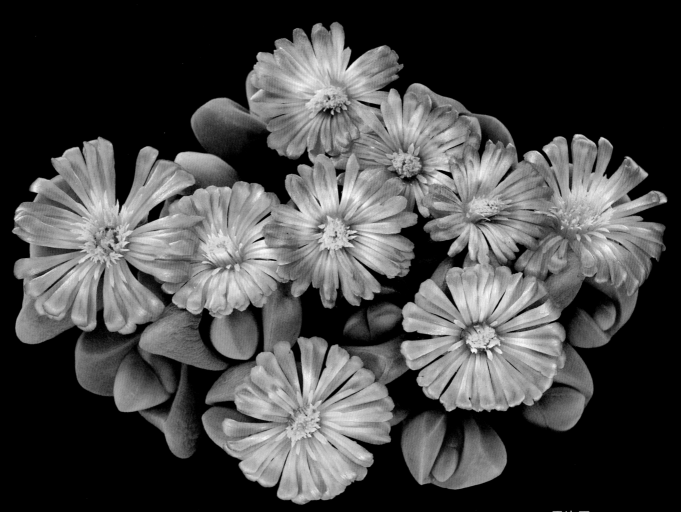

无比玉
Gibbaeum dispar

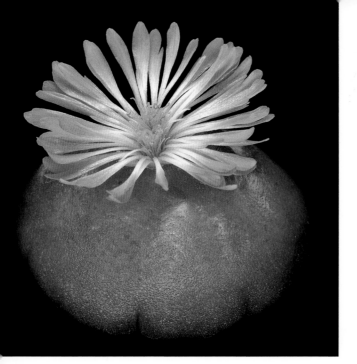

富士山
Conophytum burgeri

神风玉
Cheiridopsis pillansii

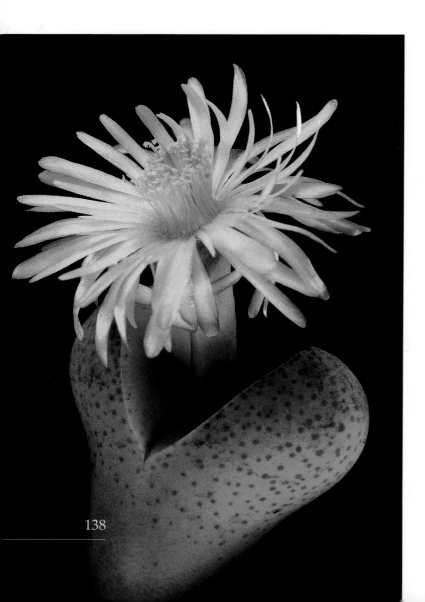

妖玉
Dinteranthus puberulus

雷童
Delosperma echinatum

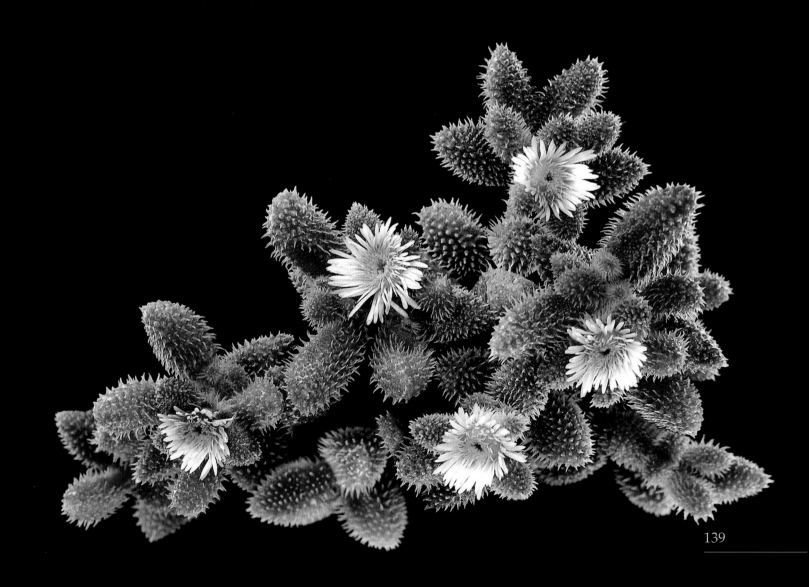

碧光环
Monilaria moniliformis

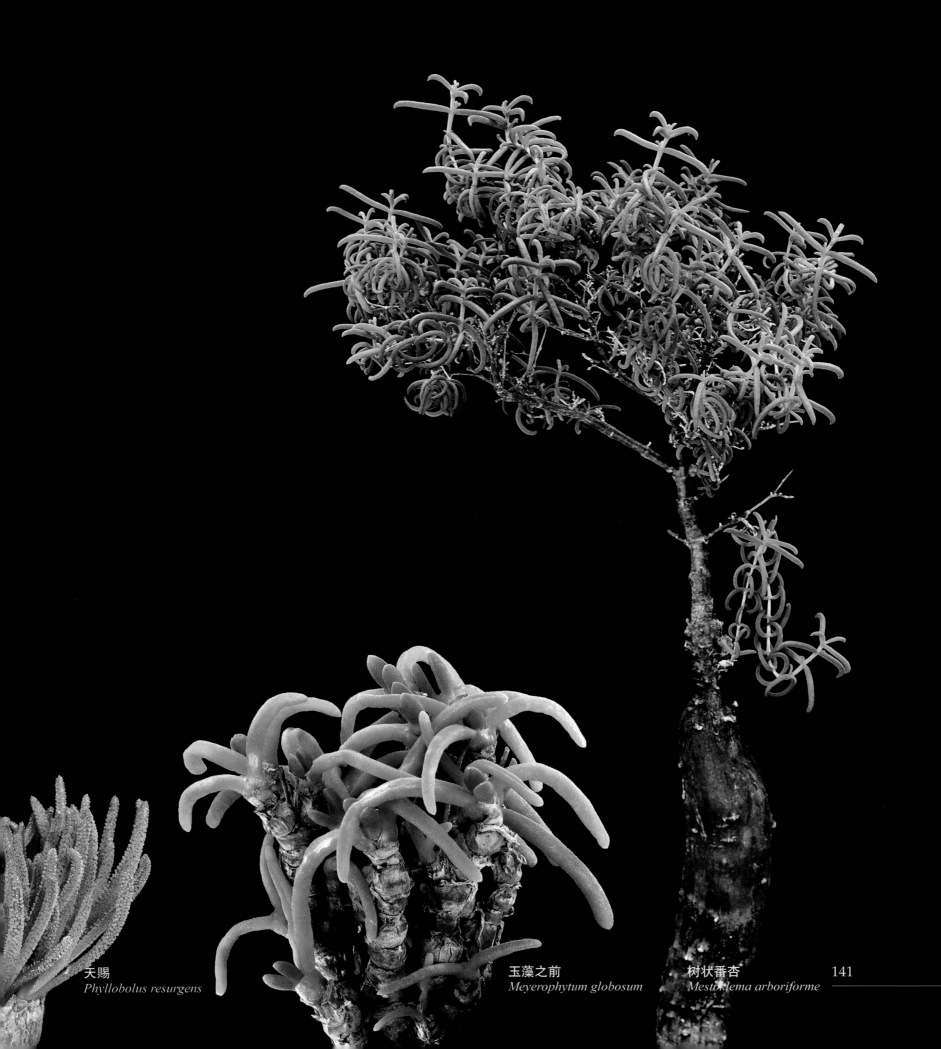

天赐
Phyllobolus resurgens

玉藻之前
Meyerophytum globosum

树状番杏
Mestoklema arboriforme

141

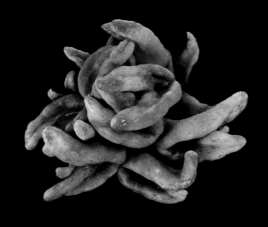

怪奇玉
Diplosoma retroversum

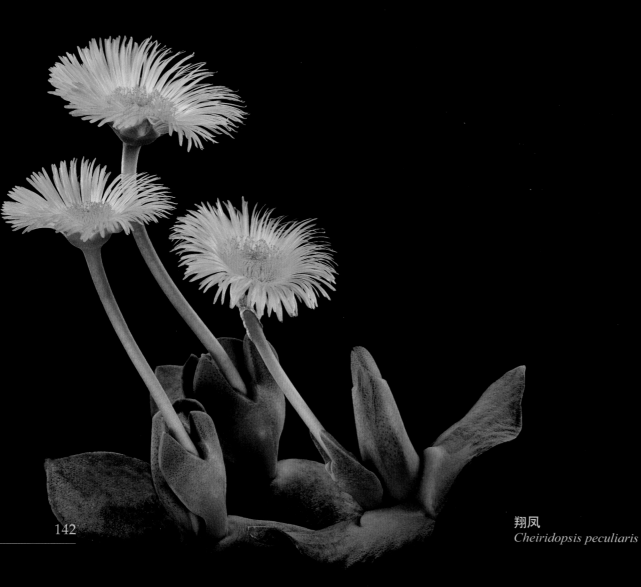

翔凤
Cheiridopsis peculiaris

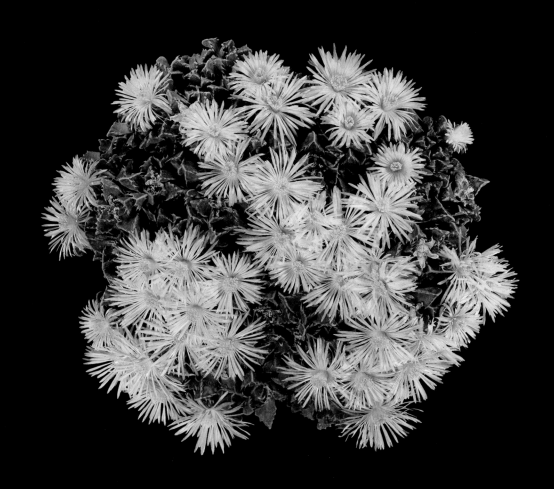

菊波
Faucaria ' Kikunami'

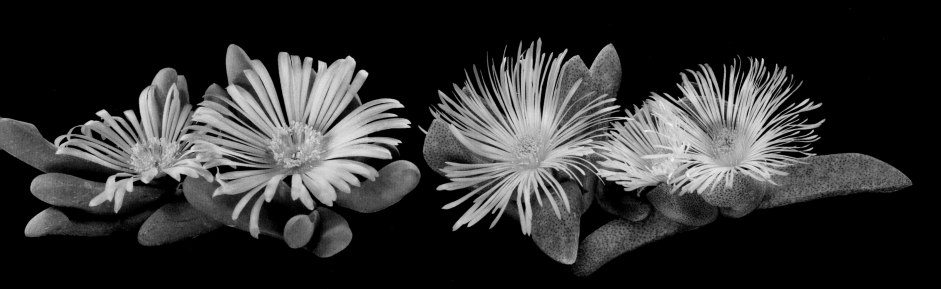

银绿
Glottiphyllum oligocarpum

阳光
Pleiospilos compactus ssp.*canus*

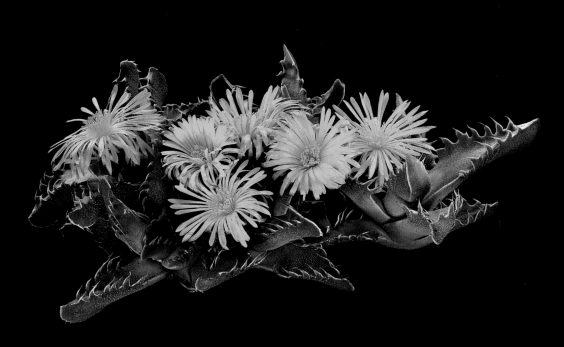

银海波
Faucaria felina

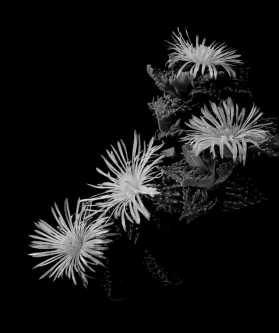

荒波
Faucaria tuberculos

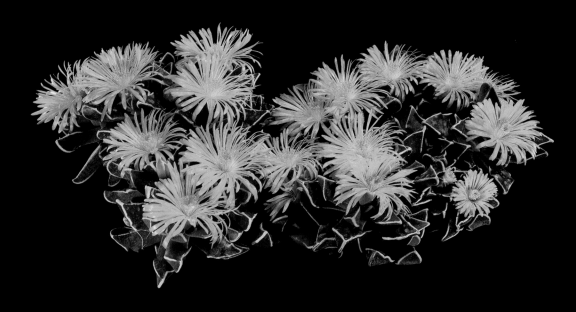

鲸波
Faucaria bosscheana

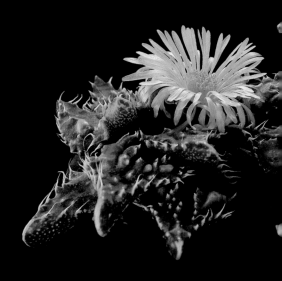

红怒涛
Faucaria tuberculos

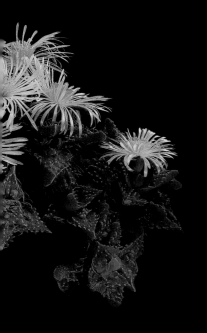

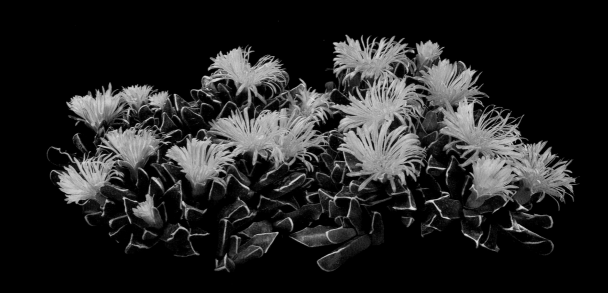

鲸波
Faucaria bosscheana

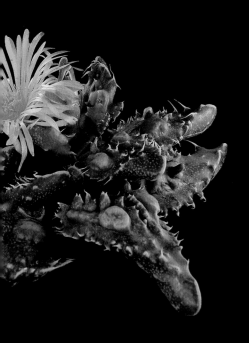

's'

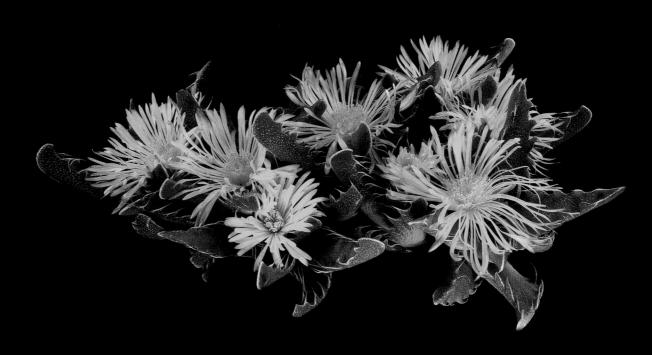

银海波
Faucaria felina

景天篇
Crassulaceae

景天科为双子叶多年生草本植物，其中多肉植物占相当大的比例，是多肉植物的重要一科。该科产地广泛，在我国也有分布。景天科多肉植物品种多样且各具形态，许多园艺品种深受人们的喜爱，已成为走进人们家庭的主要多肉植物。

Crassulaceae is a family of dicotyledon herbs and succulents account for a large proportion. A major branch of succulents, members of Crassulaceae are found worldwide and also in China. Succulents of Crassulaceae are widely varied and many of their cultivars have become familiar as houseplants.

重瓣长寿花
Kalanchoe cv.

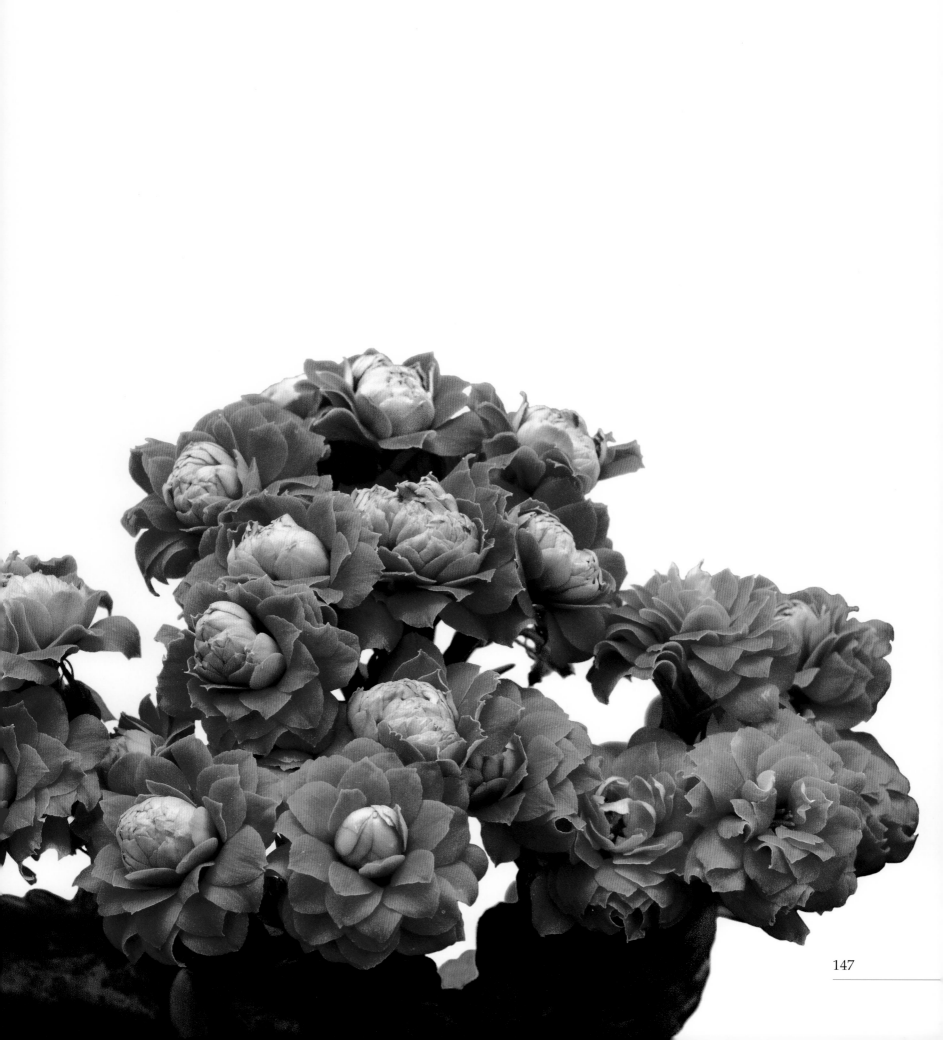

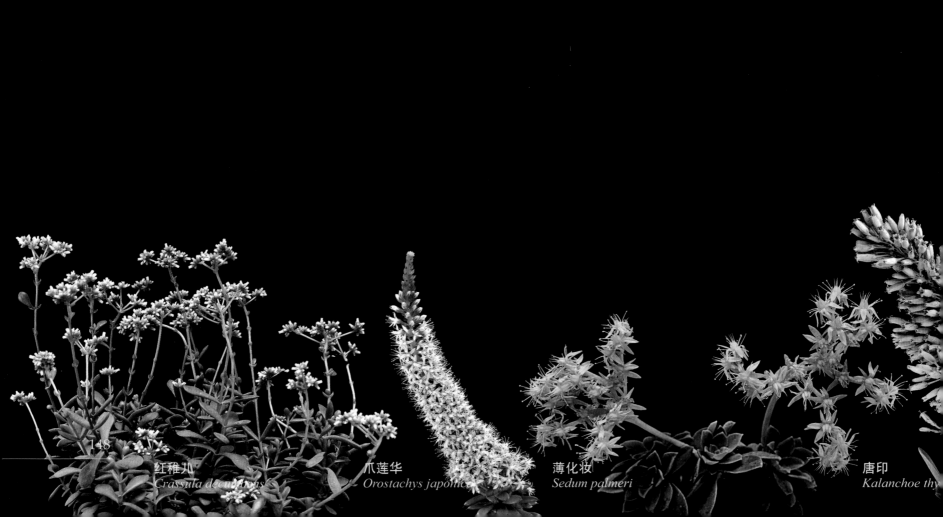

红稚儿
Crassula decumbens

爪莲华
Orostachys japonica

薄化妆
Sedum palmeri

唐印
Kalanchoe thy

148

玉珠帘
Sedum morganianum

八千代
Sedum corynephyllum

长药八宝
Sedum spectabile

特氏景天
Sedum treleasei

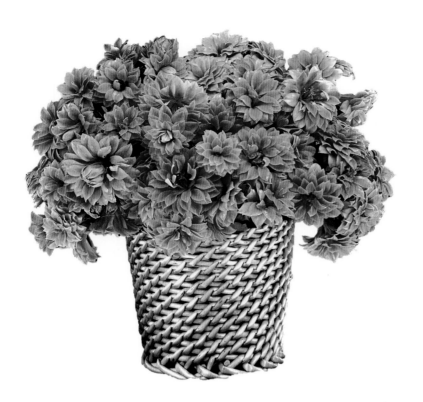

重瓣长寿花
Kalanchoe blossfeldiana 'Calandiva'

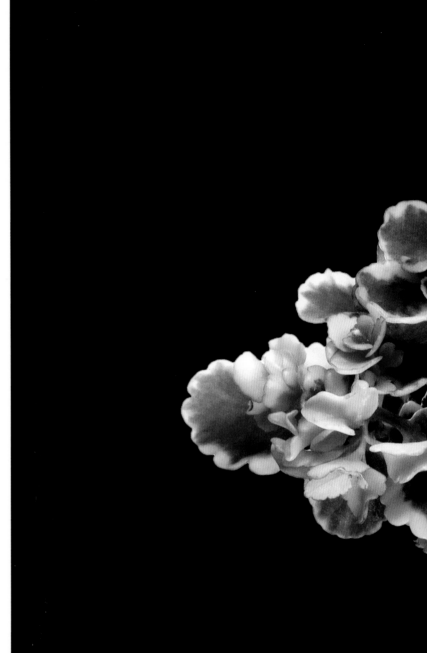

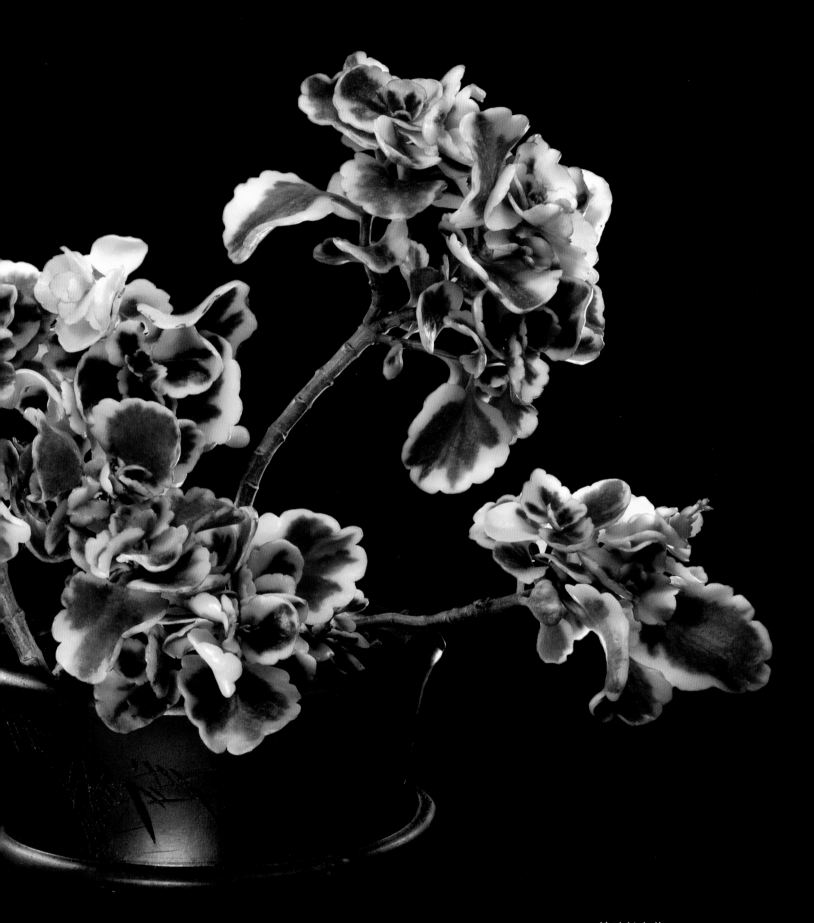

锦叶长寿花
Kalanchoe blossfeldiana ' Variegata '

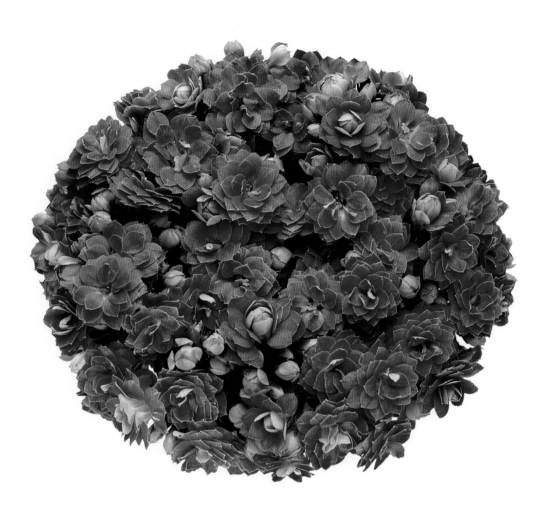

重瓣长寿花
Kalanchoe blossfeldiana 'Double Coral'

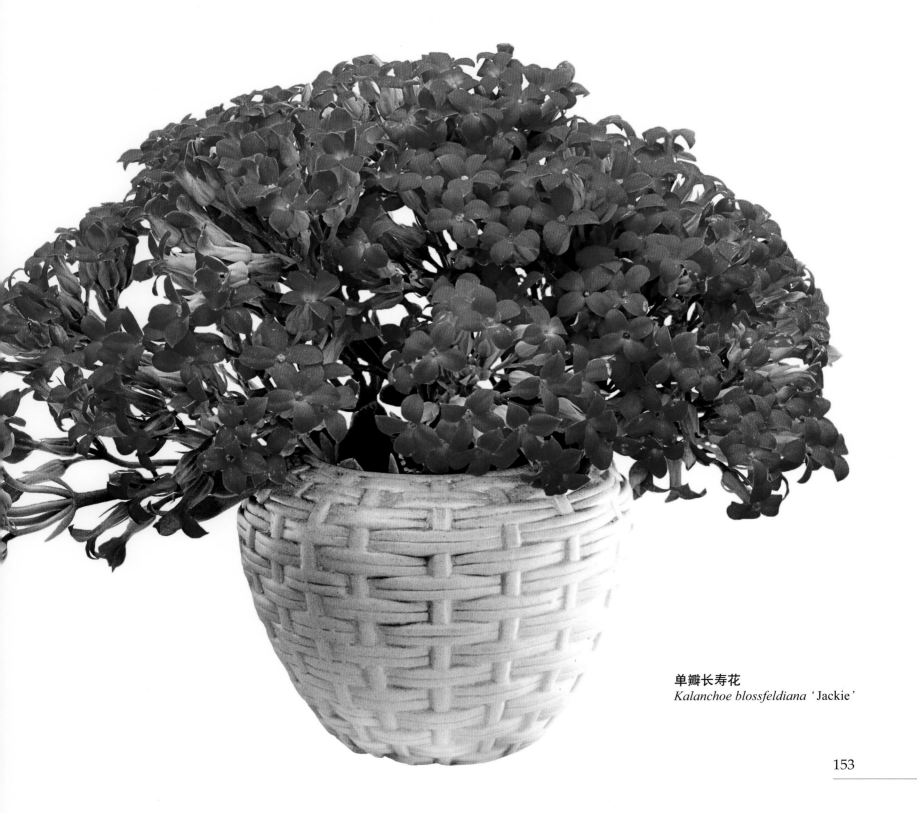

单瓣长寿花
Kalanchoe blossfeldiana ‘Jackie’

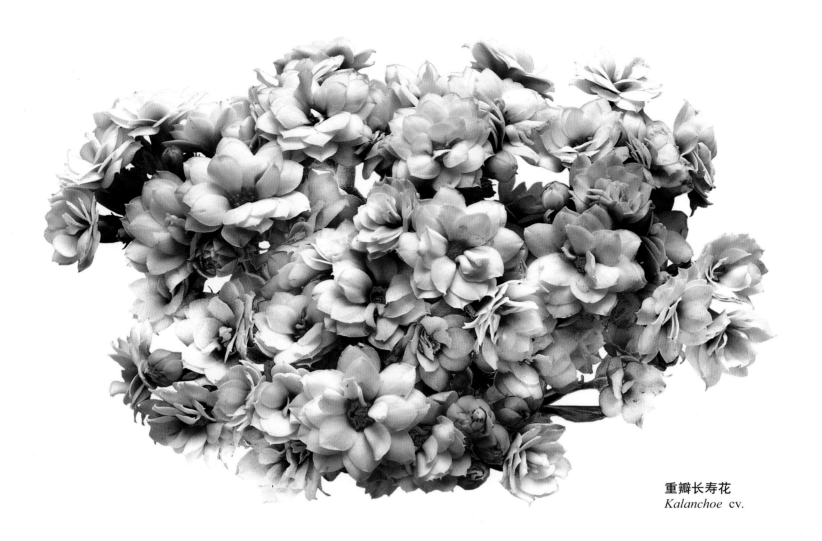

重瓣长寿花
Kalanchoe cv.

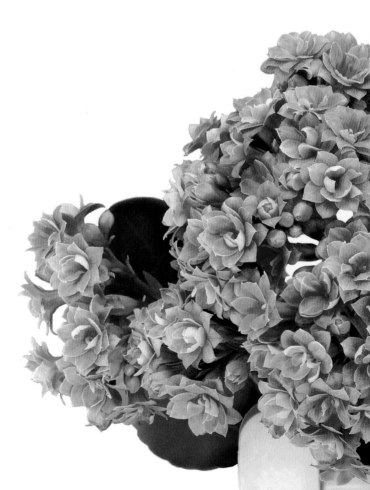

重瓣长寿花
Kalanchoe 'Sophisticated Pink'

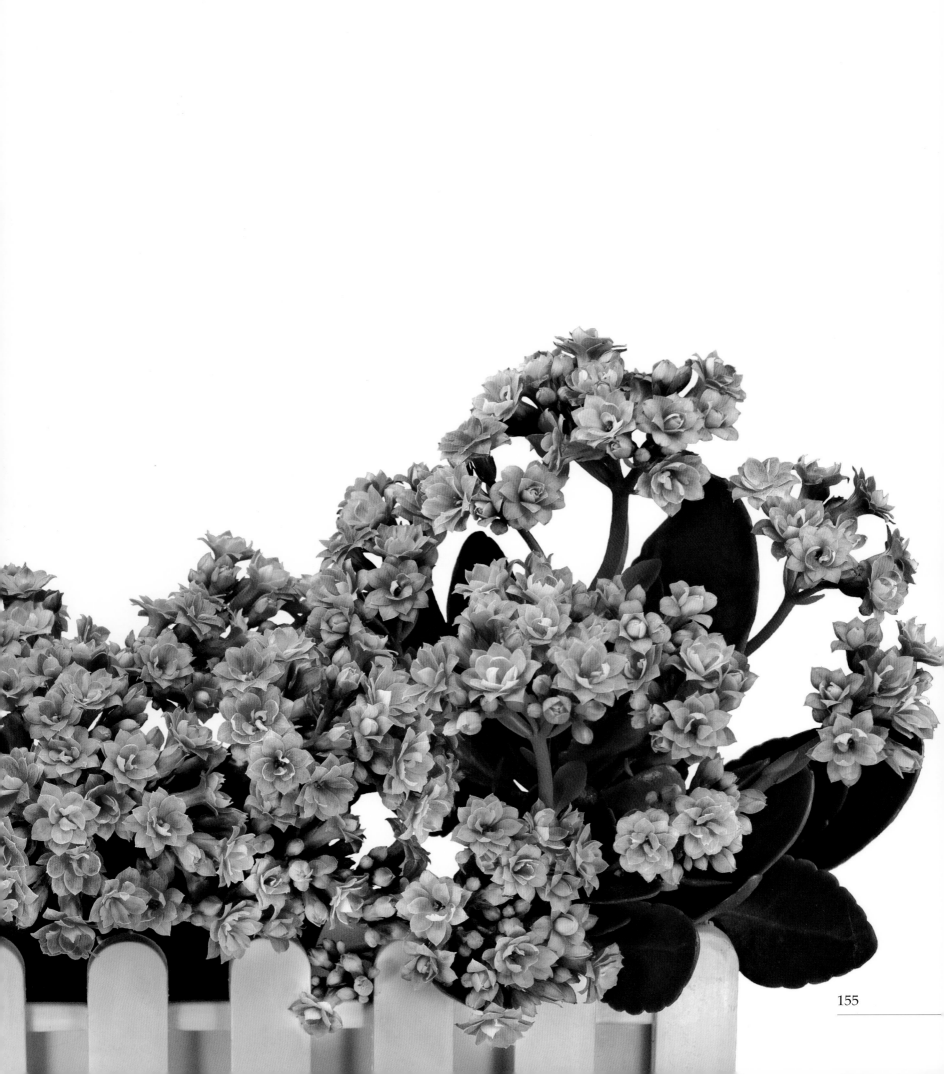

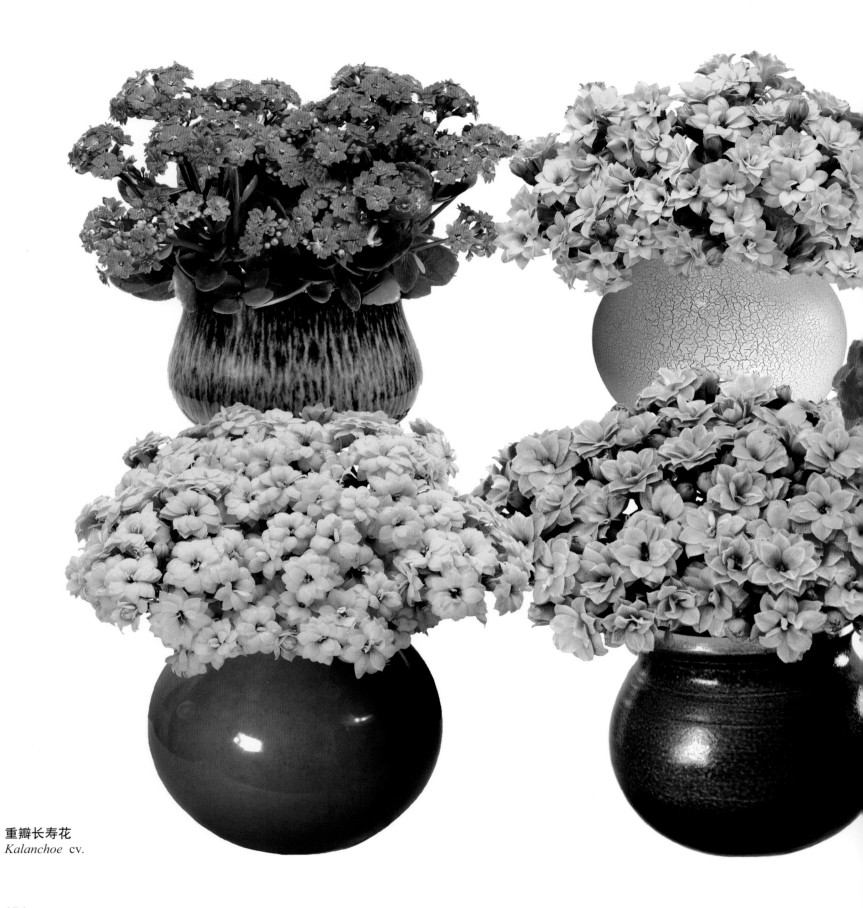

重瓣长寿花
Kalanchoe cv.

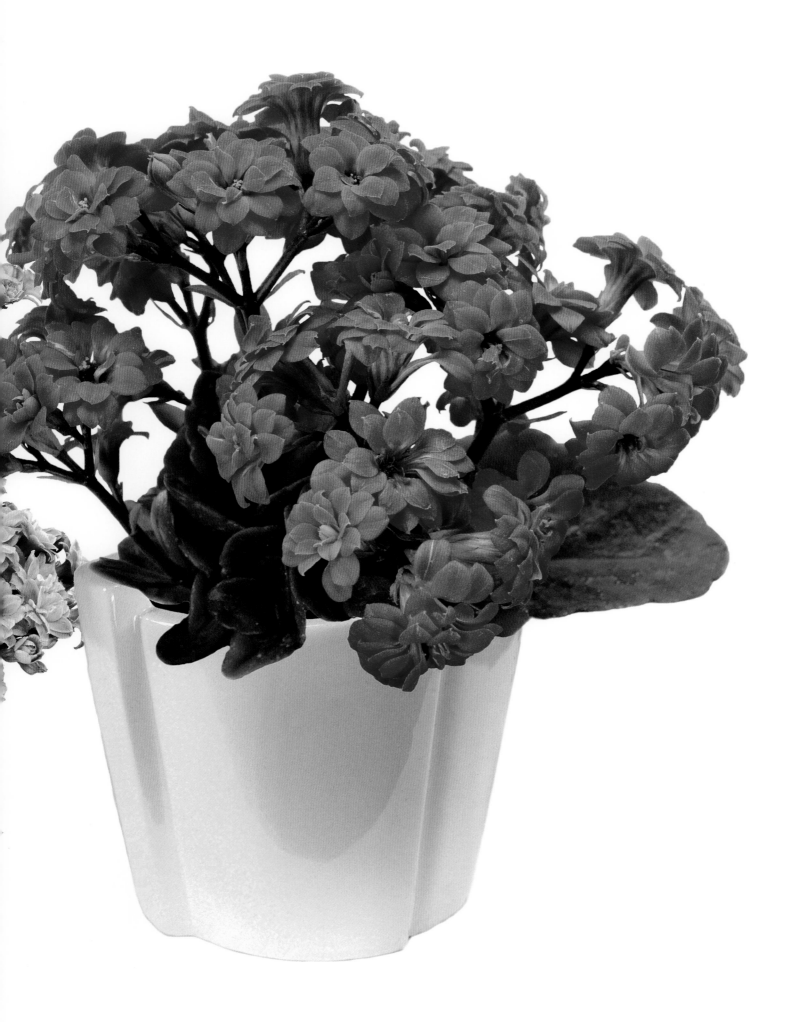

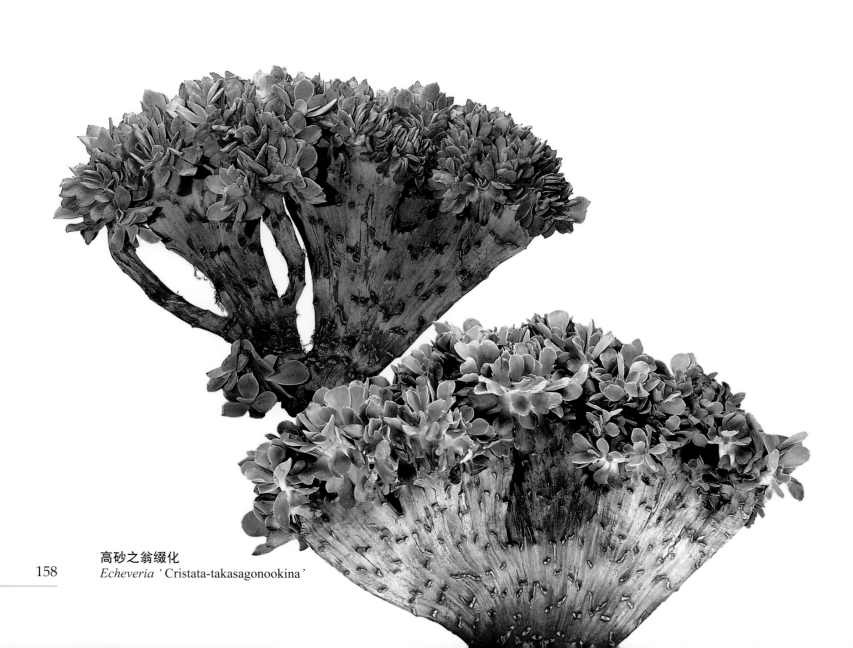

高砂之翁缀化
158 *Echeveria* 'Cristata-takasagonookina'

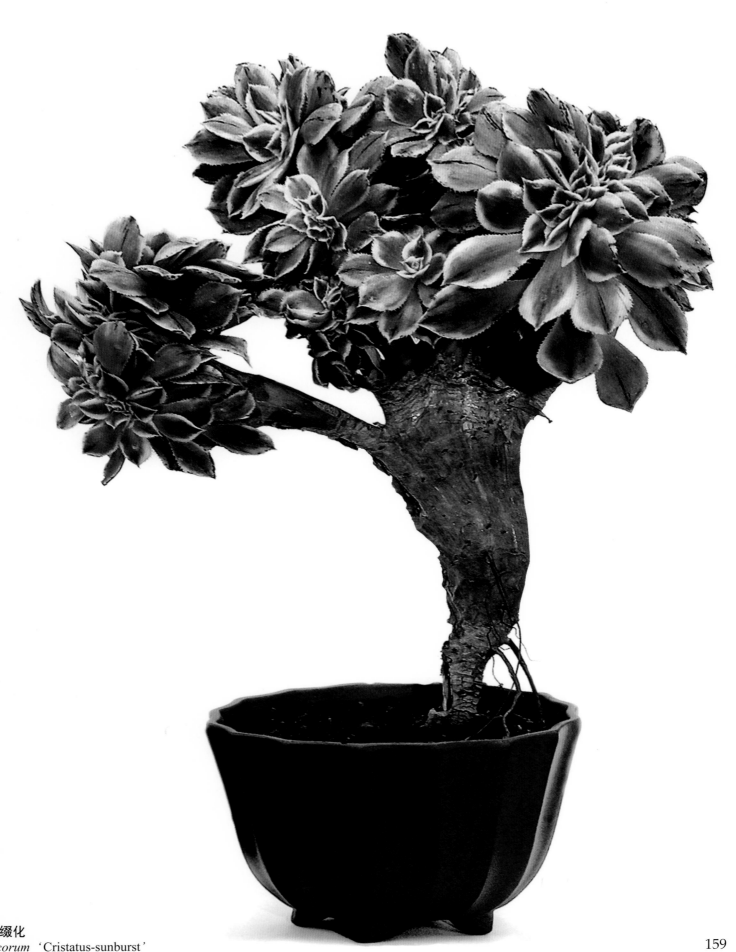

花叶寒月夜缀化
Aeonium decorum 'Cristatus-sunburst'

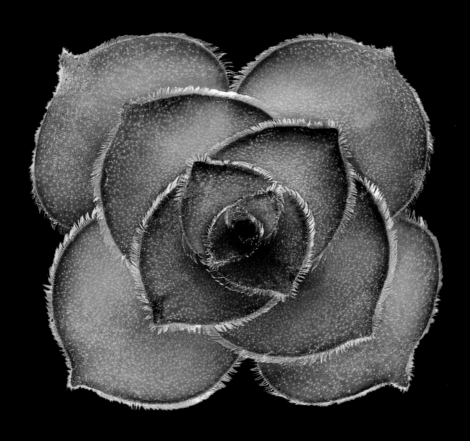

山巴
Crassula montana

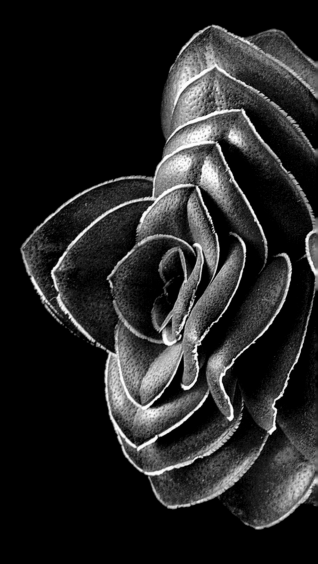

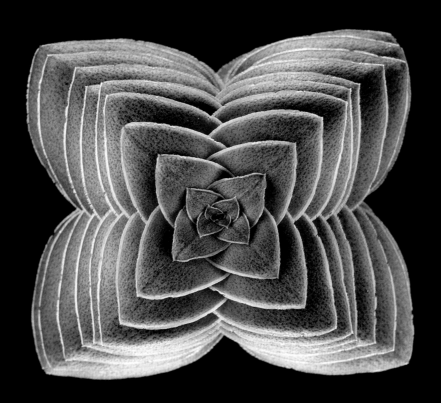

巴
Crassula hemisphaerica

巴
Crassula hemisphaerica

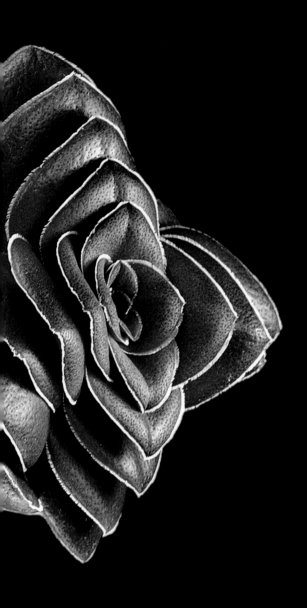

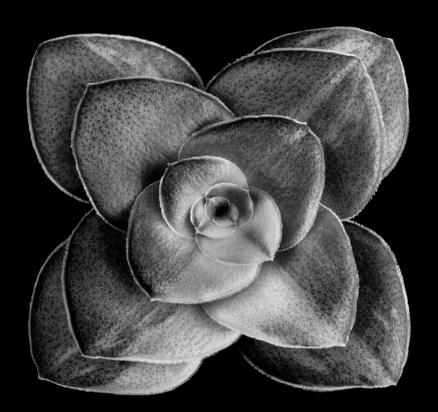

巴锦
Crassula hemisphaerica 'Tomoe Nishiki'

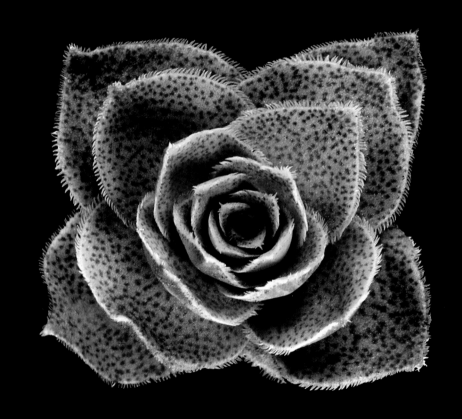

梦巴
Crassula setulosa

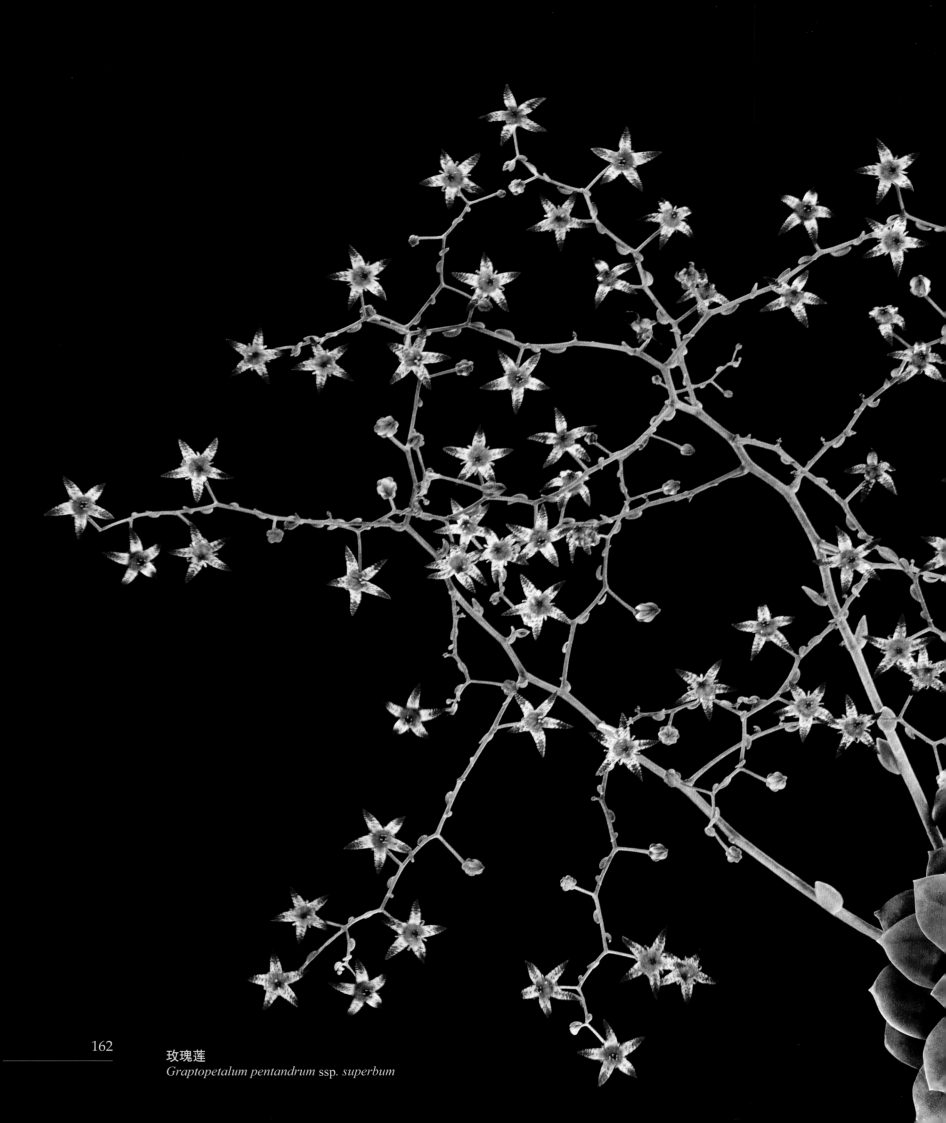

玫瑰莲
Graptopetalum pentandrum ssp. *superbum*

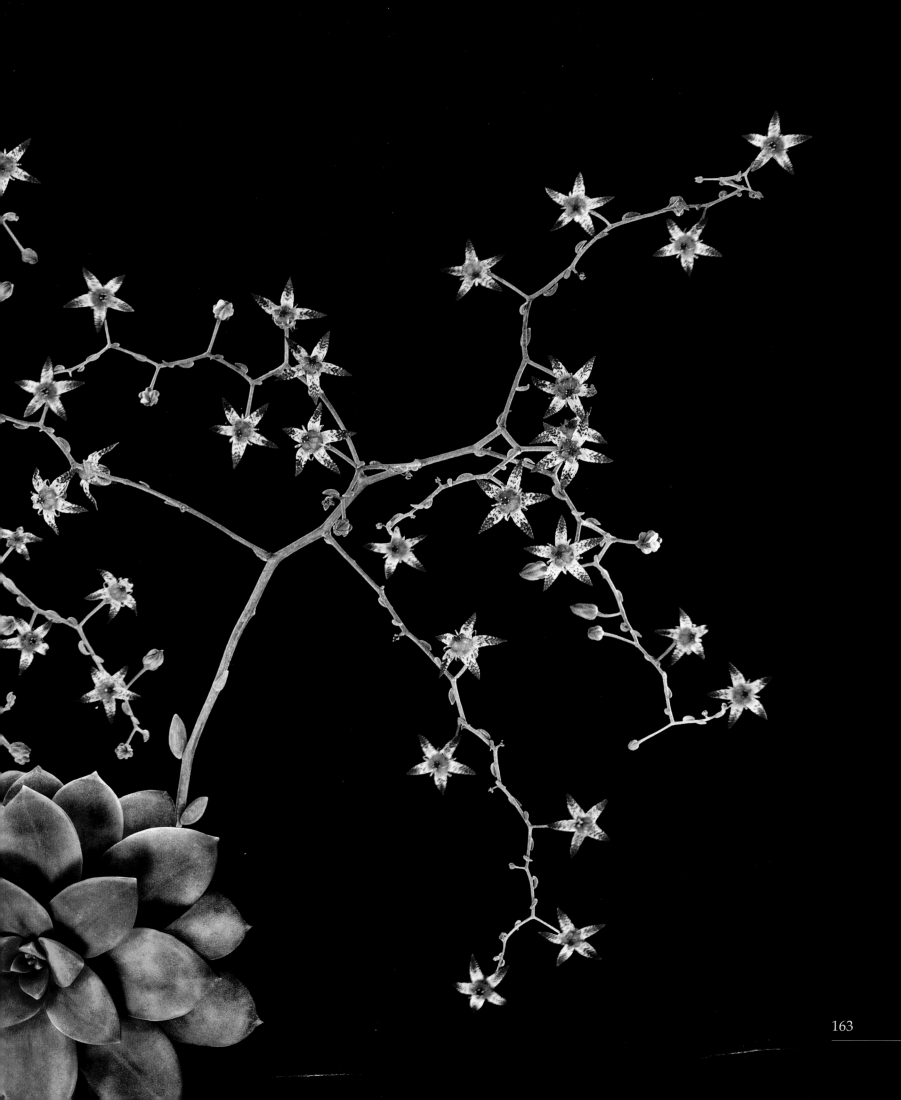

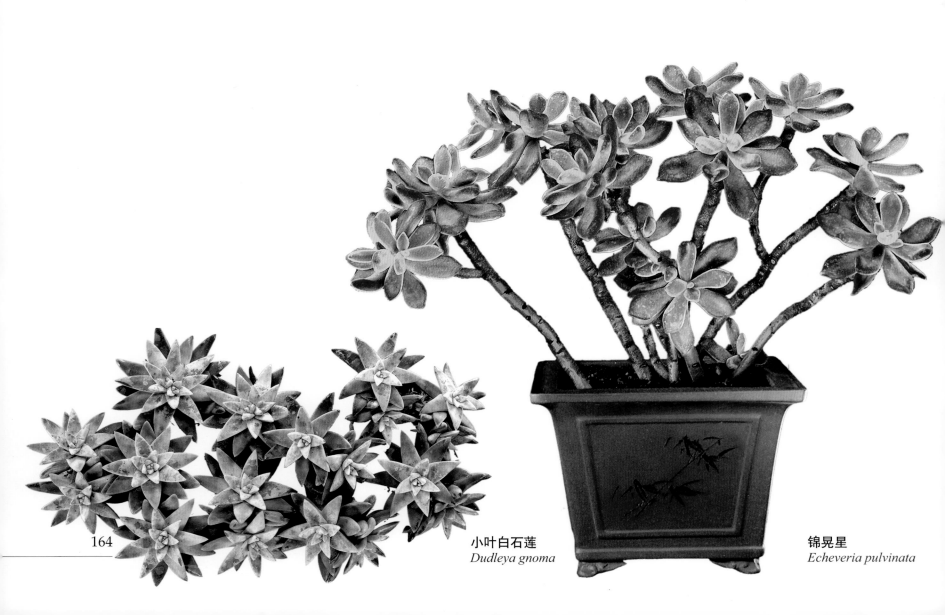

小叶白石莲
Dudleya gnoma

锦晃星
Echeveria pulvinata

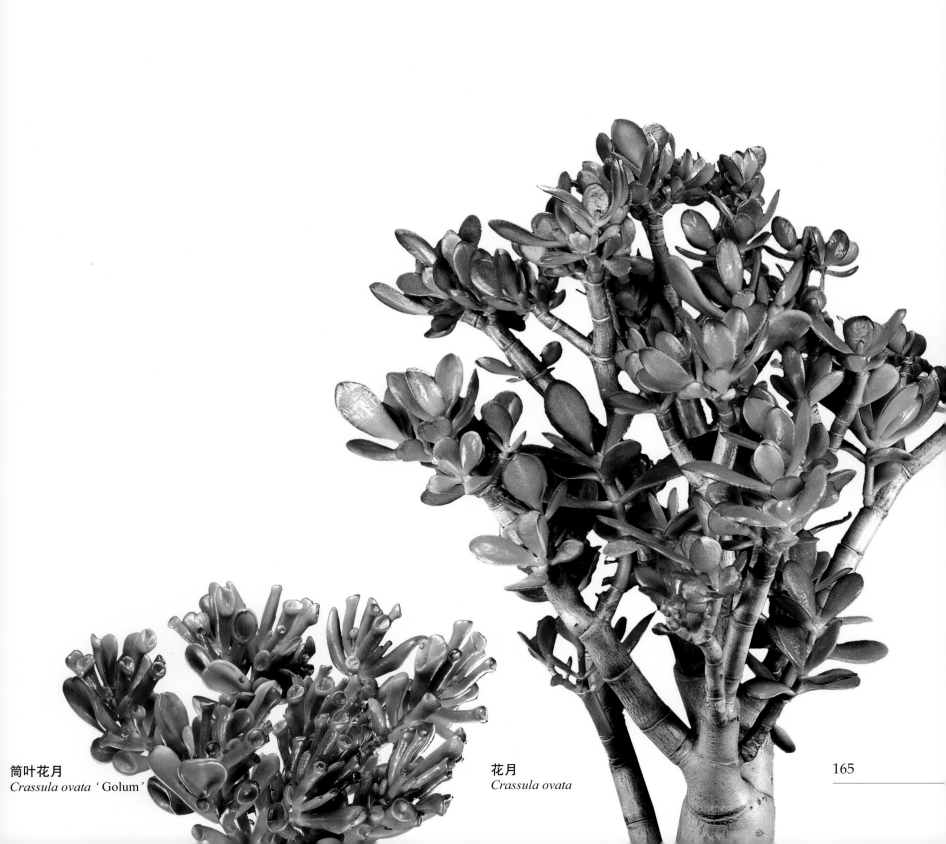

筒叶花月
Crassula ovata 'Golum'

花月
Crassula ovata

165

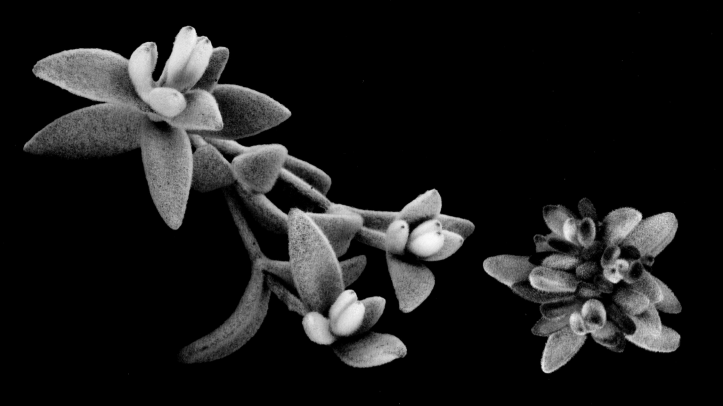

福兔耳
Kalanchoe eriophylla

红兔耳
Kalanchoe tomentosa 'Chocolata Soldier'

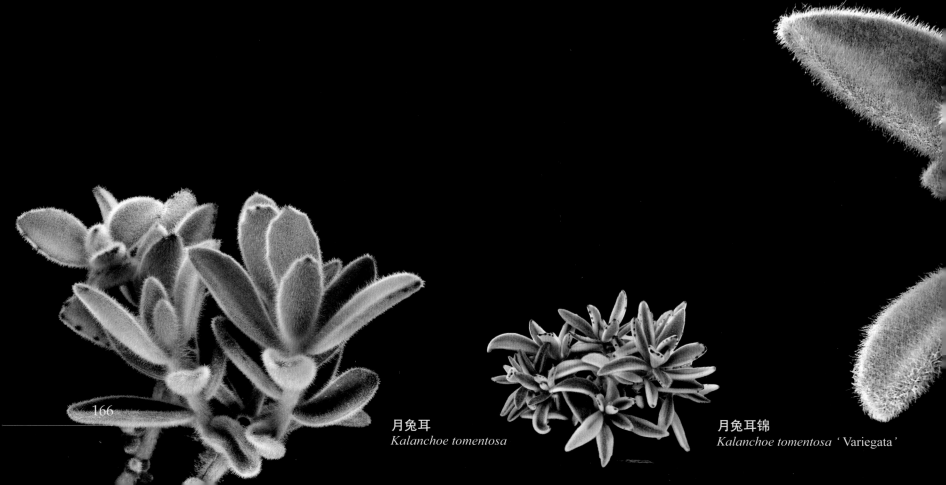

月兔耳
Kalanchoe tomentosa

月兔耳锦
Kalanchoe tomentosa 'Variegata'

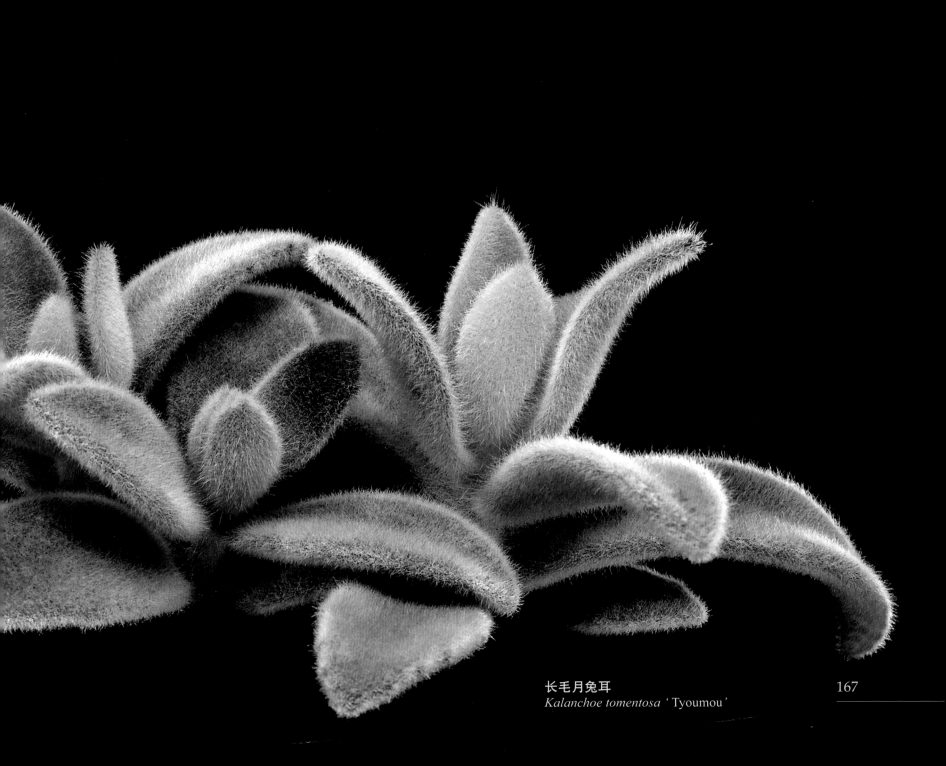

长毛月兔耳

Kalanchoe tomentosa 'Tyoumou'

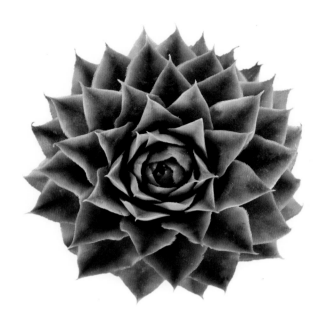

长生草
Sempervivum sp.

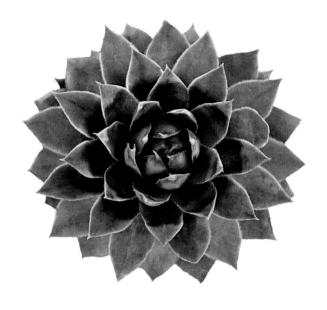

酒红长生草
Sempervivum 'Red Rum'

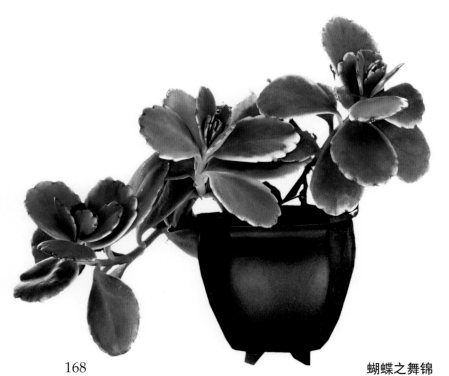

蝴蝶之舞锦
Kalanchoe fedtschenkoi 'Variegata'

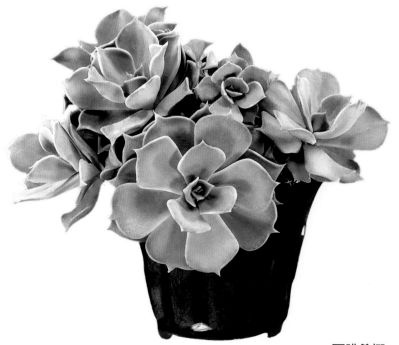

丽腊希娜
Echeveria lilacina

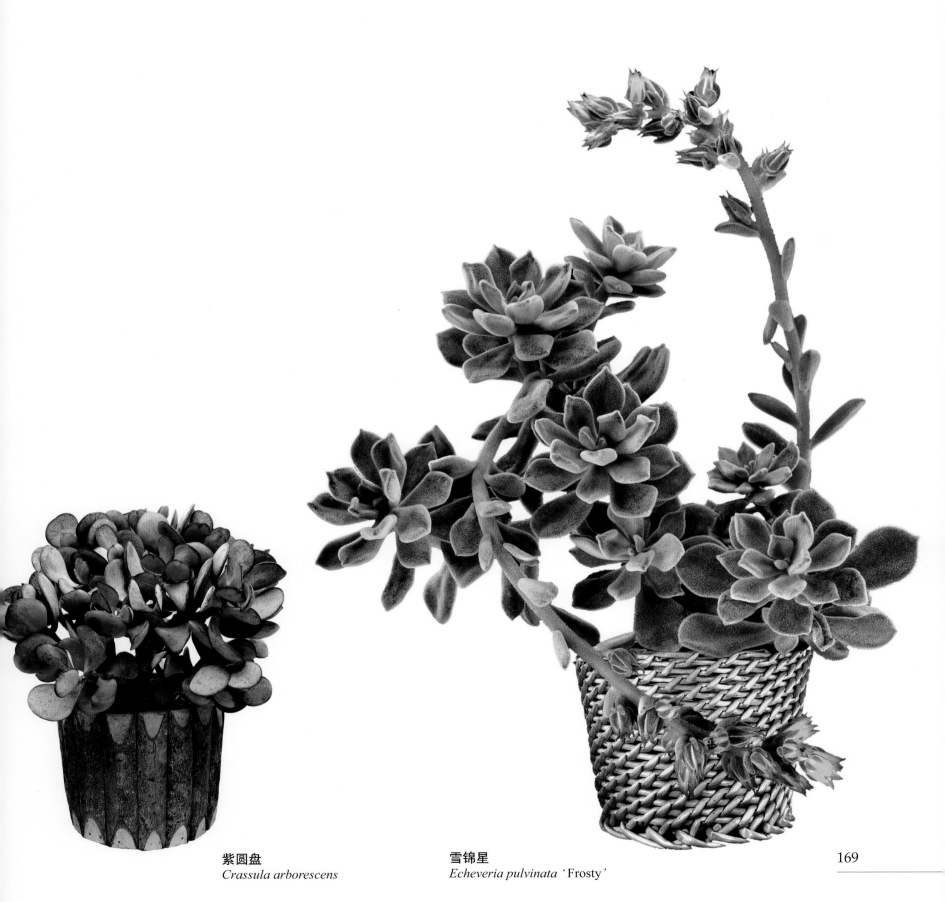

紫圆盘
Crassula arborescens

雪锦星
Echeveria pulvinata ‘Frosty’

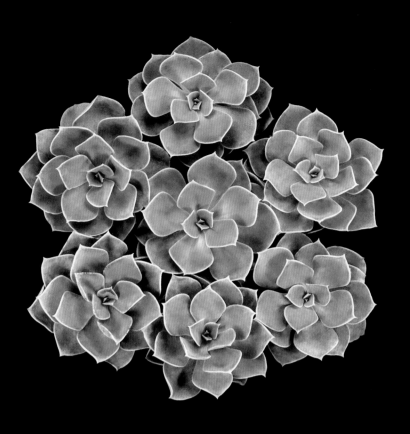

柏利莲
Echeveria ʻPerle Von Nurnbergʼ

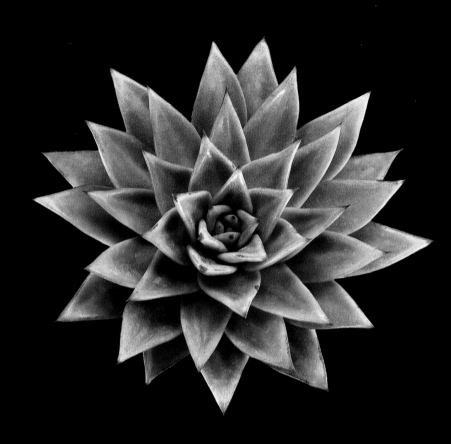

魅惑之宵
Echeveria agavoides ʻLipstickʼ

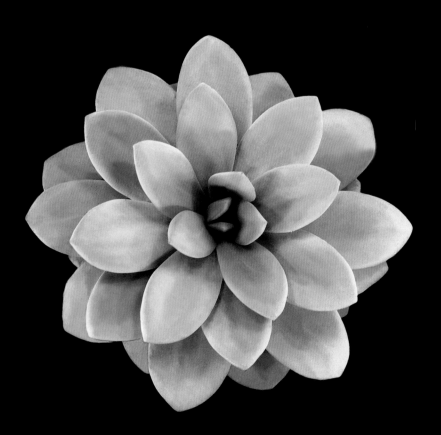

雪莲
Echeveria laui

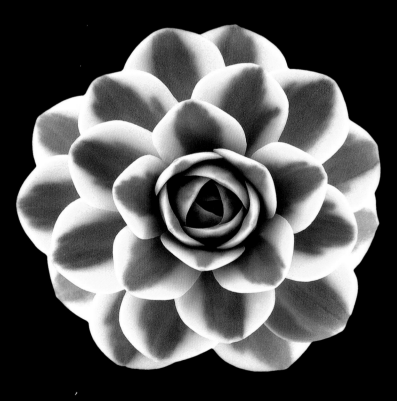

富士
Orostachys malacophylla var. *iwarenge* ʻFujiʼ

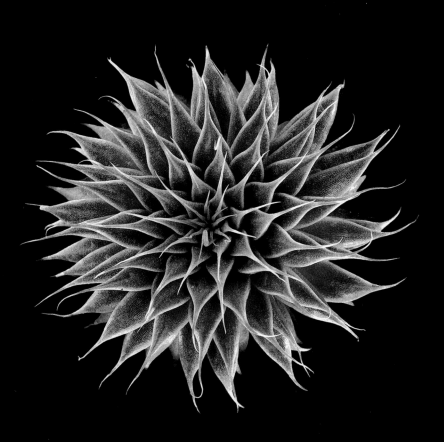

银星
×*Graptoveria* 'Silver Star'

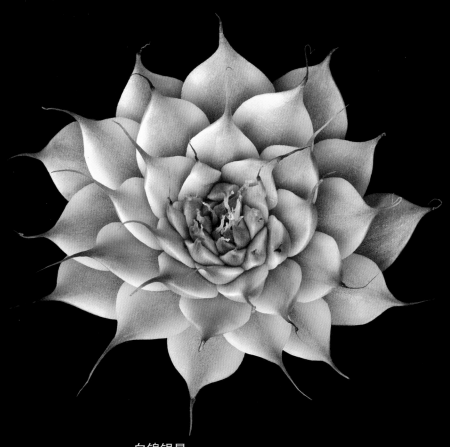

白锦银星
×*Graptoveria* 'Albovariegata-Silver Star'

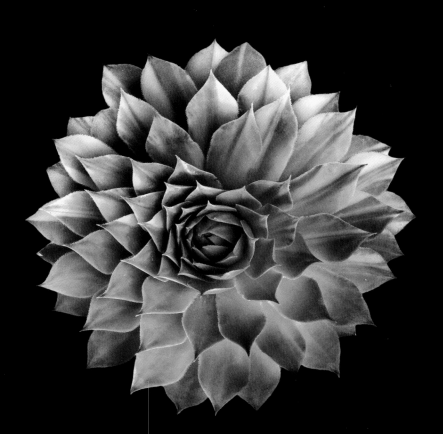

观音莲锦
Sempervivum tectorum 'Kokunka' (Variegata)

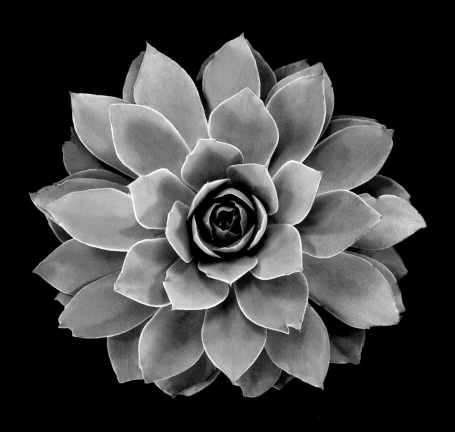

粉蝶莲
Echeveria 'Pinky'

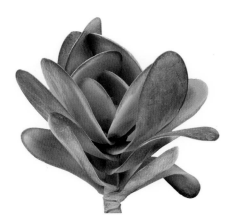

唐印
Kalanchoe thyrsiflora

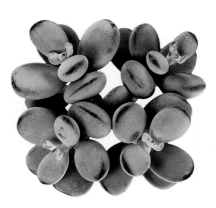

福达摩
Cotyledon 'Fukkuramusume'

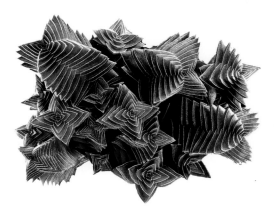

茜之塔
Crassula tabularis

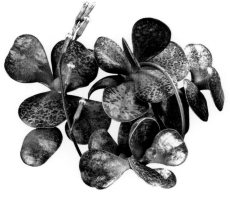

御所锦
Adromischus maculatus

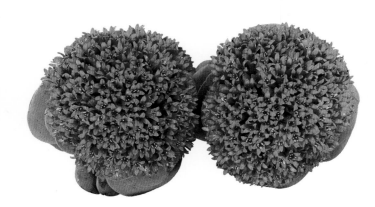

吕千惠
Crassula 'Morgan's Beauty'

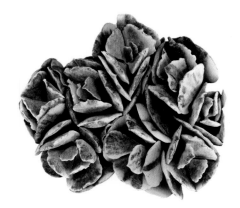

旭波锦之光
Crassula orbiculata var. *oblonga* 'Variegata'

新花月锦
Crassula ovata 'Variegata'

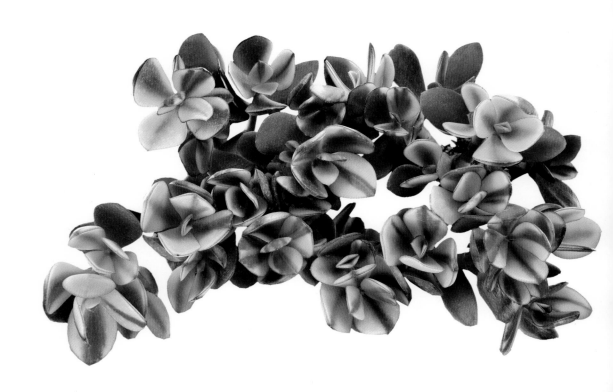

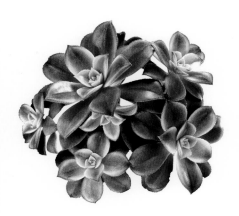

艳日辉
Aeonium decorum ‘Variegata’

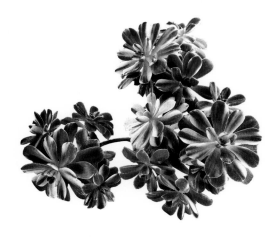

爱染锦
Aichryson aizoides ‘Variegata’

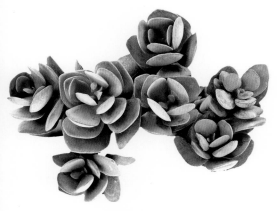

花莛伽蓝
Kalanchoe scapigera

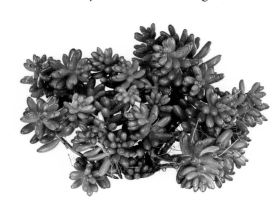

虹之玉
Sedum rubrotinctum

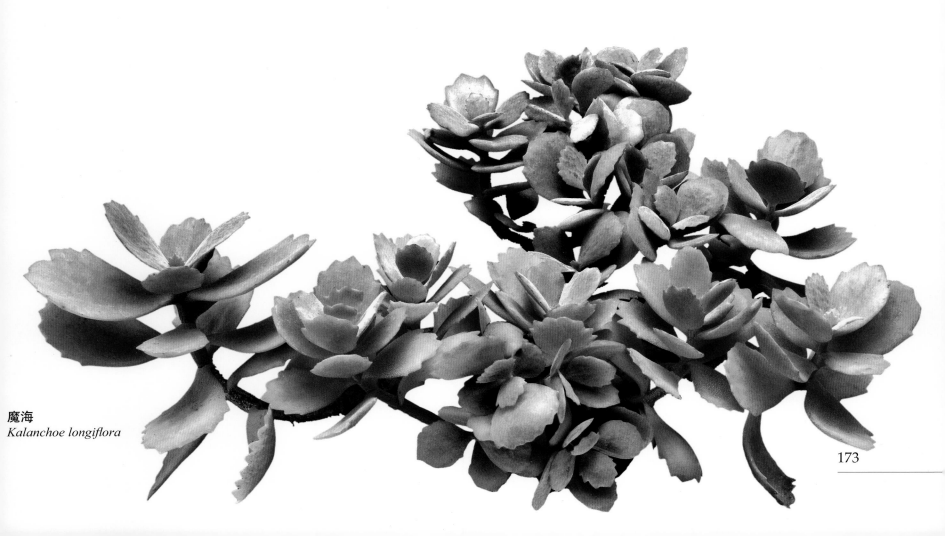

魔海
Kalanchoe longiflora

不死鸟锦
Kalanchoe ' Hushichou Nishiki '

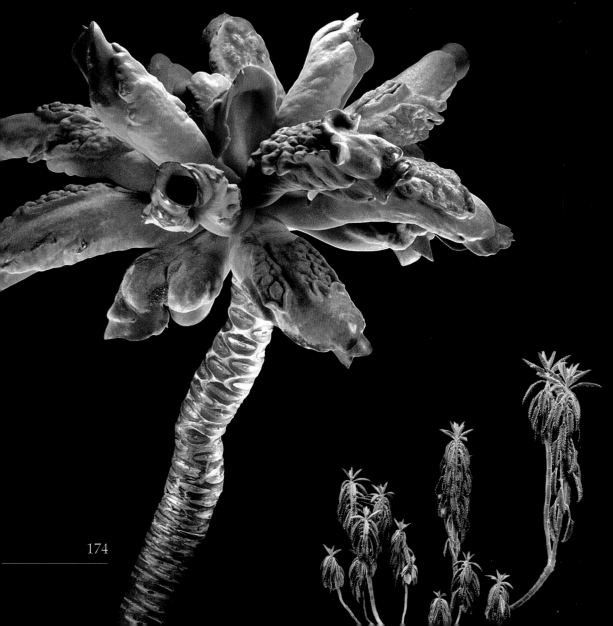

不死鸟锦
Kalanchoe ' Hushichou Nishiki '

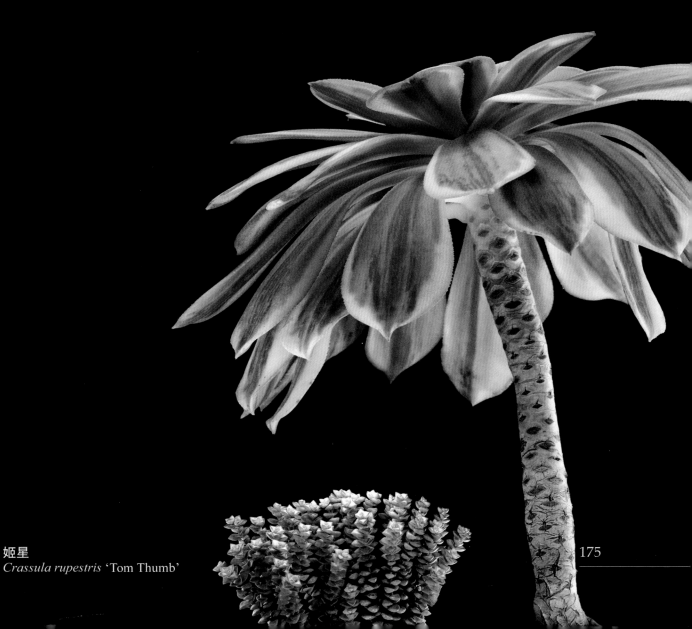

花叶寒月夜
Aeonium decorum 'Sunburst'

姬星
Crassula rupestris 'Tom Thumb'

175

赤鬼城
Crassula fusca

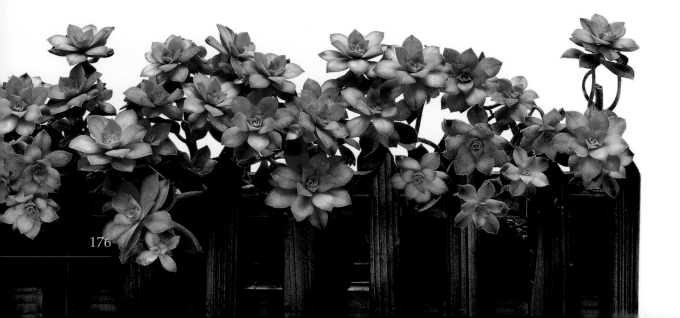

艳日辉
Aeonium decorum 'Variegata'

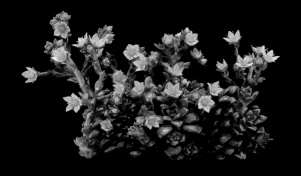

小玉
Cremnosedum 'Little Gem'

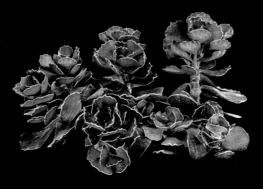

紫雀扇
Kalanchoe rhombpilosa

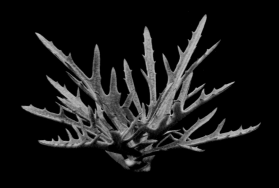

大鹿角
Kalanchoe laciniata

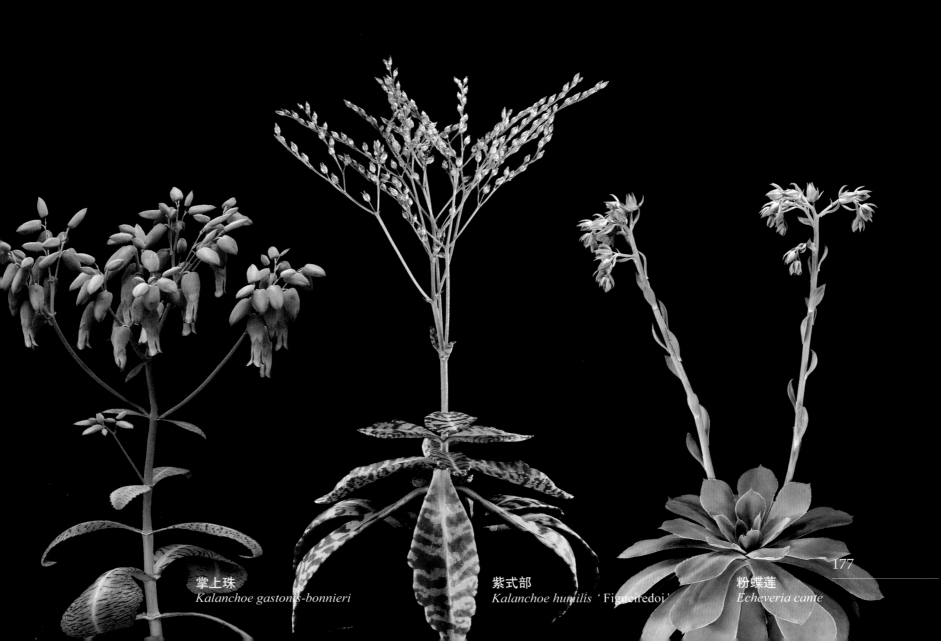

掌上珠
Kalanchoe gastonis-bonnieri

紫式部
Kalanchoe humilis 'Figueiredoi'

粉蝶莲
Echeveria cante

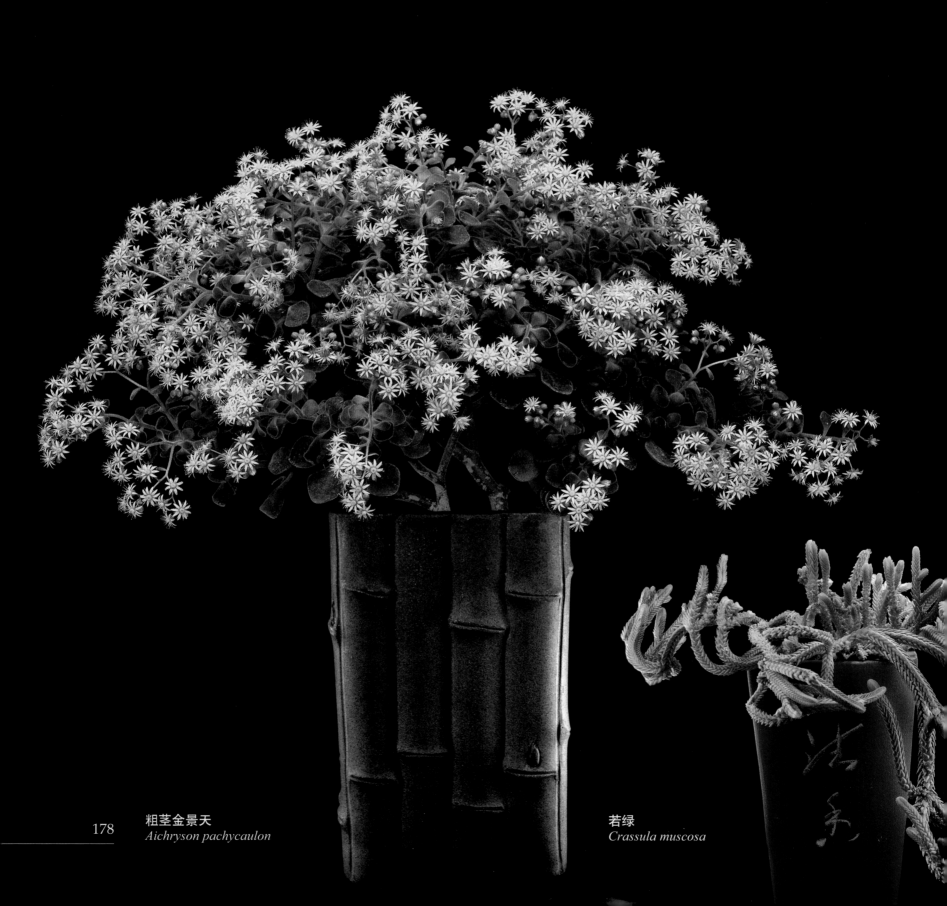

粗茎金景天
Aichryson pachycaulon

若绿
Crassula muscosa

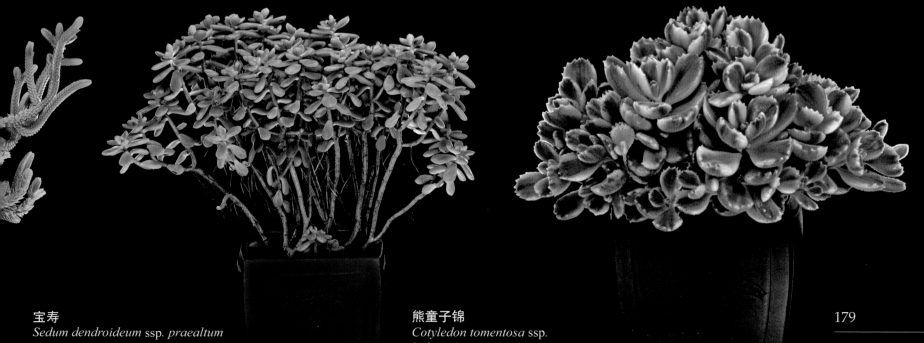

宝寿
Sedum dendroideum ssp. *praealtum*

熊童子锦
Cotyledon tomentosa ssp.
ladismithensis ‘Variegata’

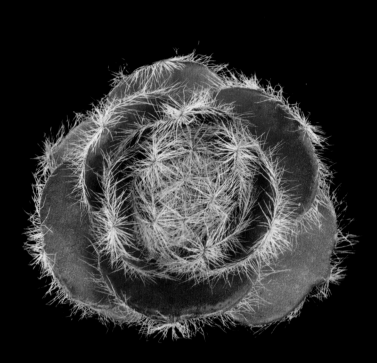

月光
Crassula barbata

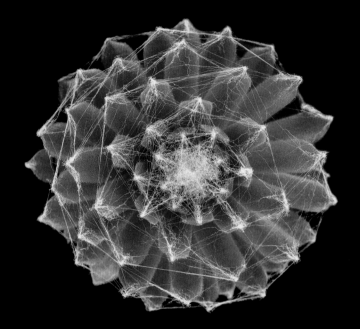

卷绢
Sempervivum arachnoideum

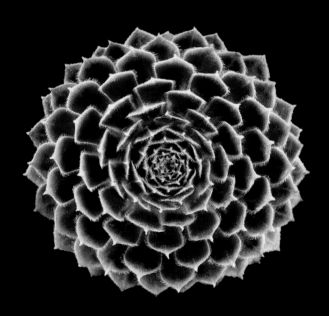

红卷绢
Sempervivum 'Grapetone'

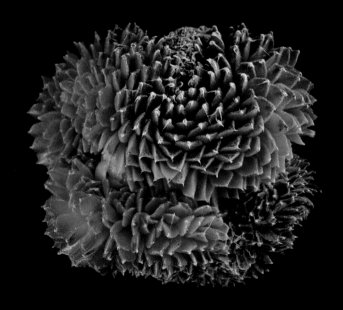

卷绢缀化
Sempervivum arachnoideum 'Cristata'

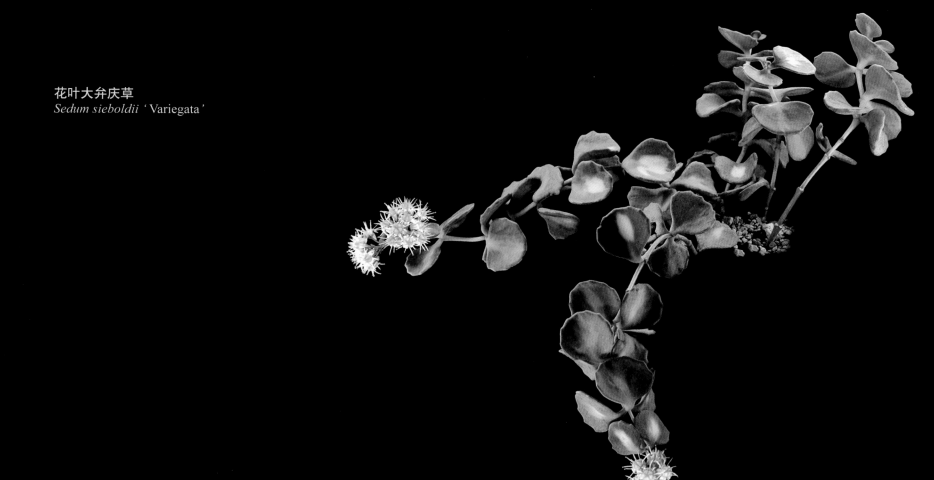

花叶大弁庆草
Sedum sieboldii 'Variegata'

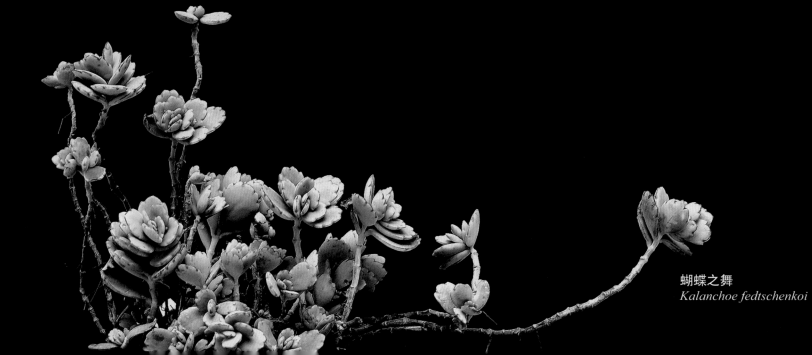

蝴蝶之舞
Kalanchoe fedtschenkoi

181

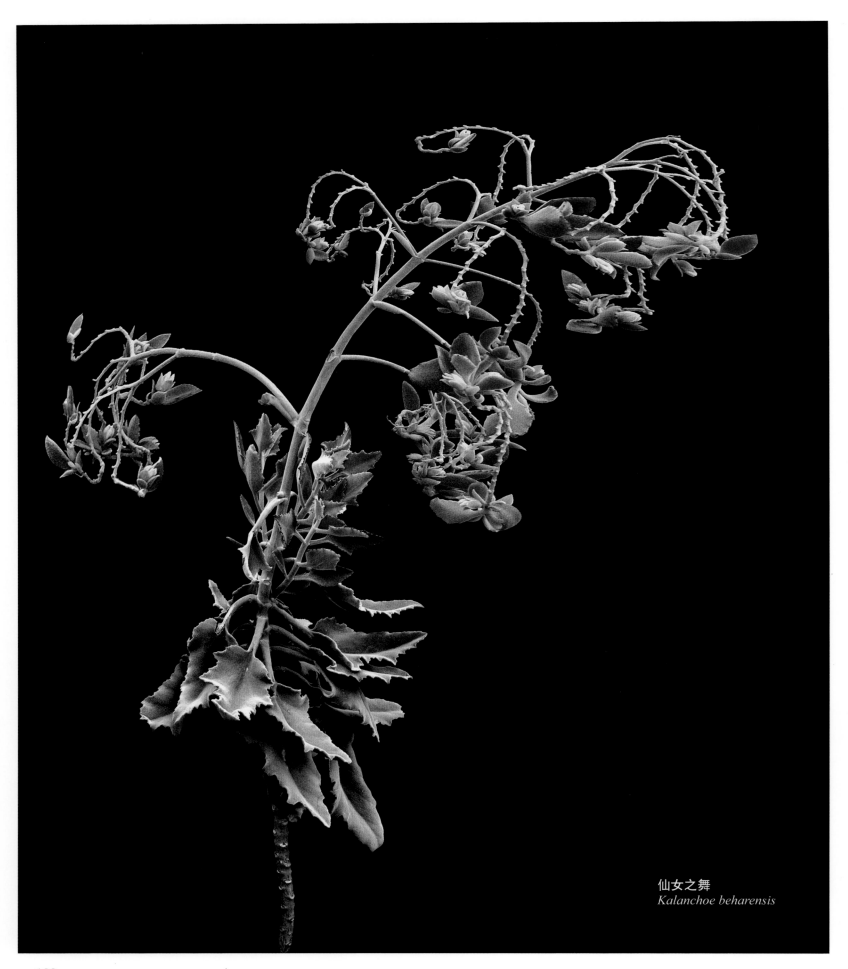

仙女之舞
Kalanchoe beharensis

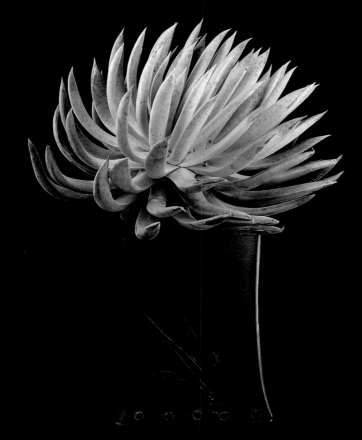

天女盃
Dudleya nubigena

缀弁庆
Kalanchoe daigremontiana

奇峰锦
Tylecodon wallichii

龙舌兰篇
Agavaceae

龙舌兰科多肉植物多产于美洲热带，在欧洲、南非、印度和澳洲也有引种和归化，现已作为观赏植物在全世界广为栽培。该科多肉植物具革质或多纤维肉质叶，呈辐射状或螺旋状生长。花序最高可达7至8米，是世界上最长的花序。经多年繁育培养，其园艺品种更是形态各异，五彩斑斓，具有极高的观赏价值。

Succulents of Agavaceae are native to the tropical Americas and have been introduced or naturalized in Europe, Africa, Asia and Oceania. Cultivated worldwide as ornamental plants, they have fibrous, leathery or fleshy leaves. their inflorescences can grow up to 8 meters, the tallest of their kind the world. After years of cultivation, their cultivars have become highly ornamental in various shapes and colors.

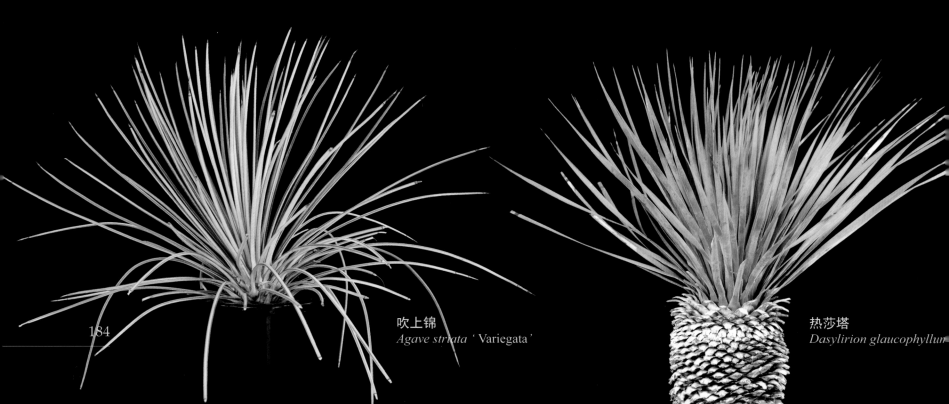

吹上锦
Agave striata 'Variegata'

热莎塔
Dasylirion glaucophyllum

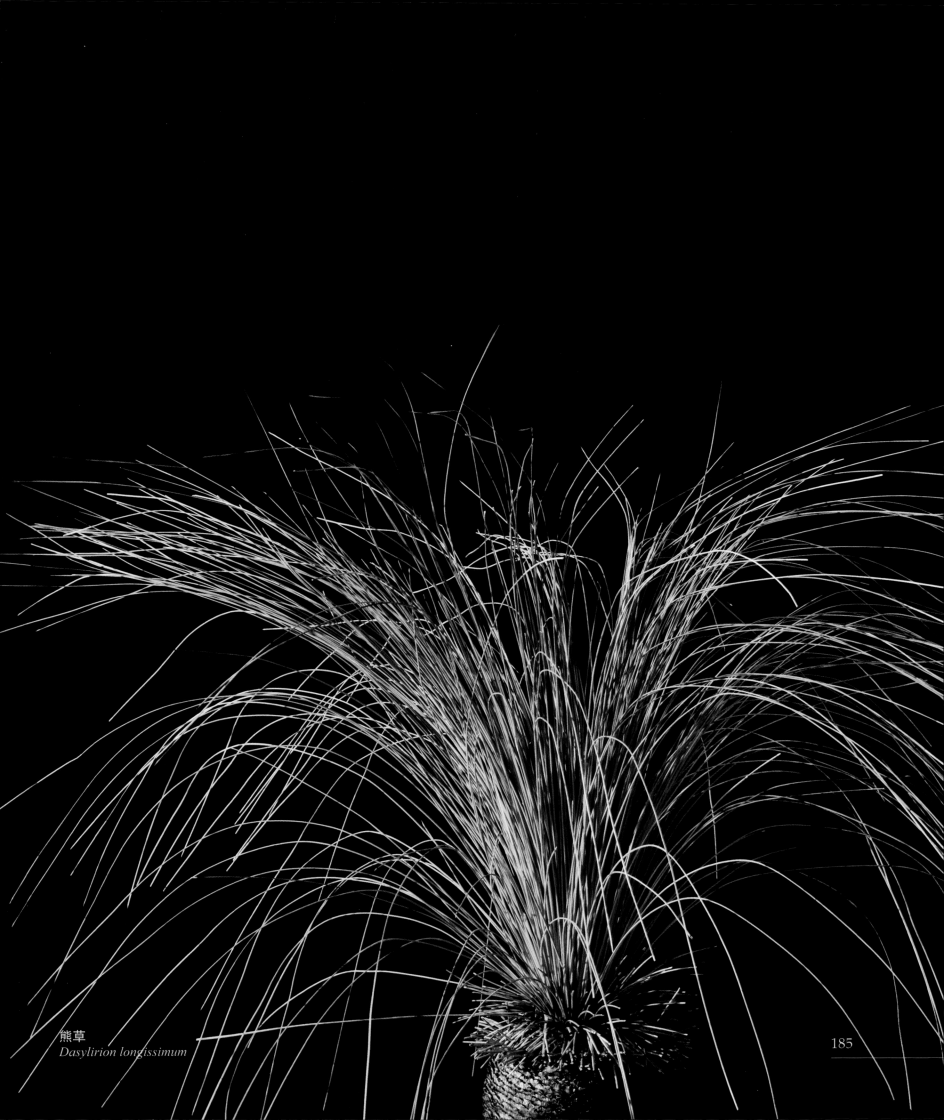

熊草
Dasylirion longissimum

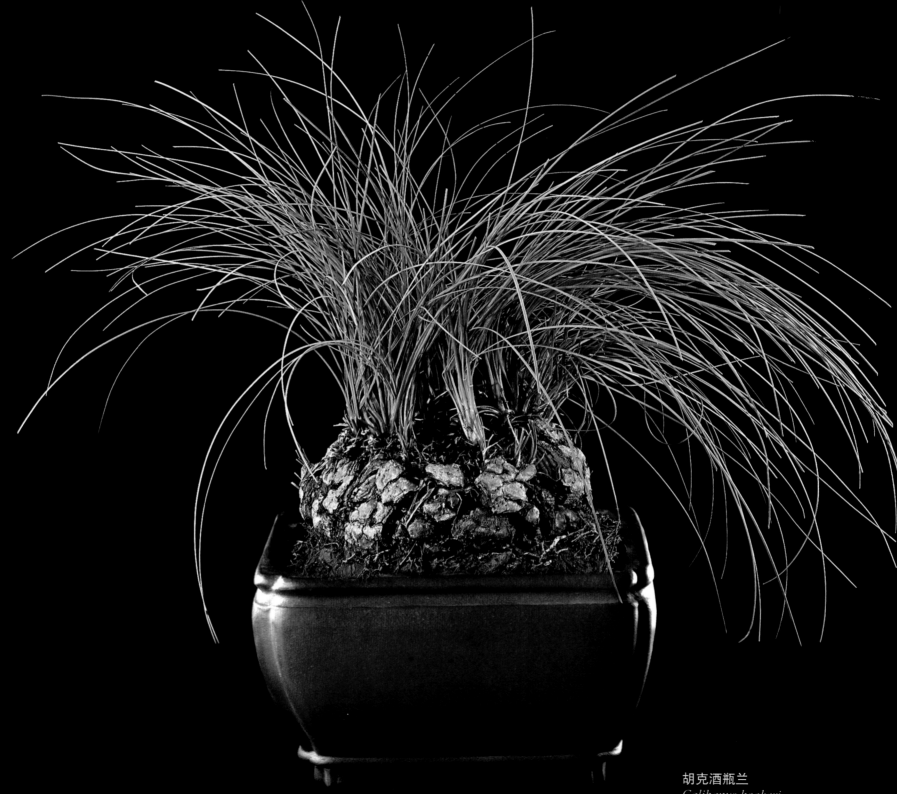

胡克酒瓶兰
Calibanus hookeri

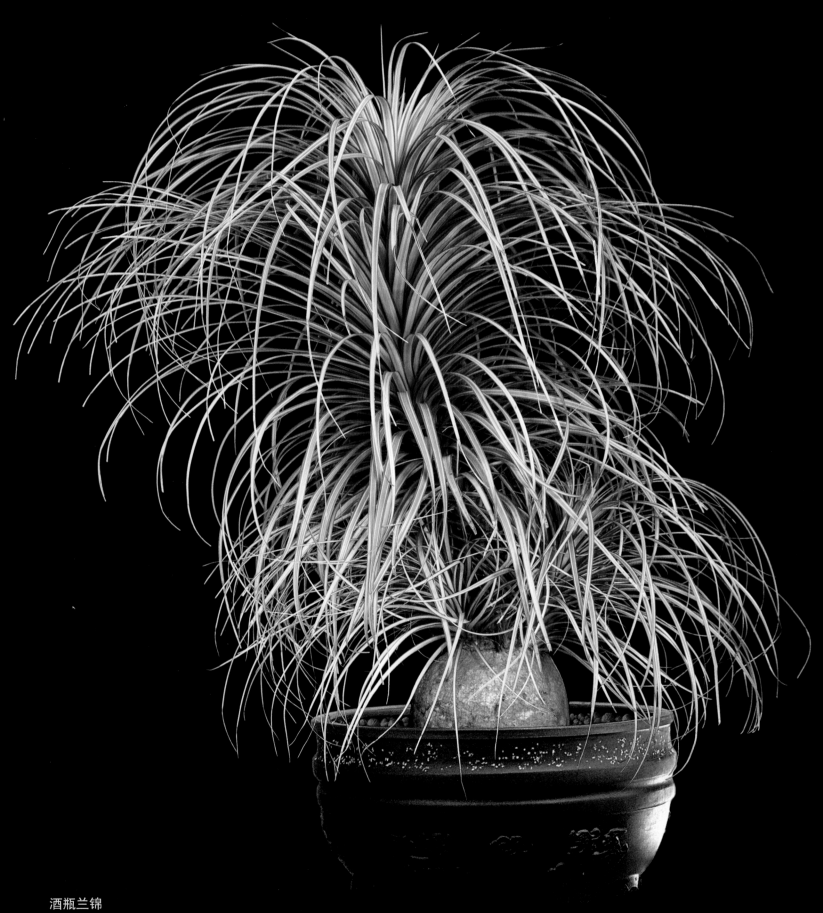

酒瓶兰锦
Beaucarnea recurvata ‘Variegata’

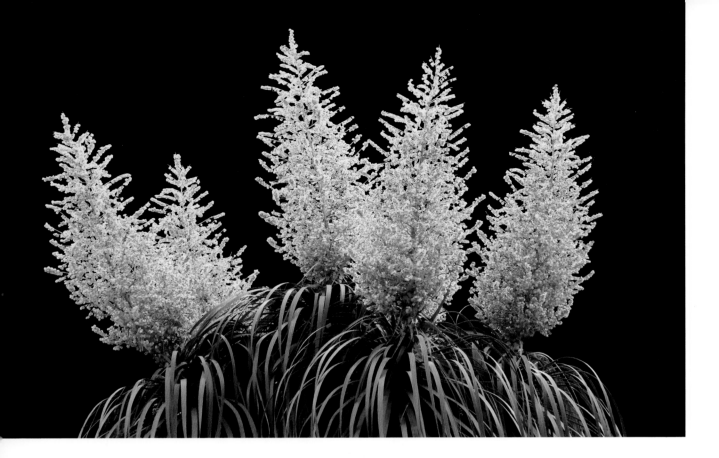

酒瓶兰
Beaucarnea recurvata

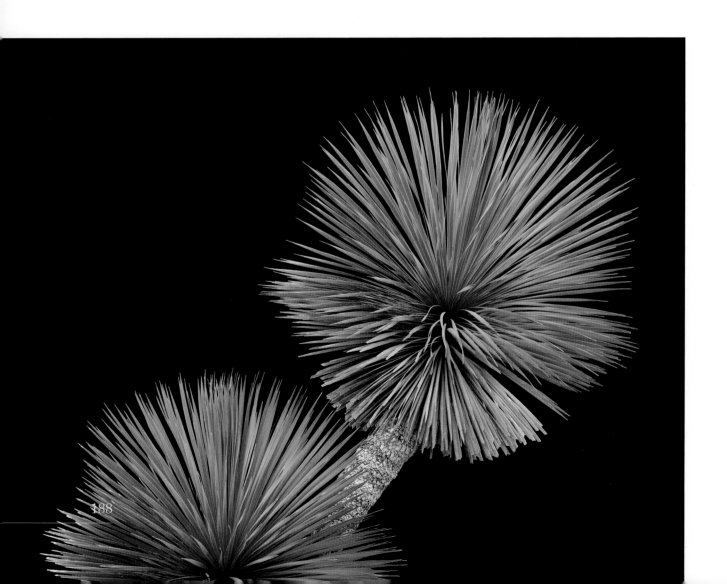

短叶丝兰
Yucca brevifolia

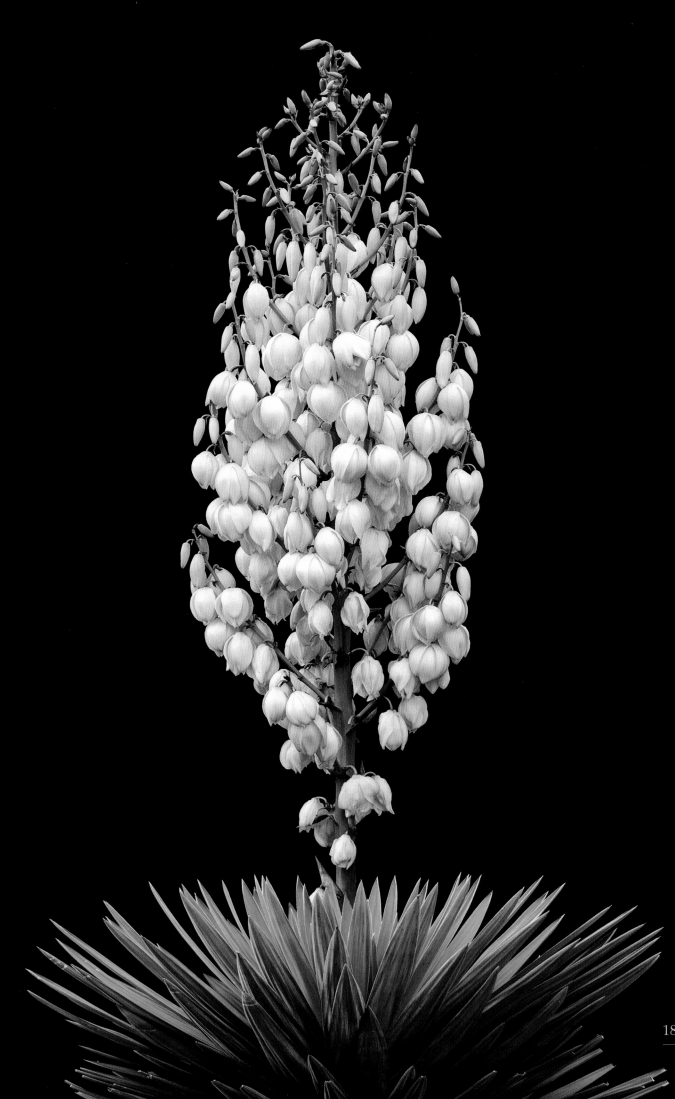

凤尾兰
Yucca gloriosa

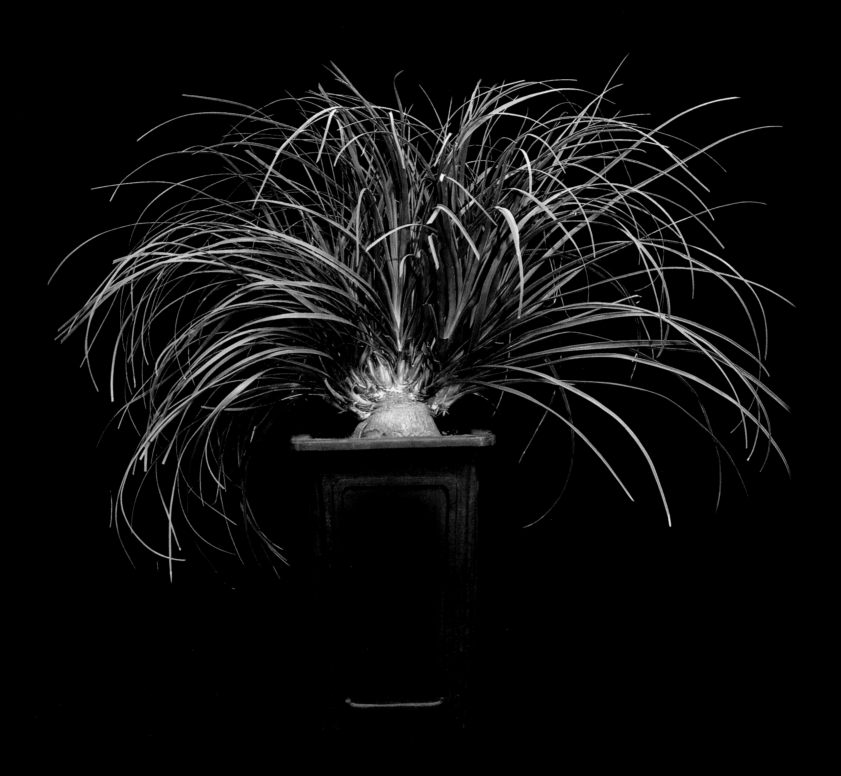

青岚
Beaucarnea stricta

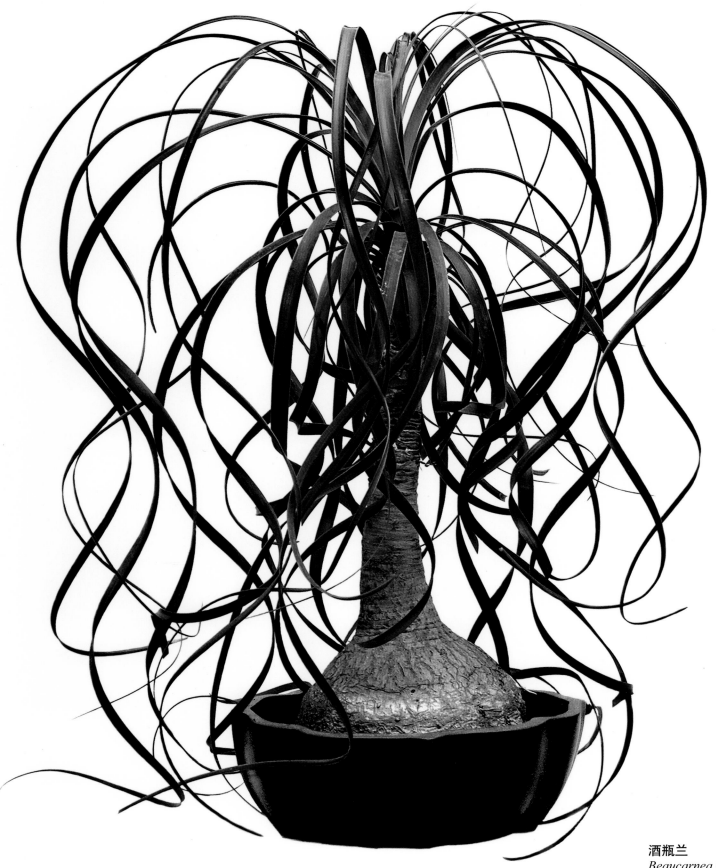

酒瓶兰
Beaucarnea recurvata

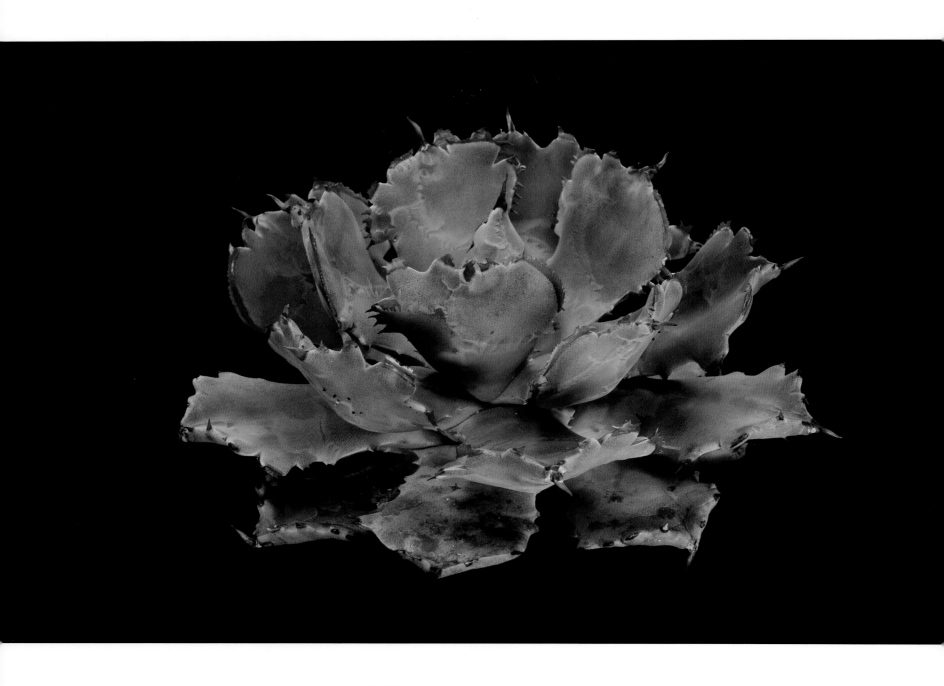

王妃甲蟹
Agave isthmensis ‘Oohi Kabutogani’

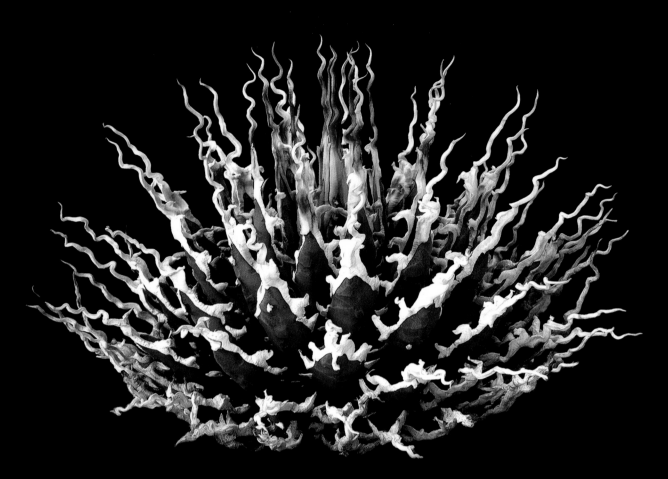

曲刺妖炎
Agave utahensis 'Flexuosa'

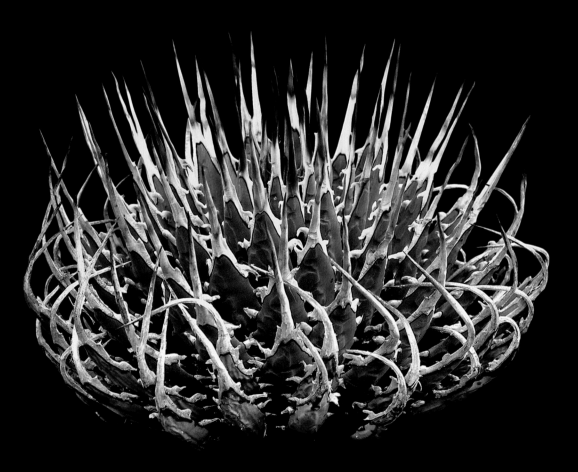

妖炎
Agave utahensis

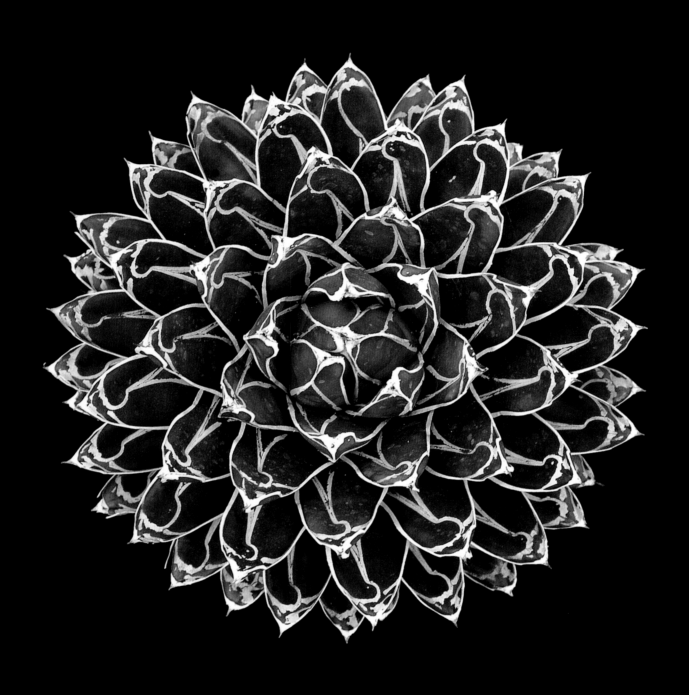

宽叶笹之雪
Agave victoriae-reginae 'Latifolia'

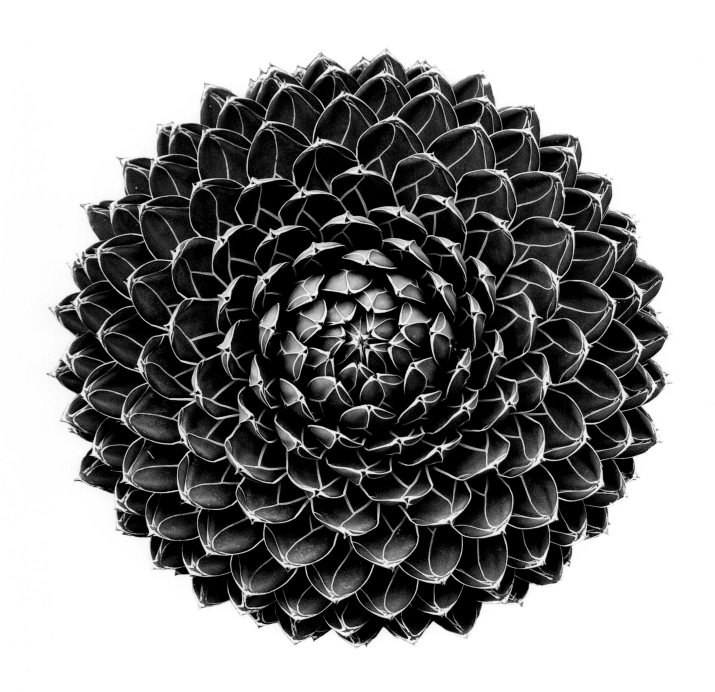

圆叶笹之雪
Agave victoriae-reginae 'Porcupine'

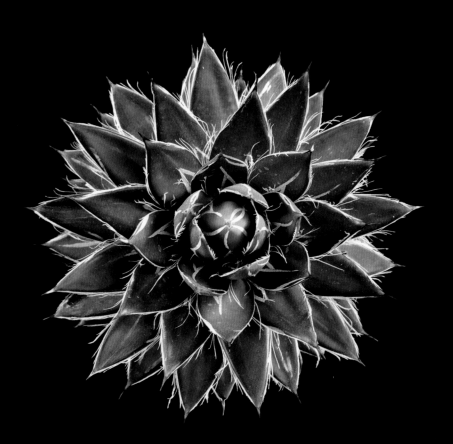

王姬笹之雪A型
Agave filifera ‘ Compacta A ’

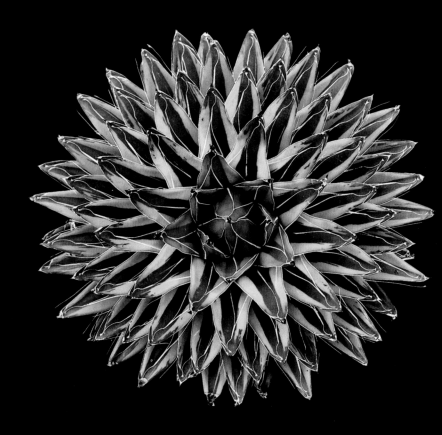

黄覆轮笹之雪
Agave victoriae-reginae ‘ Aureo Marginata ’

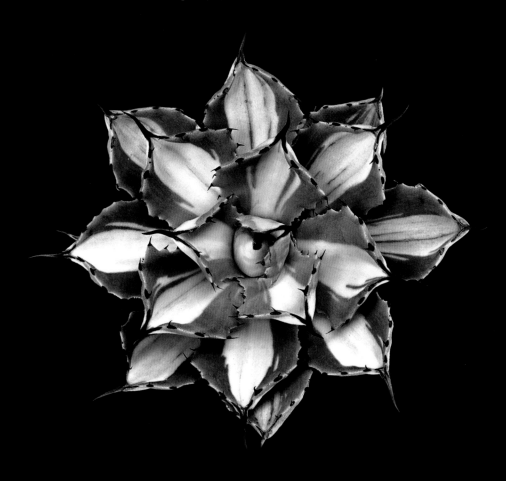

吉祥冠白中斑
Agave ‘ Kissho Kan ’

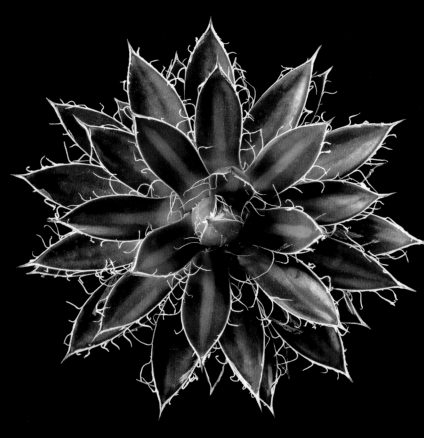

泷之白丝墨中斑
Agave schidigera ‘ Black Widow ’

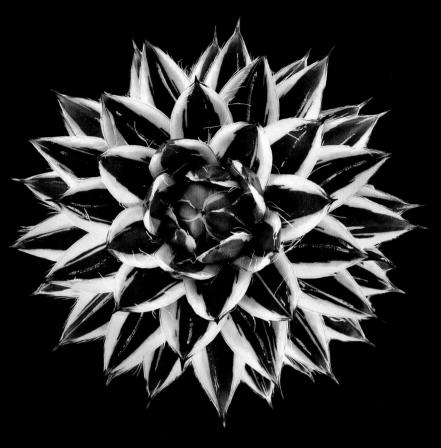

王妃笹之雪锦
Agave filifera ' Pinky '

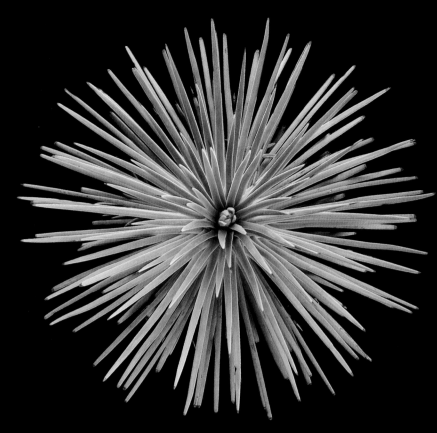

姬吹上
Agave stricta ' Nana '

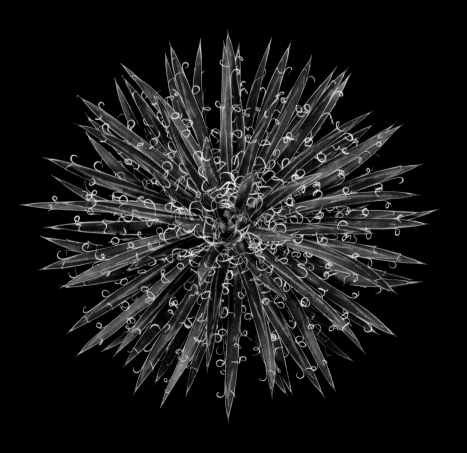

乱雪白丝
Agave × leopoldii

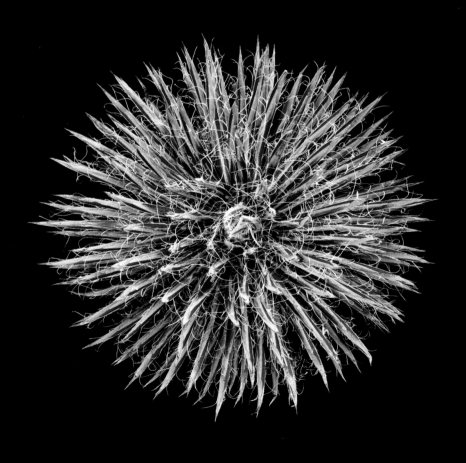

树冰
Agave toumeyana ' Bella '

197

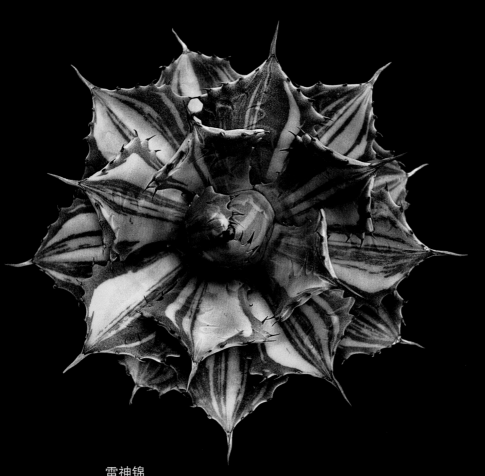

雷神锦
Agave potatorum ‘ Variegata ’

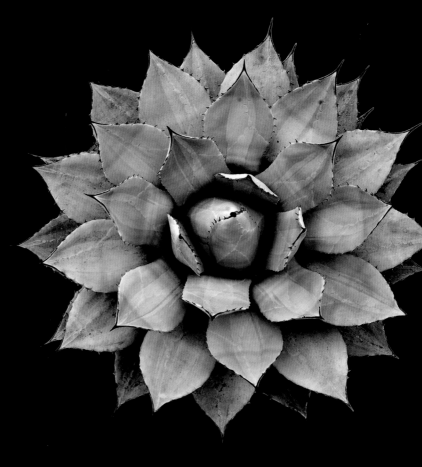

截叶吉祥天中斑
Agave parryi var. *truncata* ‘ Mediopicata Aurea ’

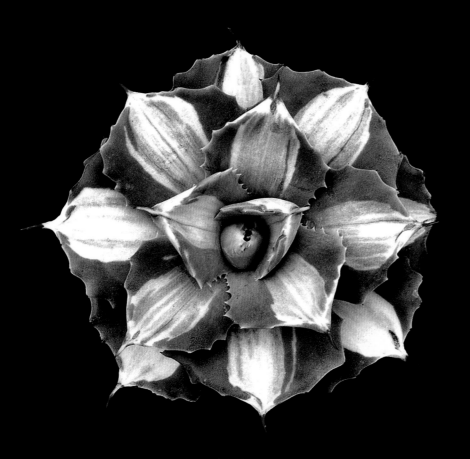

王妃雷神白中斑
Agave isthmensis ‘ Mediopicta ’

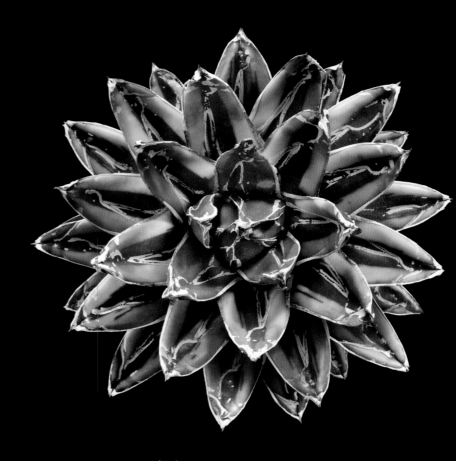

辉山
Agave victoriae-reginae ‘ Kizan ’

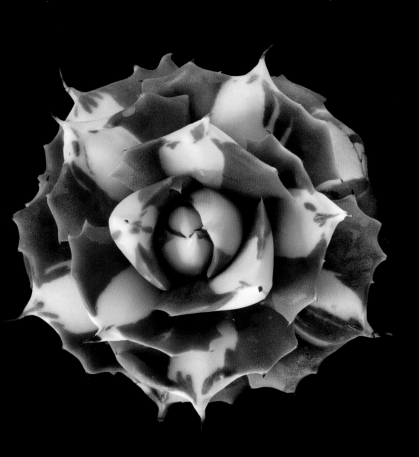

王妃雷神黄中斑
Agave isthmensis 'Ohi Reijin Ki Nakafu'

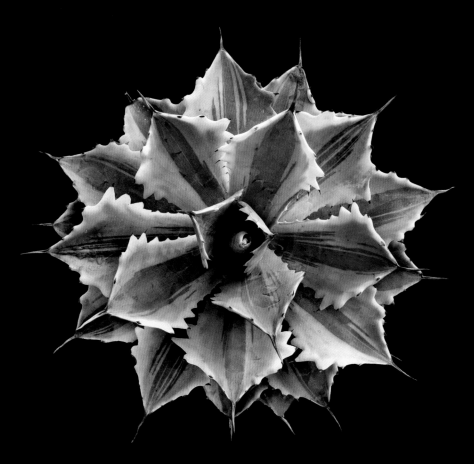

怒雷神锦
Agave potatorum 'Ikari Raijin Nishiki'

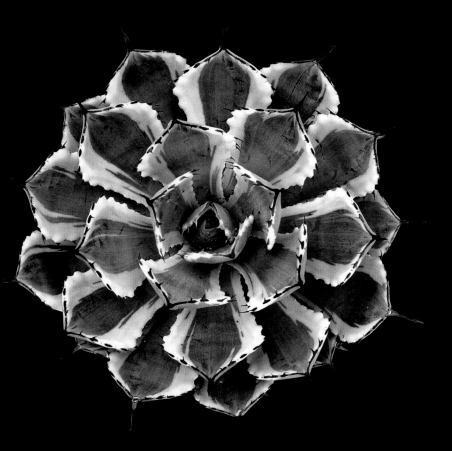

吉祥冠白覆轮
Agave potatorum 'Kisshou-kan'

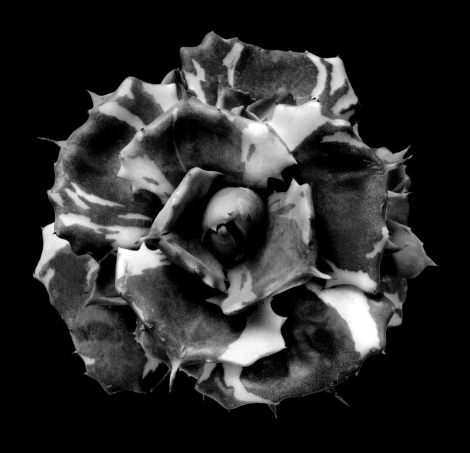

王妃雷神锦
Agave isthmensis 'Ohi Raijin Fukurin Nishiki'

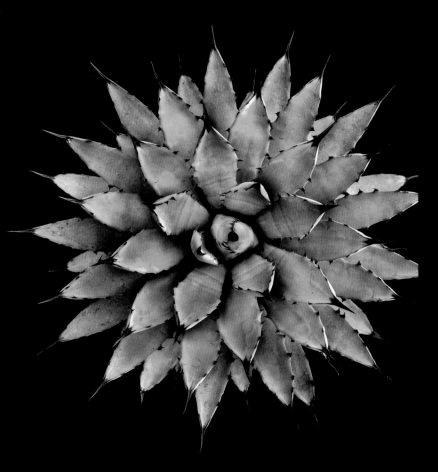

短叶八荒殿
Agave macroacantha 'Viridis'

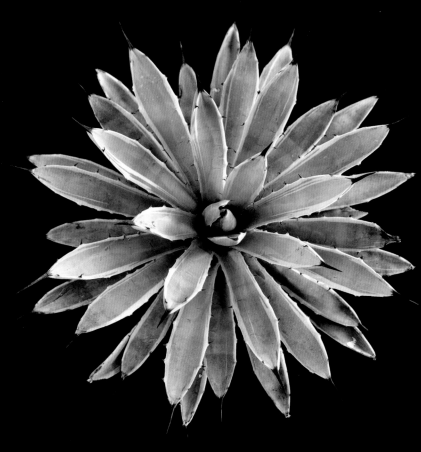

八荒殿覆轮锦
Agave macroacantha 'Blue Ribbon'

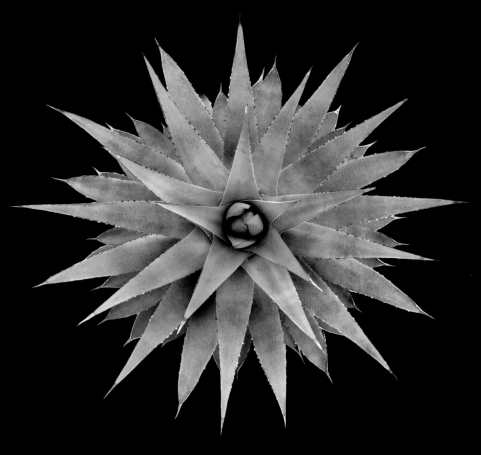

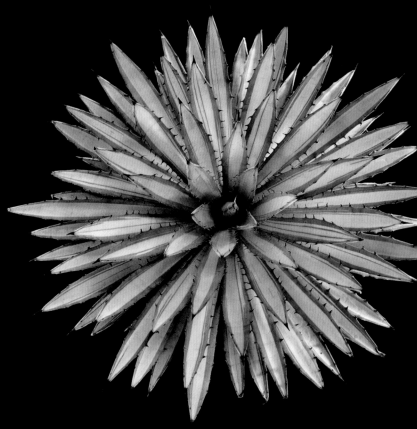

德氏龙舌兰
Agave deserti

八荒殿中斑锦
Agave macroacantha 'Hatsukoden'

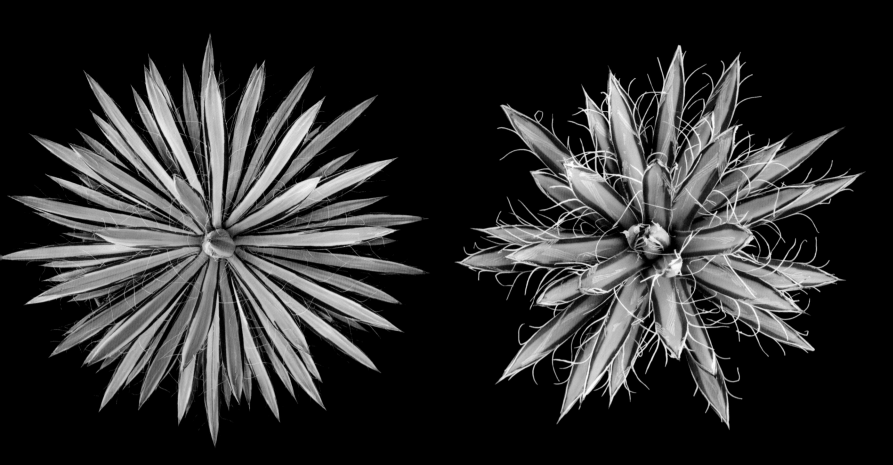

白丝王妃中斑
Agave filifera ssp. *schidigera* ‘ Shiraito No Ohi Nakafu ’

姬乱雪白中斑
Agave parviflora ‘ Shiro Nakafu ’

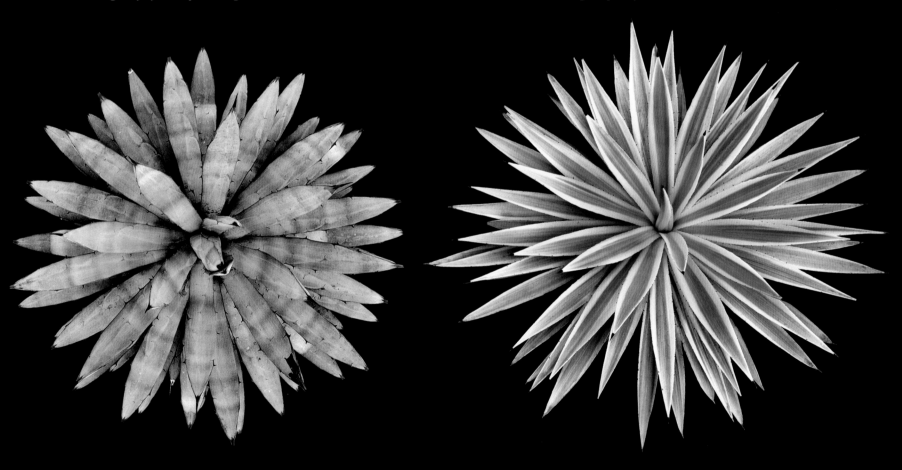

八荒殿
Agave macroacantha

白闪光
Agave vivipara ‘ Variegata ’

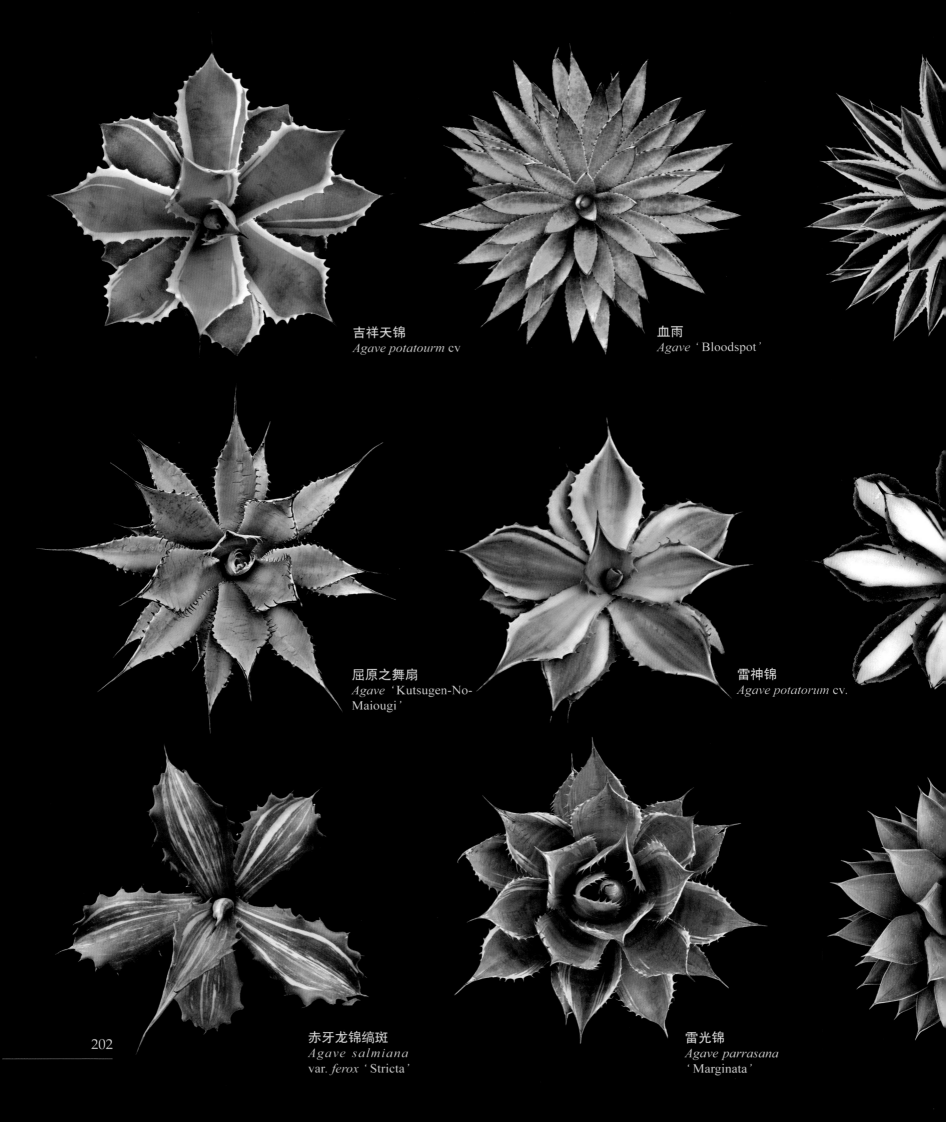

吉祥天锦
Agave potatourm cv

血雨
Agave 'Bloodspot'

屈原之舞扇
Agave 'Kutsugen-No-
Maiougi'

雷神锦
Agave potatorum cv.

赤牙龙锦缟斑
Agave salmiana
var. *ferox* 'Stricta'

雷光锦
Agave parrasana
'Marginata'

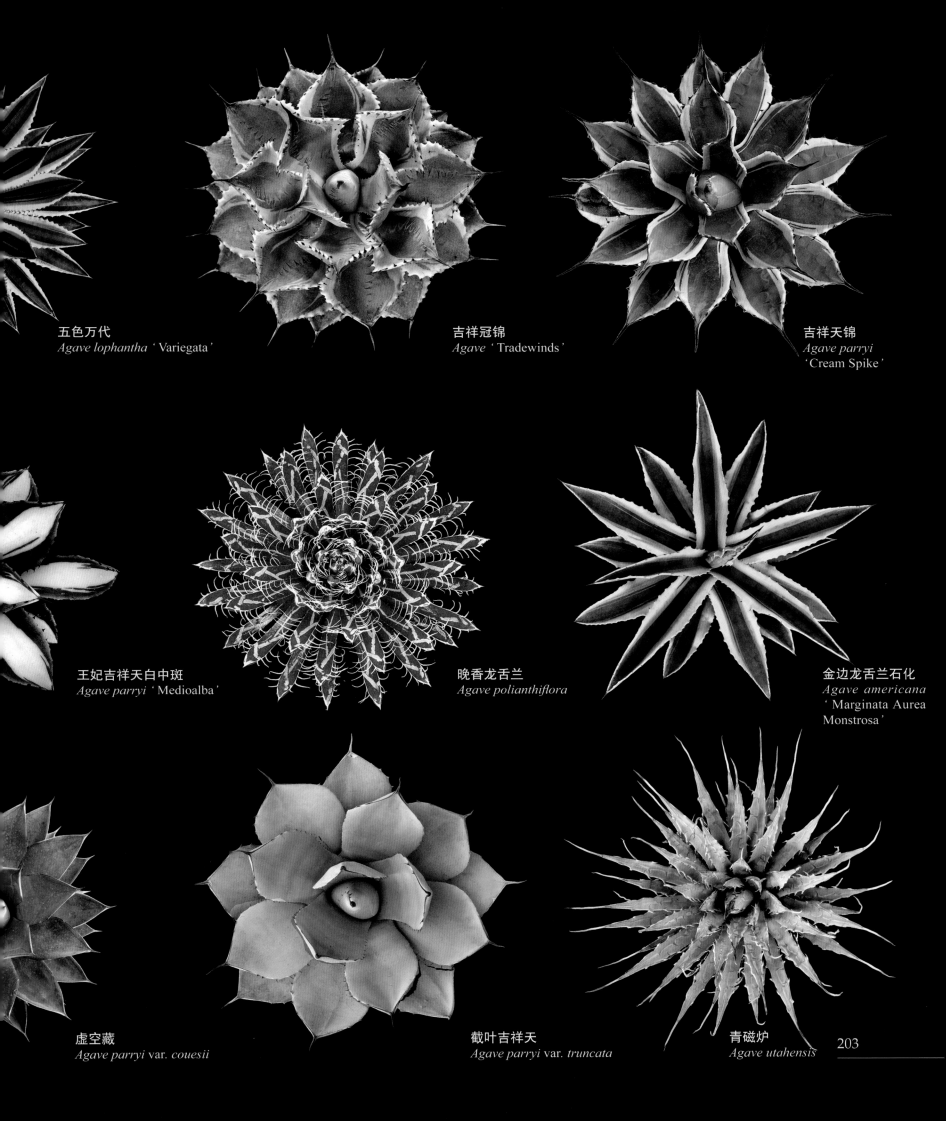

五色万代
Agave lophantha ' Variegata '

吉祥冠锦
Agave ' Tradewinds '

吉祥天锦
Agave parryi
' Cream Spike '

王妃吉祥天白中斑
Agave parryi ' Medioalba '

晚香龙舌兰
Agave polianthiflora

金边龙舌兰石化
Agave americana
' Marginata Aurea
Monstrosa '

虚空藏
Agave parryi var. *couesii*

截叶吉祥天
Agave parryi var. *truncata*

青磁炉
Agave utahensis

203

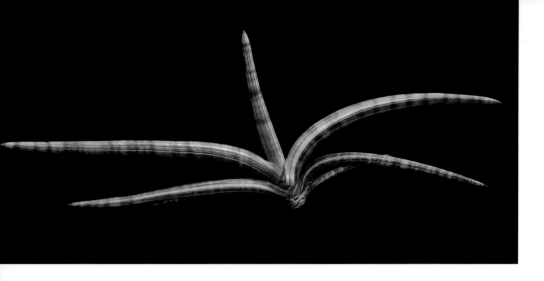

展叶虎尾兰锦
Sansevieria cylindrica var. *patula* ' Variegata '

筒叶虎尾兰
Sansevieria cylindrica

姬乱雪
Agave parvifolia

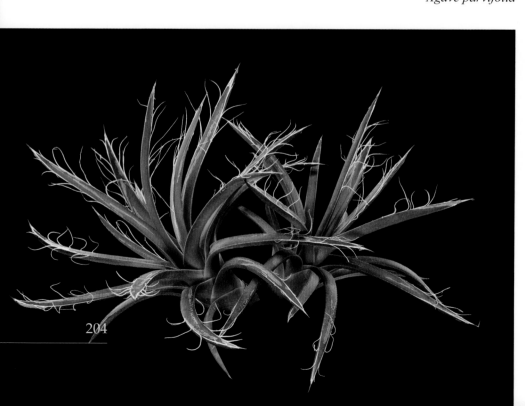

204

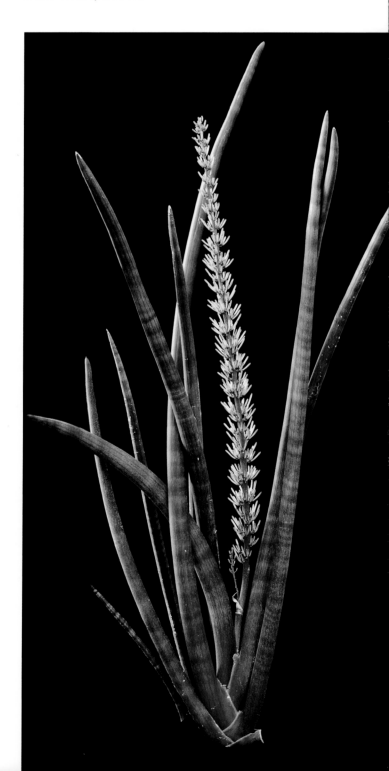

紫叶酒瓶兰
Beaucarnea oedipus

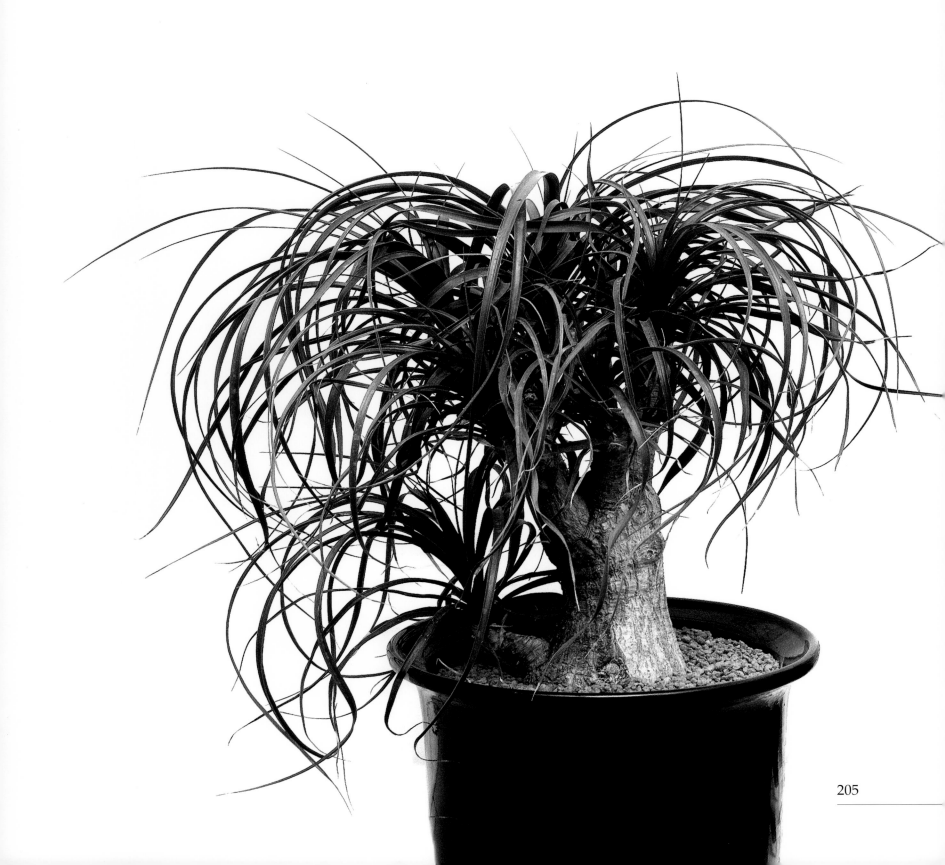

百合篇
Liliaceae

百合科多肉植物多分布于非洲、地中海沿岸及中、南美洲地区，为多年生单子叶草本植物，以叶多肉植物为主。其中十二卷属中的寿、玉扇、万象等种类，经多年的园艺培育，斑锦变异颇多，成为近年来最为流行和热门的多肉植物品种之一。该科中的沙鱼掌属和芦荟属多肉植物栽培也比较普遍。

Succulents of Liliaceae, mostly found in Africa, the Mediterranean region and Central and South America, are perennial monocotyledon herbs mainly composed of leaf succulents. Among other members of the genus, *Haworthia*, *H. retusa*, *H. truncata* and *H. truncata* var. *maughanii* are diversified in color after years of cultivation and have recently gained popularity. The genera *Gasteria* and *Aloe* are also popular cultivated succulents.

十二卷品种群
Haworthia cvs.

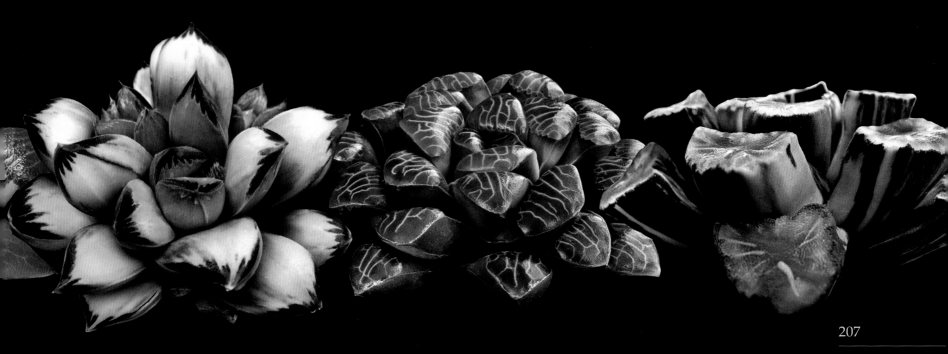

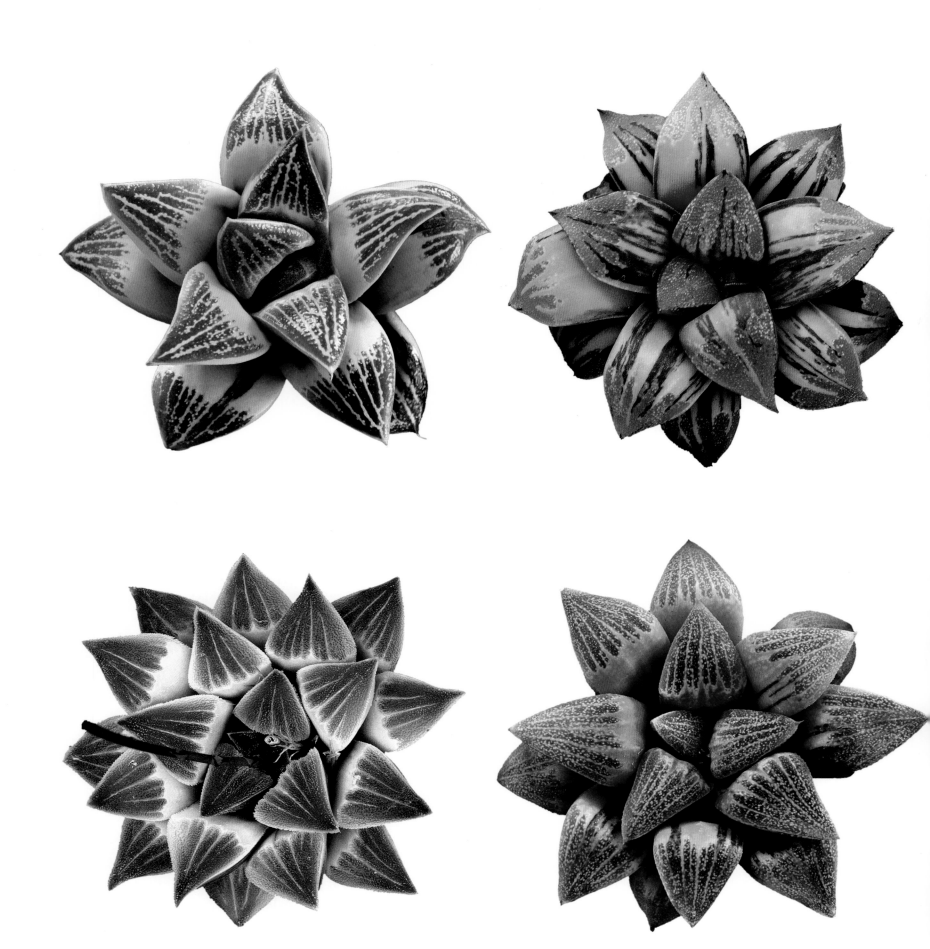

寿锦杂交品种群
Haworthia cvs.

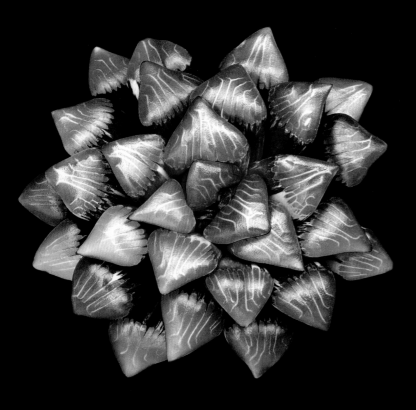

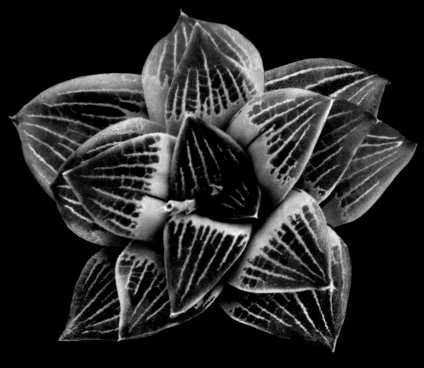

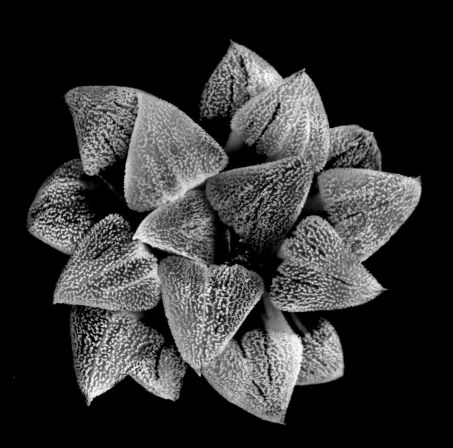

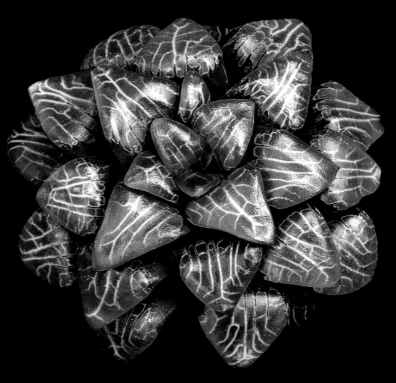

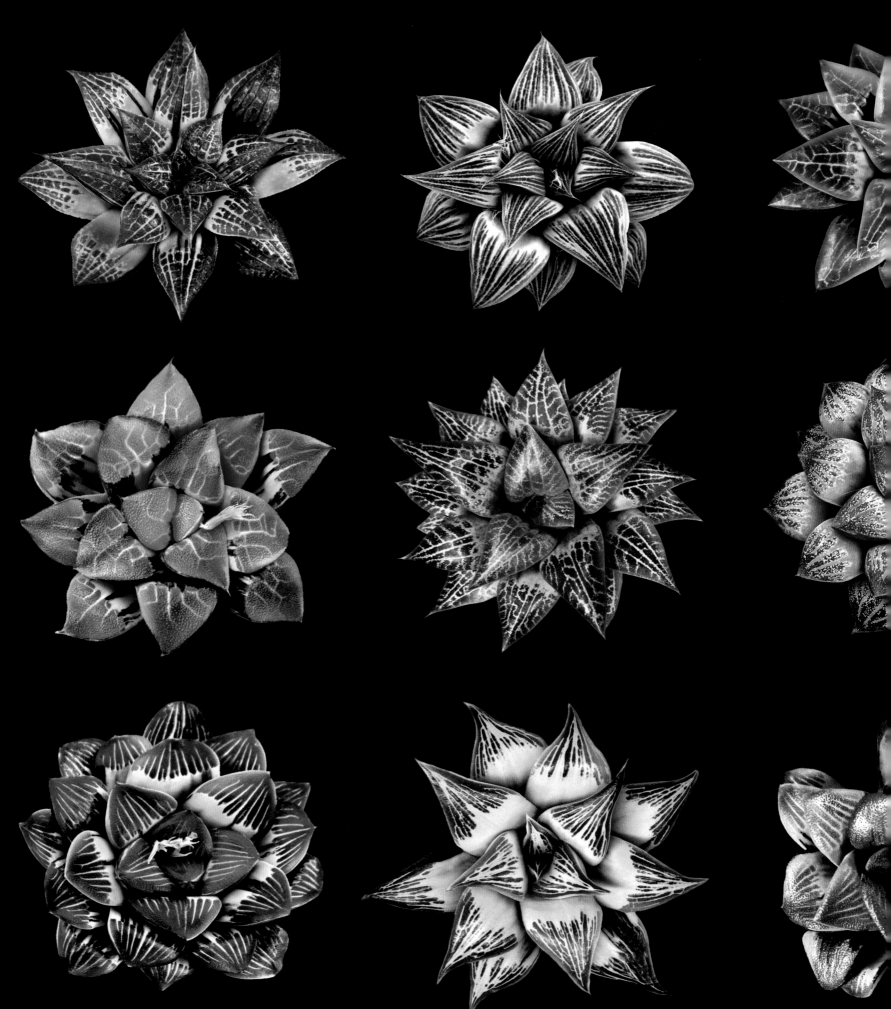

寿锦杂交品种群
Haworthia cvs.

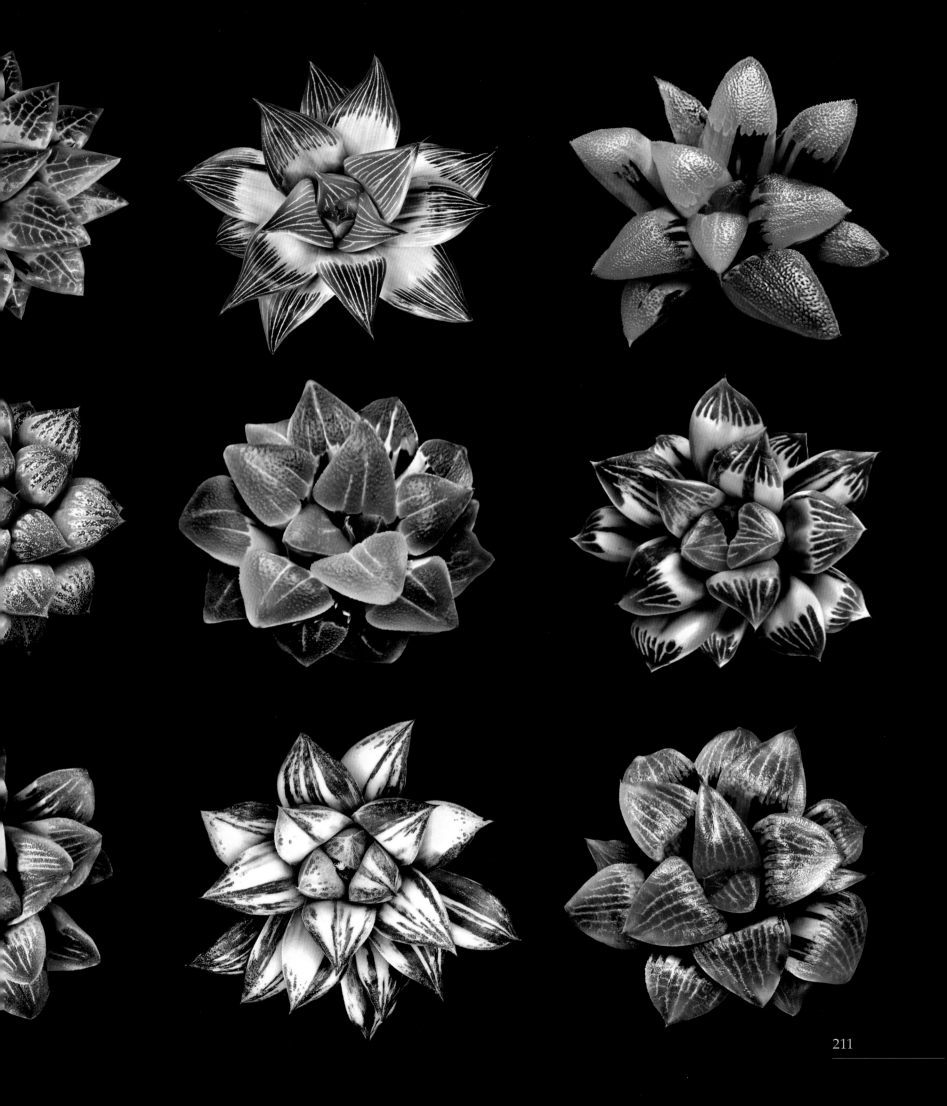

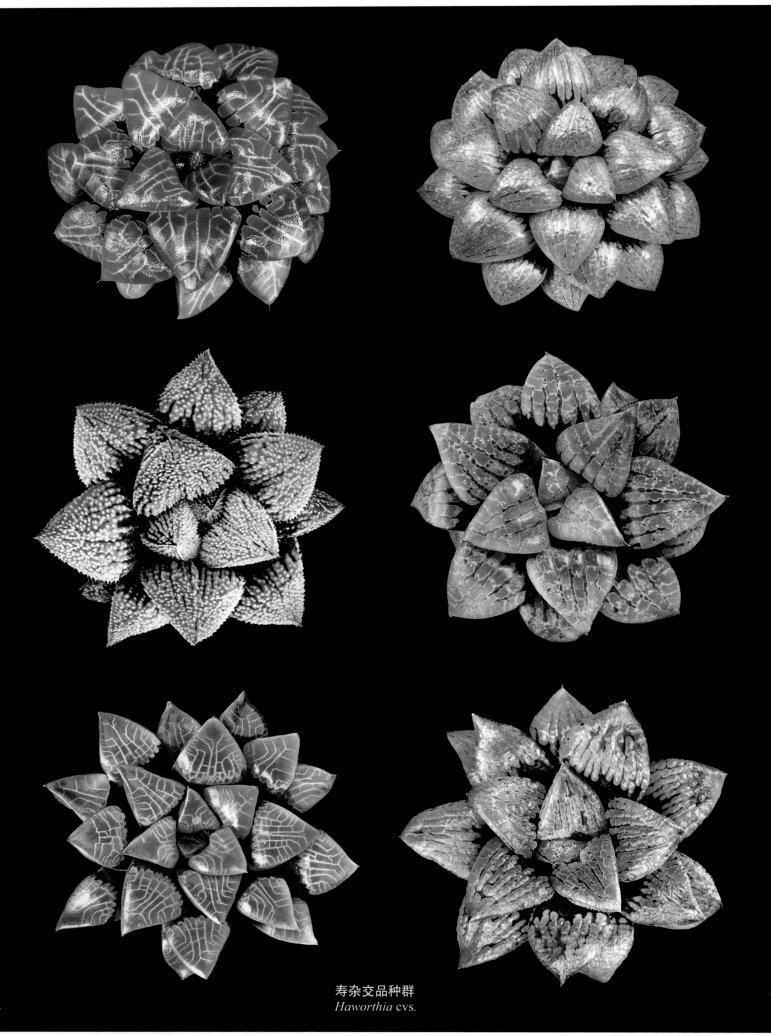

寿杂交品种群
Haworthia cvs.

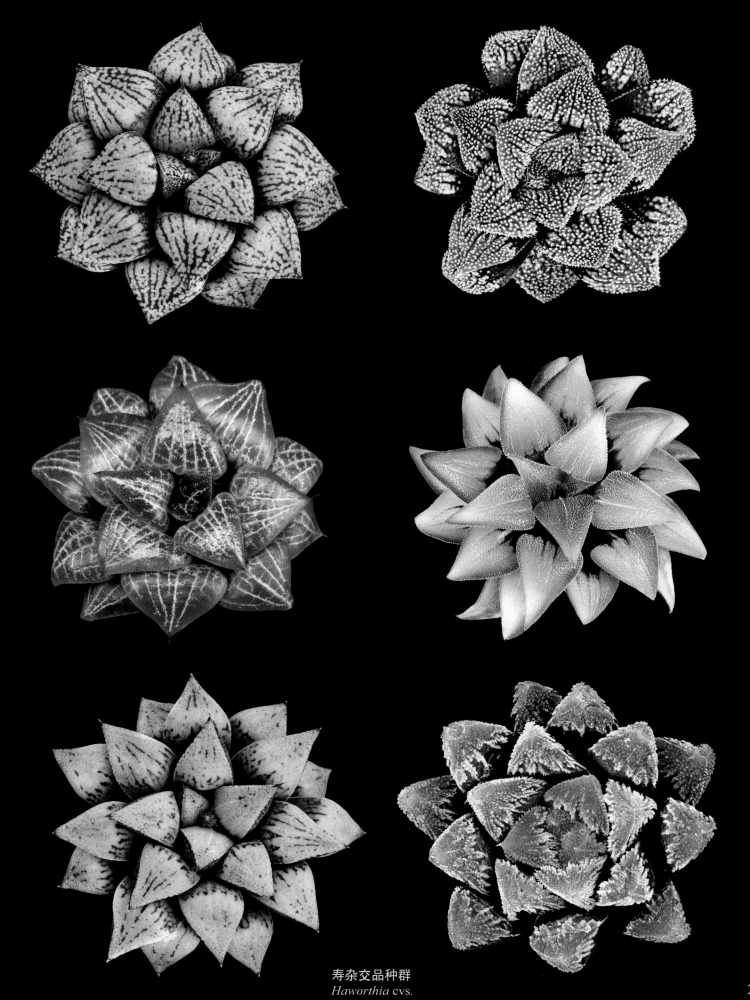

寿杂交品种群
Haworthia cvs.

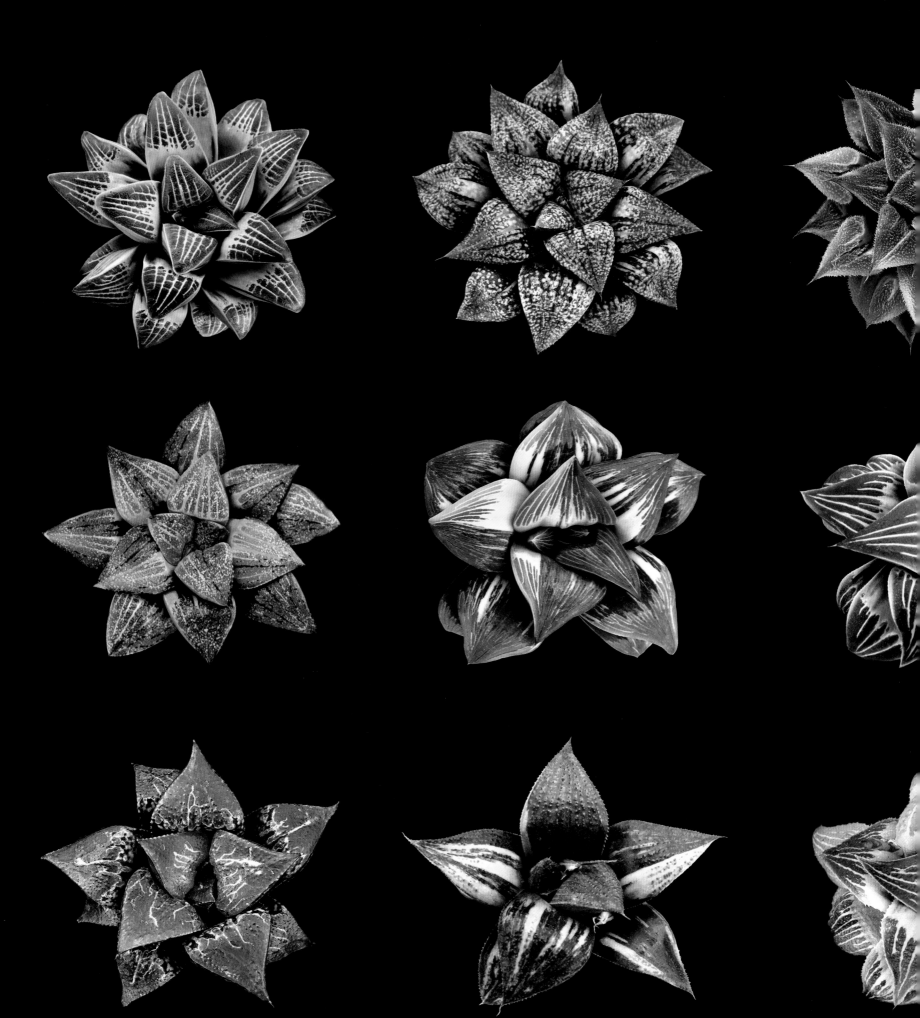

寿锦杂交品种群
Haworthia cvs.

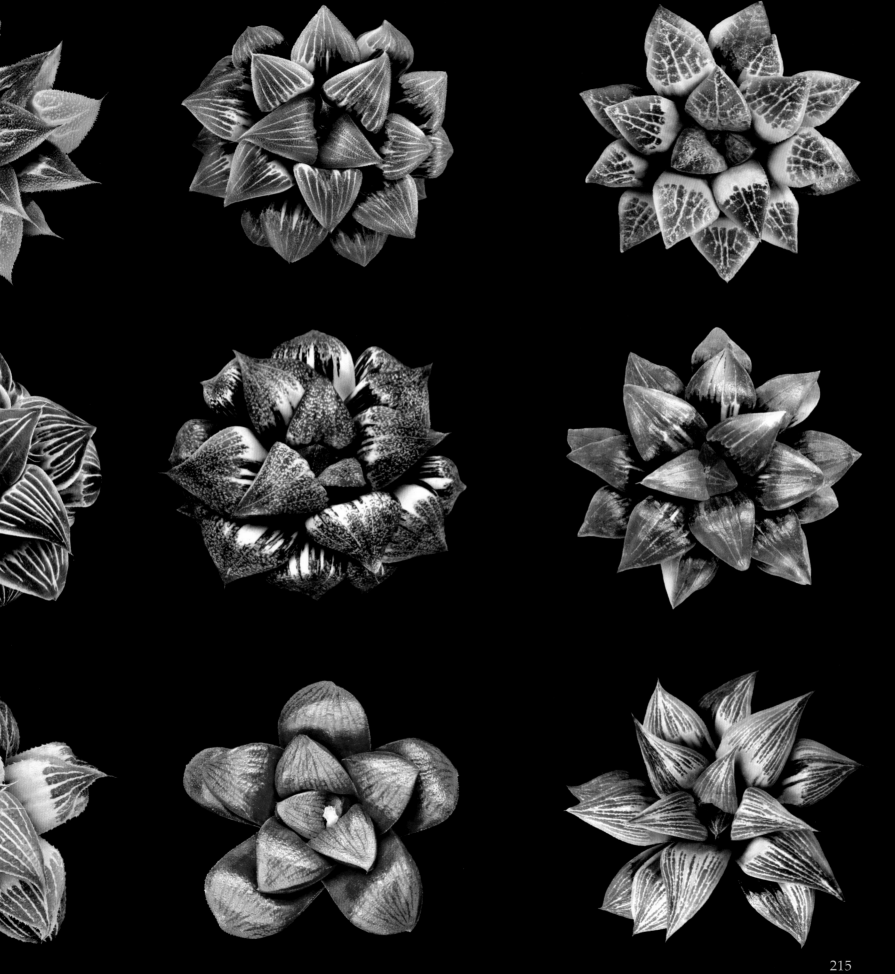

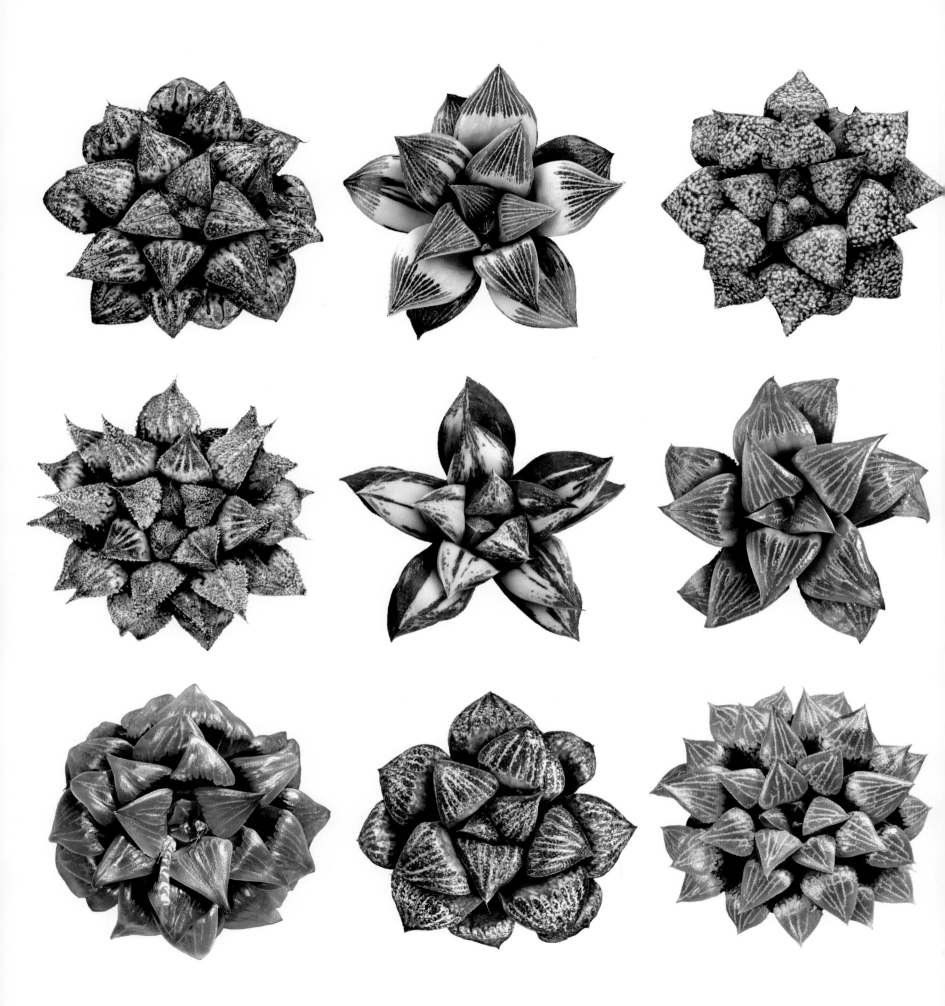

寿 寿锦杂交品种群
Haworthia cvs.

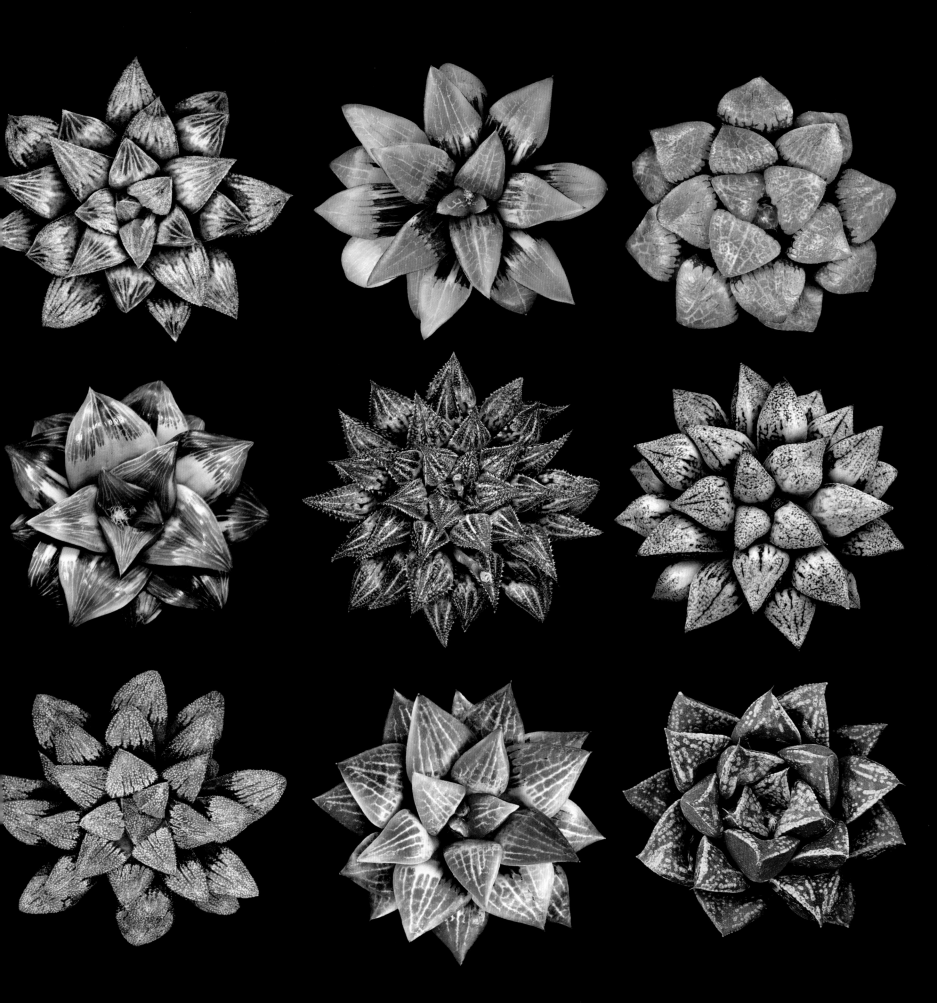

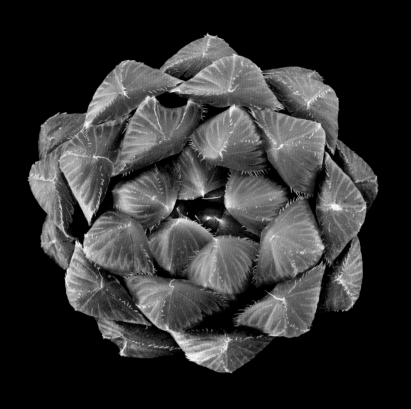
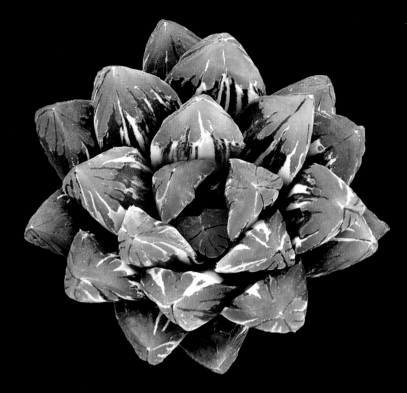
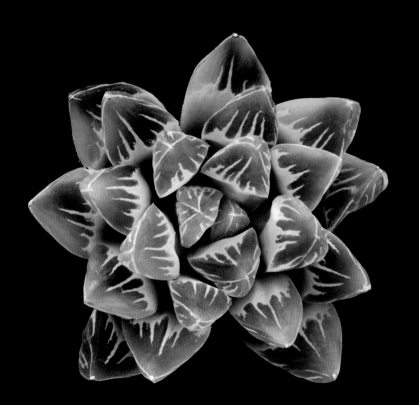
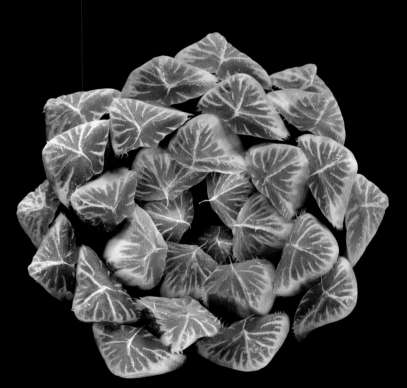

玉露　玉露锦品种群
Haworthia cvs.

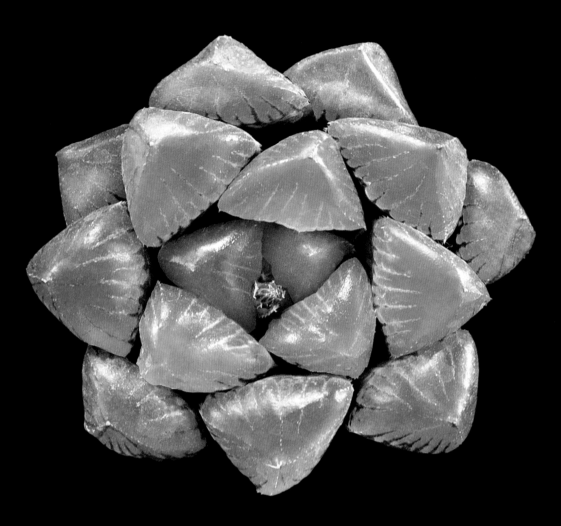

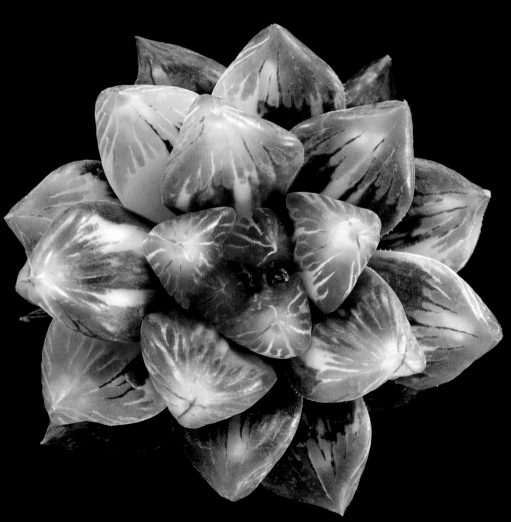

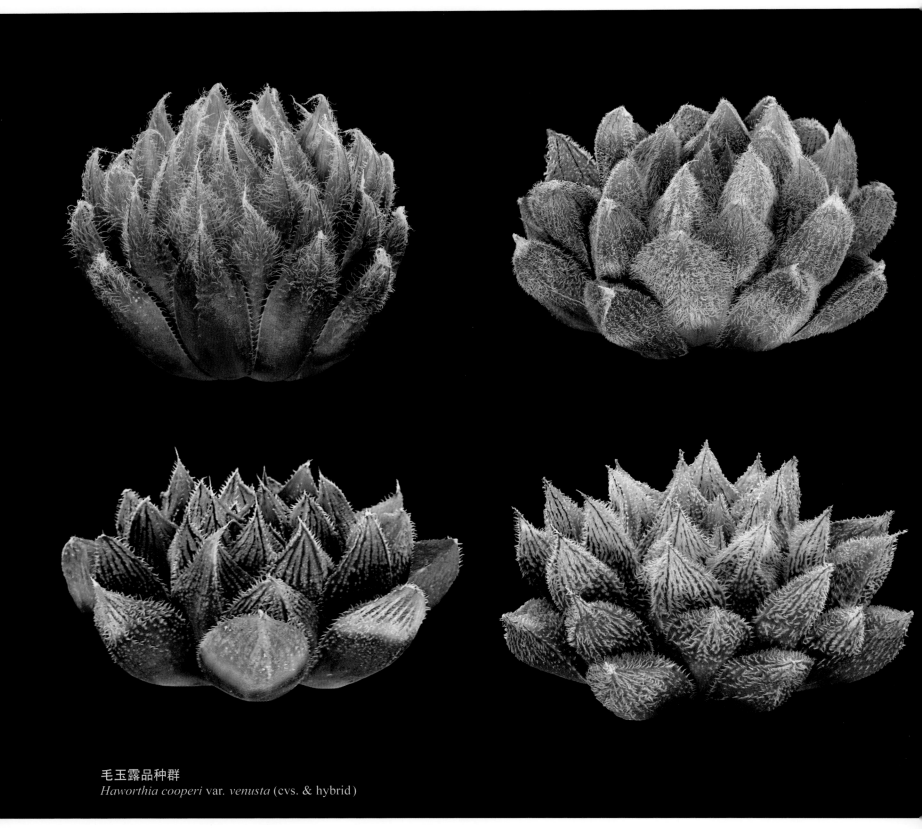

毛玉露品种群
Haworthia cooperi var. *venusta* (cvs. & hybrid)

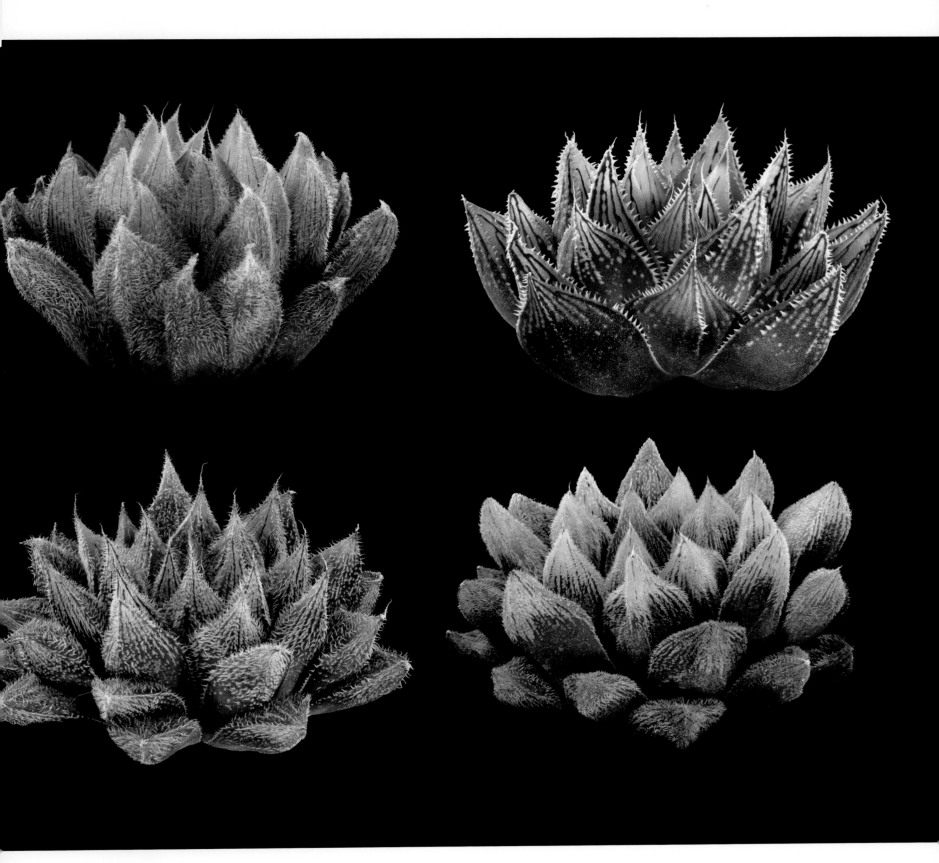

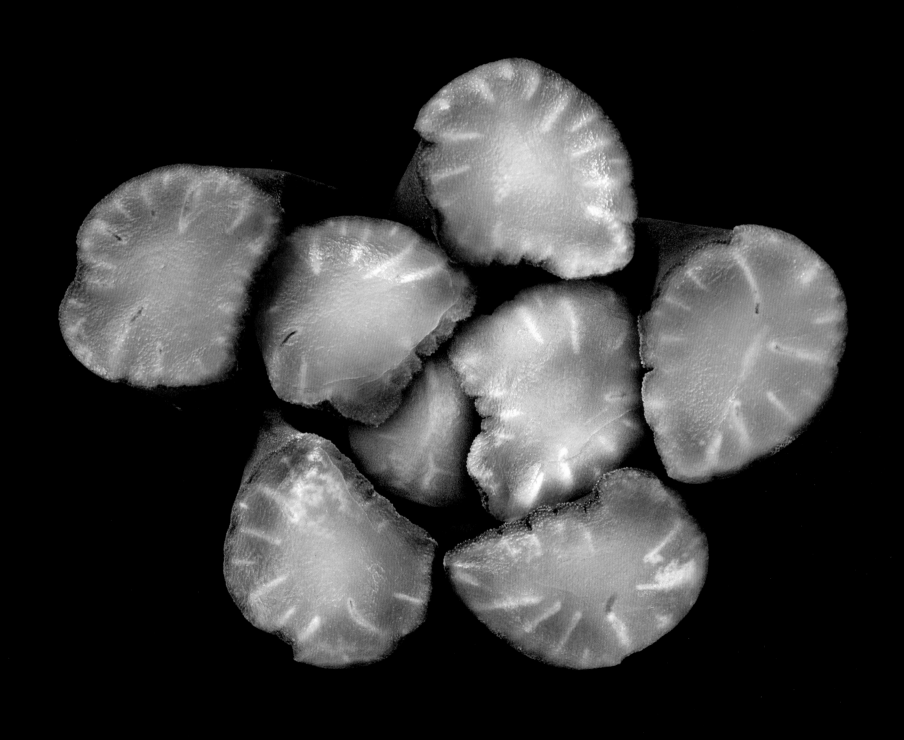

白瓷万象
Haworthia truncata var. *maughanii* cv.

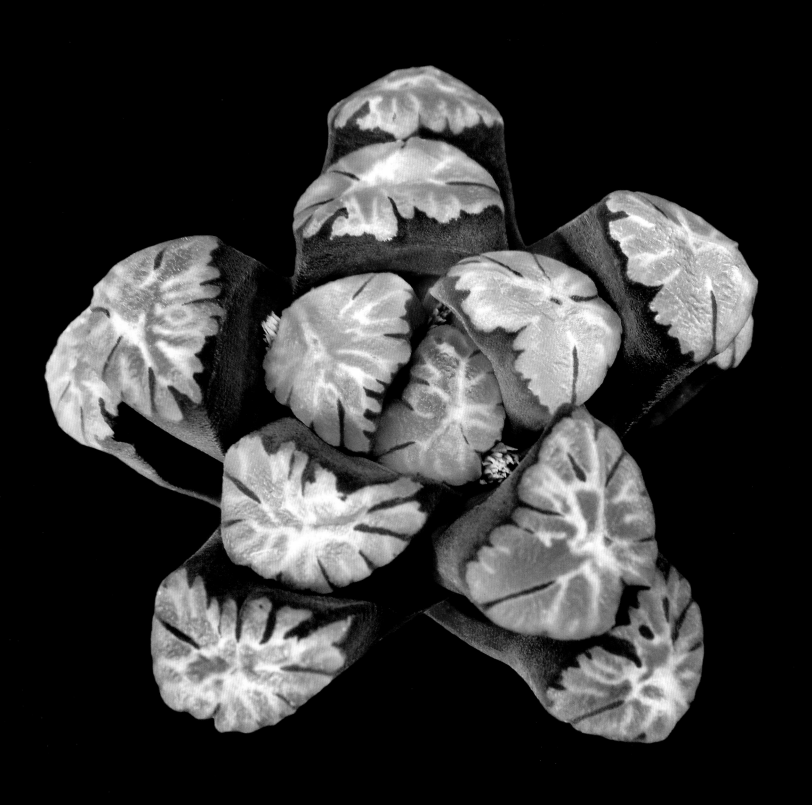

紫肌大窗万象
Haworthia truncata var. *maughanii* cv.

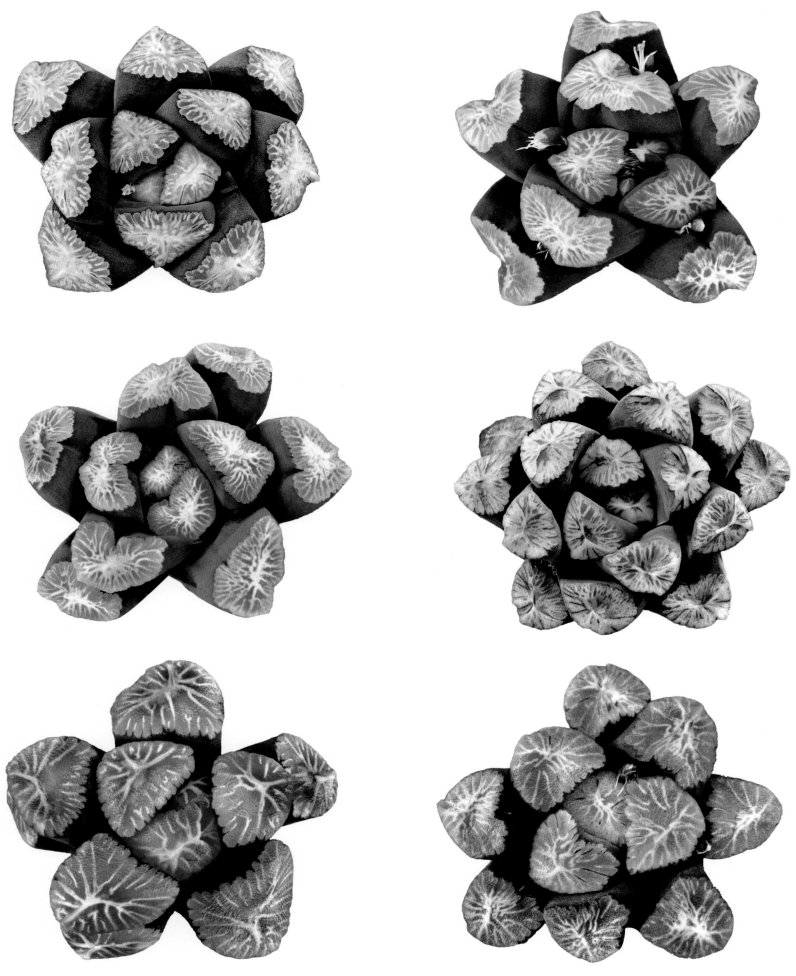

万象品种群
Haworthia truncata var. *maughanii* cvs.

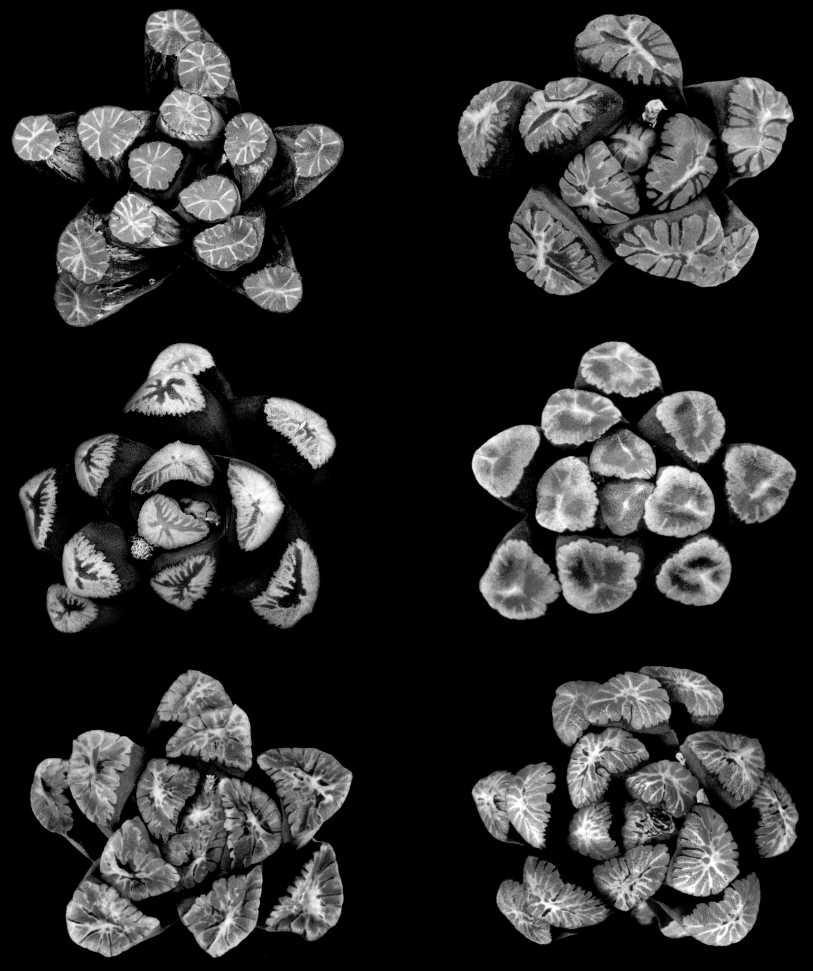

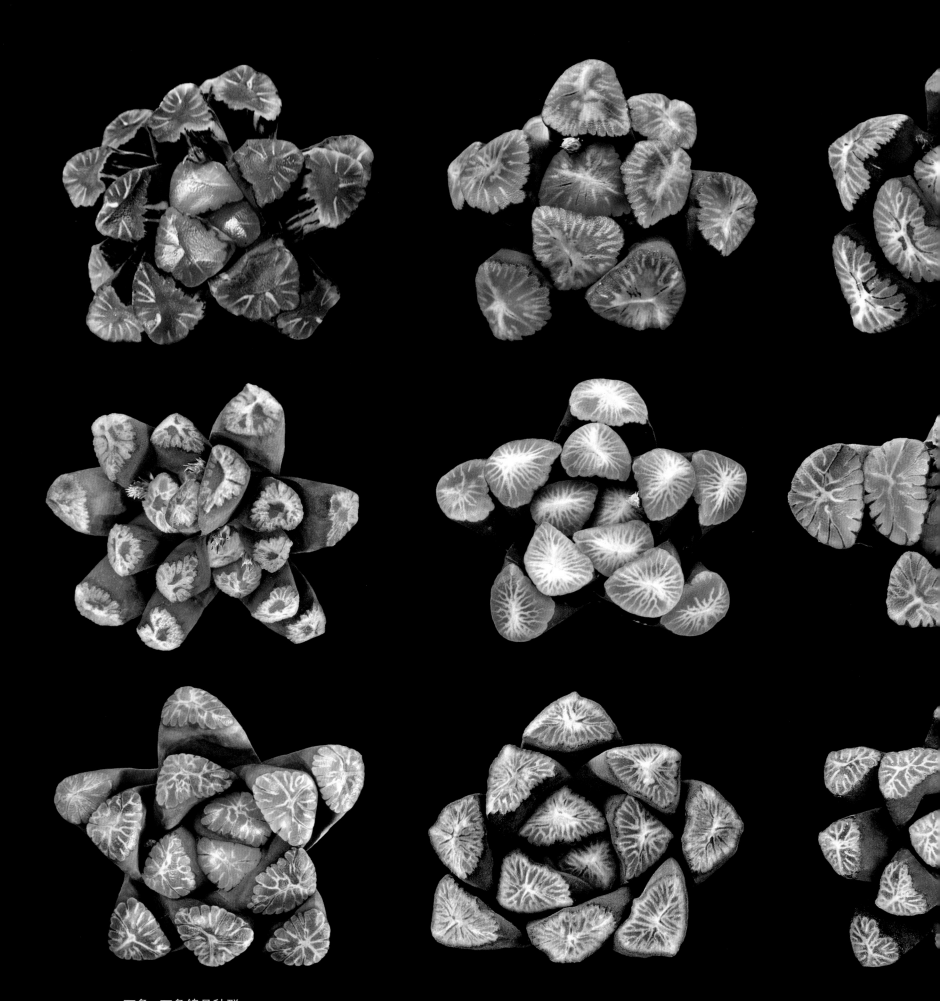

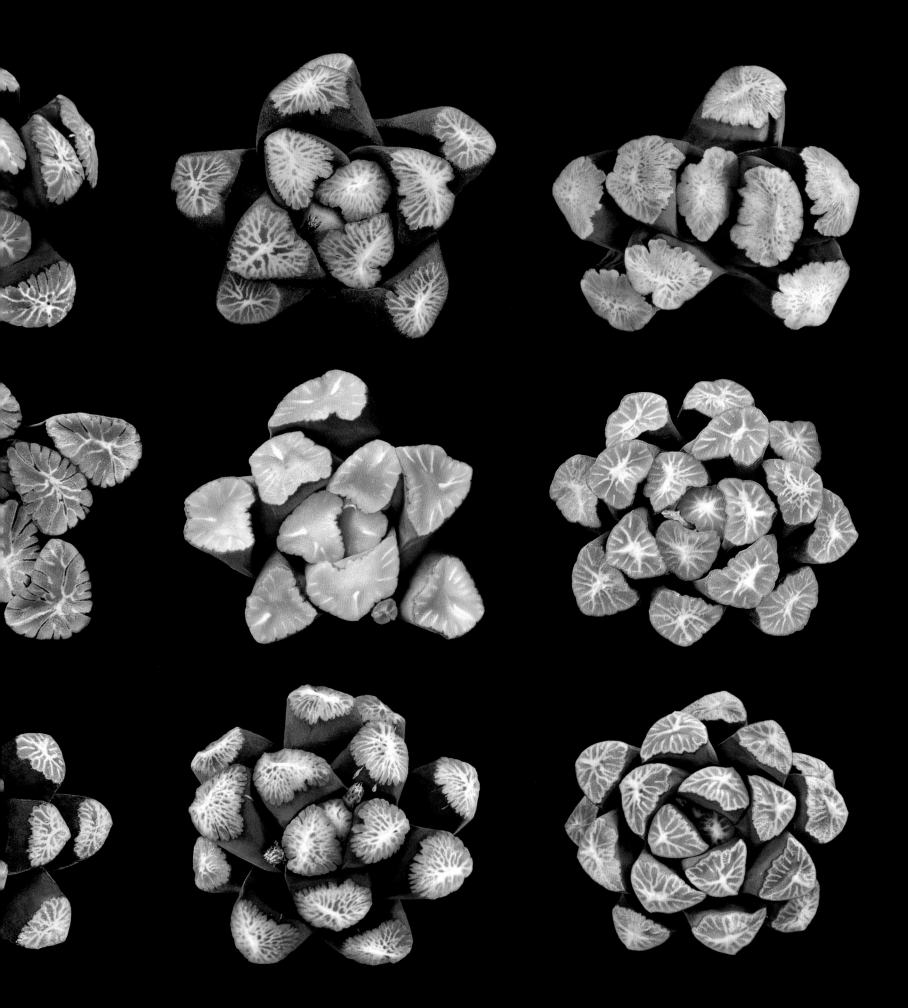

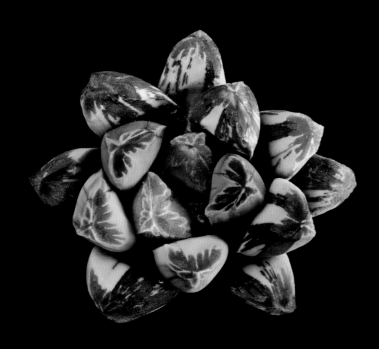

万象杂交品种
Haworthia truncata var. *maughanii* (hybrid)

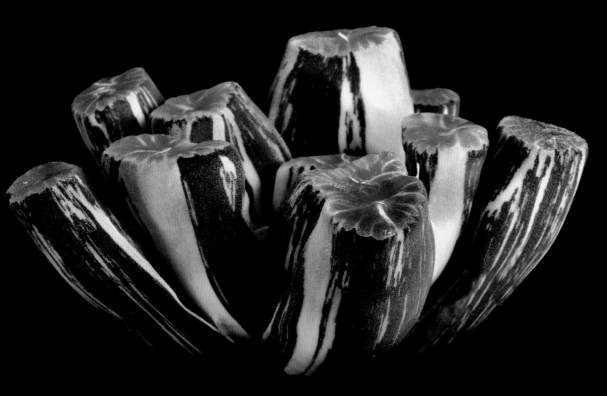

万象锦
Haworthia truncata var. *maughanii* 'Variegata'

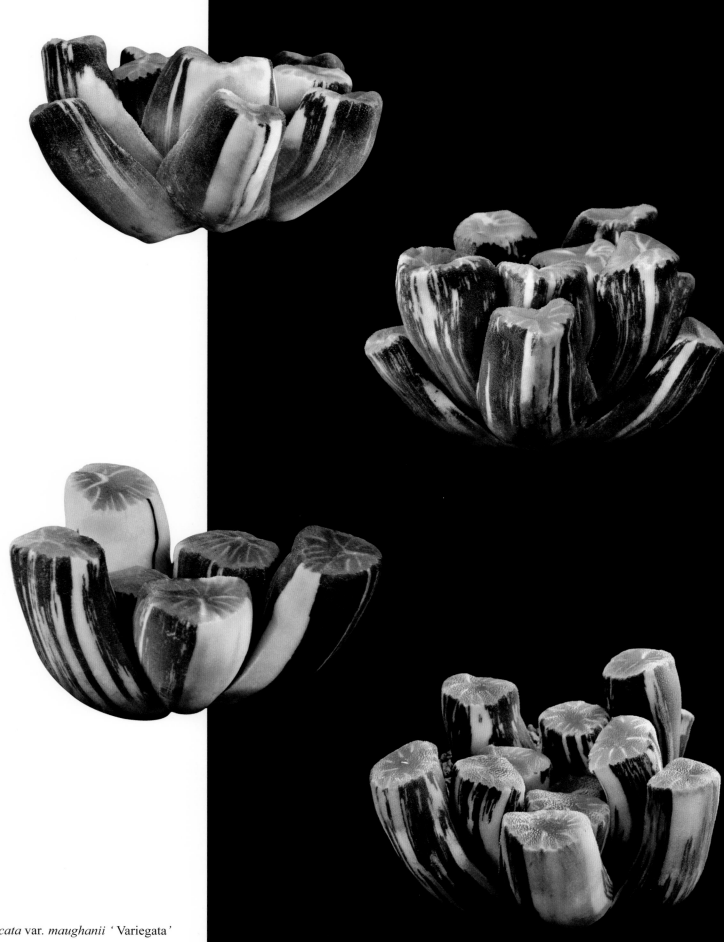

万象锦
Haworthia truncata var. *maughanii* ' Variegata '

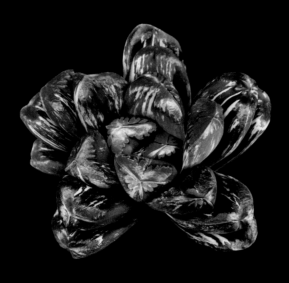

万象杂交品种
Haworthia truncata var. *maughanii* (hybrid)

万象锦
Haworthia truncata var. *maughanii* ' Variegata '

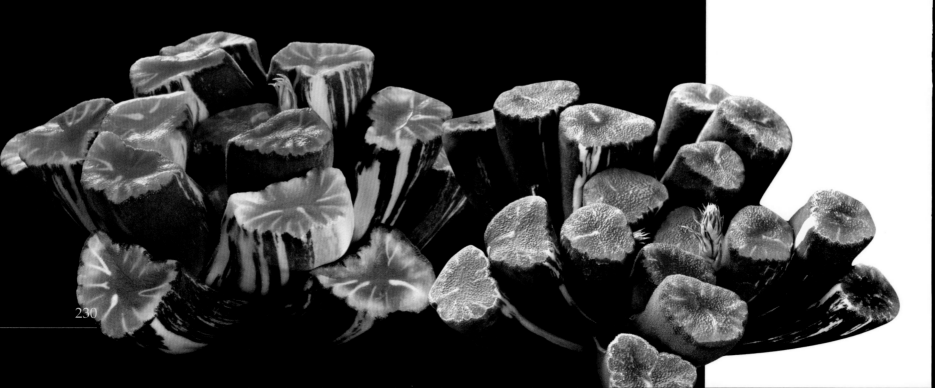

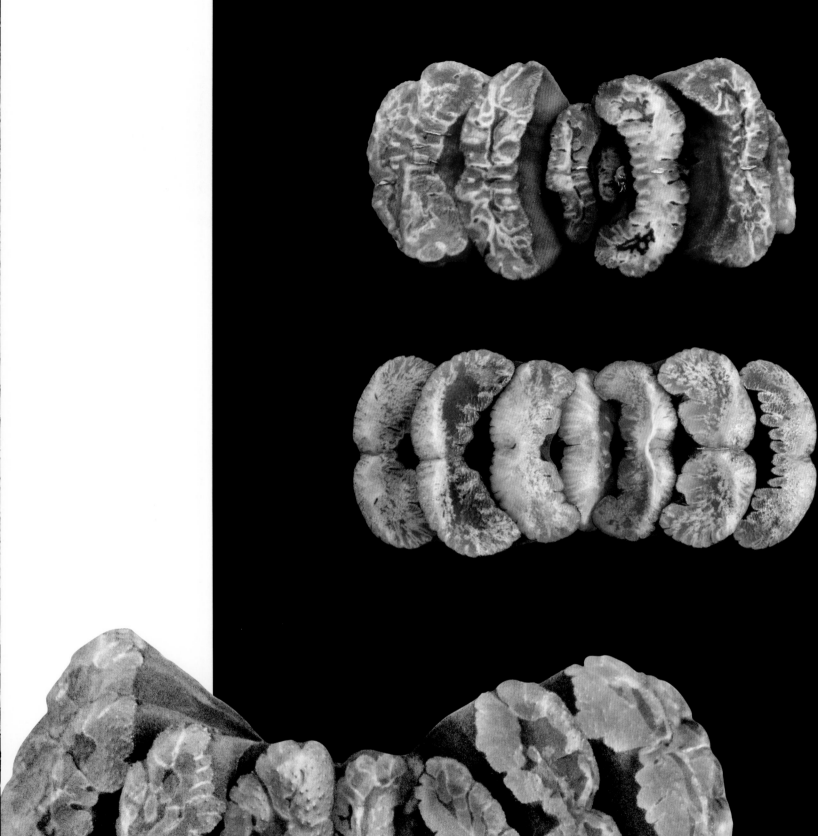

玉扇品种群
Haworthia truncata cvs.

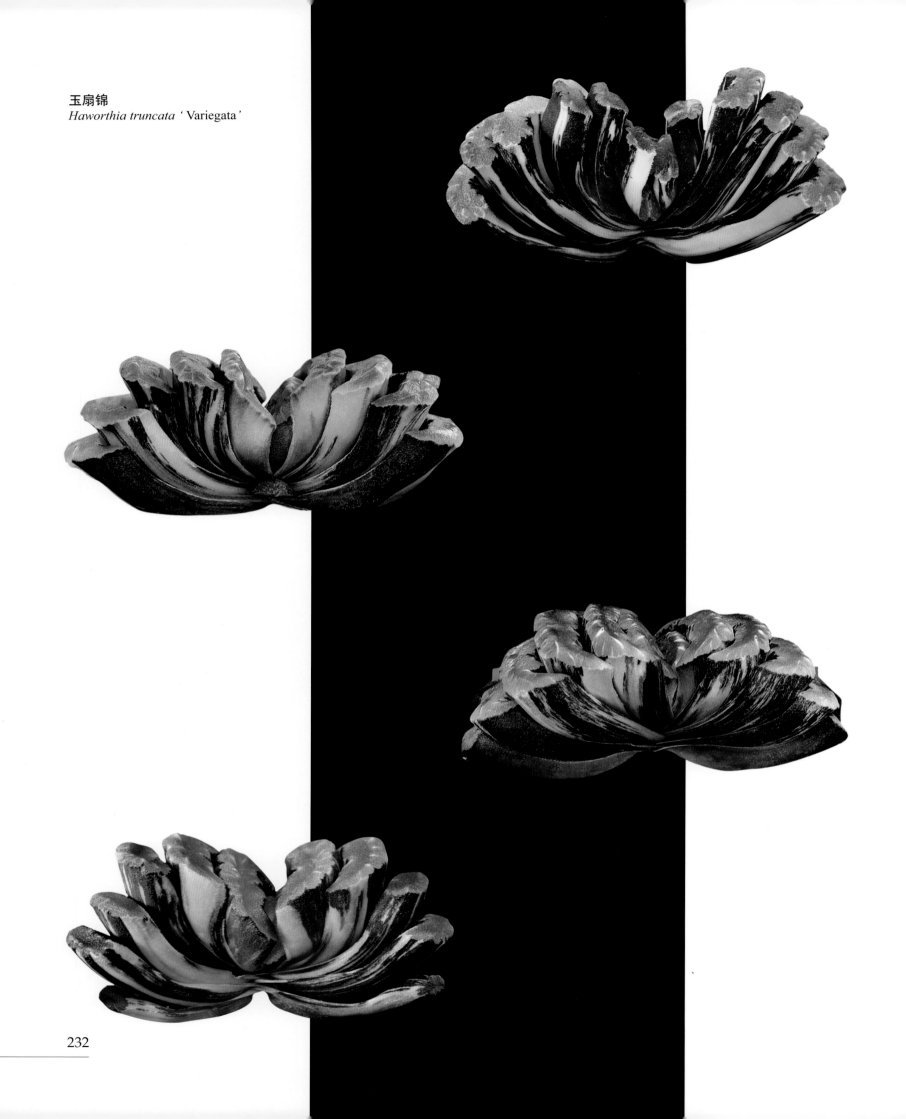

玉扇锦
Haworthia truncata ‘Variegata’

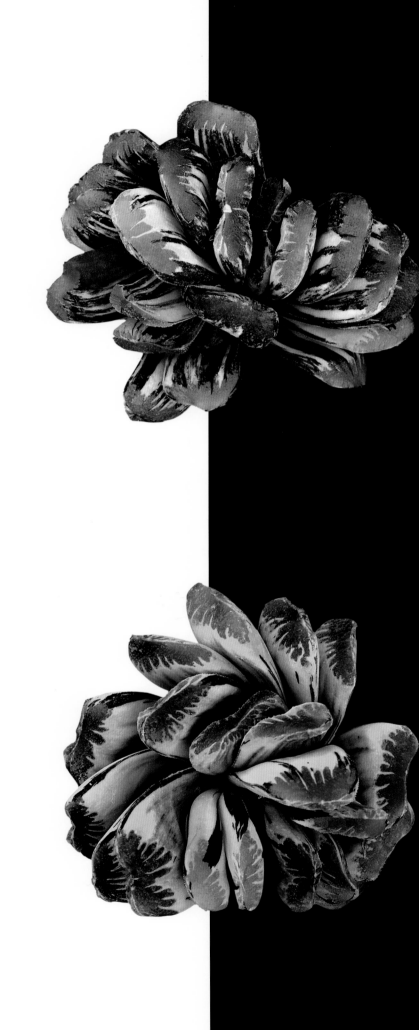

静鼓锦
Haworthia truncata 'Seikonishiki'

玉扇品种群
Haworthia truncata cvs.

玉扇品种群
Haworthia truncata cvs.

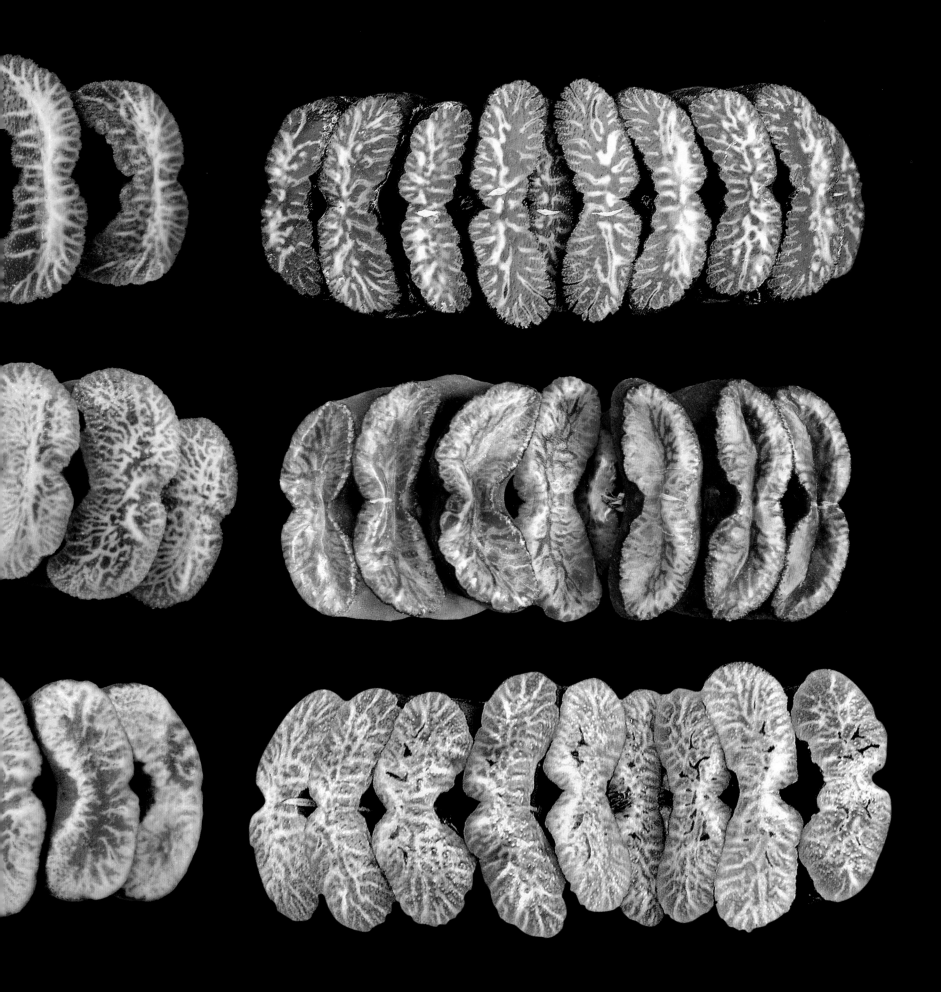

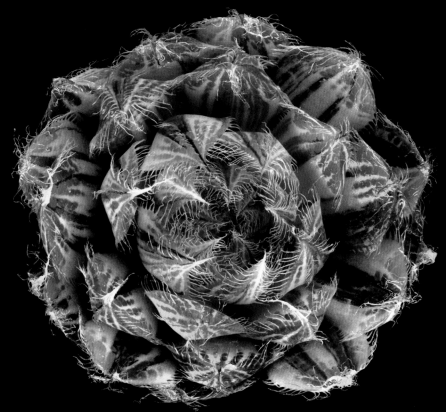

春舞之宴锦
Haworthia bolusii var. *blackbeardiana* 'Variegata'

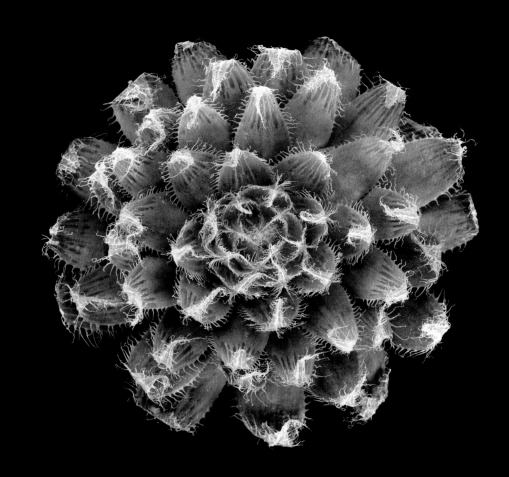

曲水之扇
Haworthia semiviva

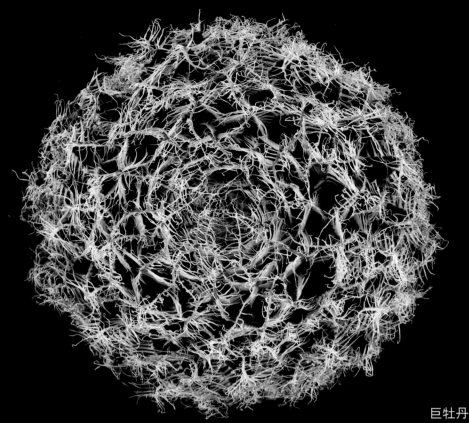

巨牡丹
Haworthia arachnoidea var. *setata*

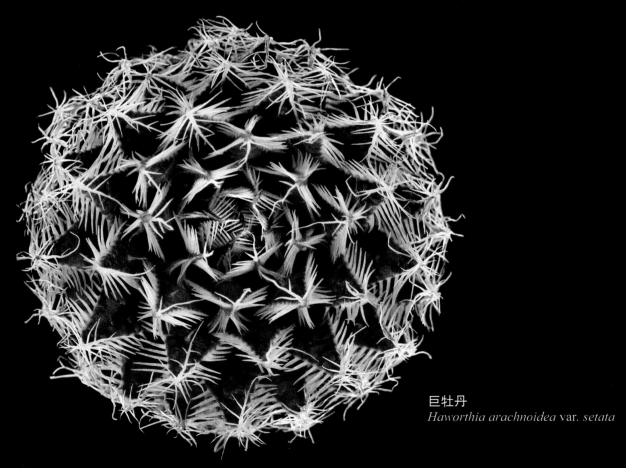

巨牡丹
Haworthia arachnoidea var. *setata*

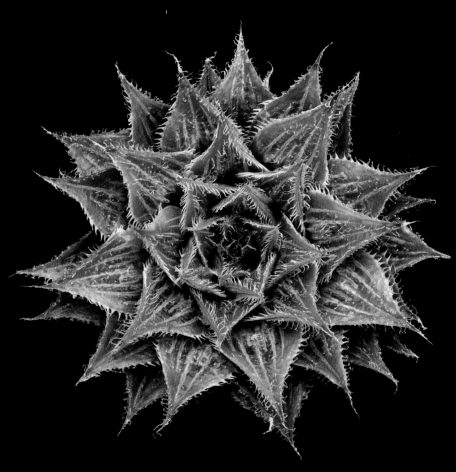

美白绫
Haworthia ' Bihakuro '

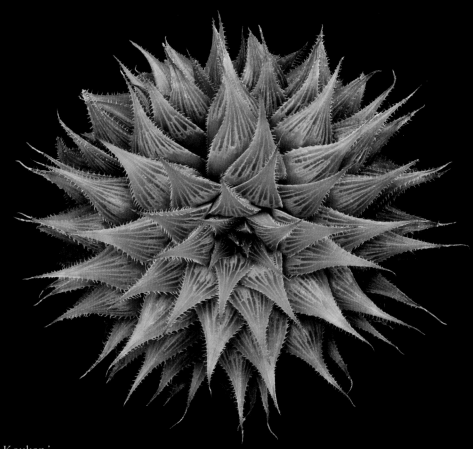

皇冠
Haworthia ' Koukan '

琉璃殿锦
Haworthia limifolia 'Variegata'

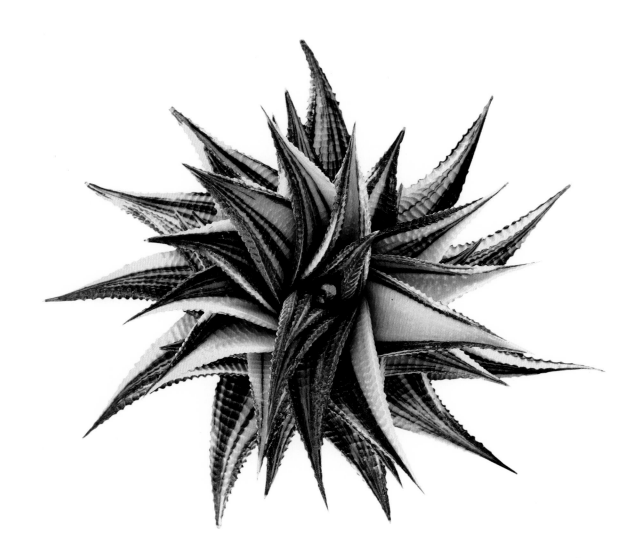

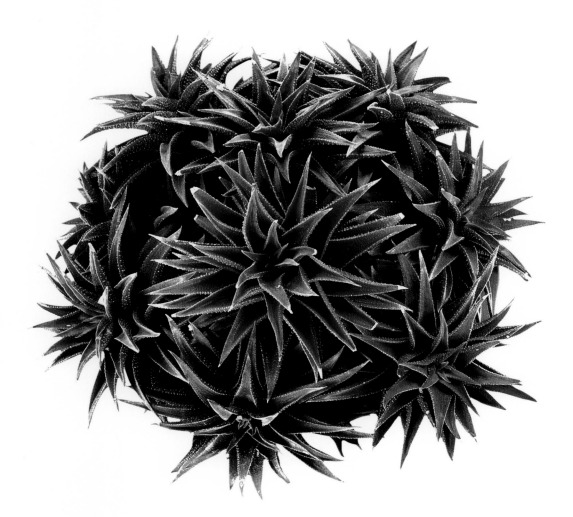

五十之塔
Haworthia viscosa

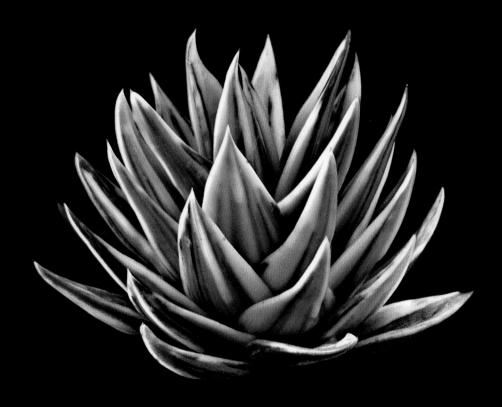

瑞鹤锦
Haworthia marginata 'Variegata'

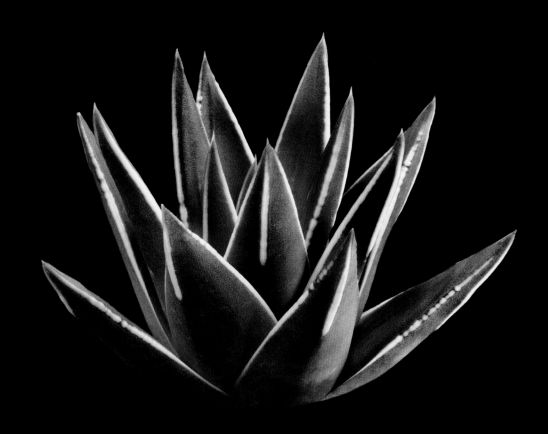

白摺鹤
Haworthia marginata

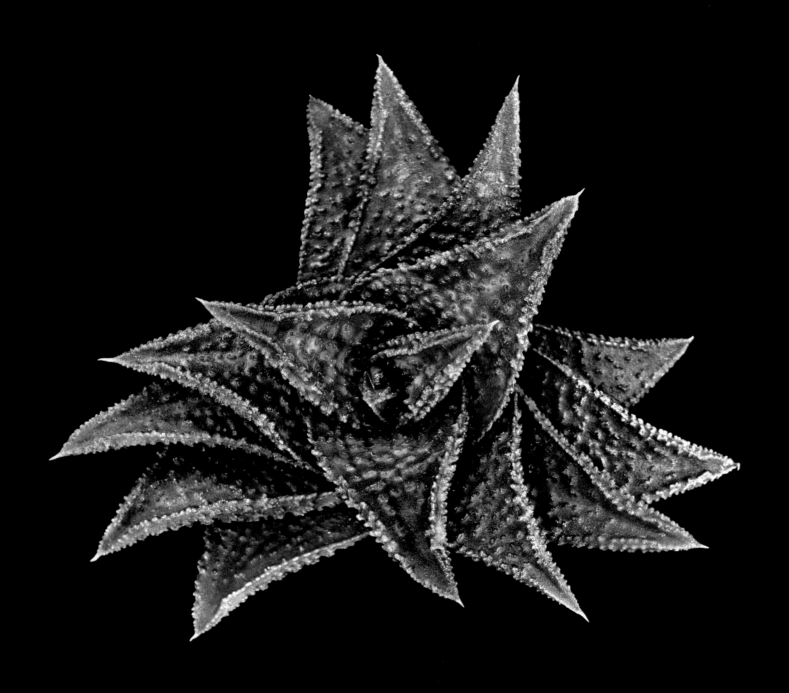

鬼瓦
Haworthia 'Onigawara'

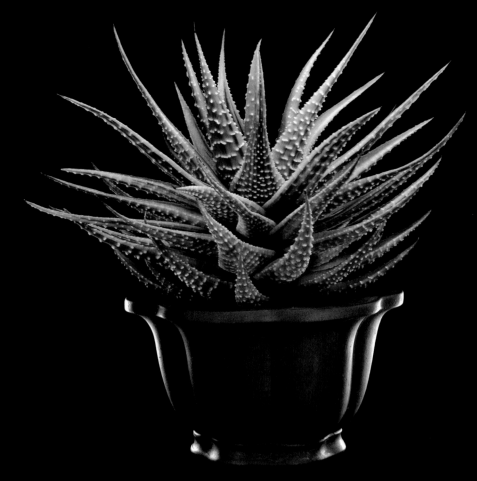

金城
Haworthia 'Golden City'

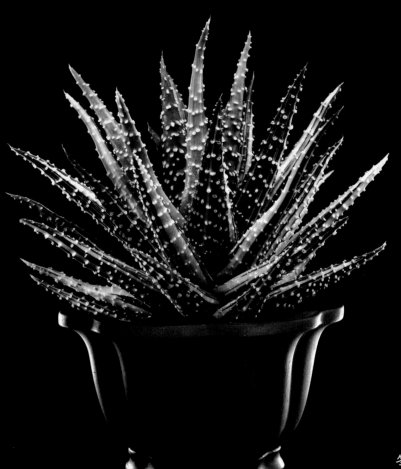

冬之星座锦
Haworthia maxima 'Variegata'

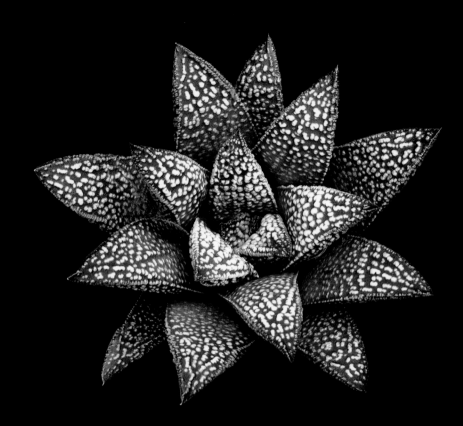

天涯
Haworthia 'Tengai'

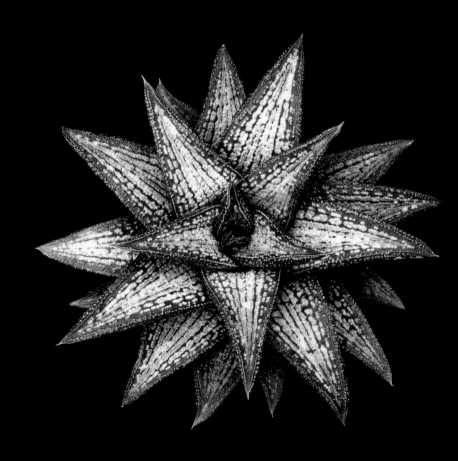

锦带桥
Haworthia 'Kintai-kyou'

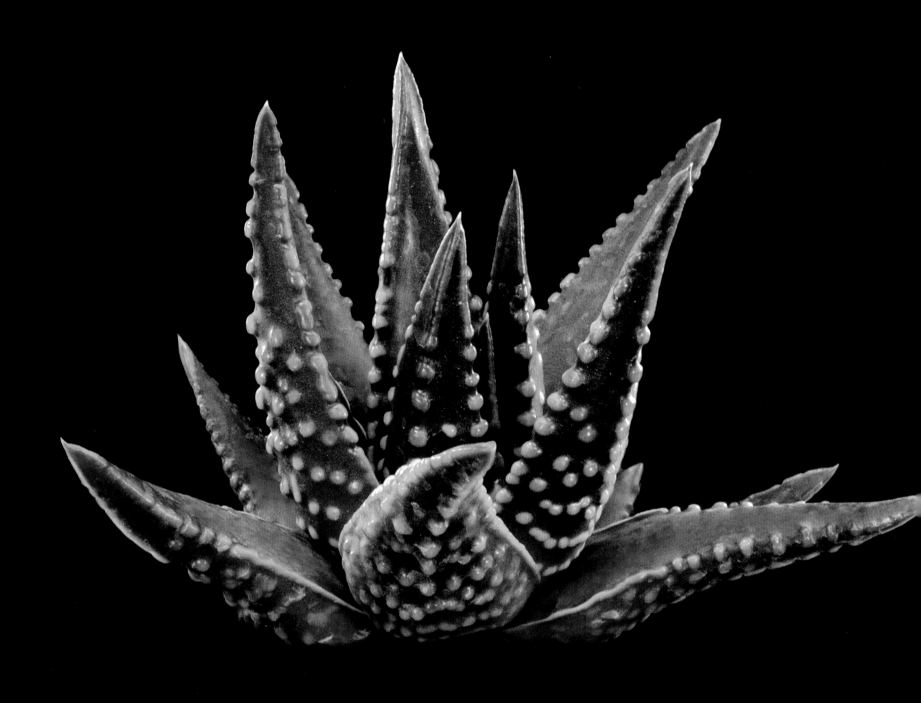

龙珠
Haworthia 'Long Zhu'

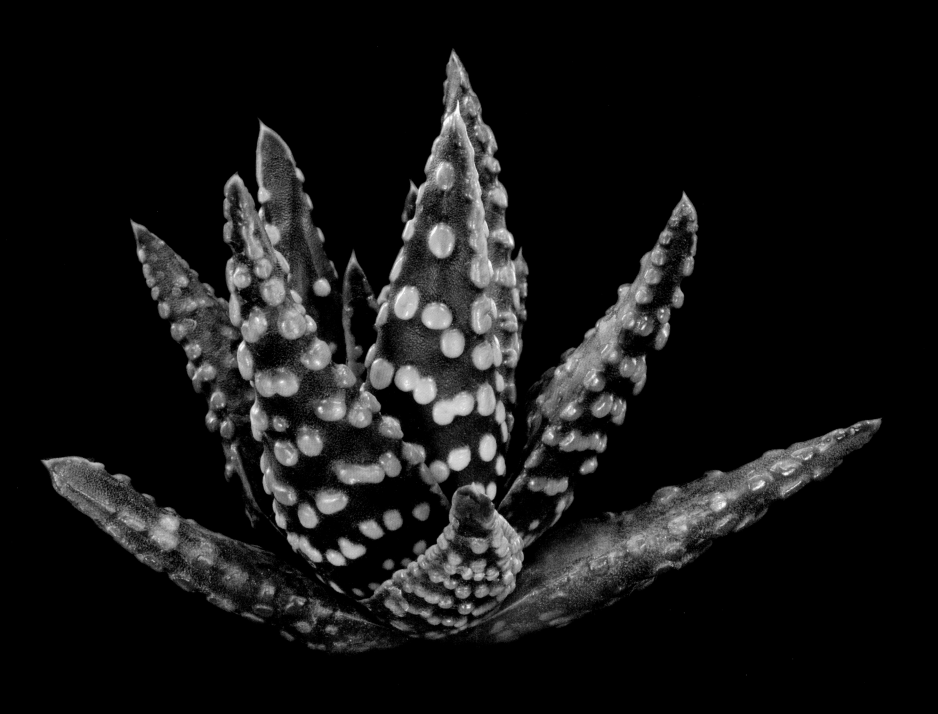

天珠
Haworthia ‘Tian Zhu’

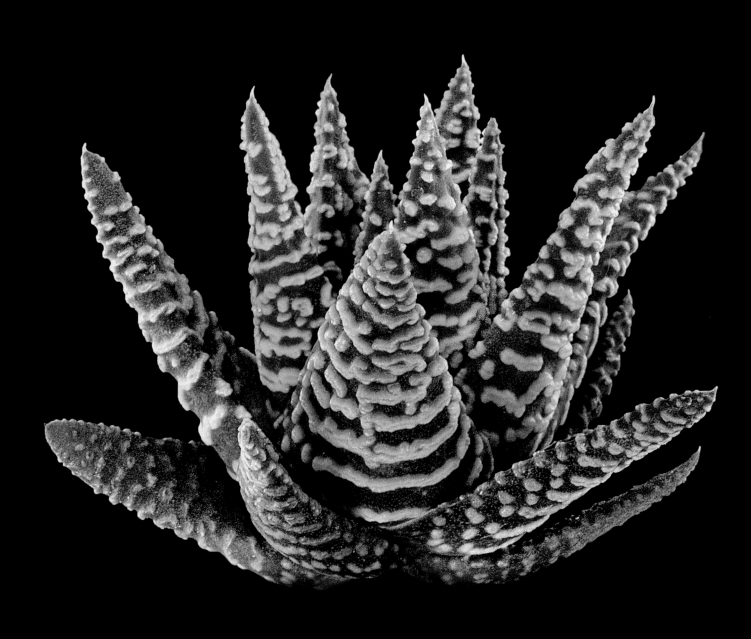

嵘岩
Haworthia ' Rong Yan '

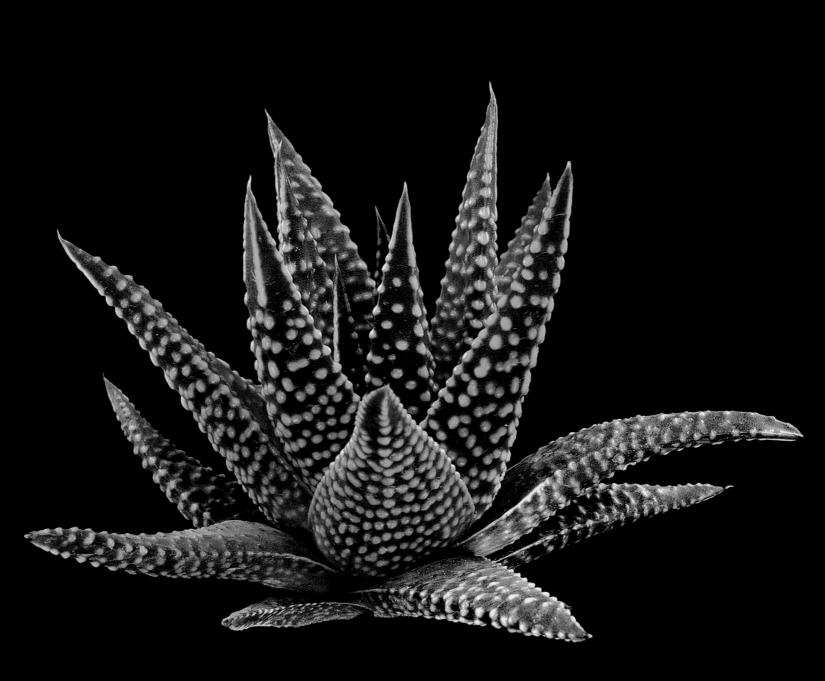

星瑞鶴
Haworthia marginata 'Hoshizuikaku'

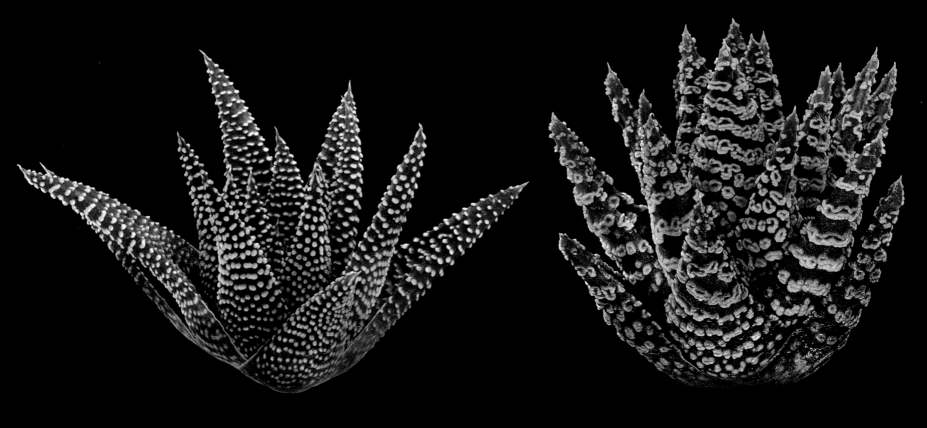

米尼玛
Haworthia minima

云母
Haworthia pumila ' Yun Mu '

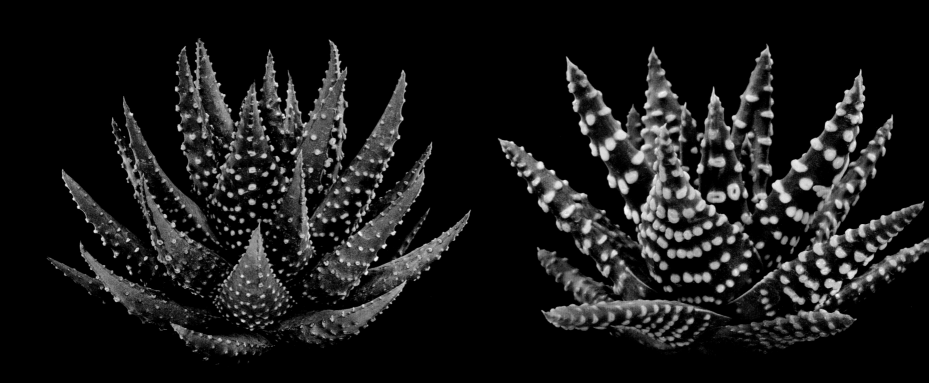

点纹冬之星座
Haworthia pumila

环纹冬之星座
Haworthia maxima

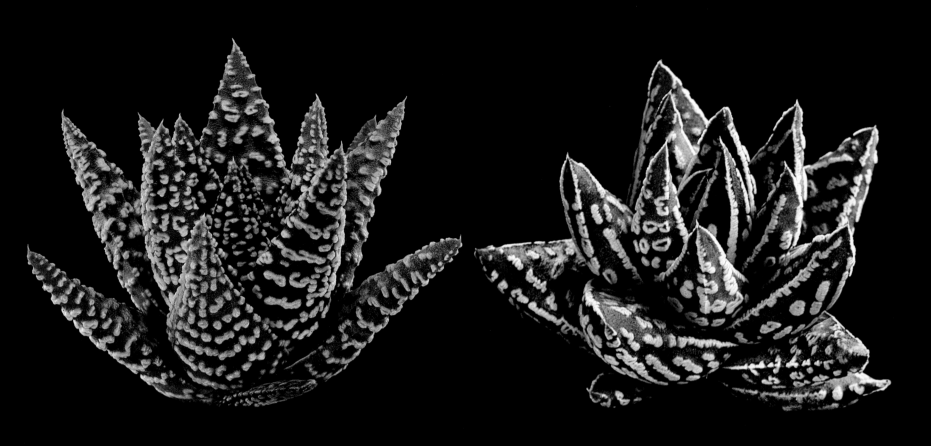

云石
Haworthia pumila ‘Yun Shi’

太守之座
Haworthia pumila ‘Tai Shou’

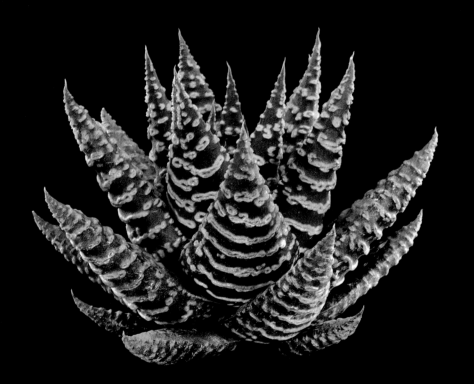

红狮星座
Haworthia pumila ‘Hong Shi’

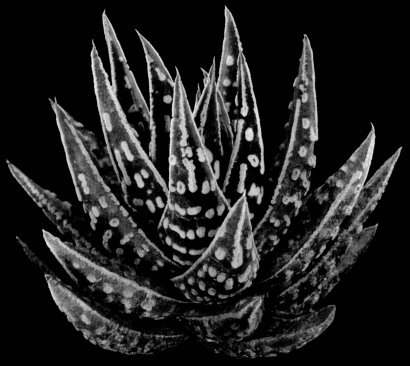

天守之座
Haworthia pumila ‘Tian Shou’

251

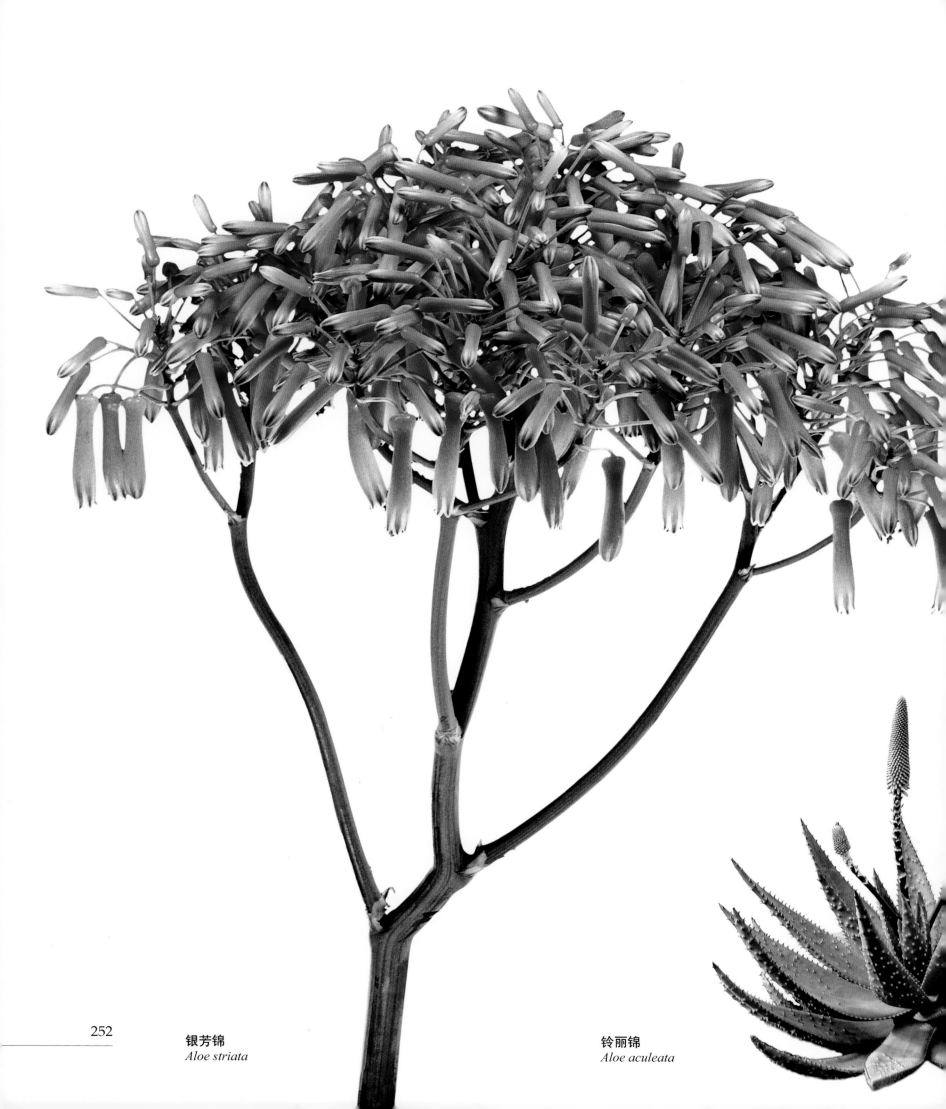

银芳锦
Aloe striata

铃丽锦
Aloe aculeata

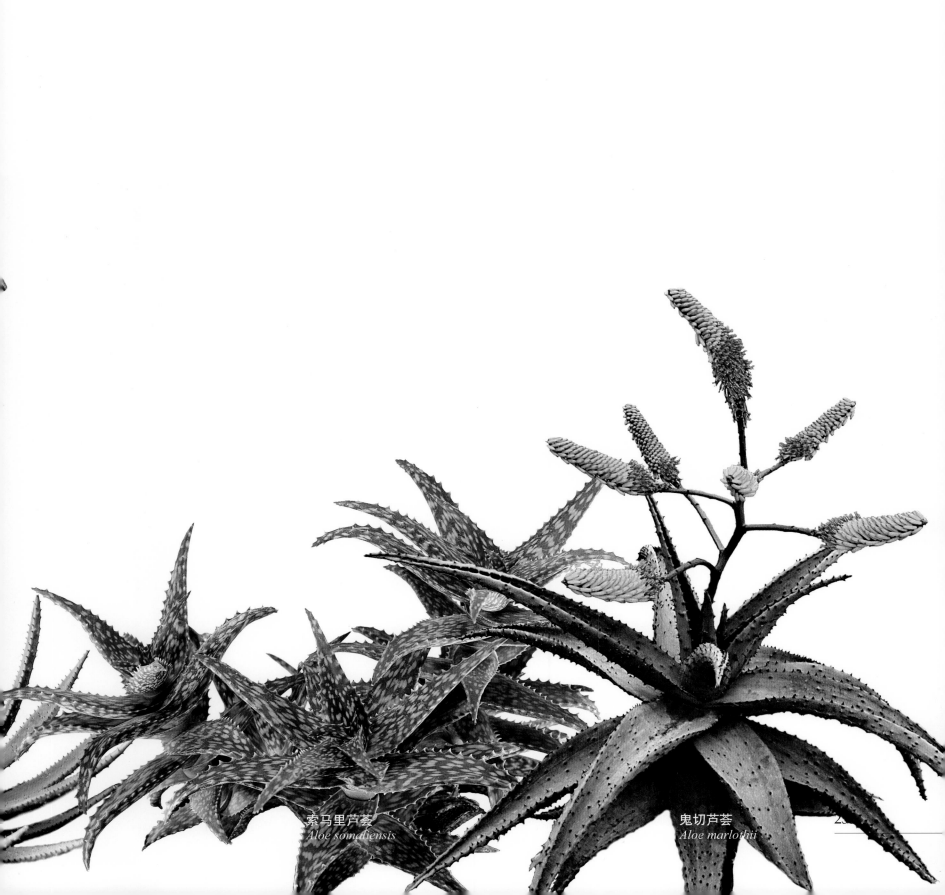

索马里芦荟
Aloe somaliensis

鬼切芦荟
Aloe marlothii

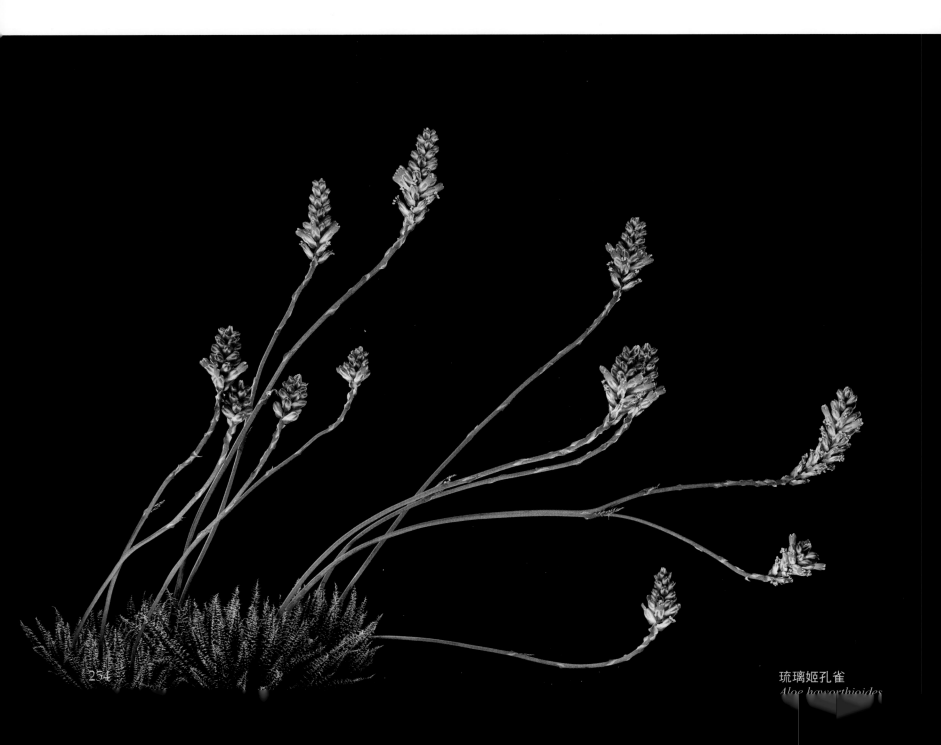

琉璃姫孔雀
Aloe haworthioides

百鬼夜行
Aloe longistyla

新卡塔娜芦荟
Aloe sinkatana

超雪芦荟
Aloe rauhii ‘Super Snow Flake’

黑魔殿
Aloe erinacea

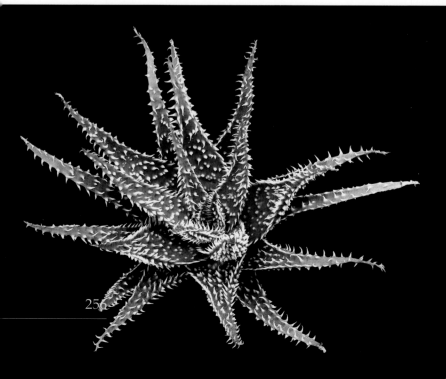

笛可孔雀
Aloe ‘Pepe’

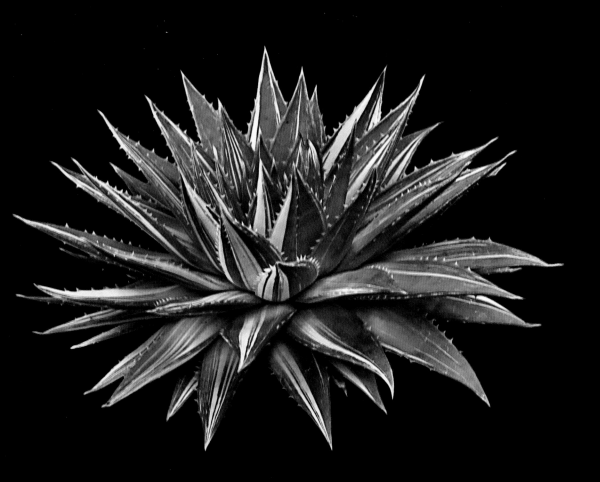

龙山锦
Aloe brevifolia 'Variegata'

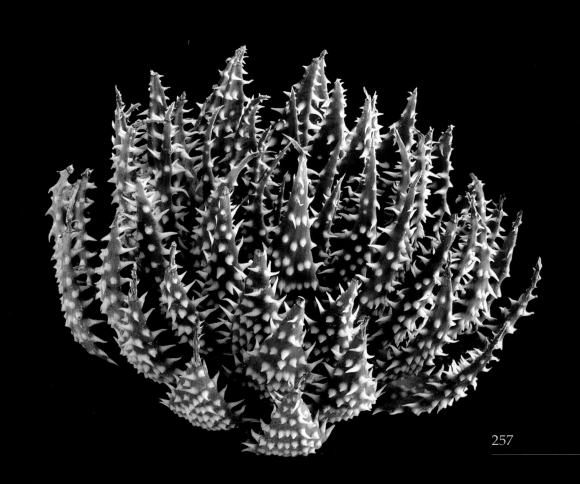

白磁盃
Aloe pratensis cv.

257

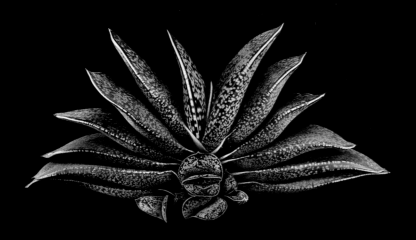

恐龙卧牛品种
Gasteria cv.

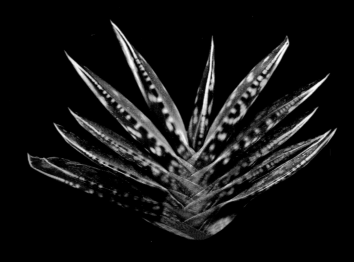

恐龙品种
Gasteria cv.

霸龙
Gasteria cvs.

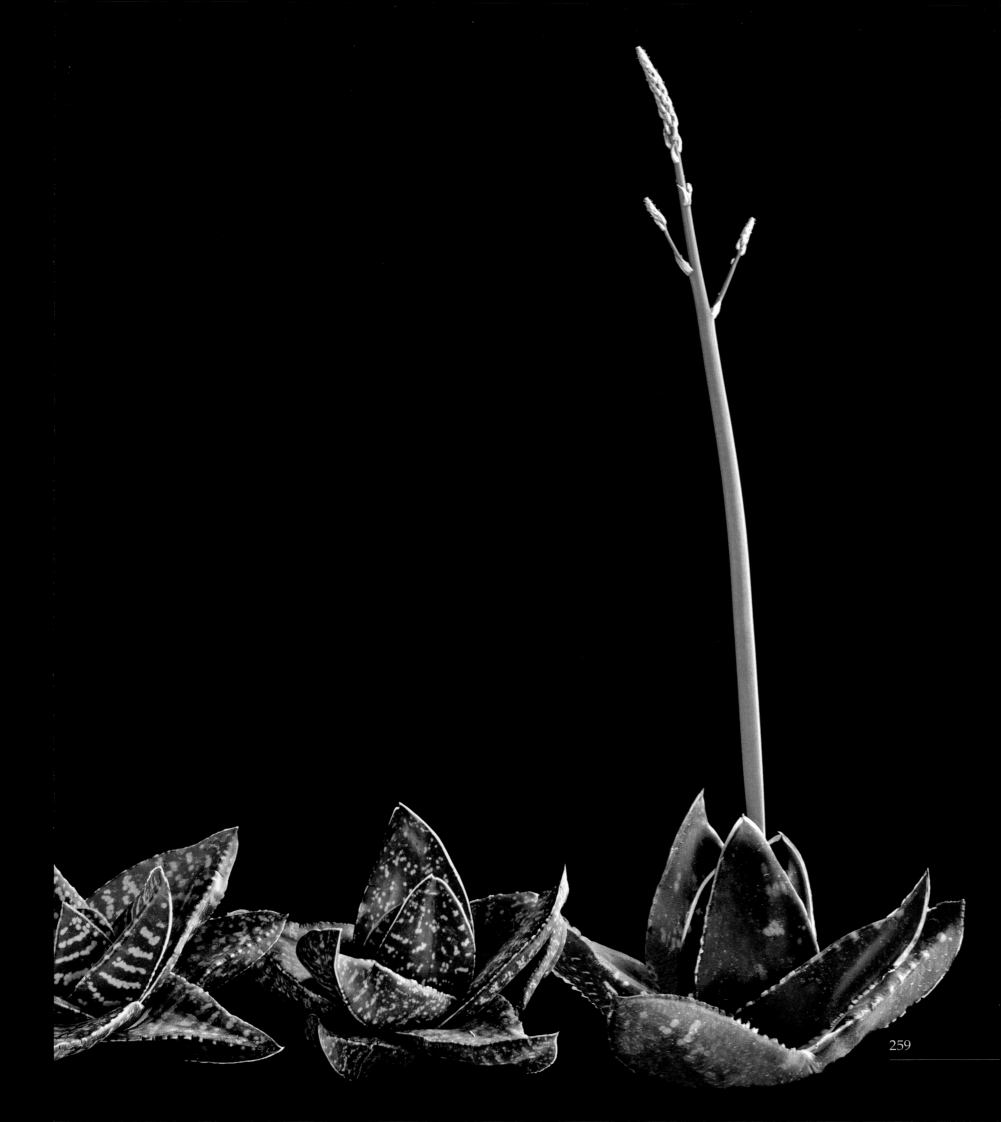

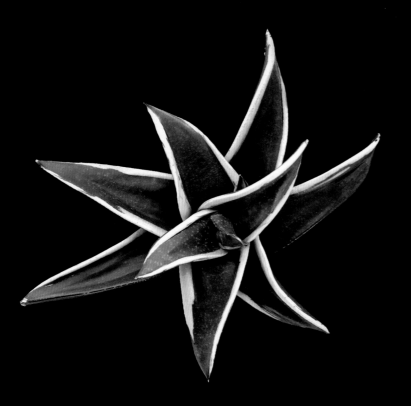

卧牛龙白覆轮
Gasteria × 'Gagyu-ryu-nishki'

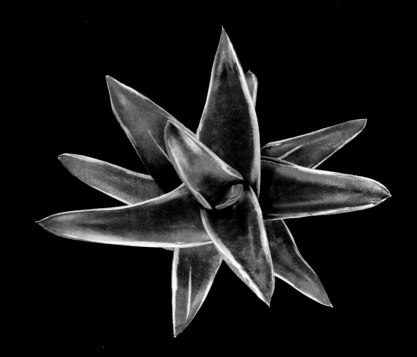

卧牛龙白覆轮
Gasteria × 'Gagyu-ryu-nishki'

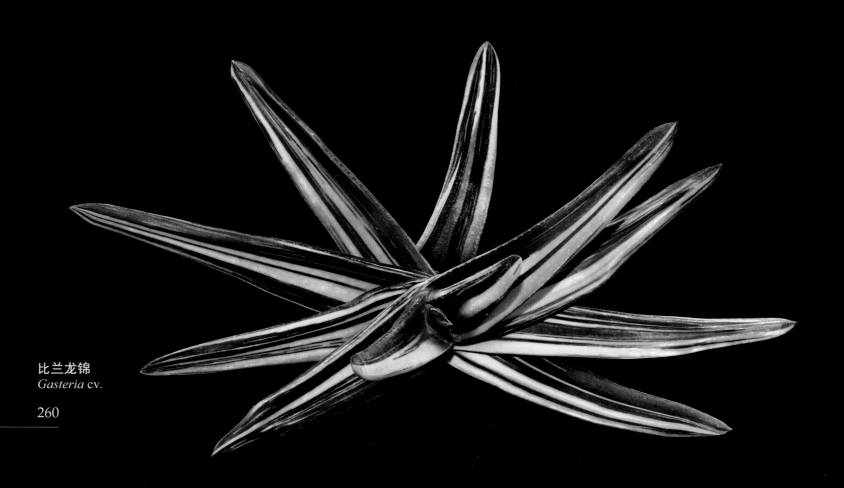

比兰龙锦
Gasteria cv.

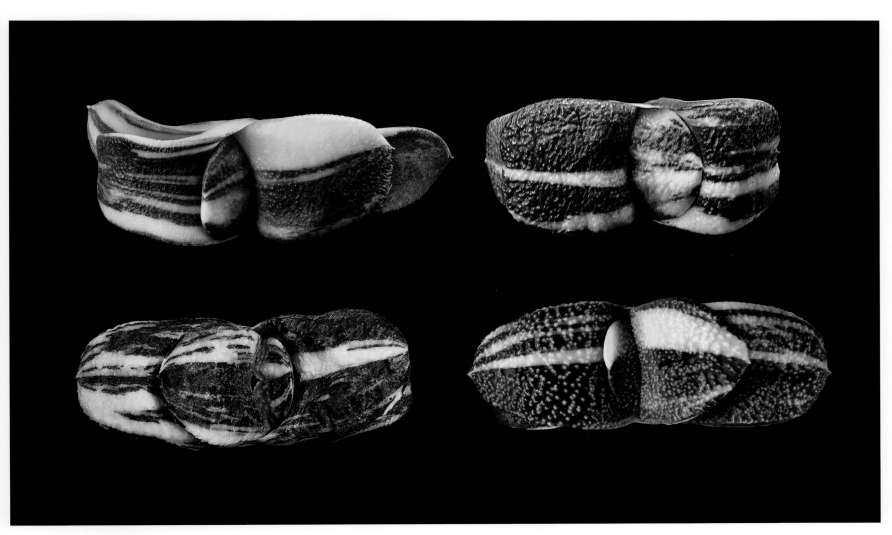

卧牛锦
Gasteria nitida var. *armstrongii*
'Variegata'

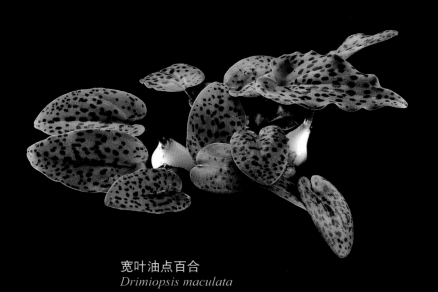

宽叶油点百合
Drimiopsis maculata

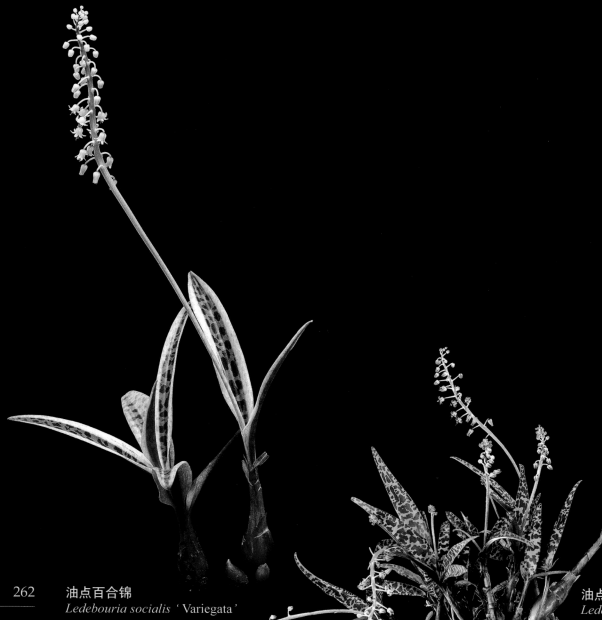

　油点百合锦
Ledebouria socialis ‘Variegata’

油点百合
Ledebouria socialis

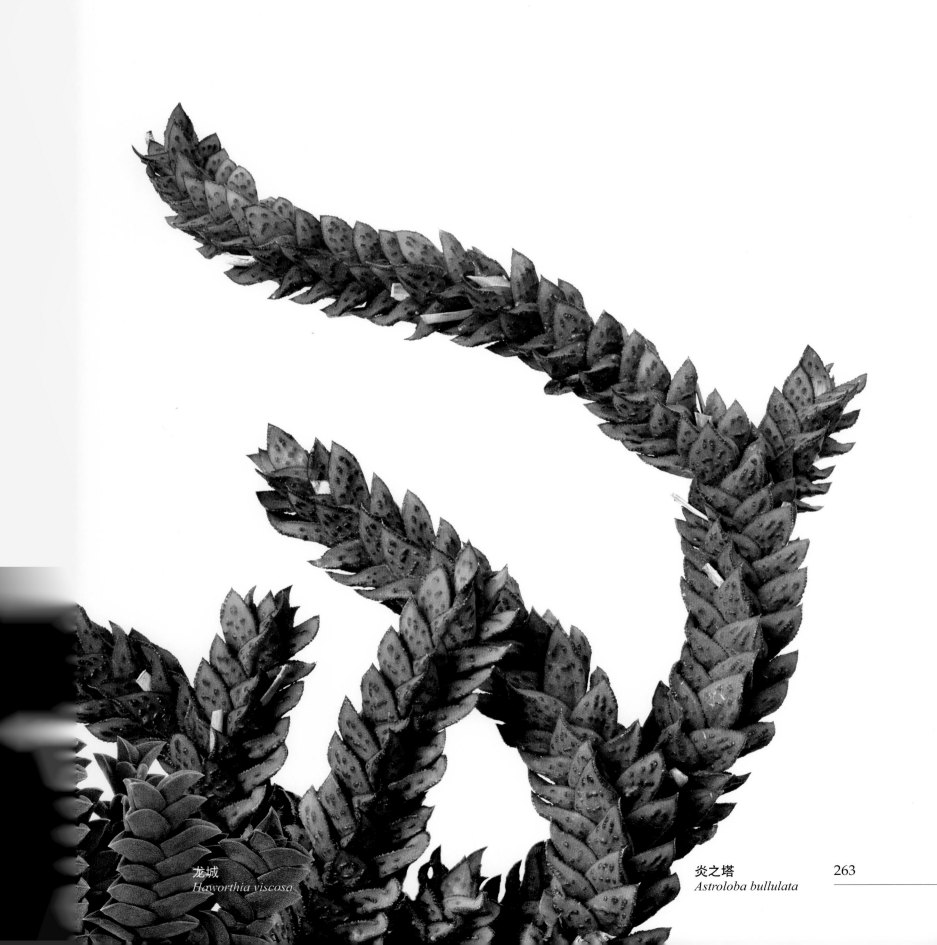

龙城
Haworthia viscosa

炎之塔
Astroloba bullulata

大戟篇
Euphorbiaceae

大戟科多肉植物属于双子叶植物，主要生长在热带和亚热带地区，全球分布广泛。大戟属是该科中最大的一属，其中多肉植物种类也最多。为肉质草本或灌木，有白色乳汁。花无花被，生于聚伞花序上。

Succulents of Euphorbiaceae are a family of dicotyledon plants which mainly grow in the tropics and subtropics around the world. *Euphorbia* is the most varied genus of Euphorbiaceae and has the most diversified succulents of the family. These plants are succulent herbs or shrubs and produce milky sap. They grow flowers without tepals on cyathia.

理氏麒麟
Euphorbia richardsiae

鬼栖木
Euphorbia hamata

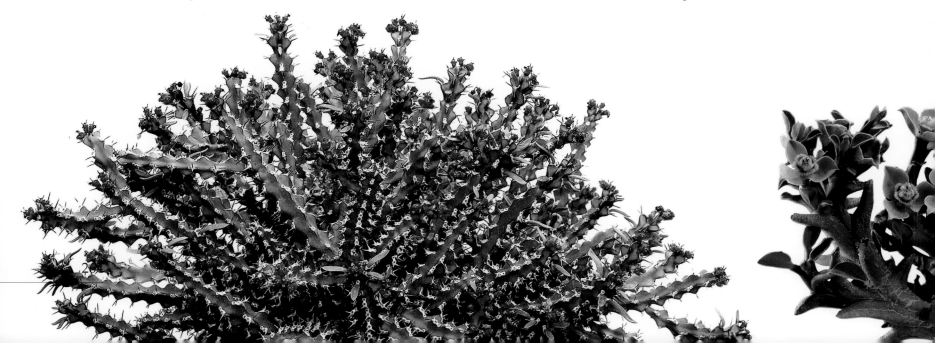

菲氏麒麟
Euphorbia phillipsiae

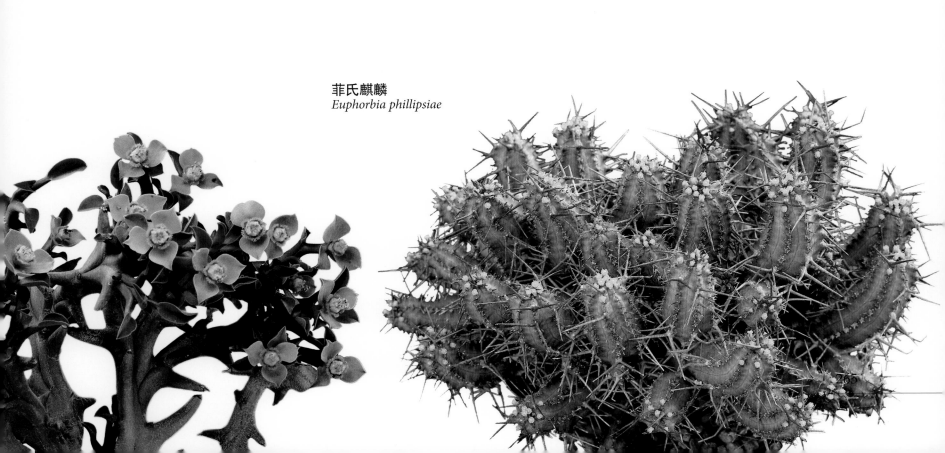

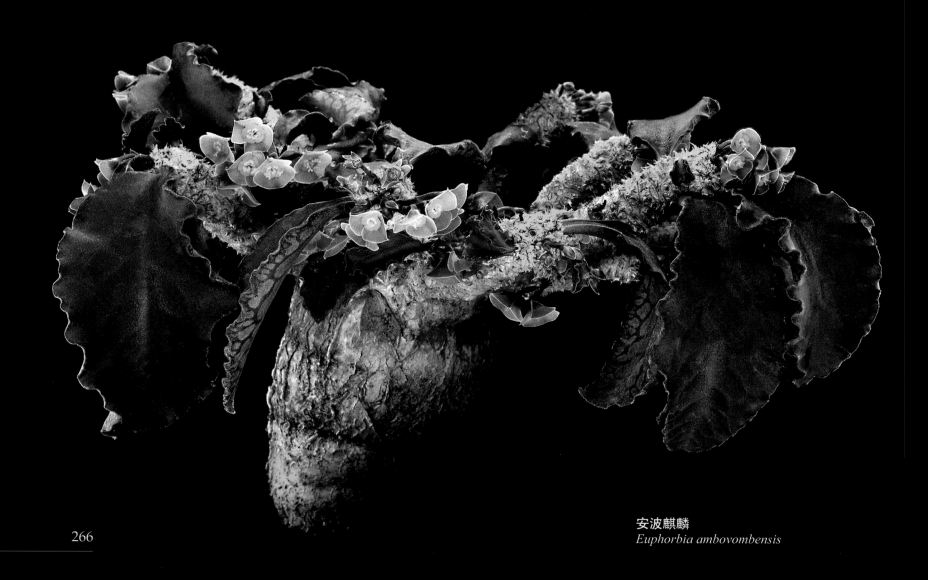

安波麒麟
Euphorbia ambovombensis

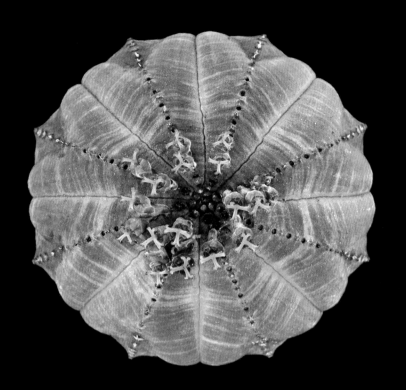

布纹球
Euphorbia obesa

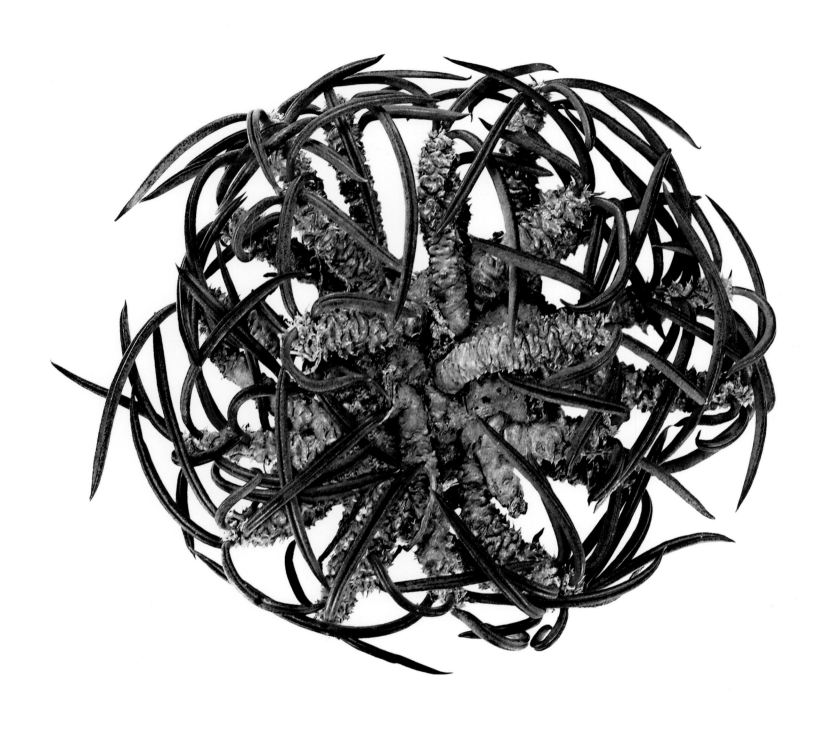

筒叶麒麟
Euphorbia cylindrifolia

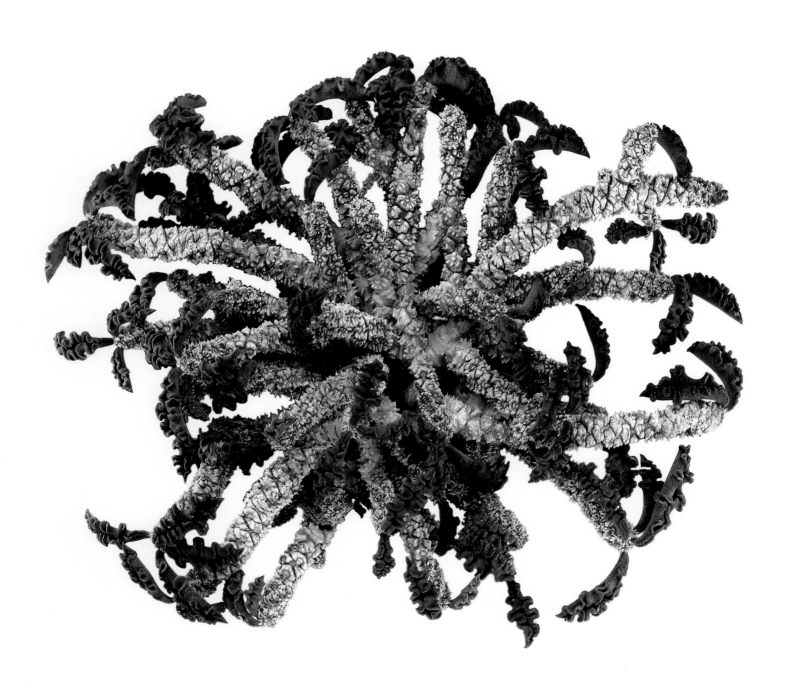

皱叶麒麟
Euphorbia decaryi

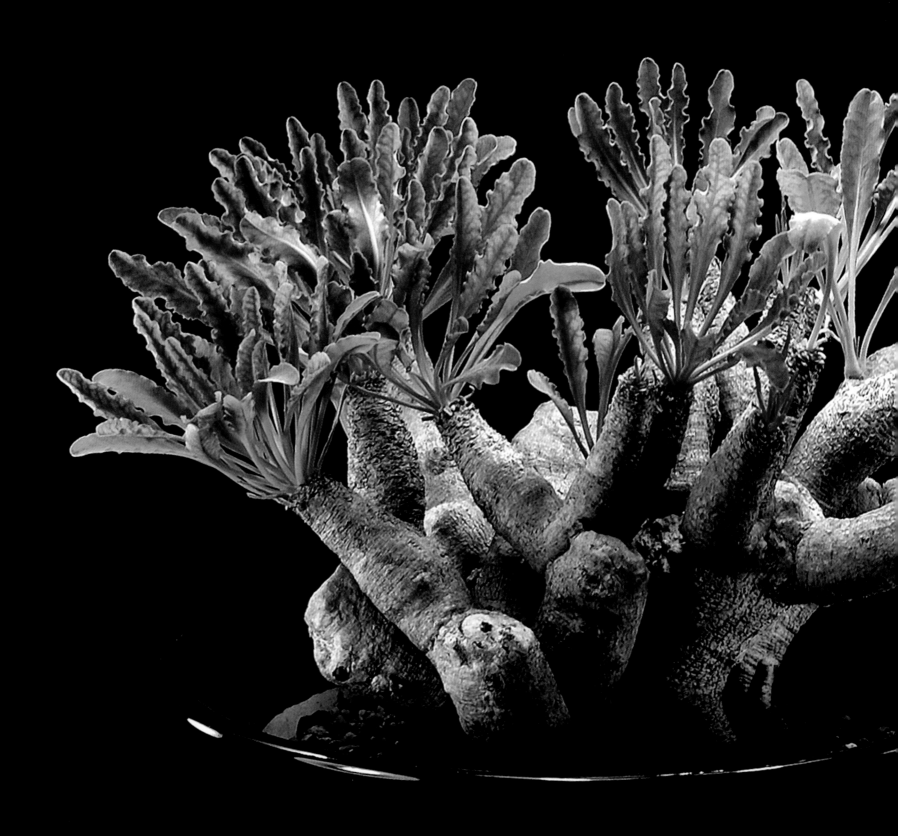

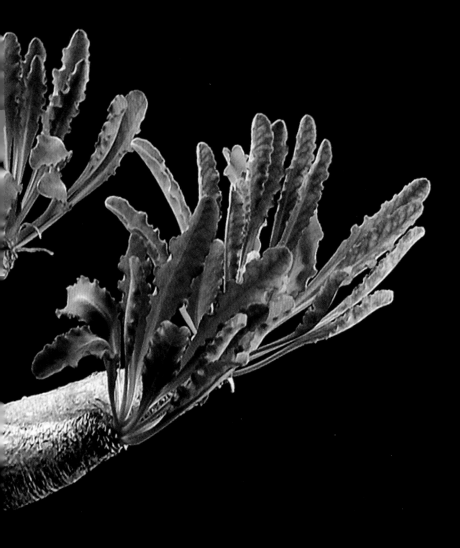

波涛麒麟
Euphorbia crispa

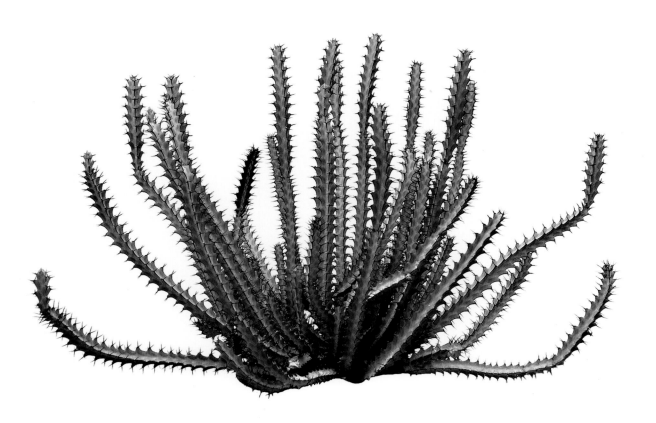

绿威麒麟
Euphorbia greenwayi

白衣魁伟玉
Euphorbia horrida var. *noorsveldensis*

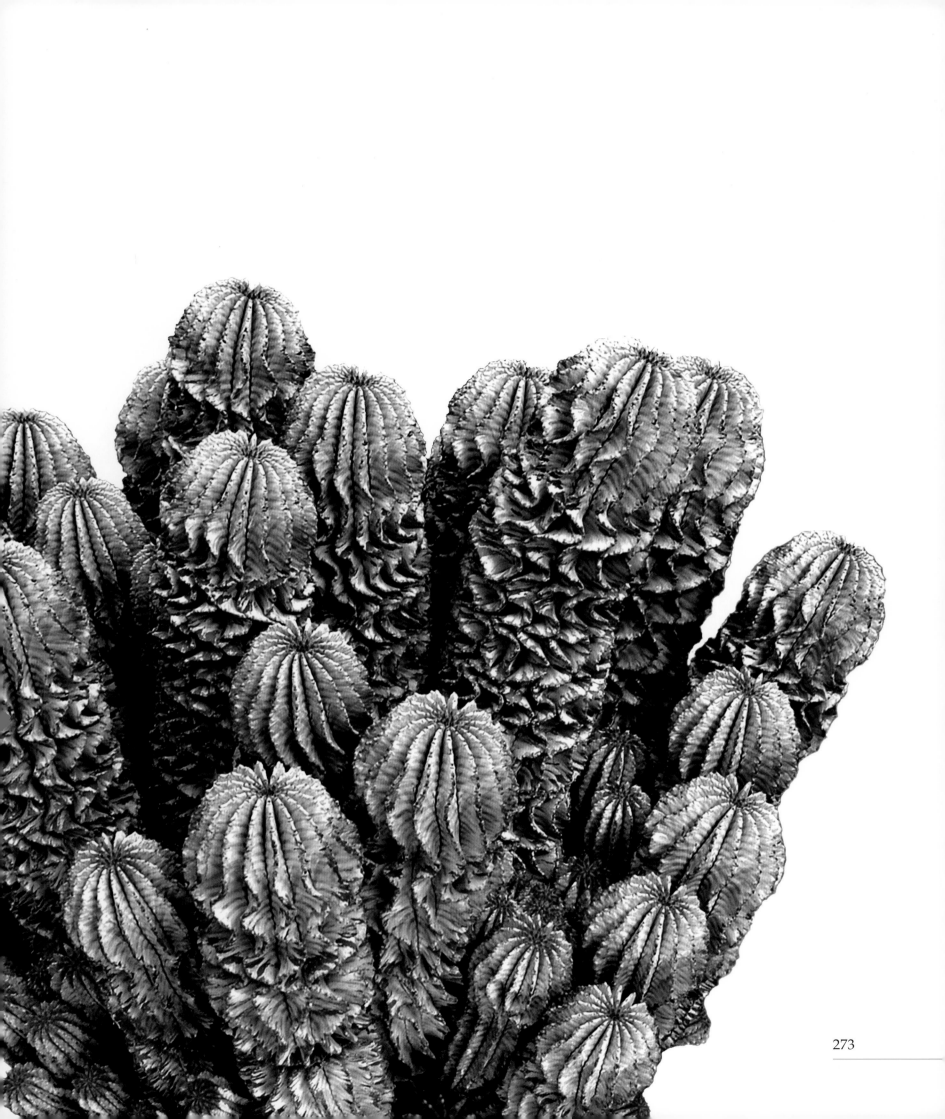

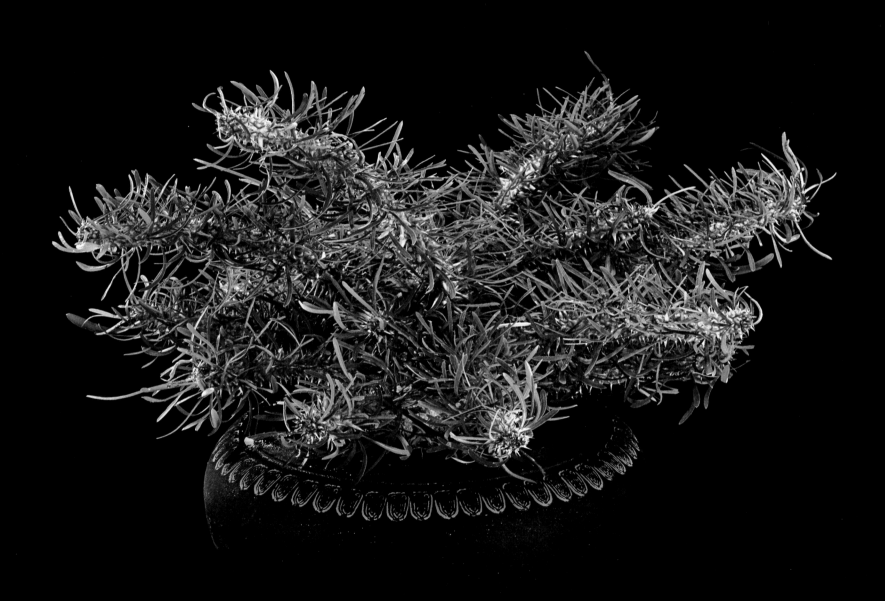

罗氏麒麟
Euphorbia rossii

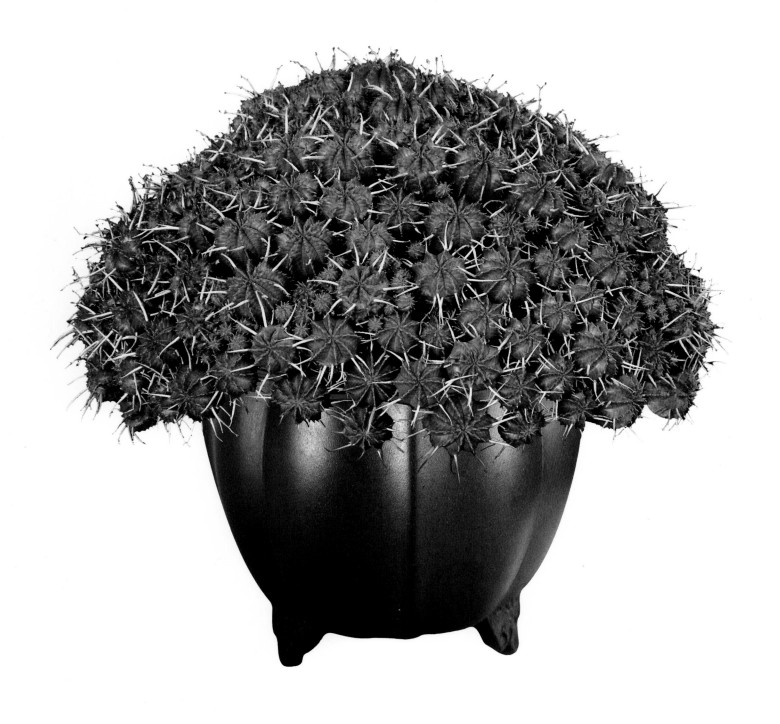

群青玉
Euphorbia meloformis ‘Prolifera’

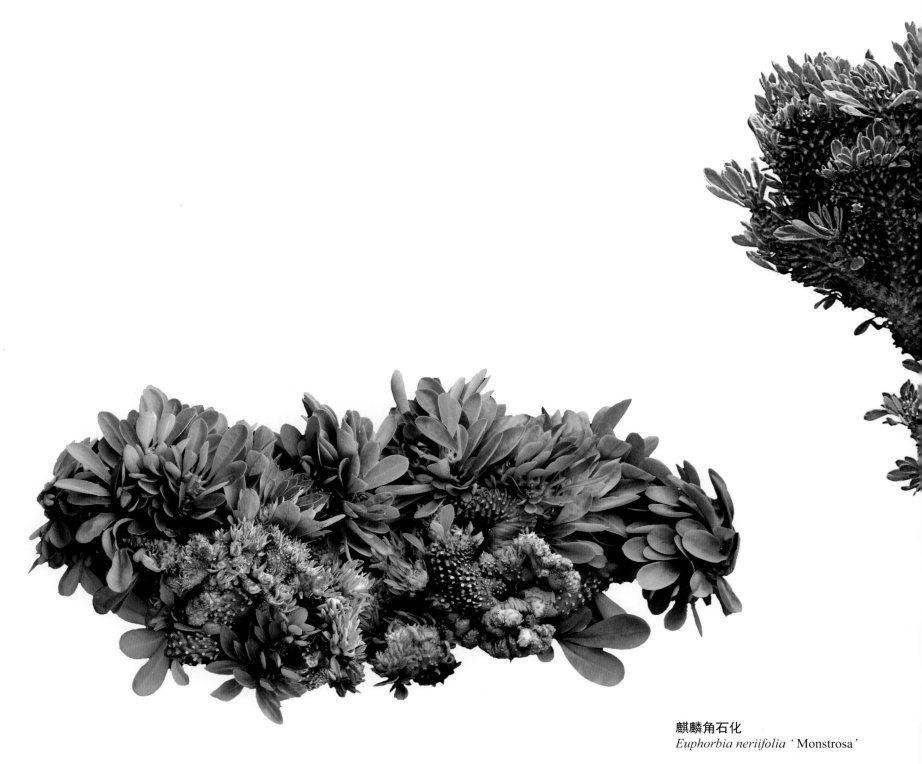

麒麟角石化
Euphorbia neriifolia 'Monstrosa'

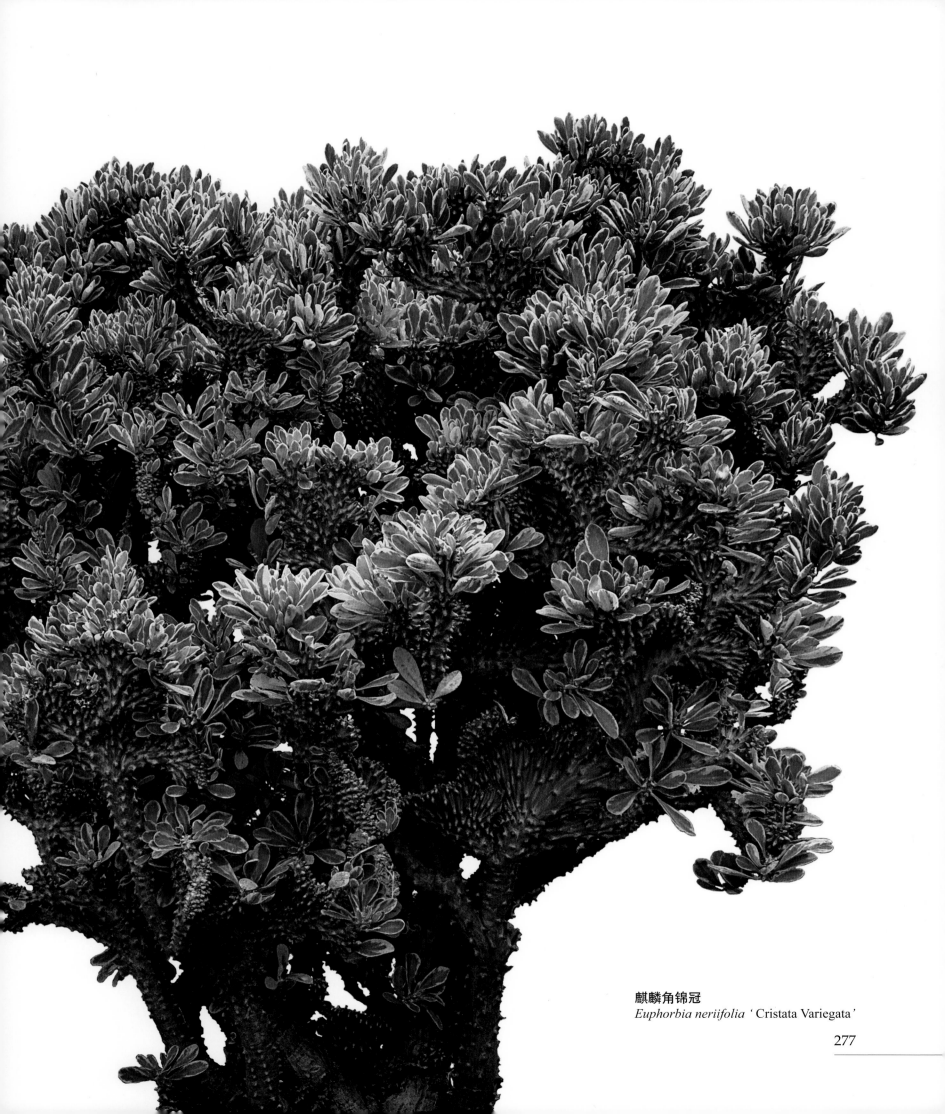

麒麟角锦冠
Euphorbia neriifolia 'Cristata Variegata'

277

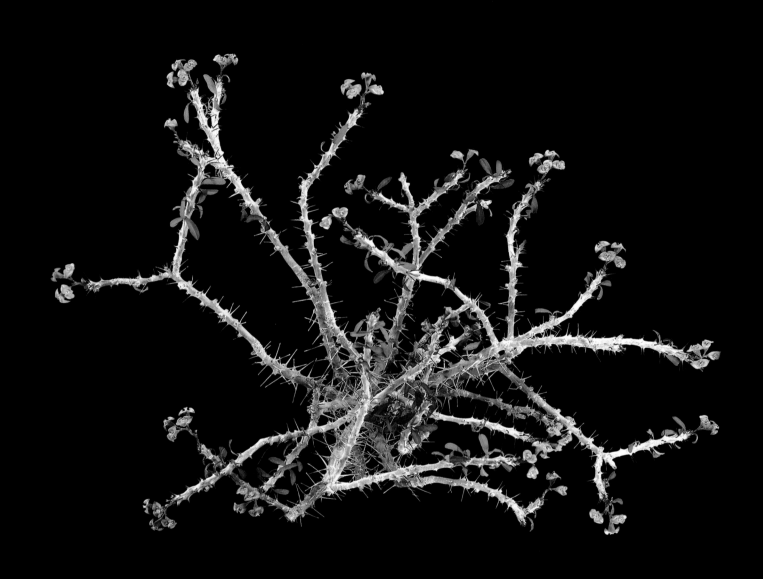

白茎麒麟
Euphorbia neobosseri

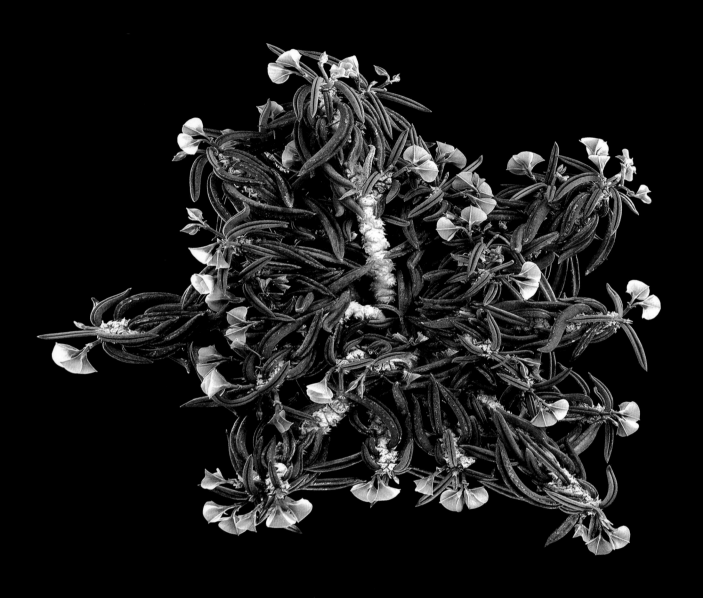

块根筒叶麒麟
Euphorbia cylindrifolia ssp. *tuberifera*

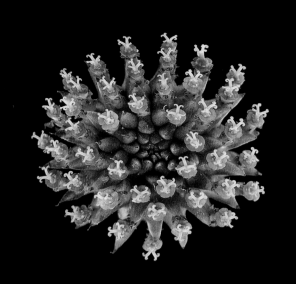

琉璃晃
Euphorbia susannae

喷炎龙
Euphorbia neohumbertii

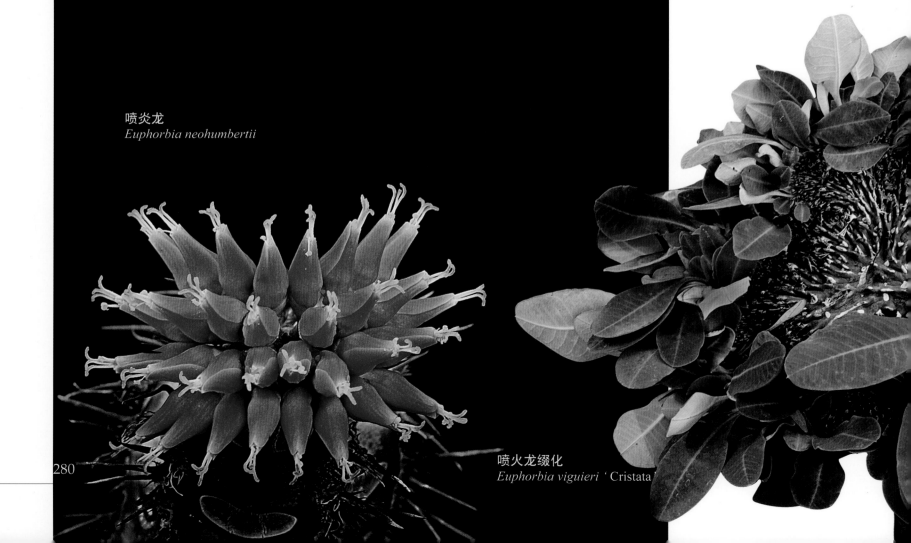

喷火龙缀化
Euphorbia viguieri ' Cristata

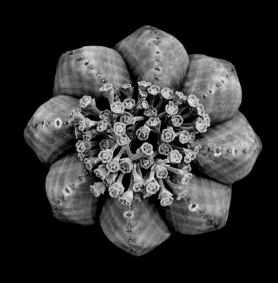

神玉
Euphorbia obesa ssp. symmetrica

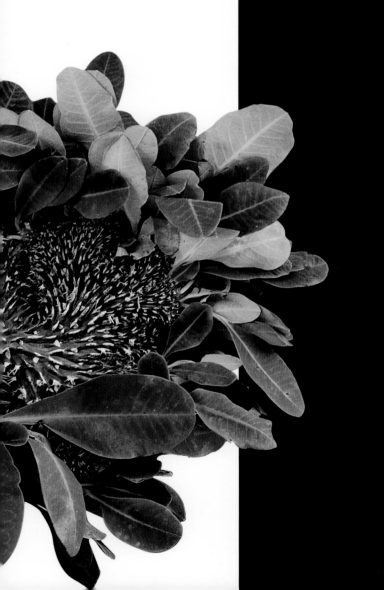

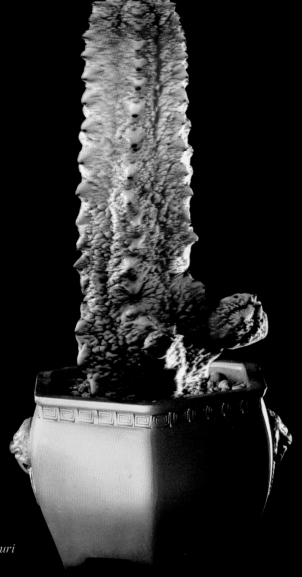

亚狄麒麟
Euphorbia abdelkuri

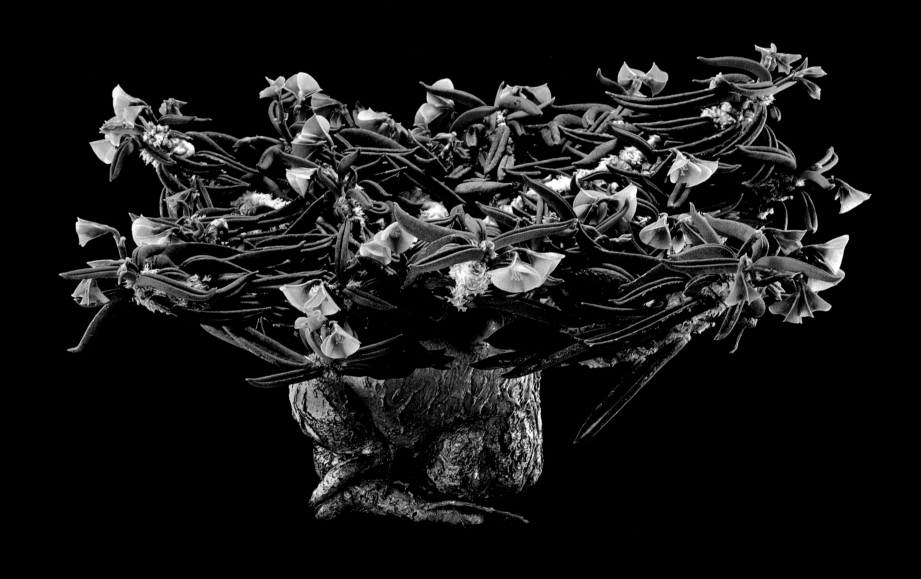

块根筒叶麒麟
Euphorbia cylindrifolia ssp. *tuberifera*

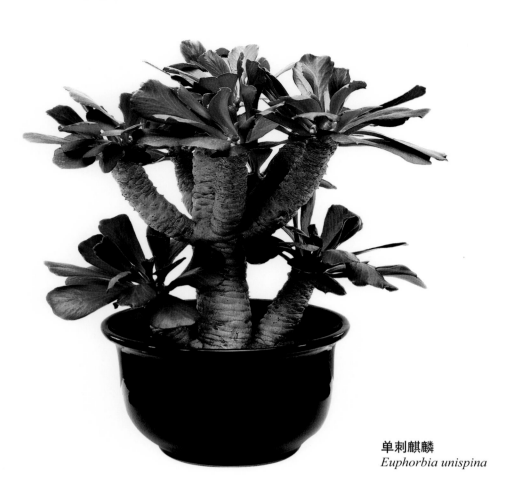

单刺麒麟
Euphorbia unispina

潘郎麒麟
Euphorbia francoisii

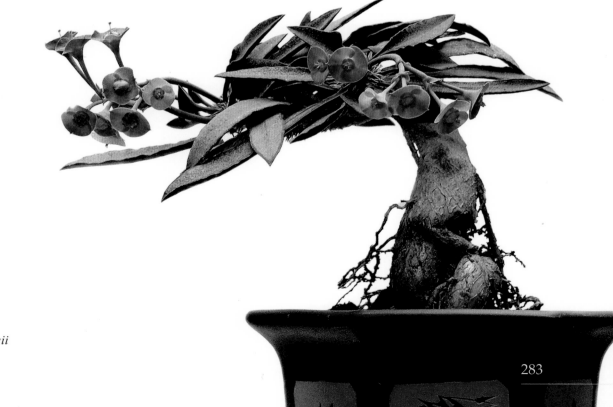

佛肚树
Jatropha podagrica

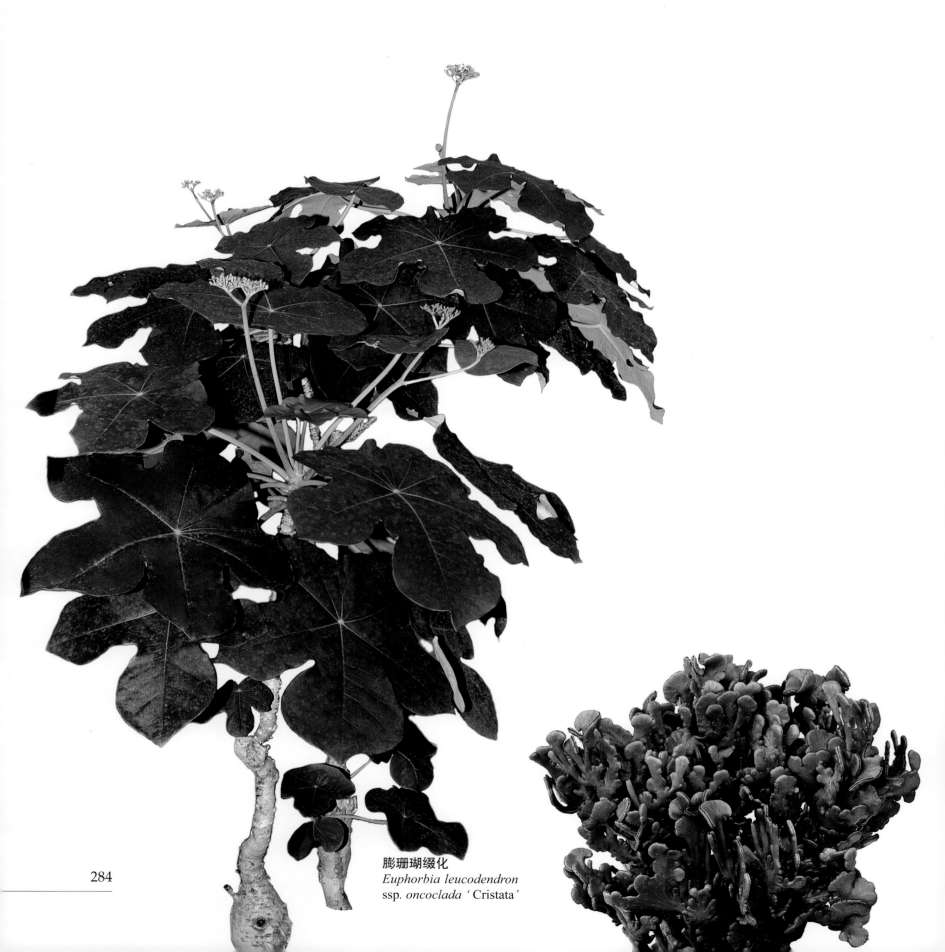

膨珊瑚缀化
Euphorbia leucodendron
ssp. *oncoclada* 'Cristata'

284

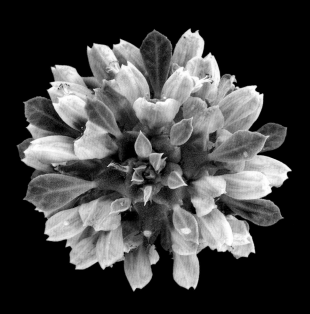

苍龙阁
Monadenium schubei

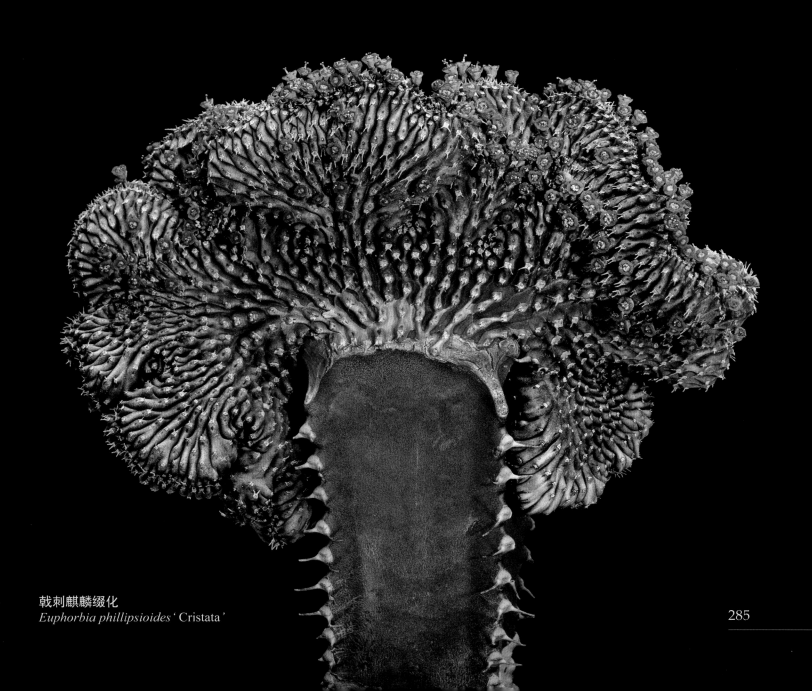

戟刺麒麟缀化
Euphorbia phillipsioides 'Cristata'

285

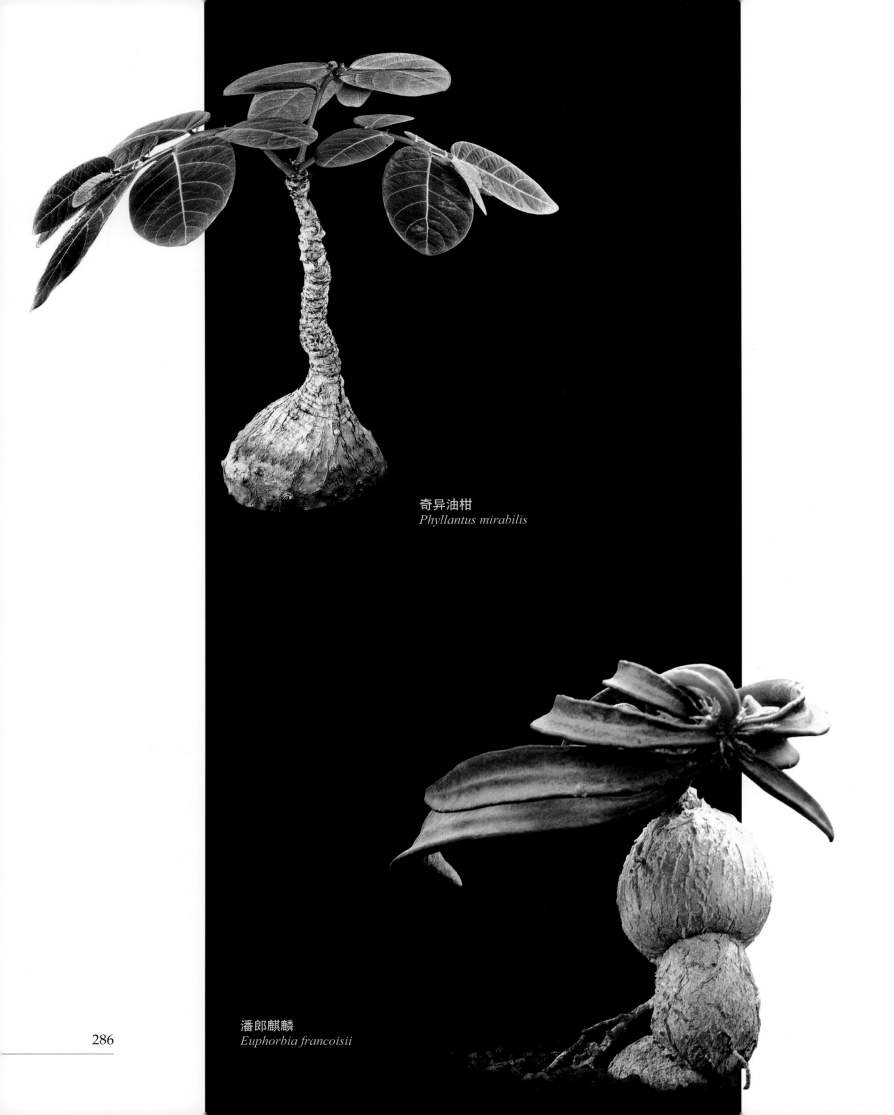

奇异油柑
Phyllantus mirabilis

潘郎麒麟
Euphorbia francoisii

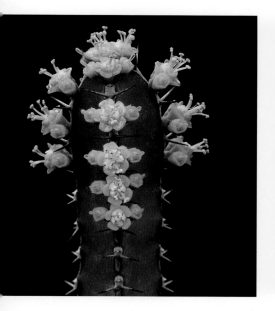

朝驹
Euphorbia 'Zigzag'

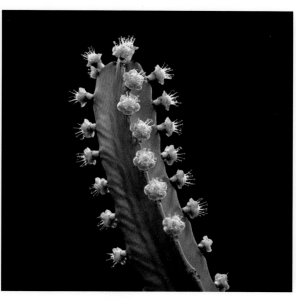

冲天阁
Euphorbia ingens

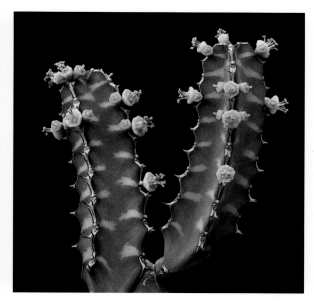

圆斑麒麟
Euphorbia × doinetiana

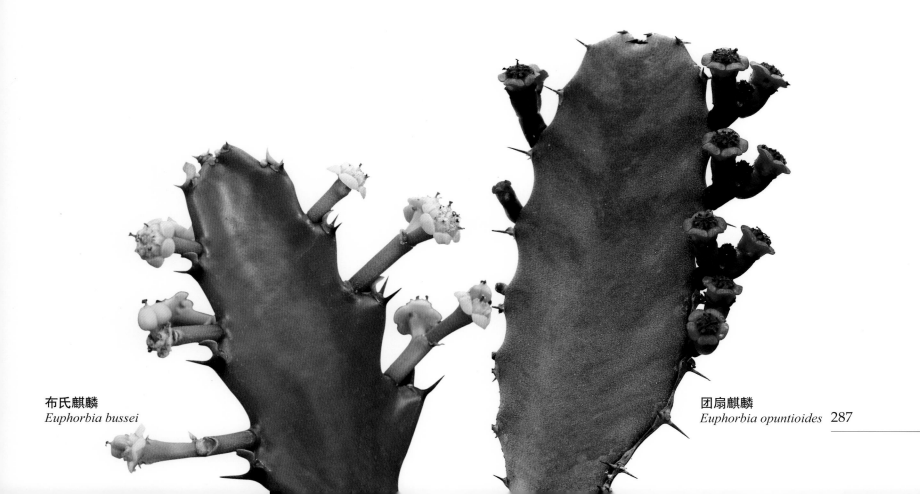

布氏麒麟
Euphorbia bussei

团扇麒麟
Euphorbia opuntioides 287

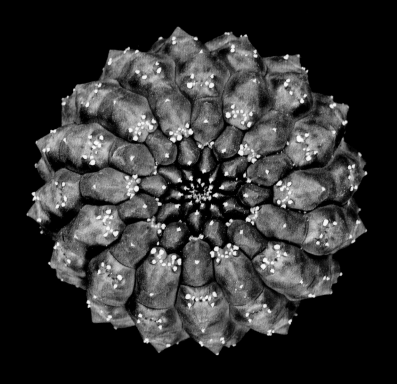

裸萼大戟
Euphorbia gymnocalycioides

鱼鳞丸缀化
Euphorbia piscidermis 'Cristata'

鱼鳞丸群生
Euphorbia piscidermis

布纹球群生
Euphorbia obesa

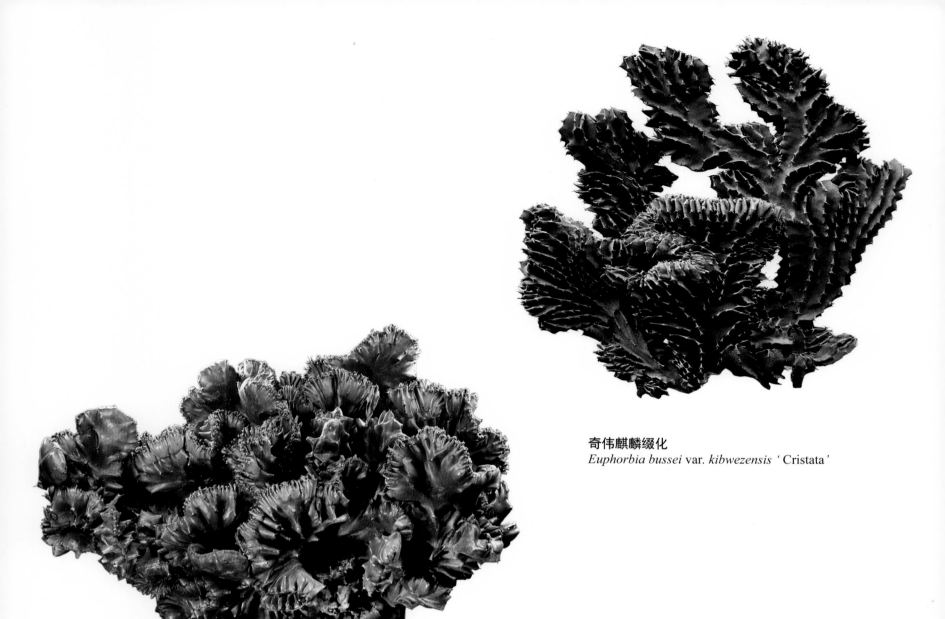

奇伟麒麟缀化
Euphorbia bussei var. *kibwezensis*‘Cristata’

帝国缀化
Euphorbia franckiana‘Cristata’

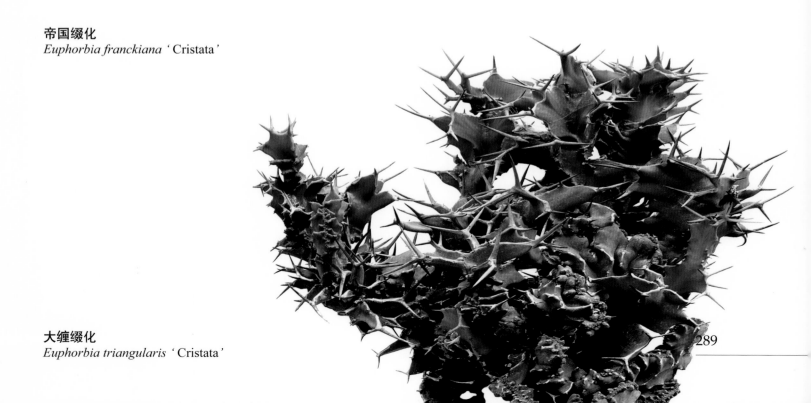

大缠缀化
Euphorbia triangularis‘Cristata’

块根篇
Caudiciform and Pachycaul Succulents

本篇所收载的多肉植物，主要为茎基部肥大的茎基型多肉植物，也包括部分具露出地表的粗大的块茎、肉质根、块根和鳞茎的植物，爱好者一般连同茎较粗短的茎多肉植物一起，统称为块根类多肉植物。这些块根类植物来自不同科属，千姿百态，形状奇特，备受养植者和爱好者的喜爱。

Succulents collected in this chapter mainly comprise plump-stemmed caudiciform succulents as well as plants that grow swollen tubers above the soil surface, thick fleshyroots, tuberoids and bulbs. Along with chunky stem succulents, they're collectively referred to as caudiciform and pachycaul succulents among enthusiasts. Belonging to different genera or families, they're favored by cultivation specialists and enthusiasts for their multifarious appearances.

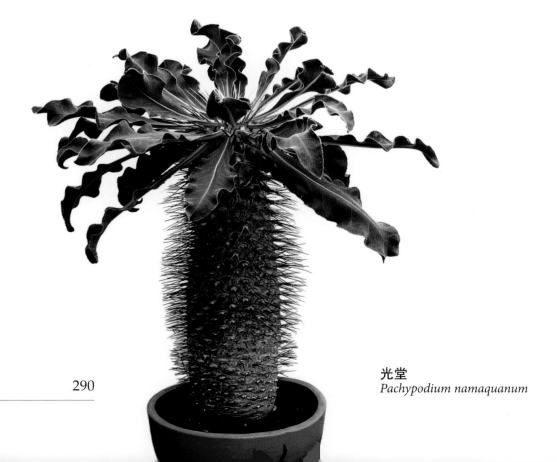

光堂
Pachypodium namaquanum

睡布袋
Gerrardanthus macrorrhizus

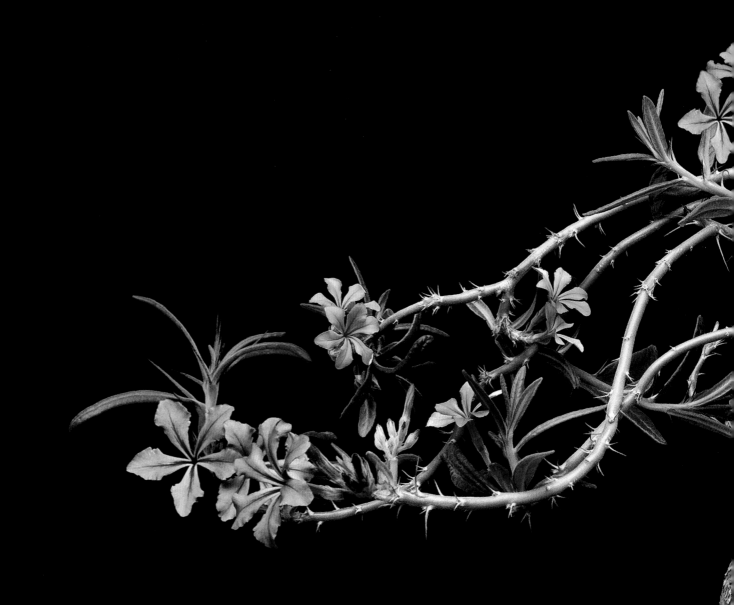

天马空
Pachypodium succulentum

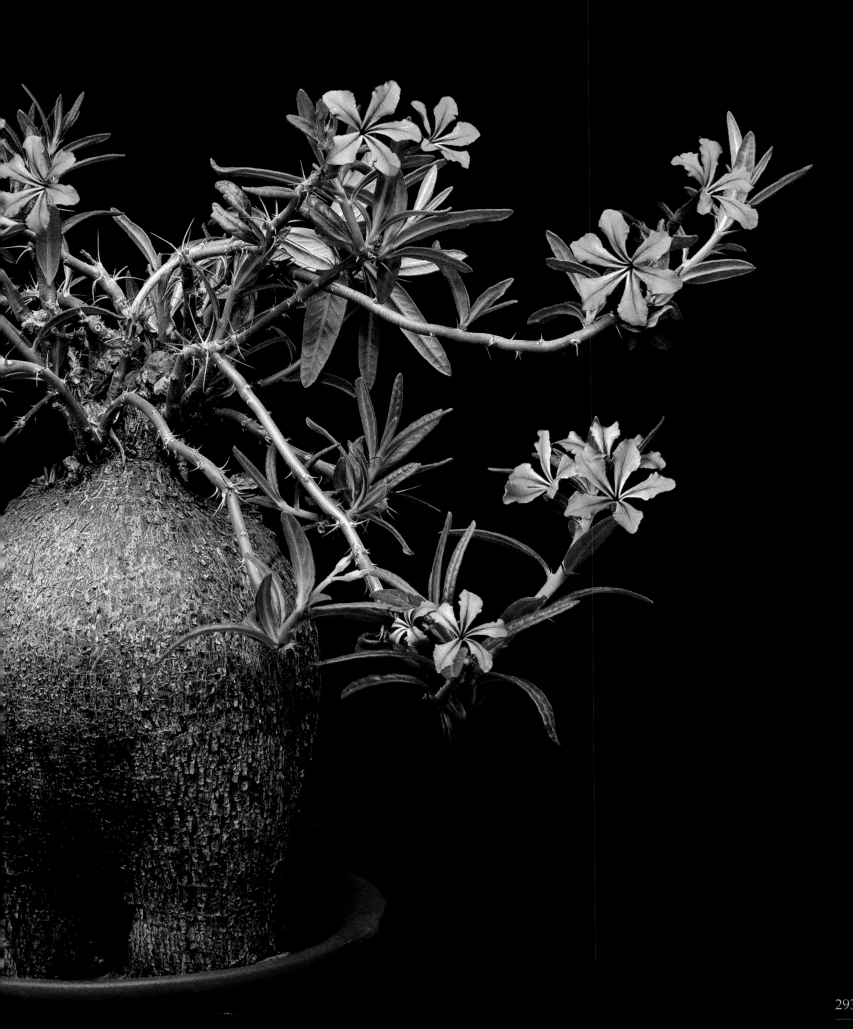

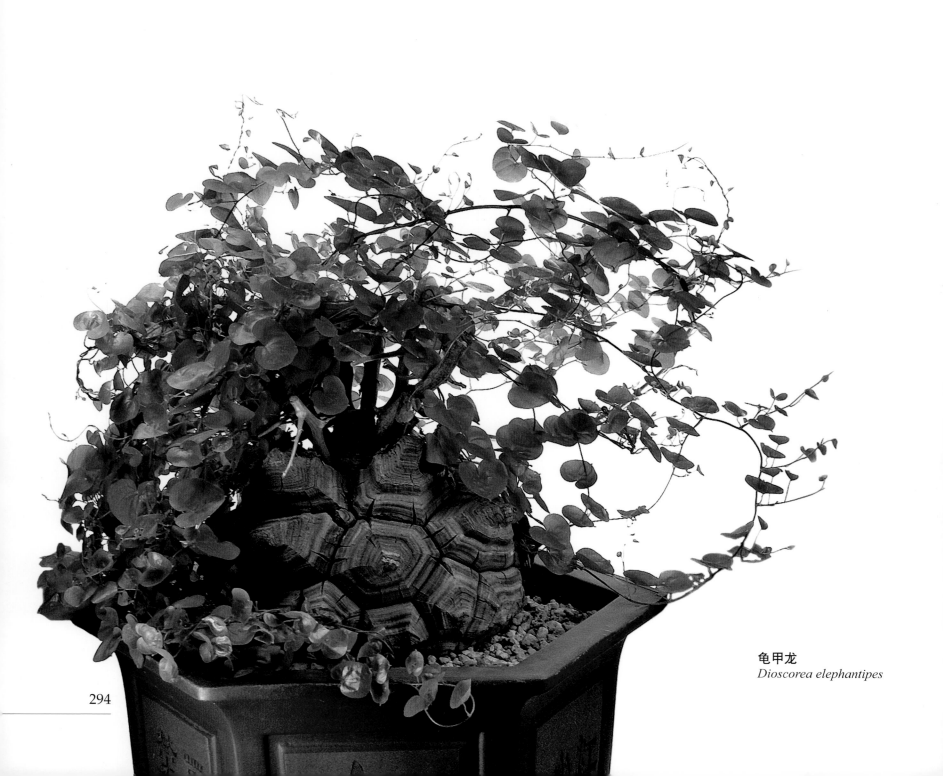

龟甲龙
Dioscorea elephantipes

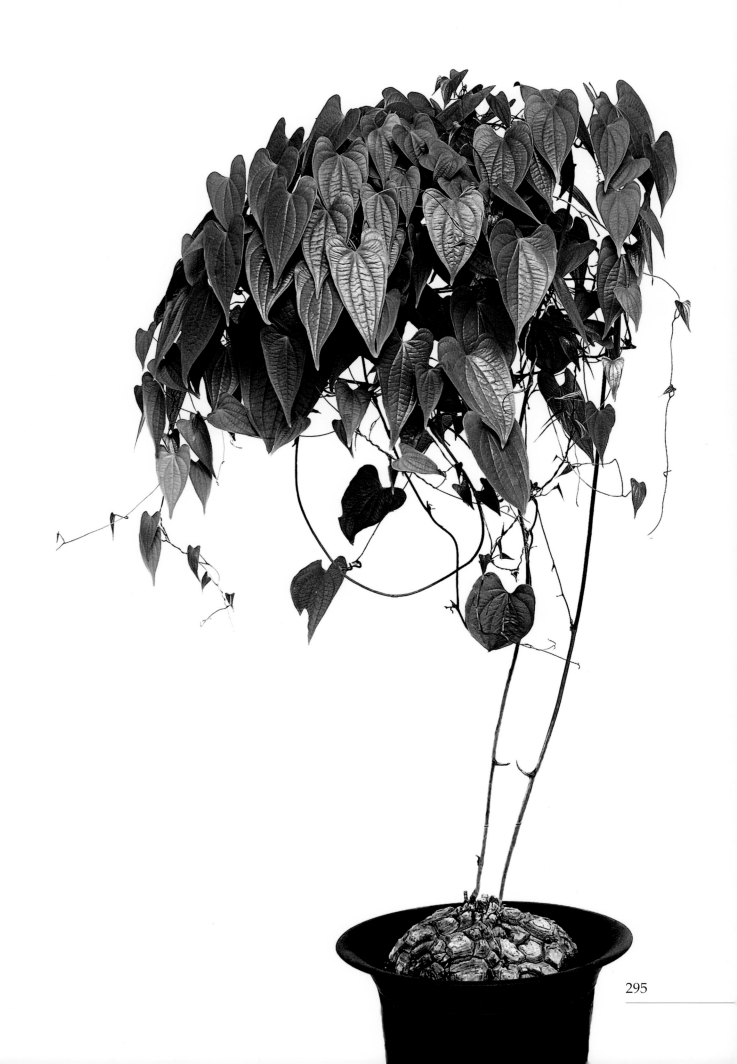

墨西哥龟甲龙
Dioscorea mexicana

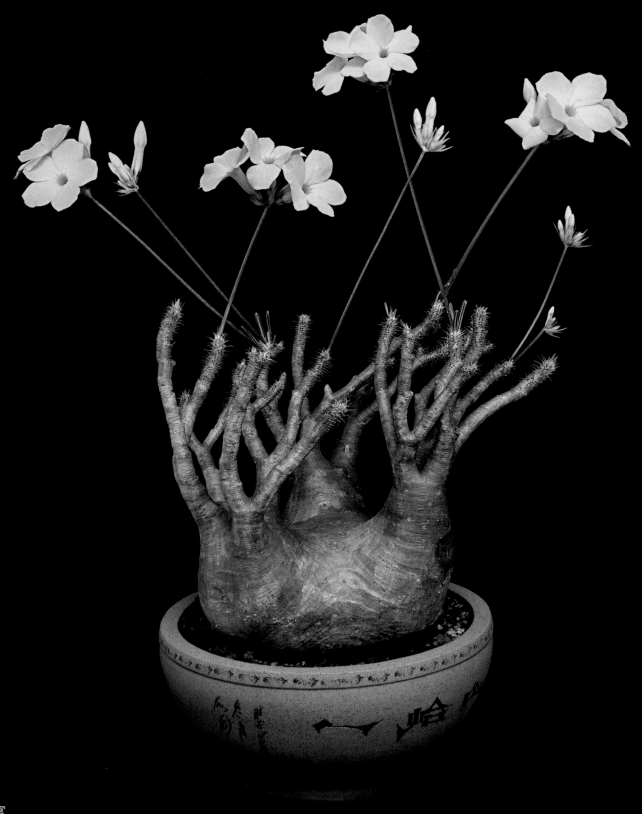

象牙宫
Pachypodium rosulatum var. *gracilius*

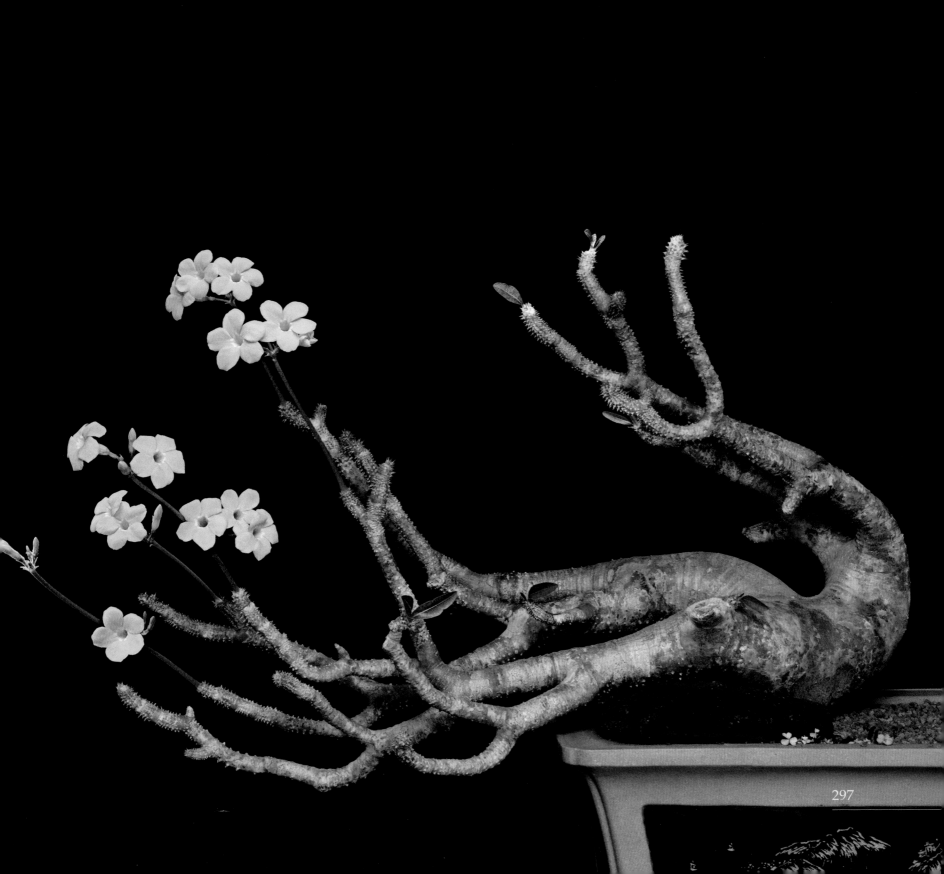

密花瓶干
Pachypodium densiflorum

297

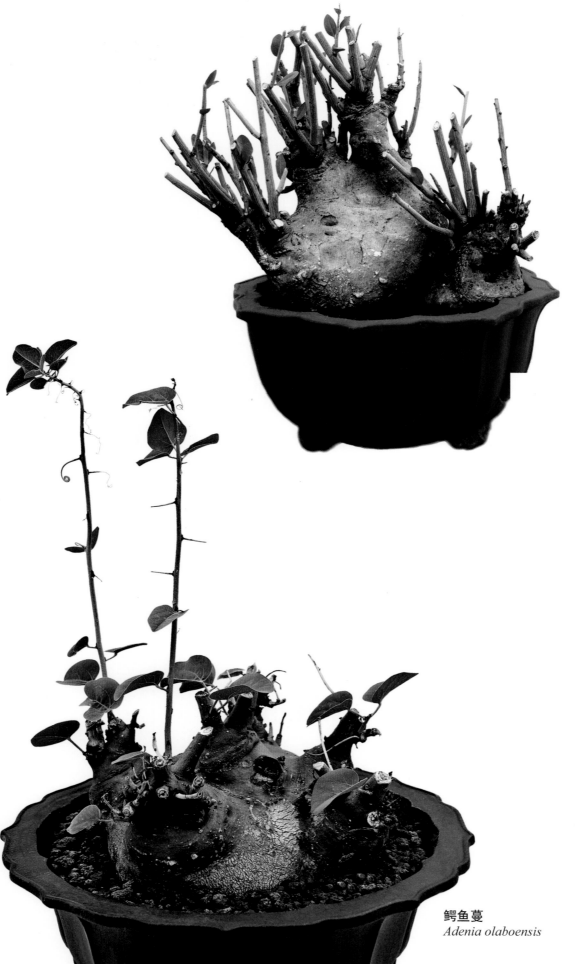

绿蝶蔓
Adenia pechuelii

鳄鱼蔓
Adenia olaboensis

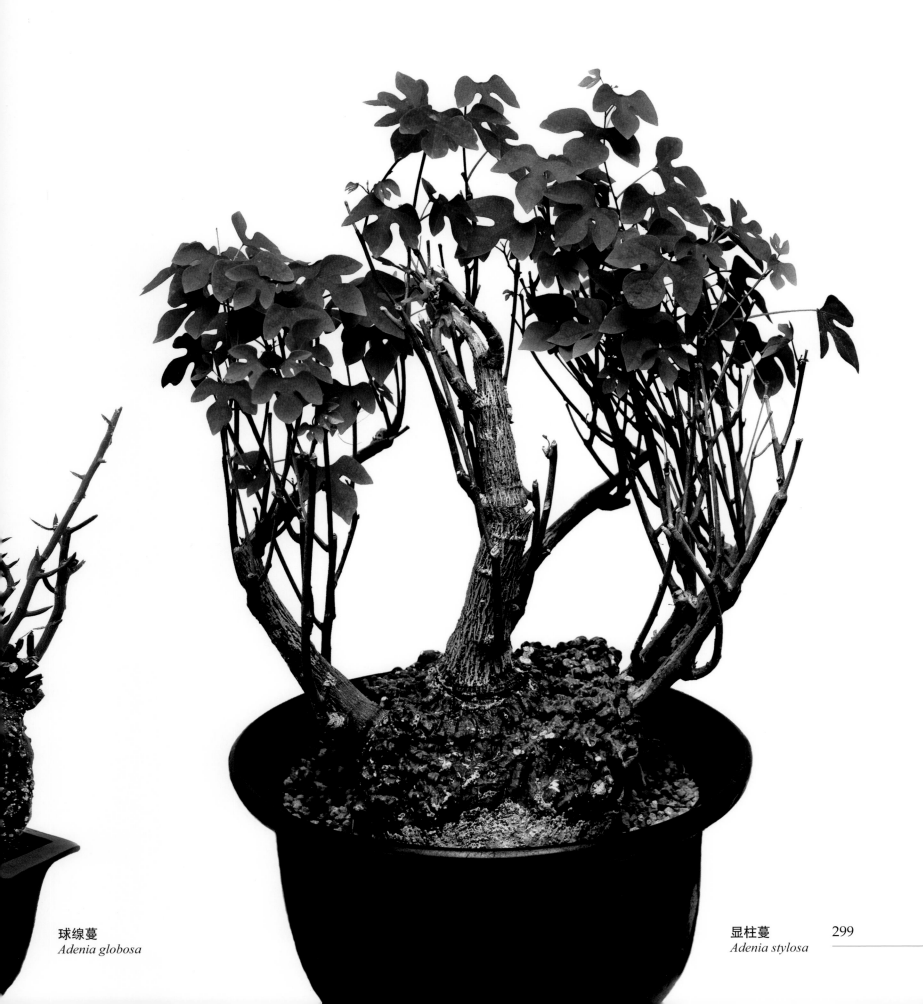

球線蔓
Adenia globosa

显柱蔓 299
Adenia stylosa

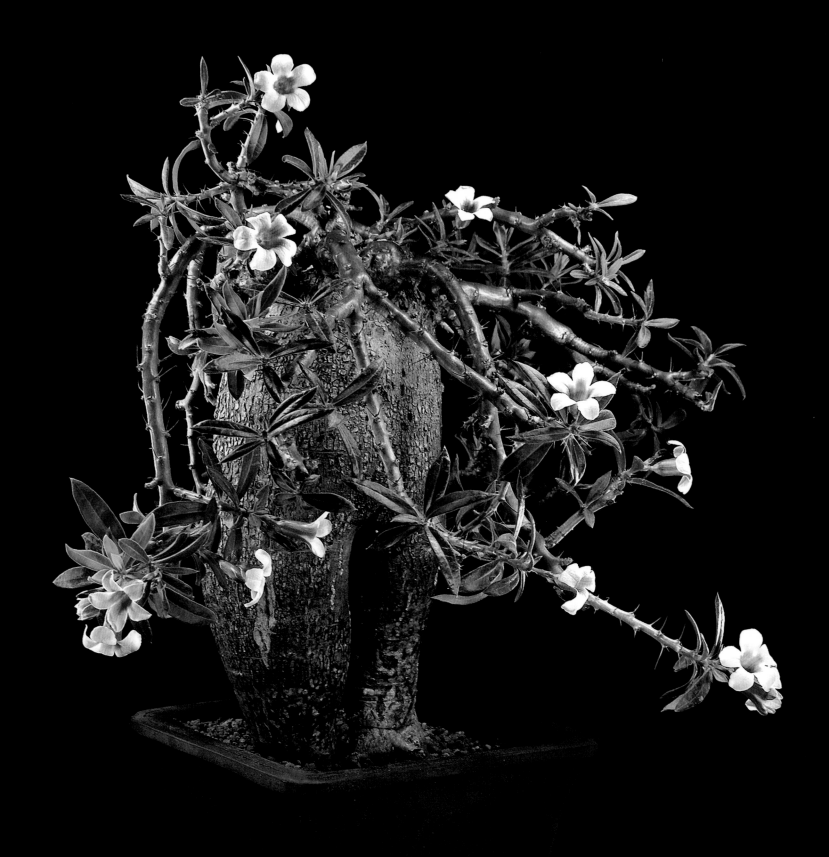

双刺瓶干
Pachypodium bispinosum

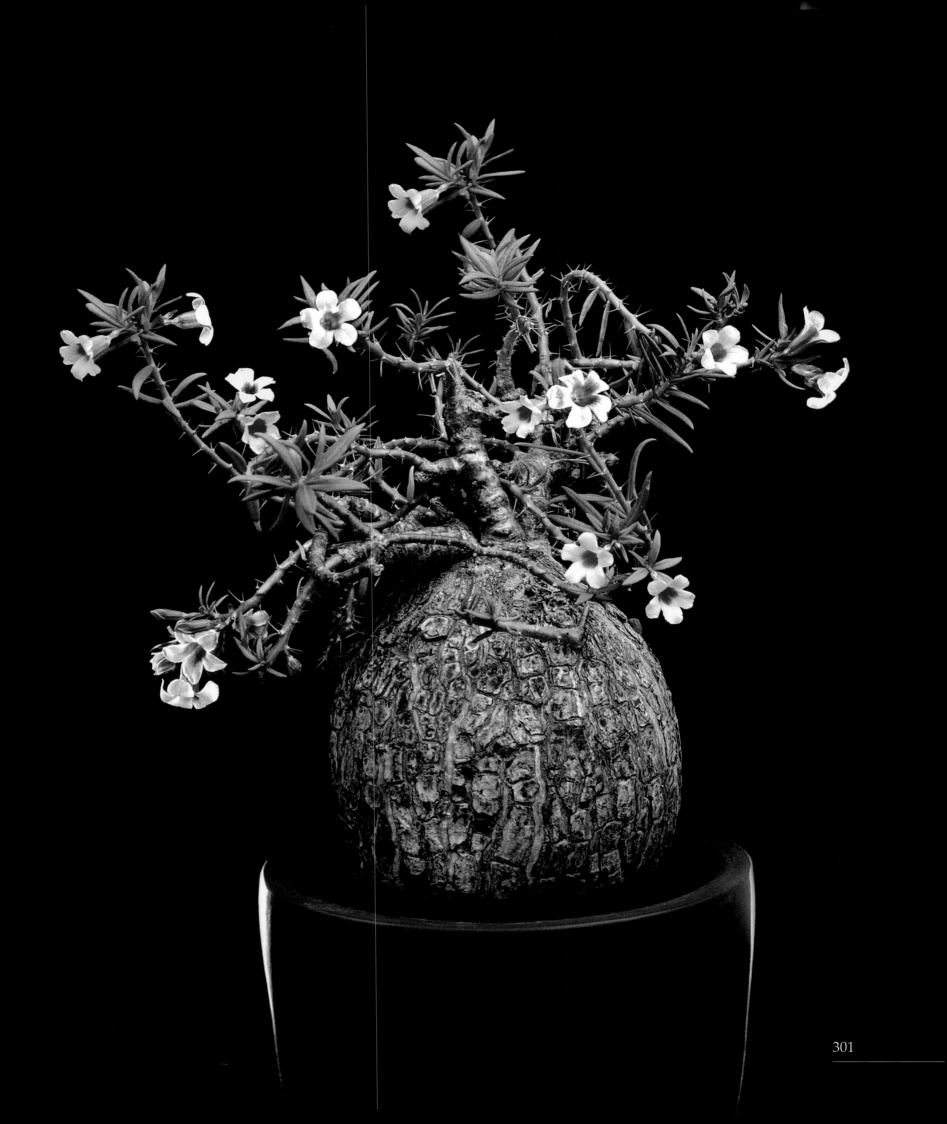

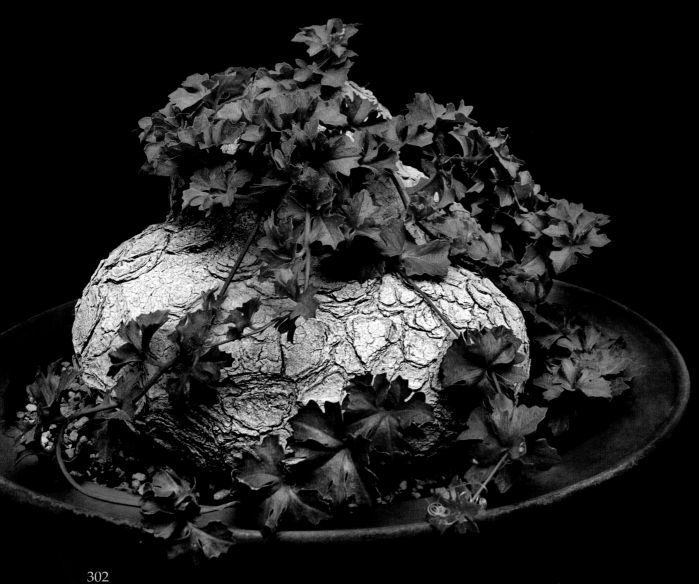

笑布袋
Ibervillea sonorae

302

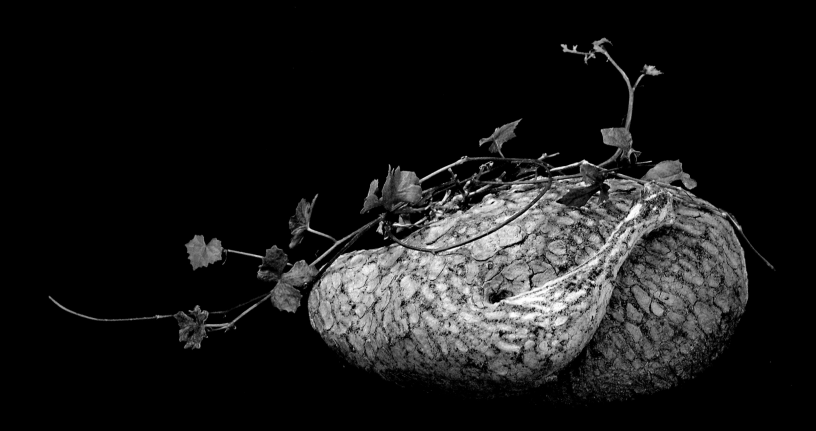

笑布袋
Ibervillea sonorae

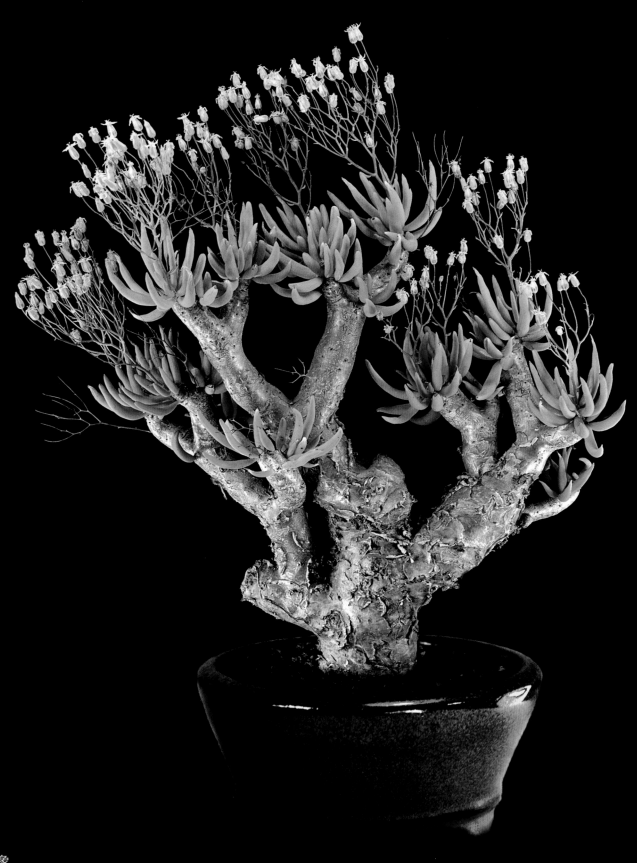

万物象
Tylecodon reticulatus

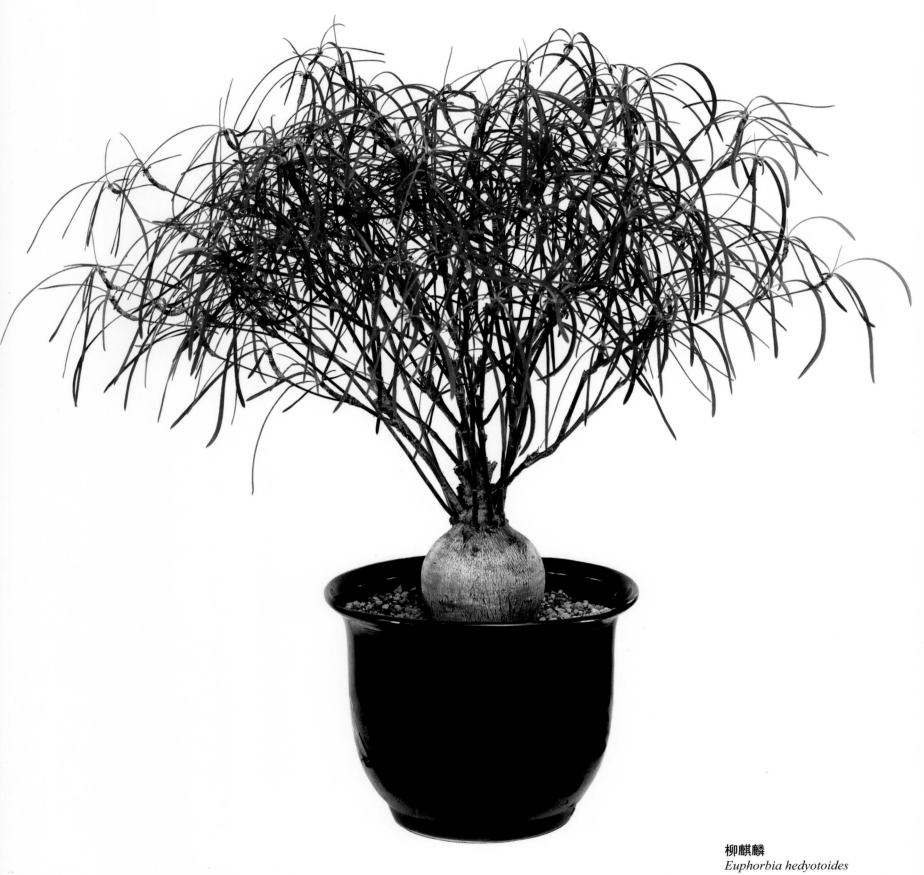

柳麒麟
Euphorbia hedyotoides

305

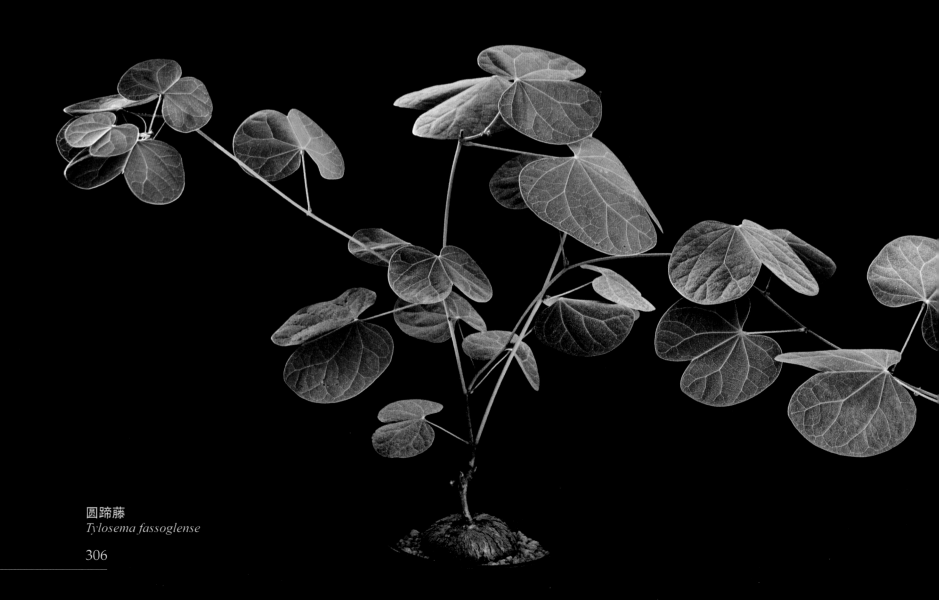

圆蹄藤
Tylosema fassoglense

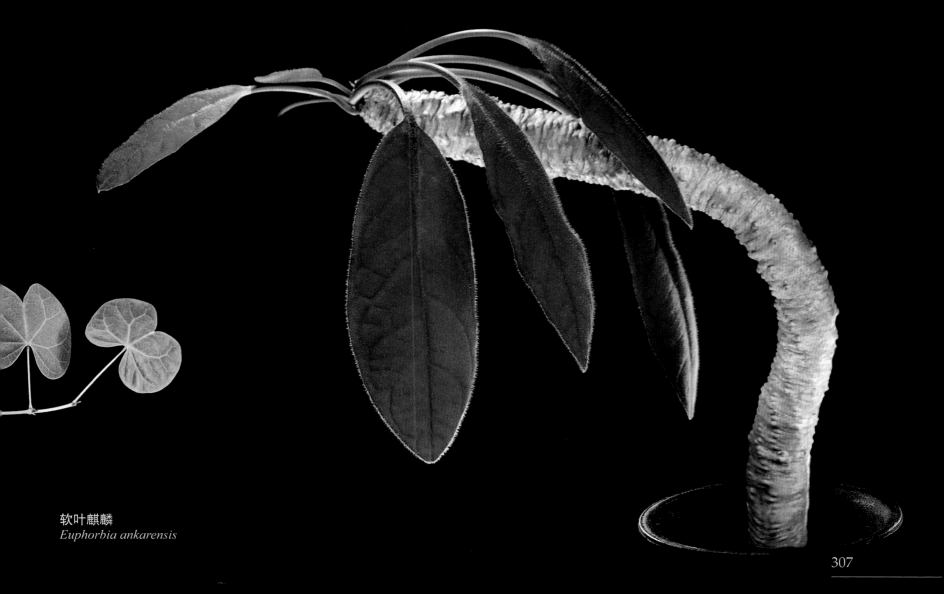

软叶麒麟
Euphorbia ankarensis

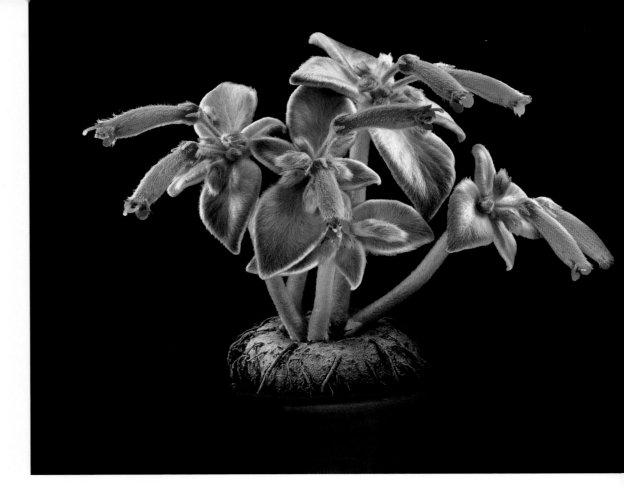

断崖女王
Sinningia leucotricha

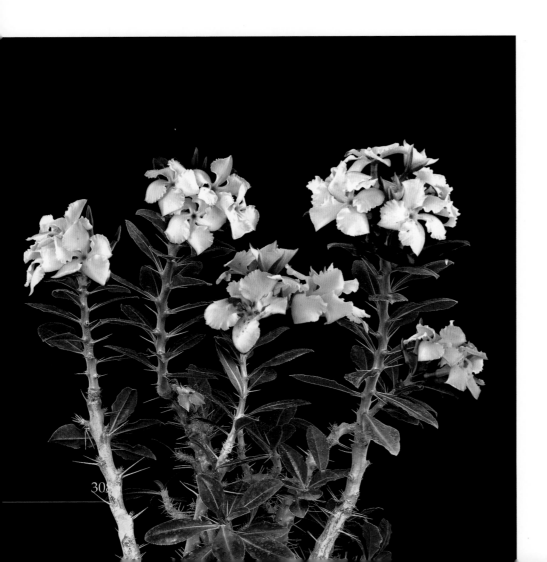

308

白马城
Pachypodium lealii ssp. *saundersii*

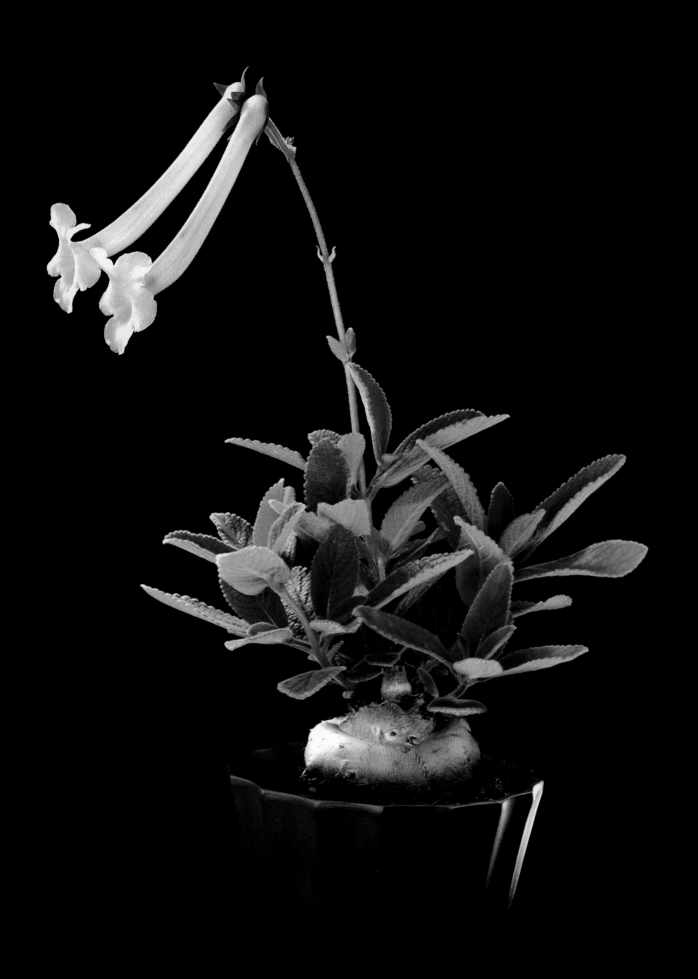

白筒花
Sinningia tubiflora

象足葡萄
Cyphostemma elephantopus

黑罗摩仫
Monsonia multifida

310

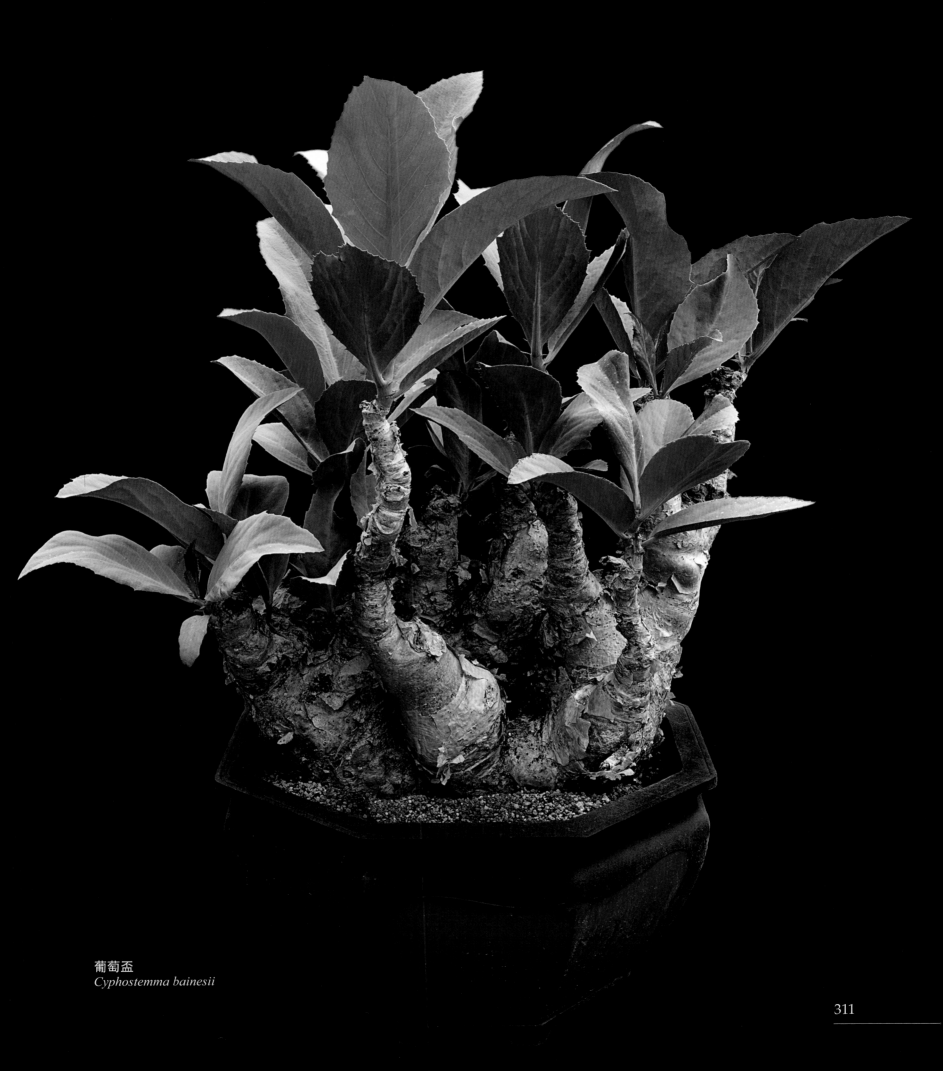

葡萄盃
Cyphostemma bainesii

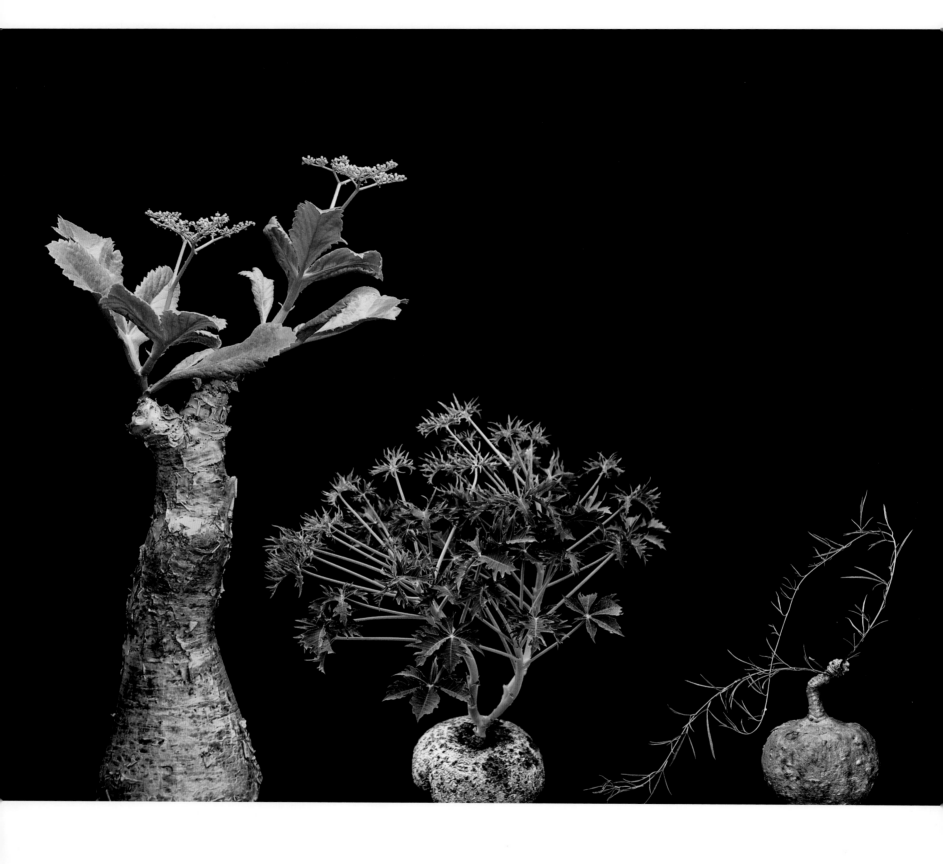

葡萄瓮
Cyphostemma juttae

锦珊瑚
Jatropha cathartica

布鲁牵牛
Ipomoea bolusiana

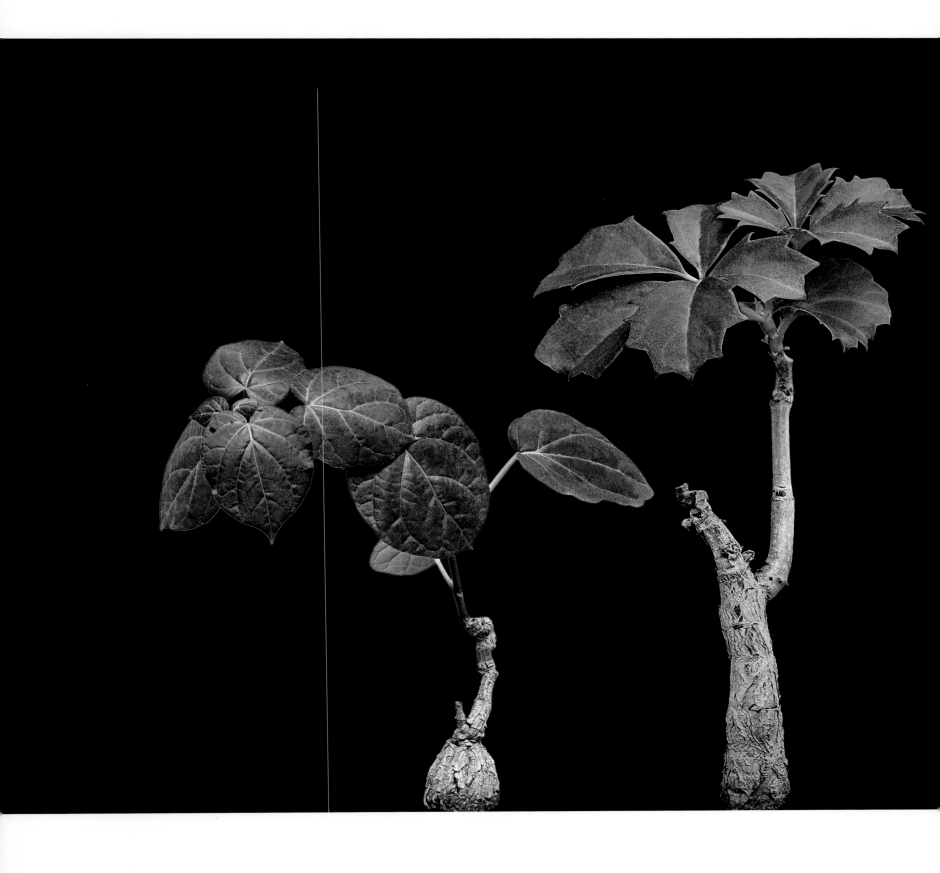

龟甲萝藦
Matelea cyclophylla

背叶梦瓮
Cissus sandersonii

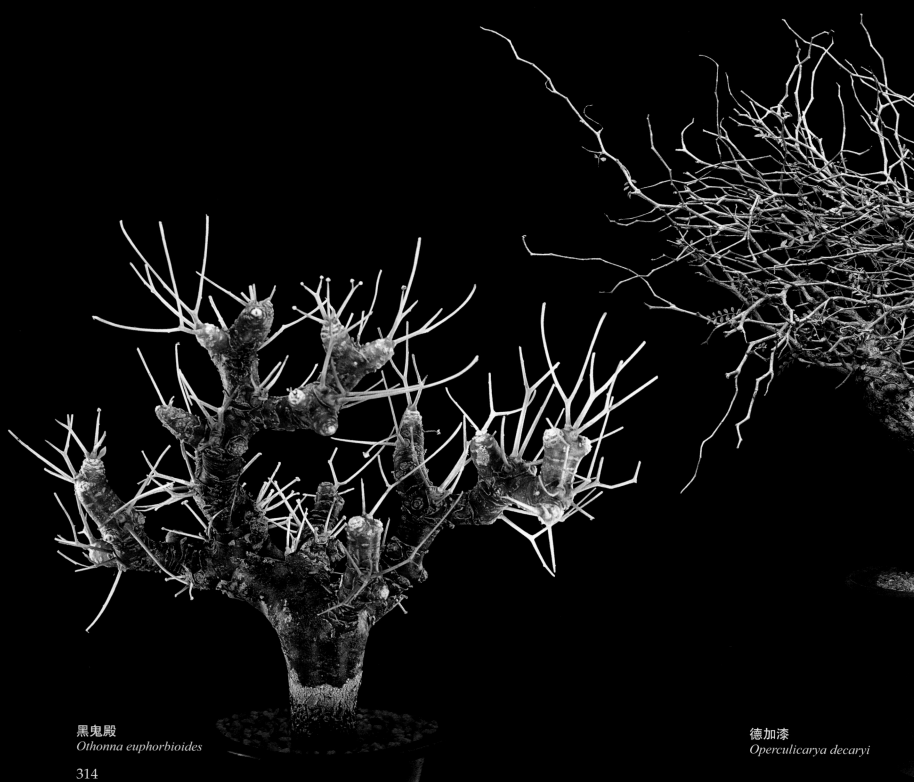

黑鬼殿
Othonna euphorbioides

德加漆
Operculicarya decaryi

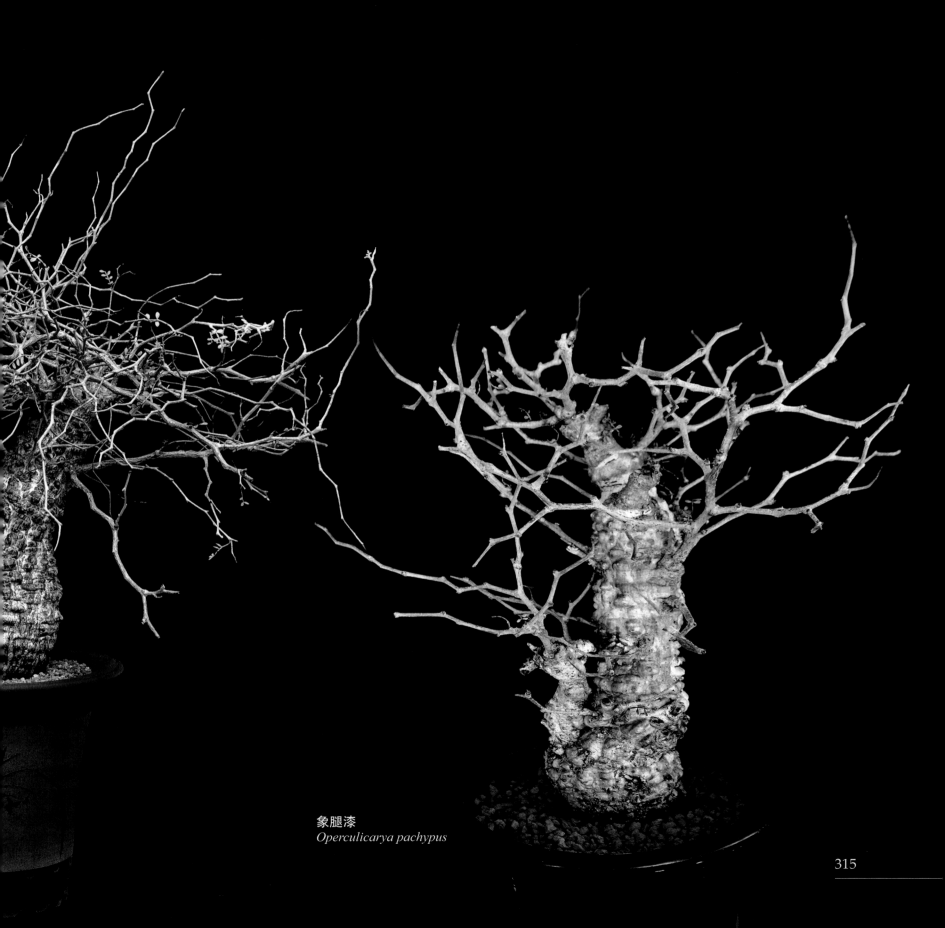

象腿漆
Operculicarya pachypus

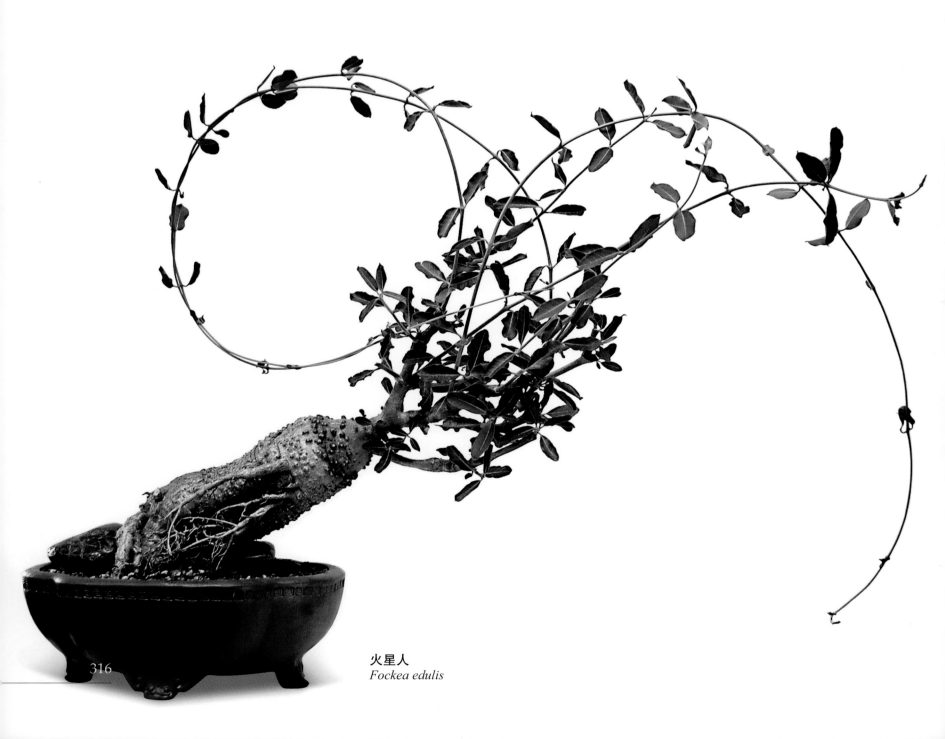

火星人
Fockea edulis

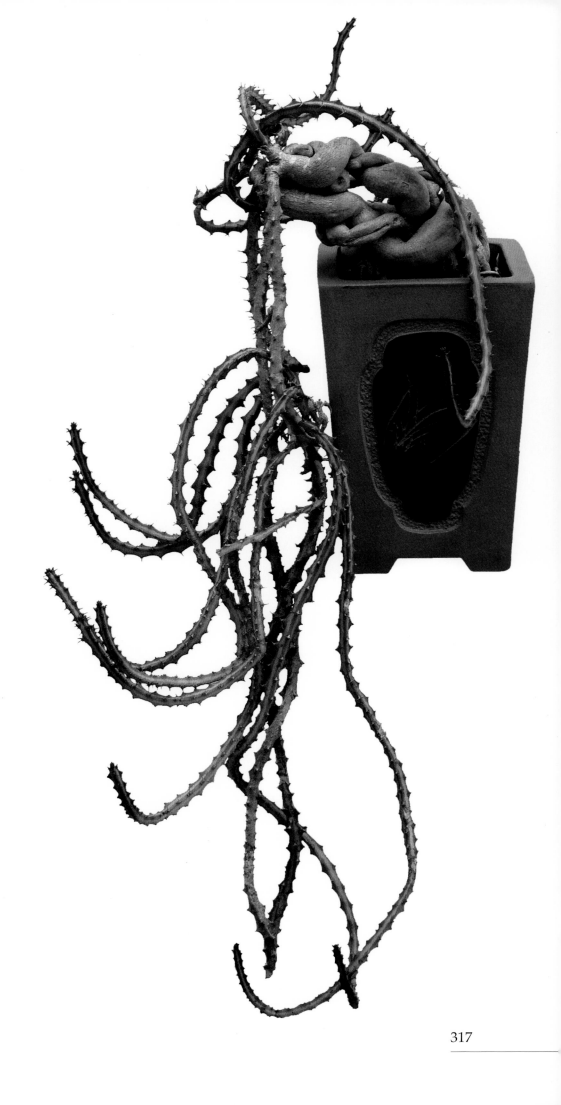

狗奴子
Euphorbia knuthii

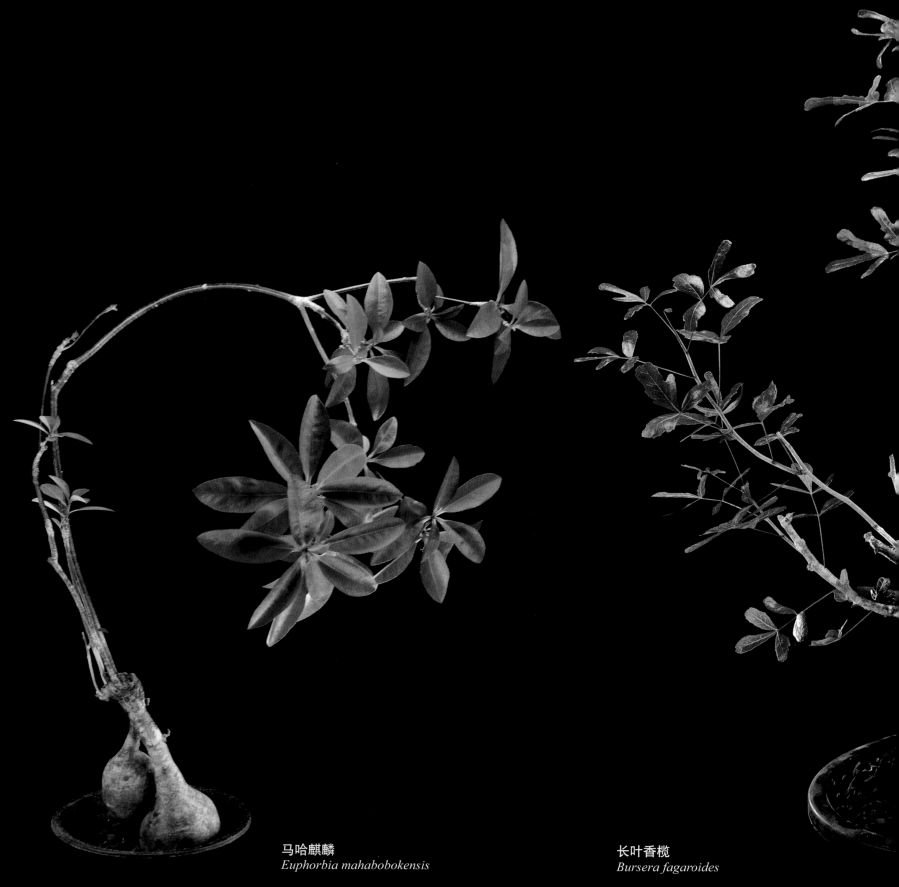

马哈麒麟
Euphorbia mahabobokensis

长叶香榄
Bursera fagaroides

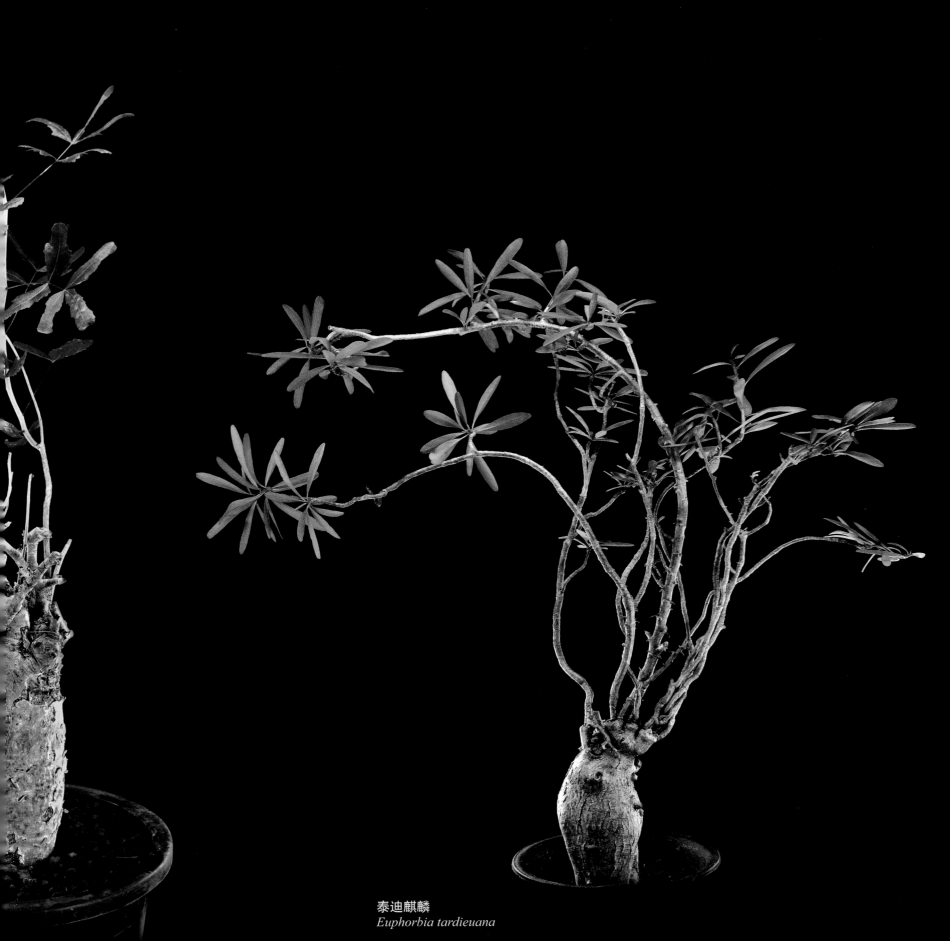

泰迪麒麟
Euphorbia tardieuana

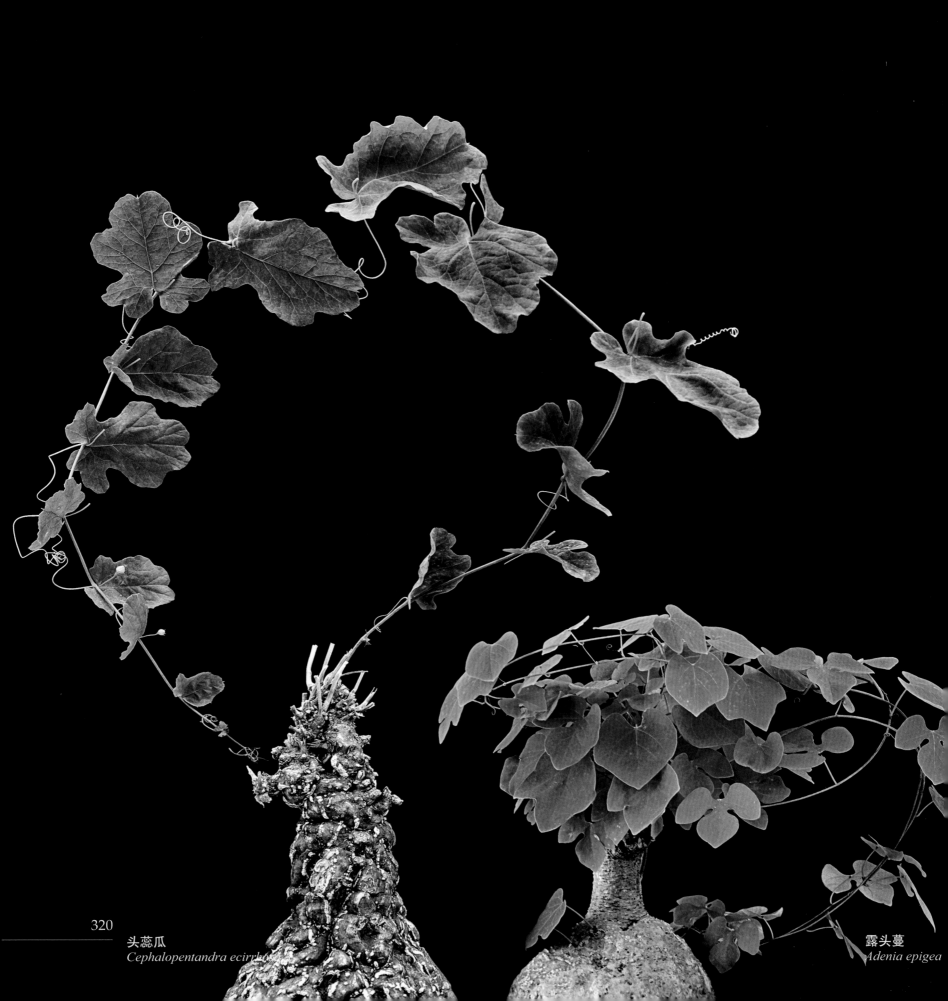

头蕊瓜
Cephalopentandra ecirrhosa

露头蔓
Adenia epigea

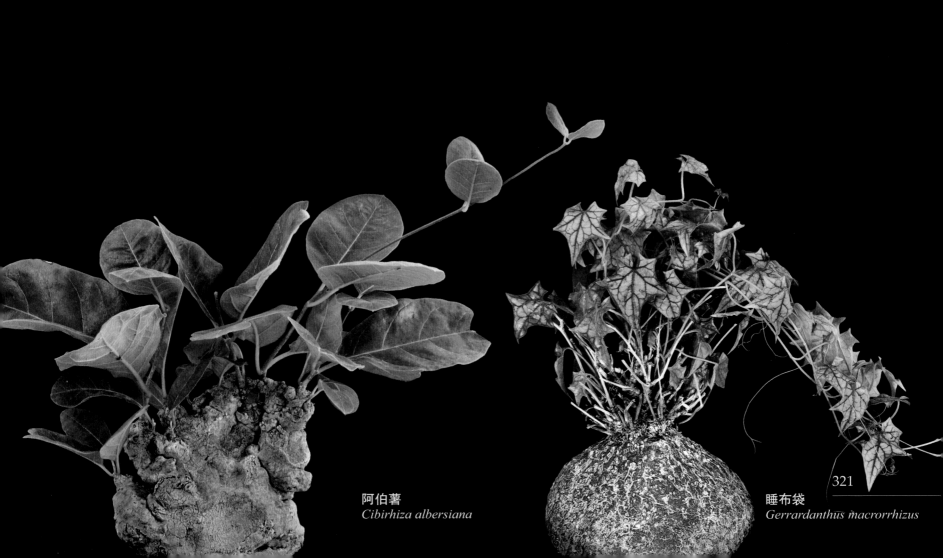

阿伯薯
Cibirhiza albersiana

睡布袋
Gerrardanthus macrorrhizus

象牙宫缀化
Pachypodium rosulatum var. *gracilius* 'Cristatum'

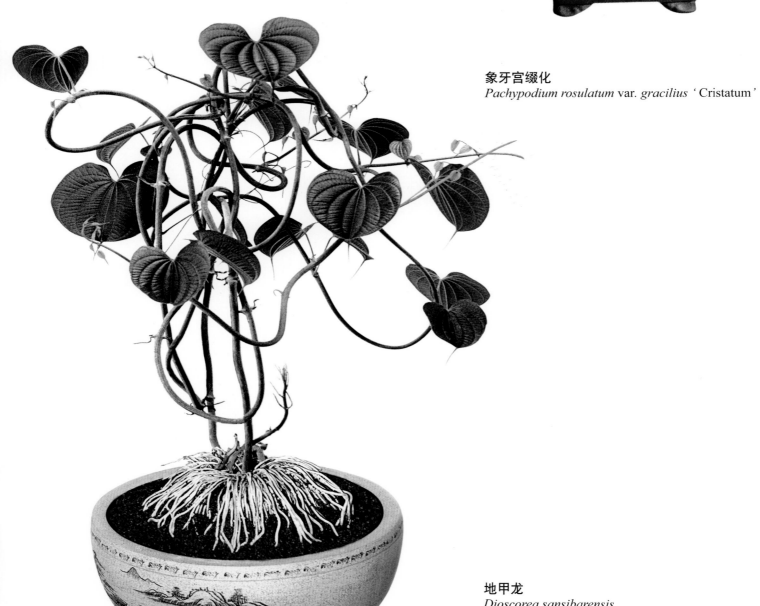

地甲龙
Dioscorea sansibarensis

榕叶香榄
Bursera schlechtendalii

绿背龟甲
Bombax ellipticum

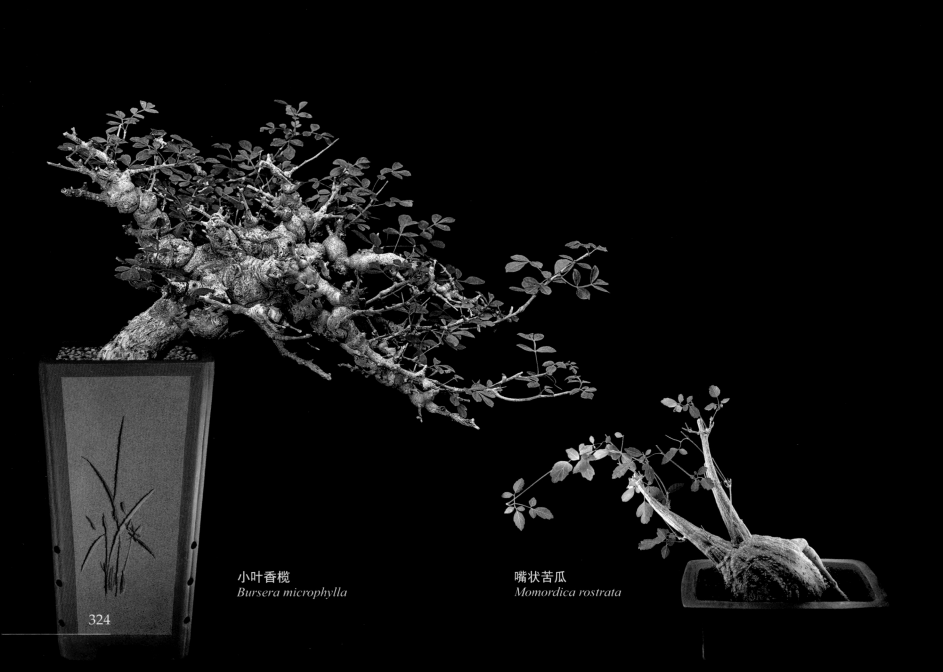

小叶香榄
Bursera microphylla

嘴状苦瓜
Momordica rostrata

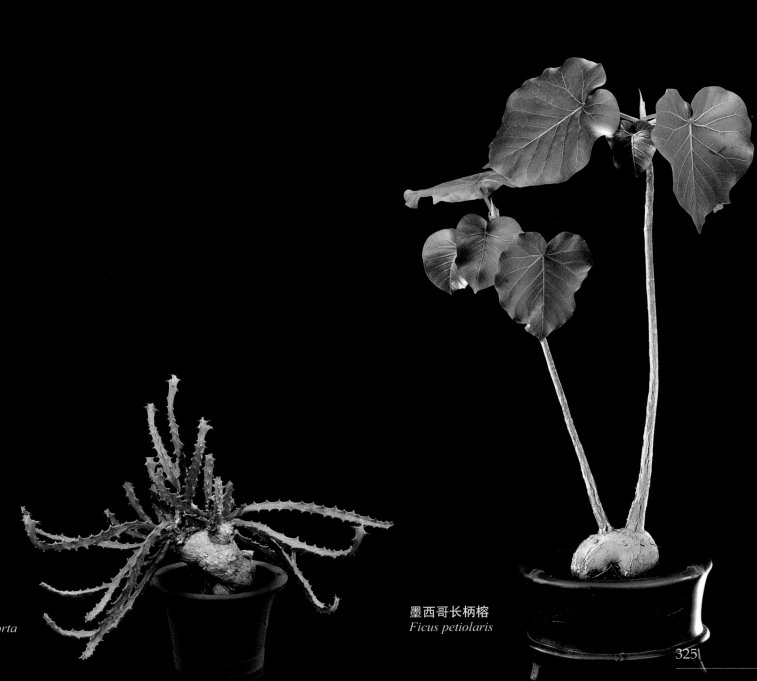

短扭麒麟
Euphorbia brevitorta

墨西哥长柄榕
Ficus petiolaris

325

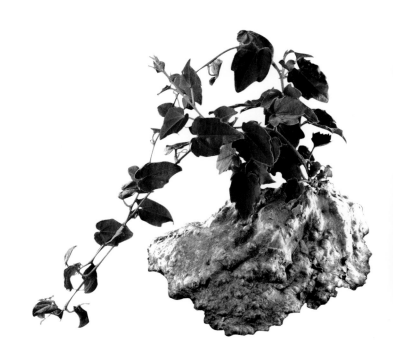

石头布袋
Xerosicyos pubescens

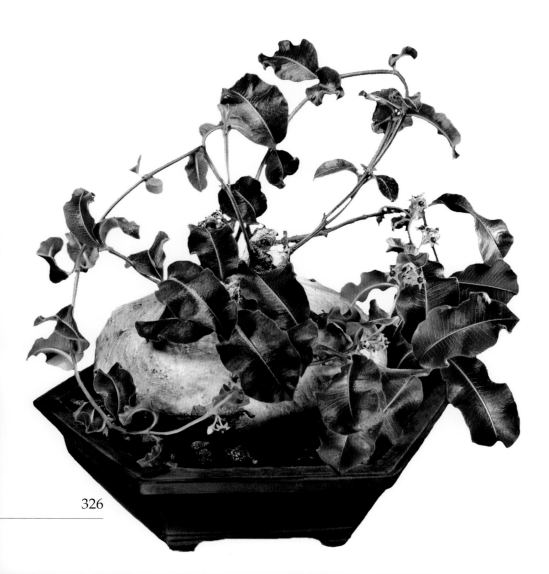

火星人
Fockea edulis

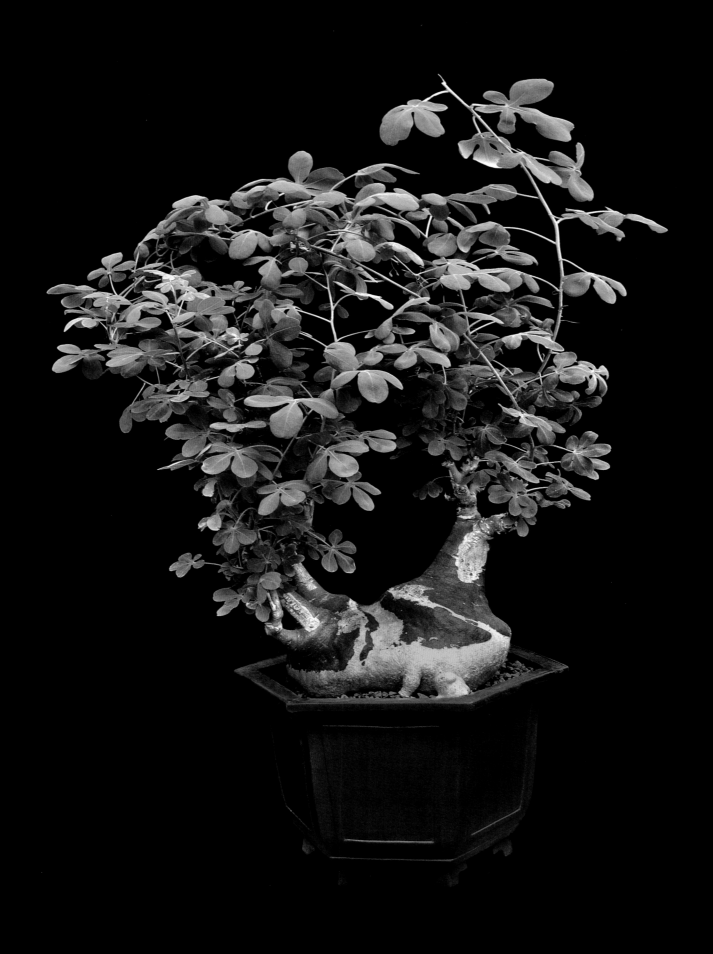

徐福之酒瓮
Adenia glauca

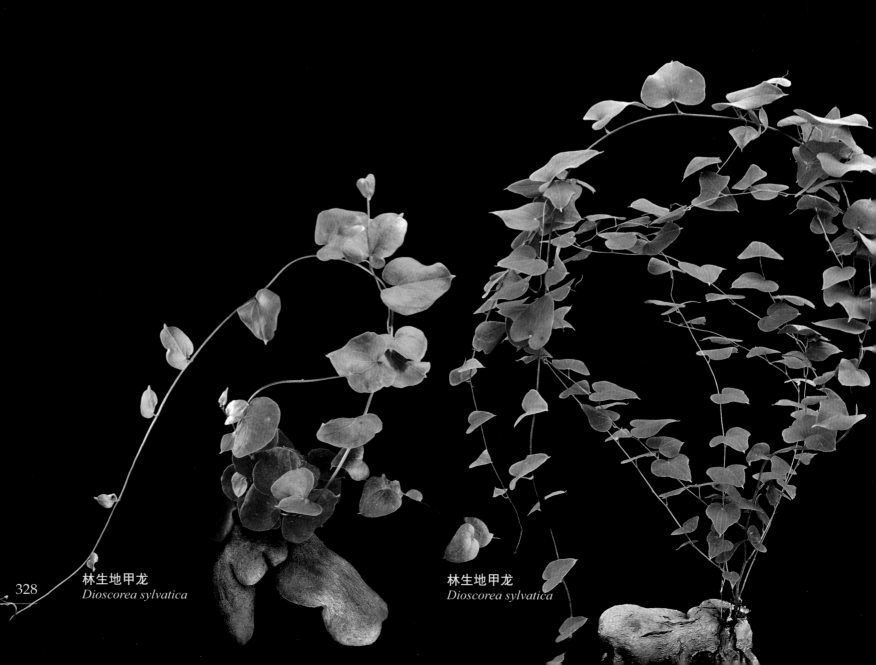

328　林生地甲龙
　　　Dioscorea sylvatica

林生地甲龙
Dioscorea sylvatica

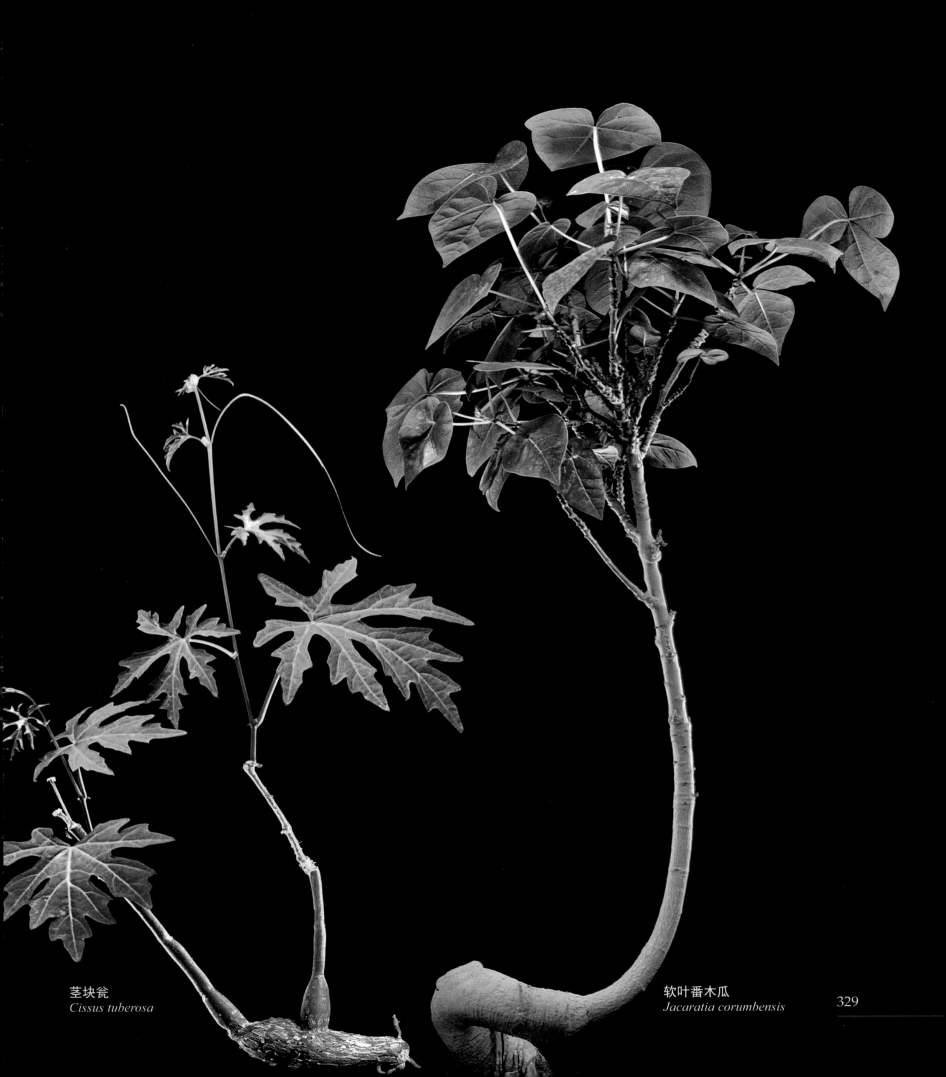

茎块瓮
Cissus tuberosa

软叶番木瓜
Jacaratia corumbensis

329

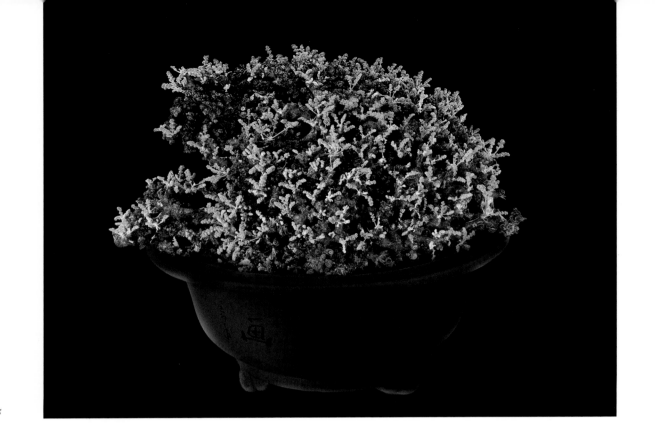

交互洋葵
Pelargonium alternans

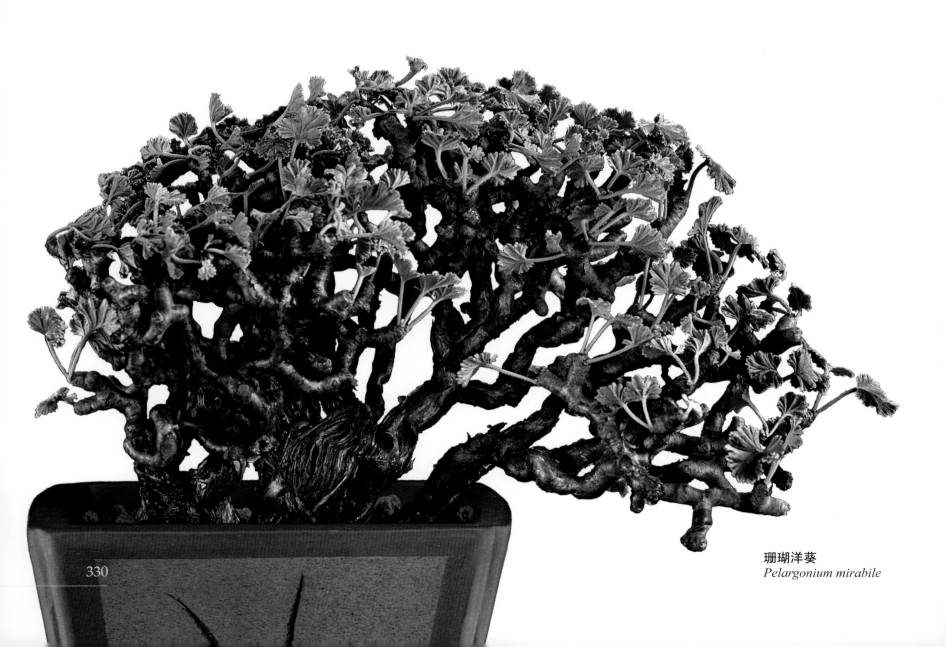

珊瑚洋葵
Pelargonium mirabile

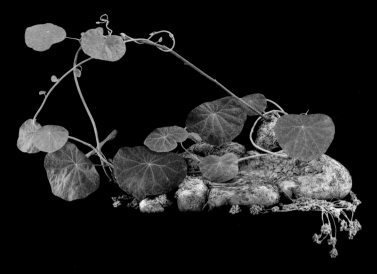

脉纹山乌龟
Stephania venosa

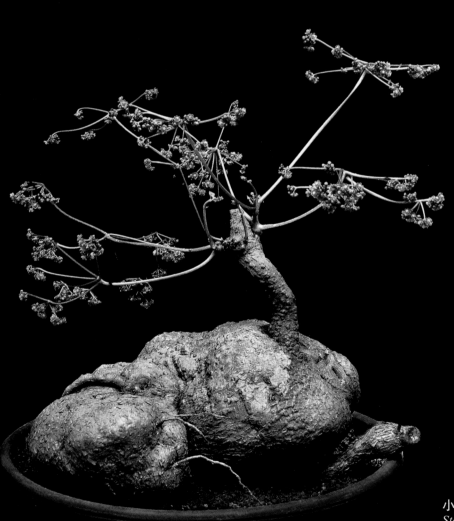

小叶地不容
Stephania succifera

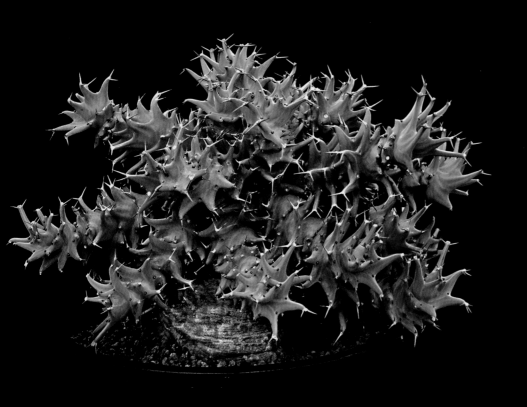

旋风麒麟
Euphorbia groenewaldii

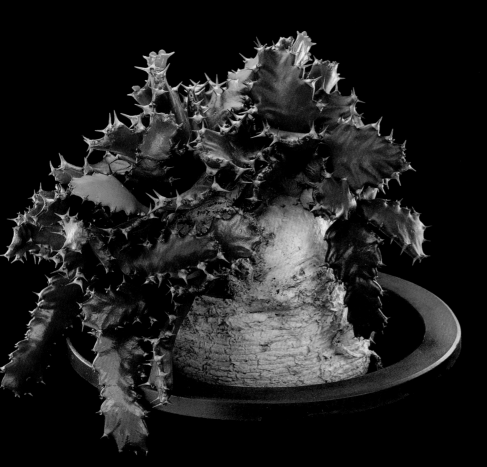

奇怪岛
Euphorbia squarrosa

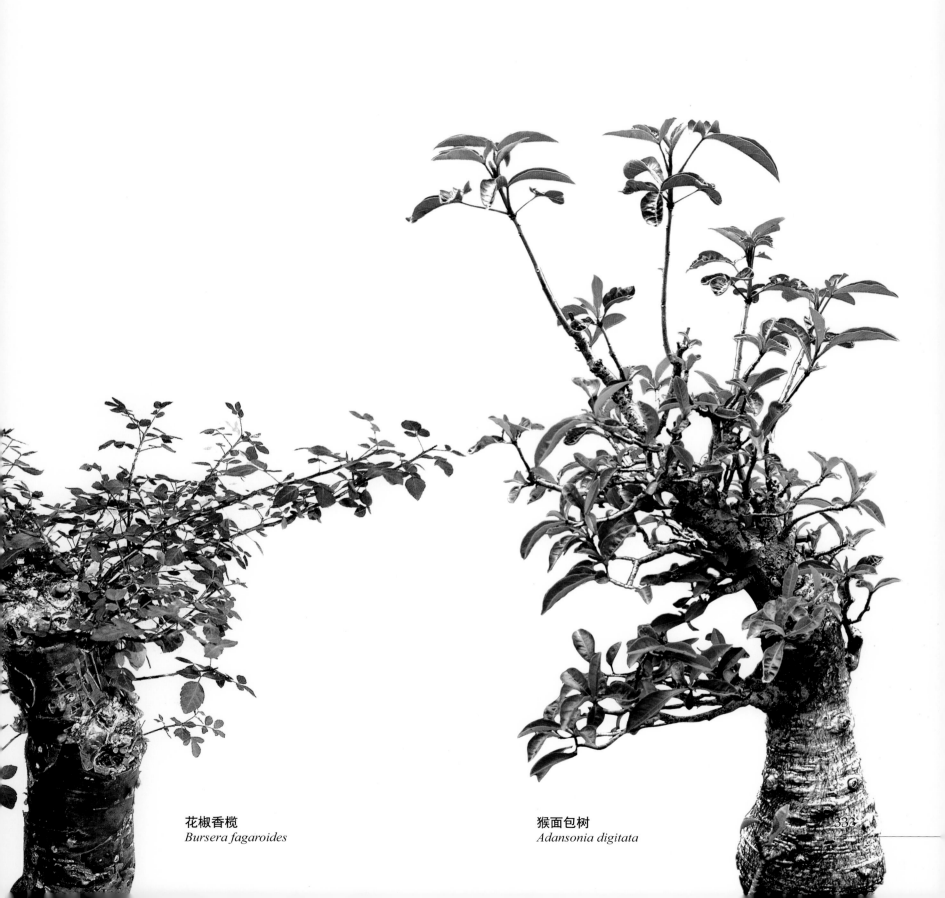

花椒香榄
Bursera fagaroides

猴面包树
Adansonia digitata

333

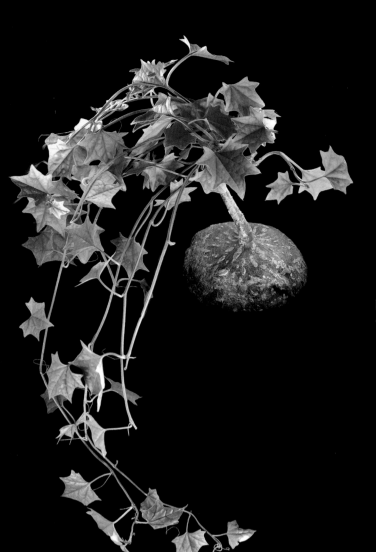

睡布袋
Gerrardanthus macrorrhizus

格氏瓮
Adenia goetzei

观峰玉
Fouquieria columnaris

后　记

　　这本画册从着手拍摄到出版，整整用了八年时间。辛勤的耕耘带来的是收获的喜悦，也了却了我一个久藏于心的美好愿望：向人们尽可能完美地展现这一独具魅力的多肉植物世界，共同体味大千世界的广阔、生命的灿烂和美丽的无限。

　　画册最终采用的七百余幅图片，是从数千张图片中精选出来的。诚然，这样一部大型画册，绝非短时间内可以完成的。首先，这些植物四时相异，冷暖有别，昼夜不同。它们有的秋冬落叶，有的夏季休眠；有的花开数日，有的仅开几个小时；有的白天盛开，有的夜晚绽放。要想把它们生命中最美的时刻留住，需要漫长的等待和虔诚的守候。其次，画册中的相当一部分图片是在室内拍摄的，可以比较从容地布光，选取最佳的拍摄角度。但也有一部分是在室外的植物园林、花棚甚至野外拍摄的，要想获得尽善尽美的画面，就需要格外下一番功夫。难度之大，可想而知。也正是在这百般的艰辛之中，却又享受着无尽的创作乐趣。每当完成一张满意的图片，那成功的满足和欣喜莫可名状。可以说，八年来就是这样如醉如痴，乐此不疲。中科院植物研究所李振宇教授，以及北京植物园等诸多专业人士为这数百棵植物的名称和学名做了反复、认真的校订，使这本画册更臻完善，且具备了一定的科普作用和研究参考价值。一部摄影作品兼具了如此功能，这确是我在筹拍之初未敢企及和奢望的。画册的编辑亦得到众多外国友人、养植业者和爱好者的倾情帮助，在此恳诚致谢，恕不一一。

　　多肉植物世界是花卉摄影的无尽宝库，有数不清的品种，拍不完的画面。我所能拍摄到的，不过是沧海之一粟，微乎其微。造化和心缘的驱使，令我的拍摄热情始终不减。因此，对我来说，画册虽然出版了，拍摄仍在继续。

李长顺

二〇一一年六月于北京

Afterword

It took me eight years to prepare this album for publication. My work has proved fruitful and has helped fulfill one of my long-cherished hopes: bringing out the best in succulents and sharing with others the wonders of our world, the splendor of life, and the boundless beauty of nature.

The collected 700 plus photos represent a selection from more than one thousand. Obviously such an album isn't accomplished on short notice. As succulents are subject to seasonal changes in climates and day length, they either wither in autumn or winter, or remain dormant during summer; some of them bloom for days but others only last a few hours; some flowers by day and others by night. So patience is required to eternalize their most glorious moments. Favorable lighting and angles are always available to photographers working indoors, but botanical gardens, greenhouses and the countryside make for demanding working conditions. One can well imagine the difficulties involved. Having said that, these difficulties are also an enjoyable part of the process of artistic creation. The joy of success always comes with a good photo. It's no exaggeration that I've been immersed in this project for the last eight years. Professor Li Zhenyu from the Institute of Botany, Chinese Academy of Sciences, and experts from Beijing Botanical Garden have carefully revised the common and Latin names of hundreds of the collected plants. They have brought this album to perfection and made it a resource for popular science and professional research. I never expected it to go so far. I also express deep gratitude to many foreign friends, cultivation specialists and enthusiasts for their willingness to offer assistance to this album.

Succulents include innumerable species and represent an inexhaustible source for flower photography, and my photos only provide an overview. My enthusiasm for photographing succulents is part of my nature, and it won't come to an end with the publication of this album.

Li Changshun
June 2011, Beijing

作者简介
Author Biography

李长顺　山东临清人，回族。毕业于北京大学俄罗斯语言文学系。多年从事翻译、外事及对台、对外宣传以及对世界各国人民的友好联络工作，任中国国际友好联络会副会长，顾问等职。

Li Changshun was born into a Hui ethnic family in Linqing, Shandong Province. Graduated from the Department of Russian Language and Literature, Peking University, he is a very experienced Russian translator. He is Vice President of the China Association for International Friendly Contact (CAIFC).